VELAZQUEZ

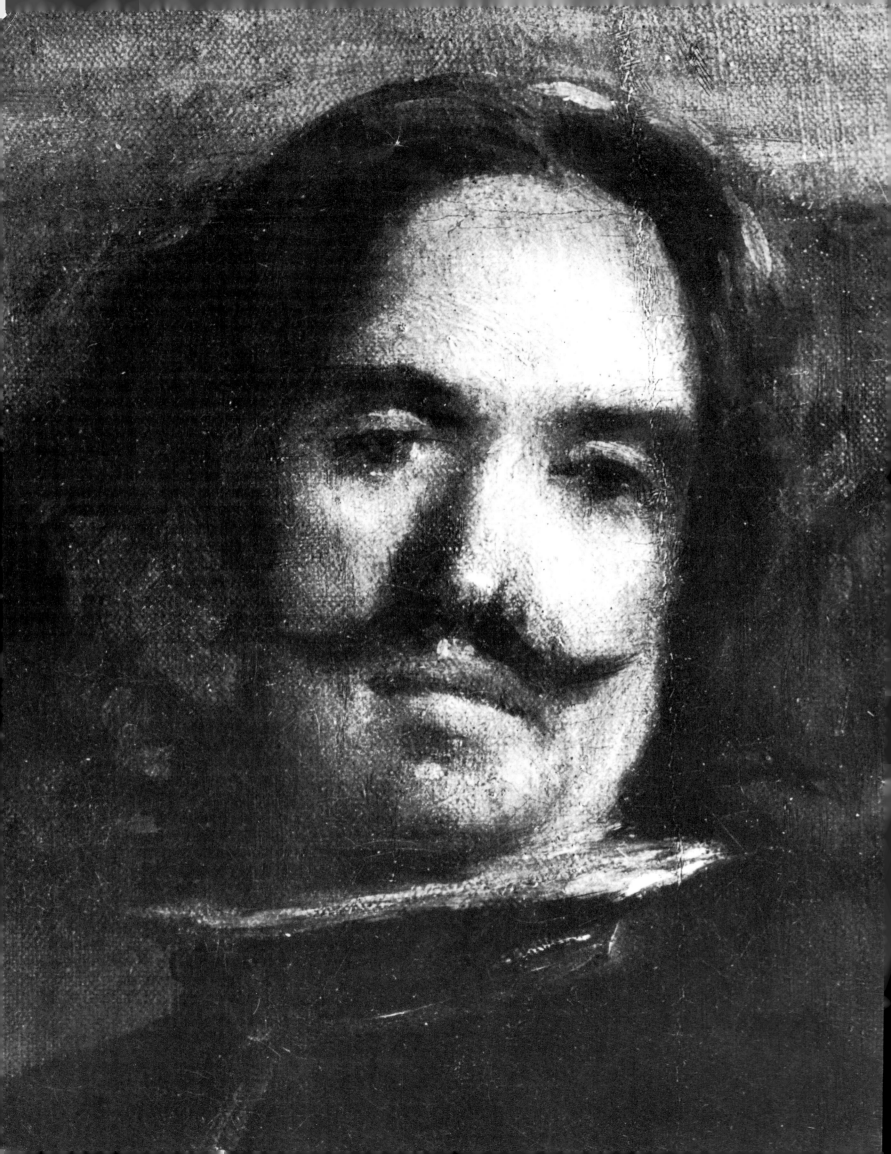

VELAZQUEZ

Enriqueta Harris

PHAIDON · OXFORD

Phaidon Press Limited,
Littlegate House, St Ebbe's Street, Oxford OX1 1SQ

First published 1982
© 1982 by Enriqueta Frankfort

British Library Cataloguing in Publication Data

Harris, Enriqueta
 Velázquez.
 1. Velázquez, Diego Rodríguez de Silva y
 I. Title
 759.6 ND813.V4

 ISBN 0-7148-2231-0

Set in Monophoto Garamond by Filmtype Services Limited, Scarborough, England
Printed in Italy by Fabbri, Milan

The publishers would like to thank the following copyright owners for permission to reproduce
photographs: Biblioteca Nacional, Madrid 160, 193; Bibliothèque Nationale, Paris 14; by per-
mission of the British Library 3 (K Top.LXXII.16), 118; Trustees of the British Museum 65;
courtesy of Christie's (photo A.C. Cooper) 204; Courtauld Institute of Art, London 205; Fototeca
Unione, Rome 141, 142; John R. Freeman & Co. 189; courtesy of the Hispanic Society of America
4, 48, 158; copyright by the Metropolitan Museum of Art, New York 148, 149; National Galleries
of Scotland 8; Alberto Palau, Seville 45; Prado Museum, Madrid 23, 155, 156; by gracious
permission of H.M. the Queen 6, 17, 18, 19; Soprintendenza archeologica della Toscana, Florence
138; SPADEM 191; by courtesy of the Victoria & Albert Museum, Crown copyright 27, 38, 39,
153, 192; reproduced by permission of the Trustees, the Wallace Collection, London 108; War-
burg Institute, London 20, 37, 50, 62, 66, 128.

Frontispiece. Velázquez at the age of 57. Close-up of the artist's face in the self-portrait in *Las Meninas*. Detail of
Plate 184.

Contents

In memory of Henri Frankfort

Preface

Many of the facts of Velázquez's life are documented. But although documents continue to be brought to light, many are still missing and those that we have relate less to his activity as a painter than to his duties as palace official, to his various employments in the royal household rather than to his post as Court Painter. Records of personal interest, including his correspondence and drawings, are lamentably scarce. We are still, therefore, dependent for much of our knowledge of the man, the artist and his work on his two early biographers. Francisco Pacheco (1564–1644), Velázquez's master and father-in-law, in his treatise *Arte de la Pintura*, published in Seville in 1649, is the source of most of the information we have about his youth and early training in Seville, his move to the court, his reception there and his first visit to Italy. Pacheco finished his manuscript in 1638 and his last reference to Velázquez is in that year. The first complete biography was not published until 1724, more than 60 years after Velázquez's death. This was contained in the *Parnaso Españo!*, the third volume of *El Museo Pictórico y Escala Óptica* by the Court Painter and scholar Antonio Palomino de Castro y Velasco (1655–1726), the 'Spanish Vasari', which was soon translated in abbreviated form into several languages. Palomino's life of Velázquez, by far the longest and most detailed of all the lives in his Spanish 'Parnassus', owes its importance to the fact that he had at his disposal a manuscript (since lost) by one of Velázquez's last pupils, Juan de Alfaro (1643–1680). This manuscript, Palomino writes, must have been intended to be made into a book, 'for after much revision and after cutting more than half the text (though I have added some things that I heard from Carreño and other elderly people), the result is still rather lengthy'. Palomino's life of Velázquez, based on Alfaro's manuscript and incorporating most of Pacheco's text as well as being enriched by the reminiscences of other people who had known the Master, has been used by all his later biographers. Stripped of its adornment of classical and poetical digressions, the information it provides is in most respects remarkably reliable, confirmed as it can be by documents and by the inventories of the royal palaces to which he had access. These, he says, he knew very well. (He knew them, moreover – the Alcázar, the Buen Retiro and the Torre de la Parada – while they were still intact.) Palomino's narrative and his chapter headings accurately reflect the growing importance in Velázquez's life story of his occupations as palace official as well as Court Painter.

The texts of Pacheco and Palomino, which form the basis of the present study of Velázquez, are published in translation in appendices. Palomino's life is printed for the first time in its entirety in English. The selection of the plates and of

paintings for discussion has been made with a view to illustrating these texts. Other works have been included either for their special importance or to make the selection as representative as possible. Many are documented but no attempt has been made to include all the documented works or all those that are considered autograph. Additional plates represent people and places associated with Velázquez and the background to his life.

I am greatly indebted to many friends and colleagues for help in the preparation of this book. I must thank Edith Helman, in particular, for her aid with the translations of Pacheco and Palomino and Philip Troutman for a specialist's careful reading of the typescript. At the Phaidon Press, the late Keith Roberts encouraged me to begin the book; Bernard Dod has had the burden of seeing it through the press and Barbara Mercer designed it. At the Warburg Institute the late Otto Kurz was a constant source of information; the Photographic Collection and Studio, especially the Curator, Jennifer Montagu, have helped in countless ways; and J. B. Trapp read my drafts and suggested improvements. These acknowledgements do not exhaust my indebtedness; I hope that those not named will accept a more general expression of thanks.

1,2. The artist's signatures: (*above*) 'Señor/ Diego Velasquez/Pintor de V. Mg.' ('Sire, Diego Velázquez Painter to Your Majesty'). Detail of *Philip IV in Brown and Silver* (Plate 79). *c.* 1631–2. (*below*) 'Alla Sant^a di N^{ro} Sig^{re}/Innocencio X^o/Per/ Diego de Silva Velasquez dela Ca/mera di S. M^{ta} Catt^{ca}' ('To the Holiness of Our Lord Innocent X by Diego de Silva Velázquez, [Gentleman] of the Bedchamber of His Catholic Majesty'). Detail of *Pope Innocent X* (Plate 150). 1650. Two of the very few extant examples of signatures on Velázquez's paintings.

1 The Artist's Life

Diego Rodríguez de Silva Velázquez was born in 1599 in Seville, where he was baptized in the parish church of San Pedro on 6 June. Both his parents, Juan Rodríguez de Silva and Gerónima Velázquez, were natives of the city, but his paternal grandparents, who were said to be of noble descent, came to Seville from Oporto (Portugal had come under the Spanish crown in 1580). Diego, the first-born of seven children, usually adopted his mother's surname – a custom in Andalusia – and signed himself *Diego Velasquez* or *Diego de Silva Velasquez* (Plates 1, 2).

Palomino's statement that before entering the studio of Francisco Pacheco Velázquez was apprenticed for a short time to the Seville painter Francisco de Herrera the Elder is unconfirmed. But it is lent credence by Pacheco's attack on 'someone who had the effrontery' to try to rob him of the glory of his old age by claiming Velázquez as his pupil. Velázquez, moreover, when applying for admission to the painters' guild, says that he had learnt his art from qualified teachers. If he did study with Herrera, he could only have been 10 or 11 years old at the time, for in September 1611, when he was just turned 12, he was formally apprenticed to Pacheco for a period of six years, to date from 1 December of the previous year. Why the contract is backdated is not known, but it has been suggested that it could be because Velázquez began his apprenticeship with Herrera while Pacheco was absent from Seville. We know that Pacheco spent some time in 1611 in Madrid and the Escorial and visiting El Greco in Toledo, and he himself, writing many years later, says that Velázquez's training lasted only five years.

The city of Seville in Velázquez's youth had become one of the most important centres of religion and religious art in Spain. It was also, as chief port of trade with the New World, a city of considerable wealth (Plate 3). Even today Seville is notable for the number of churches, convents and holy images it possesses, many of them of seventeenth-century origin, and for the daily scenes of popular piety and the splendour of its displays of public devotion, especially during Holy Week.

Velázquez in his teens would have witnessed the remarkable events of the so-called Marian War, the passionate controversy over the mystery of the Immaculate Conception which began in Seville with an attack by a Dominican preacher in 1613. Nowhere in Christendom was the doctrine more zealously defended and nowhere was the news of a papal decree of 1617, prohibiting public denial of the mystery, more enthusiastically received with popular celebrations – pageants, bullfights and church festivals.

With Hercules as its legendary founder, Seville was at the same time a city

proud of its classical heritage, nourishing archaeologists and men of letters as well as saints and churchmen. Francisco Pacheco, Velázquez's teacher, was a poet and writer as well as a painter, and he was also art censor for the Inquisition, devoting a large part of his *Arte de la Pintura* to rules for the orthodox treatment of the Christian mysteries. Pacheco's house, which Palomino was to call 'a gilded cage of art', was effectively a 'literary academy' as well as a school of painting, a meeting place for humanists, poets and scholars, theologians and painters. The young Velázquez, according to the terms of his apprenticeship, lived in the house of his master, who was required to give him board, lodging and clothes, as well as to teach him the art of painting. He would, therefore, have been in contact with Pacheco's intellectual friends as well as with his family.

Palomino, but not Pacheco, gives a list of books on art which he says Velázquez studied at this time, adding that he also had a knowledge of sacred and secular writings, and that he was friendly with poets and orators. The books he mentions, many of them recorded later in Velázquez's library – famous sixteenth-century Italian treatises on anatomy, architecture, perspective and physiognomy – would have been known to most educated artists of his time. Pacheco tells us little enough about his training of Velázquez, only that he taught him to work from nature and to make drawings for his paintings, and he mentions some executed in black and white chalk of various local models, including a young country lad who posed for Velázquez 'adopting various expressions', whereby 'he gained assurance in portraiture'. The drawings have not survived, but many of the figures that appear again and again in the early paintings were evidently among these regular models (Plates 42, 43). It was, Pacheco says, from these beginnings, the portraits and also the painting of *bodegones*, that his pupil attained truth in the imitation of nature. Palomino, after quoting Pacheco on these early drawings from the model, also declares that Velázquez's first subjects included animals and *bodegones*, a genre that Pacheco goes out of his way to praise. Palomino, but not Pacheco, describes several of Velázquez's *bodegones*, including the *Water Seller* (Plate 39), which he says was so celebrated that it was kept in his time in the Buen Retiro Palace.

4 (*Right*). Spanish School, 17th century. *Velázquez as a Young Man(?)*. Inscribed: 'BELAQVES/Joven'. Black and red chalk, 6⅜ × 4⅜ in. (16.3 × 11.1 cm.). New York, The Hispanic Society of America. The identification of the sitter, based on the inscription with the misspelt name of Velázquez, is tentative. There is some resemblance to the sitter of Velázquez's portrait of a young man (Plate 5), sometimes thought to be a self-portrait. The drawing once belonged to Sir William Stirling-Maxwell, the pioneer British collector and writer on Spanish art.

5 (*Far right*). *A Young Man Wearing a Golilla: Self-portrait(?)*. c. 1624–5. Canvas, 22 × 15⅜ in. (56 × 39 cm.). Madrid, Prado Museum. (L-R 27)
The suggestion often put forward that this may be a self-portrait is given some support by the drawing (Plate 4). The *golilla*, the collar introduced at the Spanish court in 1623, the year Velázquez settled in Madrid, is worn in both portraits. If they do represent the same sitter (Velázquez?), he appears a year or two older in the painting than in the drawing.

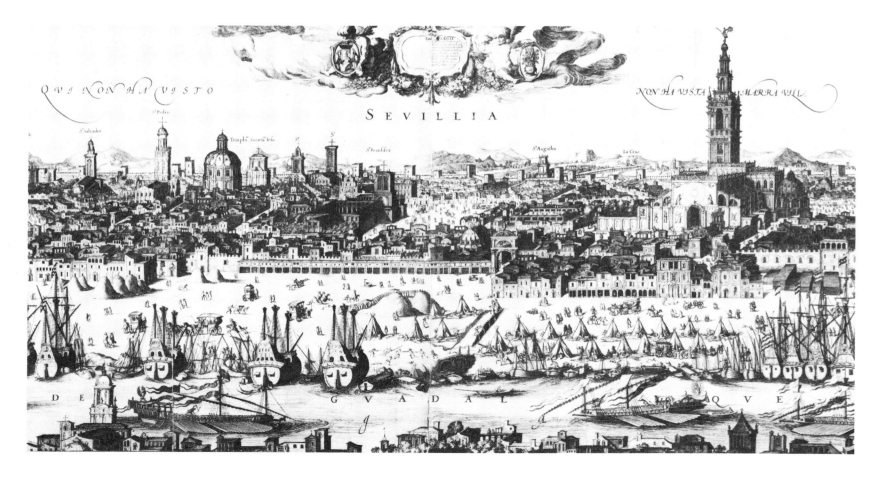

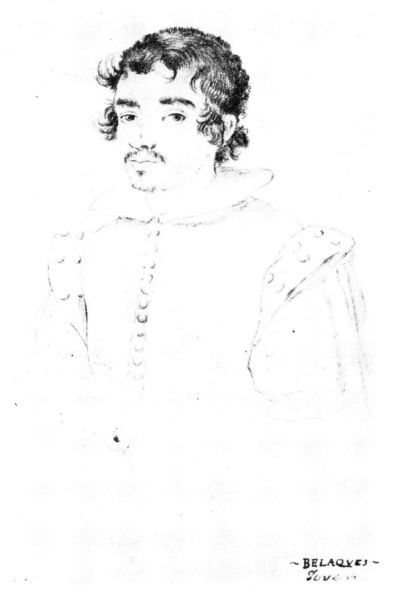

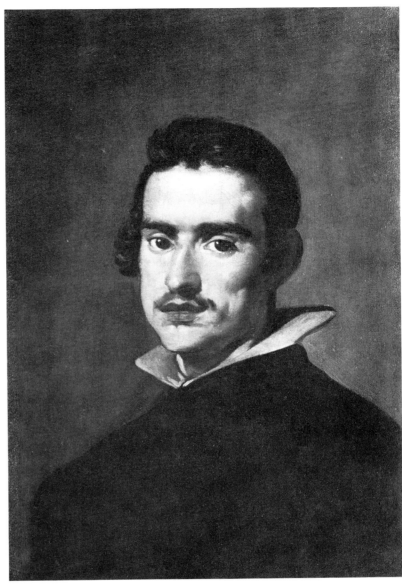

Neither biographer mentions Velázquez's early paintings of religious subjects, which were the chief occupation of Sevillian painters, whose training included the colouring of religious carved images as well as painting on canvas or panel. At the end of his period of apprenticeship, on 14 March 1617, Velázquez was examined and accepted as a 'master painter of religious images, and in oils and everything related' ('*maestro pintor de ymaginería y al olio y todo lo a ello anexo*') and was licensed to practise in Seville or anywhere else in the kingdom, to set up shop and to take assistants and apprentices.

In the following year, on 23 April 1618, Velázquez married Pacheco's daughter, Juana de Miranda, who was three years his junior. 'After five years of education and training', his father-in-law wrote many years later, 'impressed by his virtue, integrity and excellent qualities, and also by the promise of his great natural genius, I gave him my daughter in marriage.' The wedding, celebrated in a poem by Baltasar de Cepeda, was the occasion of one of the literary contests much favoured in Seville. In the year of his marriage, Velázquez painted the *Old Woman Cooking Eggs* (Plate 28), the earliest known dated work. His first daughter, Francisca, was born in 1619, in 1620 he took an apprentice, Diego de Melgar, and in 1621 his daughter Ignacia was born. There is no record of any other children.

In April 1622, Velázquez set out on his first journey to Madrid, after giving

3. *Bird's-eye View of the City of Seville*. 1617. Detail of a Flemish (?) engraving, *c.* 20 × 82 in. (50.8 × 208.2 cm.) British Library.
The inscription is an inaccurate version of the Spanish saying: 'Who has not seen Seville has not seen a marvel.' The engraving is dated in the year Velázquez was examined as Master Painter; the Church of San Pedro, where he was baptized, is seen below the 'V' of 'Visto'.

power of attorney to his father-in-law to collect money due to him, apparently for the rent of several houses that he owned in Seville (cf. Plate 8). One of the witnesses to this document was his brother Juan (born 1601), who, like Velázquez himself and the other witness Francisco López, is described as 'pintor de ymaginería', but nothing is known of Juan's activity as an artist. Pacheco gives as Velázquez's reason for going to Madrid his wish to see the Escorial, and he no doubt recommended him to the three fellow Sevillians who, he says, gave the young painter a good reception: Luis and Melchior del Alcázar, presumably the two brothers of that name who had played a prominent part in the celebrations in Seville in 1617 in honour of the mystery of the Immaculate Conception, and Juan de Fonseca, the royal chaplain, former canon of Seville Cathedral, who showed his admiration for Velázquez's painting by acquiring the *Water Seller* (Plate 39), which is recorded in his collection at his death in 1627. Velázquez's attempt on this occasion to have the King and Queen sit to him was unsuccessful, but he did paint a portrait of the poet *Luis de Góngora* (Plate 29), at the request of Pacheco, who no doubt wanted it as a model for one of his drawings for his *Libro de Retratos*, the collection of portrait drawings of famous Spaniards, accompanied by verse, on which he had been engaged for many years. It is not known how long Velázquez remained at the court, only that he was back in Seville by January 1623 and was still there on 7 July. In the following month, he had returned to Madrid and was painting the King's portrait.

According to Pacheco, Fonseca summoned Velázquez to return to the court on the order of the Prime Minister, the Conde-Duque de Olivares, a fellow Sevillian, although born in Rome. The portrait Velázquez painted of his host Fonseca, mentioned by Pacheco, was taken to the palace where it was seen and admired by everyone and won him the opportunity of painting a portrait of the King. There was some delay on account of the King's many engagements – at the time he was entertaining the Prince of Wales, who had come to Madrid to woo the King's sister – but already on 30 August Velázquez had painted the portrait. (Velázquez had clearly arrived some weeks earlier.) It was so successful, Pacheco goes on to say, that Olivares declared that the King had never before been successfully painted. At this time, he says, Velázquez also made a sketch of the Prince of Wales, who rewarded him with 100 escudos. This is no doubt the portrait referred to in the account book for the Prince's Spanish journey: 'paid unto a painter for drawing the Prince's picture, signified by Mr Porter for the Princes ... 1100 [reals]'. Because of the date of the entry, 8 September, after the Prince had left Madrid, it has been suggested that the portrait may have been made at the Escorial, where he stopped on his way home. None of these portraits painted in 1623, neither Fonseca's, nor the King's, nor that of the Prince of Wales (cf. Plate 6), is known today.

Velázquez's future was now assured. He was ordered by Olivares, Pacheco writes, to move to Madrid with his household, which consisted so far as we know of his wife, two daughters and probably his apprentice Diego de Melgar, who still had three years to serve; and on 6 October 1623, he was appointed Painter to the King with a salary of 20 ducats a month, and as a special concession it was arranged that he was to receive additional payment for his paintings.

Velázquez's was the first appointment of Court Painter made by the young King Philip IV, who had come to the throne in 1621 at the age of 16. For Velázquez it was the first of many official appointments at the palace, some of them honorary, some with onerous duties. Henceforth, from the age of 24 until his death, he was to work in the service of the King and to live in close contact with him. Only twice did he leave the royal entourage, to go to Italy. When

6. Daniel Mytens (*c.* 1590–1647). *Charles I when Prince of Wales.* Dated 'ANNO 1623'. Canvas, 80⅜ × 51 in. (204.2 × 130 cm.). Royal Collection.
Probably the portrait painted soon after the Prince returned to London from Madrid for which Mytens (9 October) received payment of £30: a full-length portrait of Charles delivered to the Spanish Ambassador. Velázquez's sketch painted only a few weeks earlier must have looked very different.

8. Spanish School 17th century. *The Alameda de Hercules, Seville.* Canvas, 42 × 64 in. (106.5 × 162.5 cm.). Private collection.
One of several paintings of the great tree-lined promenade that still exists; at its entrance the so-called columns of Hercules, the traditional founder of the city, with statues of Hercules and Julius Caesar on top. Velázquez as a young man owned houses in the Alameda, facing the columns. The painting came from the collection of King Louis-Philippe of France, where it was attributed to Velázquez.

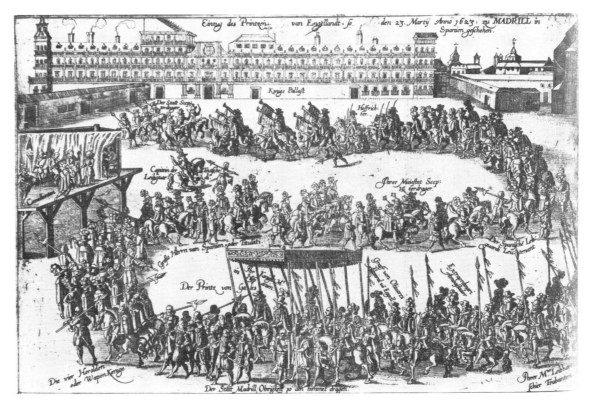

7. *The Arrival of Charles Prince of Wales at the Alcázar, Madrid*. Anonymous engraving with German inscriptions, 7¾ × 11⅜ in. (19.6 × 29 cm.).
The Prince's arrival in Madrid, 'incognito', to woo Philip IV's sister the Infanta Maria was followed by his public entry on 23 March 1623 with great ceremonial and weeks of festivities. An English business agent describes the occasion: 'It was a very glorious sight to behold; for the custom of the Spaniard is, tho' he go plain in his ordinary habit, yet upon some Festival or cause of Triumph there's none goes beyond him in gaudiness' (James Howell, *Epistolae Ho-Elianae*, London, 1892, I, p. 166).

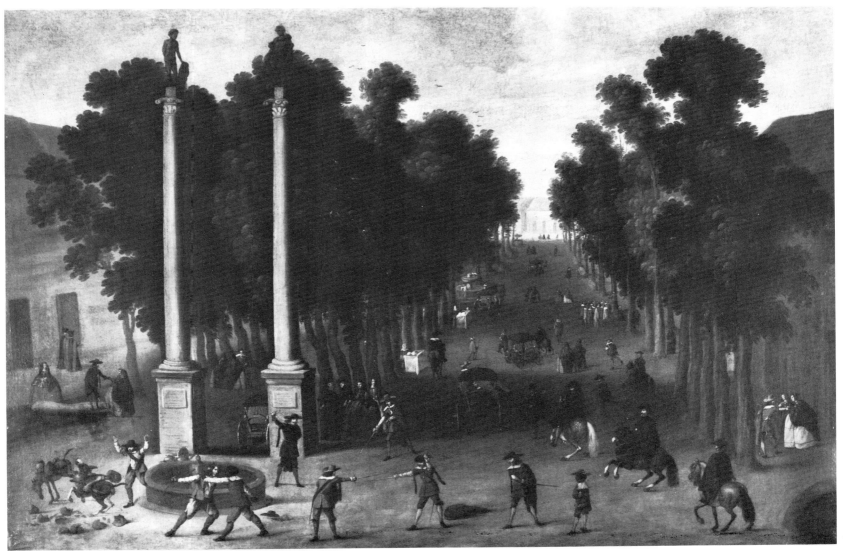

Velázquez settled at the court, Madrid was the rapidly growing capital of Spain (Plate 9), with a royal household noted for its extravagance and dominated by the most rigid etiquette and the most elaborate ceremonial of any European court. Though Philip IV made many vain attempts during his reign to save the country from financial ruin by the introduction of sumptuary laws, he put no curb on his acquisitions of works of art, with which he enriched the collection inherited, together with his love of painting, from his grandfather and great-grandfather, Philip II and Charles V. Except that his payments were usually in arrears, Velázquez's activity as Court Painter, and later as the person responsible for the selection as well as the arrangement of the decorations of the royal apartments, appears to have been unaffected by the growing economic crisis. Nor does the story of his career make more than a passing reference to the wars in which Spain was engaged abroad and at home during most of his life.

The first painting that Pacheco mentions after Velázquez's appointment as Painter to the King is an equestrian portrait of Philip IV. According to Pacheco, the portrait, 'painted from life, even the landscape', was exhibited outside the church of San Felipe in the Calle Mayor (Plate 10), where Pacheco himself was witness to the admiration and envy it aroused. Velázquez, he says, was awarded payment of 300 ducats and a pension of a further 300. The pension, an ecclesiastical benefice, required papal sanction, and Velázquez, in his appeal for dispensation to enjoy the benefice assigned to him by the King 'because of his poverty and family commitment', expressed the hope that his married state would be offset by the fact that he had no son to inherit the pension, his only descendants being daughters. The necessary papal sanction was granted, according to Pacheco, in 1626. Unfortunately, this first equestrian portrait of the King, that earned Velázquez these extra emoluments, has also not survived. It is described in the diary of Cavaliere Cassiano dal Pozzo, the famous Italian connoisseur and collector, who came to Madrid in 1626 with the legation of Cardinal Francesco Barberini: 'a portrait of the present King on horseback, armed, life-size, with a fine land-

9. 'LA VILLA DE MADRID CORTE DELOS REYES CATOLICOS DE ESPANNA', *c.* 1630. Anonymous Dutch engraving, published by F. de Wit, Amsterdam. 16½ × 28½ in. (41.9 × 72.5 cm.).

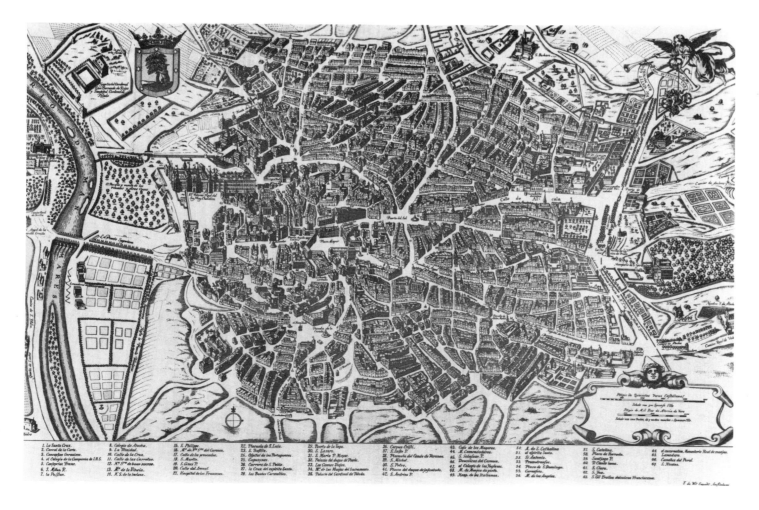

10. *The Church of San Felipe in the Calle Mayor.* Detail from Pedro Texeira, *Topographia de la Villa de Madrid,* Antwerp, 1656.

In front of the church was the forecourt with steps, the '*gradas de San Felipe*', a famous meeting-place in Madrid, where Velázquez exhibited his first equestrian portrait of Philip IV (Pacheco).

scape . . . by a Spanish painter' (he does not name the artist). The portrait hung in the newly decorated *Salón nuevo* – later to be renamed the *Salón de los espejos* – the showroom in the royal palace, in a place of honour opposite Titian's equestrian portrait of *Charles V at Mühlberg* (Plate 85). Cassiano's diary also provides the only first-hand record of any adverse criticism of a painting by Velázquez: when referring to a portrait of Cardinal Barberini, just painted, he complains of its 'melancholy and severe air' ('*riusciva d'aria malinconica e severa*').

Not long afterwards, a very different charge was brought against Velázquez, according to his friend, the painter and writer on art, Jusepe Martínez (1602–82). His skill as a portrait painter aroused the envy of some unnamed critics, who dared to accuse him of only being able to paint heads, whereupon the King ordered him to paint a large canvas representing the *Expulsion of the Moriscos*, in competition with three other painters. Vicente Carducho, Eugenio Caxés and Angelo Nardi are named as his competitors by Palomino, who also provides the only detailed description that we have of Velázquez's painting, which hung in his time in the *Salón de los espejos* and perished in the fire that destroyed the Alcázar, the Habsburg palace in Madrid, in 1734. Palomino also transcribes the inscription on the painting with the date, 1627. The judges, according to Pacheco, who only briefly mentions the painting 'made in competition with three painters of the King', were Giovanni Battista Crescenzi and Juan Bautista Maino, both 'connoisseurs of painting', who acclaimed Velázquez the winner.

Velázquez's success in the competition was followed by his appointment, probably intended as a reward, as Gentleman Usher in March 1627, an office he later (in 1634) had transferred to his son-in-law, Juan Bautista Martínez del Mazo, and in September 1628 he was awarded an additional daily allowance in kind, to the value of 12 reals.

In the summer of 1628, when Velázquez was 29 years old, there occurred what must have been one of the major events in his life: the visit to Spain of the great Flemish painter Peter Paul Rubens, 22 years his senior. On his previous visit, in 1603, Rubens had praised the Titians and other Old Master paintings in the Spanish royal collection but had complained of the worthlessness of Spain's modern painters, 'the incredible incompetence and carelessness of the painters here'. Now, according to Pacheco, he sought the company of no artist other than Velázquez, cementing a friendship that had begun by correspondence. Unfortunately, the correspondence has not survived; there is no mention of the Spanish artist in the extant letters of Rubens. The two artists must have spent many hours and days together and watched one another at work. Pacheco, in his chapter on Rubens, mentions the visit they made together to the Escorial, and it was probably this visit that Rubens recorded in a drawing (cf. Plate 11) and recalled in letters written many years later (1640), though without reference to his companion. Palomino adds that the sight of all the great paintings the two artists saw on their visit to the Escorial revived the desire Velázquez had to go to Italy, and Rubens may well have encouraged him with an account of all the famous works of art to be seen there. He may too have planned to accompany Velázquez, for we know he had hoped to make a tour of Italy on his way home and to travel to Naples with the Queen of Hungary, the sister of Philip IV, towards the end of March, but her departure was delayed and Rubens left Madrid for Brussels en route for London for peace talks on 29 April 1629. Velázquez, after being promised several times that he could go, eventually left for Italy in August.

Pacheco's treatise is our chief source of information about Velázquez's first journey to Italy, and some of the details he gives are so personal that they could only have come from Velázquez himself, perhaps in letters that he sent home to

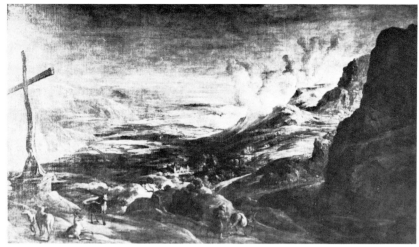

11. Verhulst after a drawing by Rubens. *View of the Escorial. c.* 1640. Panel, 23⅝ × 39⅜ in. (60 × 100 cm.). Private collection.
Rubens in a later letter (April 1640) describes the mountain scene, the wooden cross and the hermit with a mule, of which he says he made a drawing on the spot when he was in Spain in 1628–9; and in a further letter he mentions a copy of the drawing made by Verhulst. Possibly the occasion was his visit to the Escorial with Velázquez, recorded by Pacheco.

his family. Who else could have told Pacheco, for instance, that Cardinal Sacchetti had wanted the artist to stay with him in Ferrara and eat with him, but that Velázquez excused himself because he did not eat at ordinary hours, though he offered to change his ways? Pacheco's account is repeated and enlarged by Palomino, who also adds descriptions of the places Velázquez visited on his way to Rome. The documents relating to his journey include letters from some of the Italian ambassadors in Spain announcing his visit, describing him as a young portrait painter, a favourite of the King and Olivares, who was said to be going to Italy 'to see and study things of his profession', though there was some suspicion that he might be engaged in espionage. Flavio Atti, the Ambassador from Parma, who voiced this suspicion, wrote that Velázquez was taking with him letters from the Nuncio and all the other ambassadors.

The royal permit for Velázquez to go to Italy and receive his salary during his absence was issued on 26 June 1629; the King also gave him money for his journey, according to Pacheco, and Olivares gave him money and a medal with the portrait of the King and letters of recommendation. He sailed from Barcelona on 10 August 1629 in the company of Ambrogio Spinola, whom a few years later he was to immortalize in his *Surrender of Breda* (Plate 122). (Spinola was being sent to Milan to uphold the Spanish claim in the conflict over the succession to the dukedom of Mantua; he died in 1630, following Olivares's denial of his power to negotiate peace.) They arrived in Genoa on 23 August, and Velázquez probably accompanied Spinola as far as Milan and then went on to Venice. There, according to Pacheco, he stayed with the Spanish Ambassador – Cristóbal de Banfente y Benavides – who entertained him, and because of the hostile atmosphere (Venice supported France against Spain), sent his servant with Velázquez when he went out sightseeing. Palomino adds that while he was in Venice, Velázquez spent some time making drawings, especially after Tintoretto's *Crucifixion*, and that he also made a copy (he does not say whether a drawing or painting) of Tintoretto's *Communion of the Apostles* [*Last Supper*], which he took back to Spain. From Venice, Velázquez went on to Ferrara where he was received by the governor, Cardinal Giulio Sacchetti, a former Nuncio in Spain (1625–6), who because of Velázquez's unusual eating hours ordered a Spanish servant of his to find lodgings for the artist and look after him in every way, including accompanying him on the road to Cento, where Pacheco says he spent a 'short but very enjoyable time'. From there he hurried on to Rome, passing through Loreto and Bologna but not stopping to present his letters of introduction.

Arrived in Rome, Velázquez was given rooms in the Vatican Palace through the good offices of the nephew of Pope Urban VIII, Cardinal Francesco Barberini. The Cardinal, Pacheco says, was a good friend to Velázquez during his stay in Rome. He had met Velázquez, of course, during his visit to the Spanish court

in 1626, when he had sat to him for the portrait criticized by Cassiano dal Pozzo as 'melancholy and severe'. That Velázquez himself was perhaps of a melancholy disposition is suggested by the reasons, recounted by Pacheco, that he gave for leaving his lodgings in the Vatican: 'they were very isolated and he was very lonely there'. All he wanted was to be able to go there when he liked and be able to make drawings after Michelangelo's *Last Judgement* and the paintings of Raphael. He chose the Villa Medici as the most suitable place to spend the summer, because it was 'high and airy' and had 'antique sculptures to copy'. So in April 1630 the Keeper of the Villa Medici was approached by the Spanish Ambassador, the Conde de Monterrey, and wrote to Florence for permission to give lodgings in the 'Giardino della Trinità de' Monti' to a painter to the King of Spain, who was said to be 'the most exquisite painter of portraits from the life'. The reply from Florence, dated 14 May 1630, was to the effect that orders had already been sent for Velázquez to be accommodated. (The exchange of letters on this subject are the only documents we have relating to Velázquez's stay in Rome.) Permission to stay in the Villa Medici was a favour granted by the Grand Duke of Tuscany to distinguished visitors to Rome, among them Galileo Galilei, who arrived there from Florence in the same month as Velázquez, and Velázquez may well have been one of the guests who were said to have particularly enjoyed the great scientist's conversation.

After remaining there for over two months, Velázquez had an attack of fever that obliged him to move nearer to the house of the Spanish Ambassador, who sent him his doctor and medicines and also sweetmeats.

The only painting that Pacheco mentions that Velázquez painted in Rome is a self-portrait (now lost) which he himself owned; perhaps it was intended as a model for a drawing for his own *Libro de Retratos*. On his way back to Spain, he says, Velázquez stopped in Naples, where he painted 'a beautiful portrait of the Queen of Hungary to bring to His Majesty'. He does not mention the presence in Naples of Ribera, whom Velázquez would surely have met. Velázquez, he goes on to say, returned to Madrid after an absence of a year and a half, 'arriving at the beginning of 1631'. Philip IV's sister María, whose betrothal to the Prince of Wales had come to nothing, had left Spain, where she was married by proxy to the King of Hungary in June 1630, and on 8 August made her entry into Naples, where she remained until 18 December. Velázquez, therefore, must have left Rome for Naples some time between August and December 1630; the precise length of his stay there, the date of his departure and of his arrival back in Spain are not known.

Palomino makes no mention of the self-portrait painted by Velázquez in Rome, but he is the source of our information that the two great figure compositions, *Joseph's Blood-stained Coat Brought to Jacob* (Plate 72) and the *Forge of Vulcan* (Plate 71), were painted in Rome to take back to the King, and this has never been doubted. The paintings are first recorded a few years later, in 1634, in a document

12. Attributed to Jusepe Leonardo (1601–1652/3). *The Buen Retiro Palace and Gardens. c.* 1637. Canvas, 51⅛ × 120 in. (130 × 305 cm.). Madrid, Royal Palace. One of a series of 17 paintings of royal palaces and country seats made by Leonardo and other colleagues of Velázquez for the decoration of the Torre de la Parada, paid for 1637–9. Another painting of the series is reproduced in Plate 13.

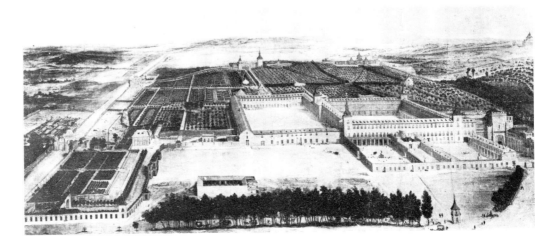

of payment to Velázquez for 18 paintings for the Buen Retiro Palace, which include some Italian works that he presumably purchased for the King in Italy.

Back at the Spanish court, Velázquez returned to his chief office as portrait painter. In 1633, he was given the unusual task, with Vicente Carducho, of inspecting a collection of portraits of the royal family for likeness, decorum and artistic quality. Many of them were condemned. Two months after he had left for Italy, the Queen, after having borne five short-lived daughters, gave birth to a hoped-for son and heir, Prince Baltasar Carlos. During the artist's absence, the King had not only not sat to any other painter, Pacheco proudly records, but he had waited for his return to have the young Prince painted, which Velázquez promptly did (Plate 80). Pacheco goes on to describe the King's generous and kindly treatment of his favourite painter and the interest he took in watching him at work, as well as his patience in sitting for three hours at a time for his equestrian portrait.

Pacheco unfortunately brings to an end his biographical notes on Velázquez without mention of the two major projects on which the artist was engaged in the 1630s: the decoration of the Buen Retiro Palace and the Torre de la Parada. He gives a brief account of the royal favours that he, as father-in-law, had received, as well as Velázquez. Within the space of two years, he says, Velázquez had been appointed Gentleman of the Wardrobe and Gentleman of the Bedchamber with key, this last appointment having been made in 1638, the year in which he writes. He expresses the hope that through Velázquez members of the profession might expect advancement and concludes with two poems dedicated to Velázquez's lost equestrian portrait of the King, one of them a sonnet by himself. In 1639 Pacheco made his will leaving all his possessions to his daughter, Velázquez's wife. He died on 27 November 1644, five years before the publication of his *Arte de la Pintura*.

Palomino's account of the years between Velázquez's two journeys to Italy is more digressive and less coherent than the rest of his biography, lacking the basis provided by Pacheco for the earlier period and the evidence of Alfaro and other living informants who had known the artist in his later years. He describes Velázquez's royal equestrian portraits and the *Surrender of Breda* in the *Salón de Reinos* in the Buen Retiro Palace but says nothing of when they were painted or the decorative scheme of which they formed part, or of the series of battle scenes by his colleagues at court and the participation of his fellow citizen, Francisco Zurbarán, who had been summoned to the court to contribute some of the battle scenes and the series of *Labours of Hercules*. In his life of Zurbarán, Palomino says it was in 1650 that Zurbarán made these last paintings, having been summoned to Madrid by Velázquez at the King's command. In fact the *Salón de Reinos* was finished by April 1635, according to a dispatch from the Tuscan Ambassador, who names the subjects of the paintings on the walls but not the artists involved. It is the Portuguese poet, Manuel de Gallegos, who first records Velázquez's name in connection with paintings in the Buen Retiro, in a long panegyric published in 1637. Documents of payment to the various artists concerned date from 1634 and 1635. The building of the palace had been begun in 1630, while Velázquez was in Italy, as a place of recreation on the outskirts of Madrid, a gift from Olivares to the King. The decoration of its chief room, the *Salón de Reinos* (Plate 120), one of the few portions of the palace that exist today (now the Army Museum), was possibly devised by Velázquez to celebrate the achievements of the reign of Philip IV with representations of Spanish victories to date in the Thirty Years War (victories that were soon to be turned to defeat), together with the triumphs of the King's mythical ancestor Hercules, and presided over by the

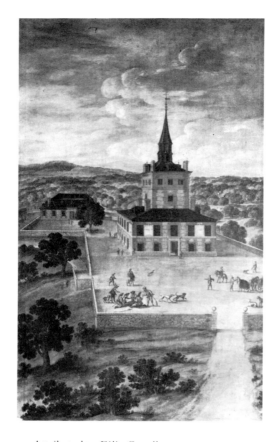

13. Attributed to Félix Castello (1595–1651). *The Torre de la Parada.* *c.* 1637. Canvas, 84½ × 50⅝ in. (214.5 × 128.5 cm.). Madrid, Municipal Museum.
One of a series of paintings of royal palaces and country seats made by colleagues of Velázquez (six by Castello) for the decoration of the Torre de la Parada. See also Plate 12.

equestrian portraits of the King, his Queen, his parents and his son, the heir to the throne.

The year after the decoration of the *Salón de Reinos* was completed, Velázquez was raised to the rank of Gentleman of the Wardrobe and, according to a Madrid newsletter of 28 July 1636, 'he was aspiring to become one day Gentleman of the Bedchamber and be knighted, following the example of Titian'. About this time he became engaged on work for the Torre de la Parada (Plate 13), a royal hunting lodge a few miles outside Madrid, which was in process of being rebuilt (1635–7). The bulk of the paintings for the decoration of the Torre were ordered from Rubens in Antwerp: more than 50 mythological scenes, for which Rubens himself submitted sketches, and a similar number of animal and hunting subjects. The paintings, executed by Rubens and his assistants, arrived in Spain in 1638. The extent of Velázquez's collaboration in the project is not clear from the one contemporary document we have referring to his work for the Torre. This is a request for arrears of money owing to him, dated 24 December 1636, and pressing for payment 'in order that he might the better attend to Your Majesty's service on the occasion of having been ordered to paint for the Torre de la Parada [which is] undergoing very great alterations'. The last words '*en la Reforma muy grande*' have led to the suggestion that Velázquez may have been concerned with the redesigning of the Torre; more probably he was to contribute paintings of his own and possibly supervise the choice and arrangement of the paintings from Antwerp. It has also been suggested that he might have sent designs for some of the hunting scenes to be executed in Flanders.

The question of what paintings Velázquez himself made for the Torre is another problem. When the first inventory of the paintings in the Torre was made in 1701, 60 years after its completion, there were four portraits, probably of dwarfs, a *Boar Hunt* (Plate 127), portraits of the King, the Cardinal Infante Ferdinand and Prince Baltasar Carlos in hunting costume (Plates 87–9), and the paintings representing Mars, Aesop and Menippus (Plates 129, 130, 132). The royal huntsmen and the hunt must almost certainly have hung there from the beginning, if they were not actually painted for the Torre, and there is good reason to believe that the *Mars* and the fablist *Aesop* and *Menippus* also formed part of the original decoration. The case for the presence of the dwarfs, as members of the court, is less convincing. But the hanging of paintings in the royal palaces was often a question of space and availability rather than appropriateness of subject-matter. Palomino, who no doubt visited the Torre before its sack by Austrian troops in 1710, only describes (somewhat fancifully) the portraits of the King and his brother in the Torre, which he calls 'a country seat for recreation belonging to Their Majesties'. The few earlier visitors make no mention of Velázquez in their eulogies of the Torre; even the Duke of Modena, who came to Madrid in 1638 and praised the Torre 'among the memorable things he had seen', mentions only the paintings by Rubens and other Flemish artists. This is the more surprising since the Duke was in contact with Velázquez and sat to him for his portrait (Plate 96).

Palomino judged Velázquez's portrait of the Duke of Modena to be perhaps the foremost of many notable portraits painted by him at the time. This was possibly an equestrian portrait, painted after the Duke's departure, rather than the bust portrait, which he presumably took with him and for which he rewarded the artist, according to Palomino, with a gold chain, among other things. After the Duke had left Madrid, his Ambassador complained that Velázquez had the same fault as other '*valenthuomini*', which was never to finish his work and never to tell the truth; he was also very expensive, but the portrait would be 'marvellous'; he

considered him to be as good as any of the most renowned portrait painters, ancient or modern. The Duke took away with him yet another portrait by Velázquez, a miniature of the King on the back of a diamond jewel in the form of an eagle, which his Ambassador described as 'so life-like and beautiful that it is truly an amazing thing'.

Velázquez's many and varied duties offer some explanation for his relatively small production, though there is more than one reference to his phlegmatic temperament and to his slowness to finish. Apart from his contributions to the decoration of the royal palaces, he was concerned (1637) with valuing the painted decorations for the festivities celebrating the arrival in Madrid of the Princess of Carignan and the election of the King of Hungary. It was also his duty to paint the portraits of important foreign visitors – the Duchesse de Chevreuse (cf. Plate 14) as well as the Duke of Modena sat to him in 1638 – and distinguished Spaniards at the court, such as Cardinal Borja (Plate 16). He was also responsible for the portraits of the royal family that were sent abroad, and for these there can be little doubt that he sometimes employed assistants, although they were sent in his name.

We know little or nothing of the working of Velázquez's studio; nothing is known even of his best-known follower, Juan Bautista Martínez del Mazo, before he married Velázquez's daughter Francisca in 1633. One of the earliest royal portraits attributed with good reason to Mazo is a portrait of Baltasar Carlos

14 (*Below left*). *Marie de Rohan, Duchesse de Chevreuse* (1600–79). Engraving published by Daret, Paris, 1653. Having fled from France to escape the anger of Richelieu, Marie de Rohan made her entry into Madrid in December 1637, and remained until February 1638. In January 1638 Velázquez was reported to be 'portraying her with her French airs and French dress'. She is said to have been fair with blue eyes, and noted for her high spirits and *décolletage*. Velázquez's portrait has never come to light.

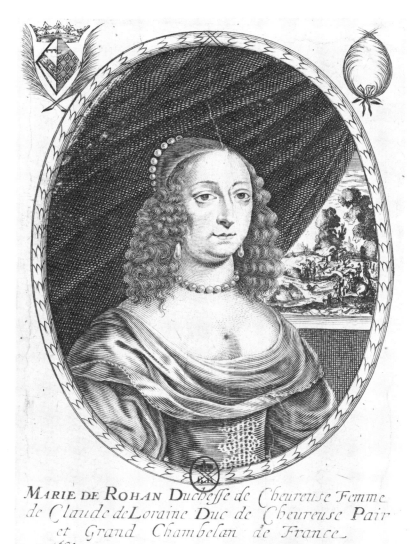

MARIE DE ROHAN Duchesse de Cheureuse Femme
de Claude de Loraine Duc de Cheureuse Pair
et Grand Chambelan de France.
1654.

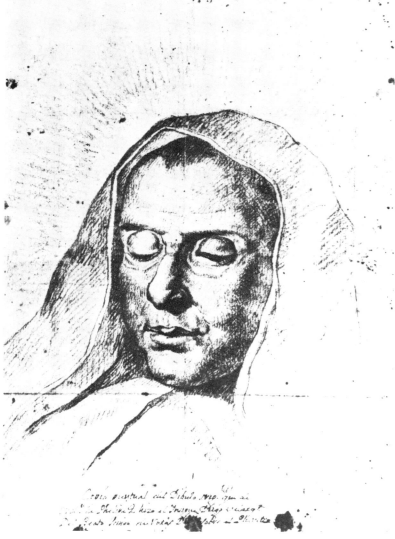

16. *Study for the Head of Cardinal Borja.*
1643–5. Black chalk drawing, 7⅜ × 4⅝ in.
(18.6 × 11.7 cm.). Madrid, Academy of San
Fernando. (L-R 98)
According to Juan Carreño, Velázquez
painted a portrait of Borja when he
occupied the see of Toledo, and because
he did not accept money he was rewarded
with a rich dressing gown and some silver
jewels. Palomino mentions the portrait,
but none of the painted versions known
today is generally accepted as autograph.
The drawing is one of the very few
considered to be by Velázquez's hand.

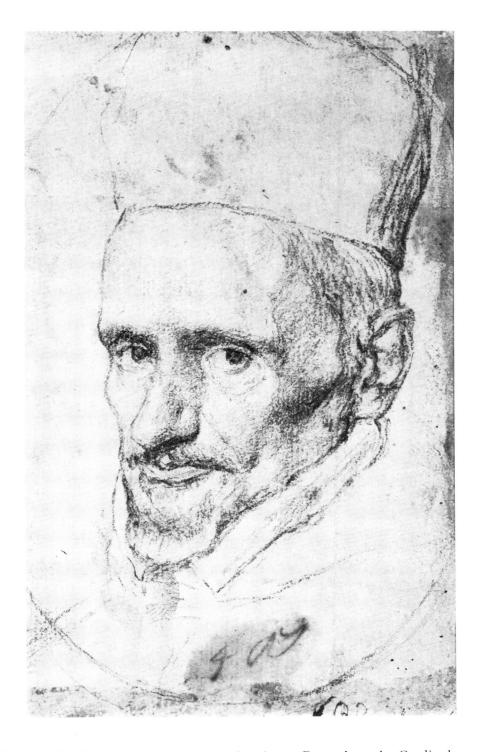

15 (*Left*). After Velázquez, *Father Simón de
Roxas.* Inscribed: *Copia puntuat del Dibujo
origl. que de/Ordn de Phelepe 4 hizo el Insigne
Diego Velazq.ᶻ/Del Beato Simon de Roxas
Dib ... sobre el Pheretro* ('Faithful copy of
the original drawing which by order of
Philip IV the famous Diego Velázquez
made of the Blessed Simón de Roxas, on
his bier'). Black chalk drawing, Madrid,
private collection.
Presumably a copy of Velázquez's study
for the (lost) posthumous painting of the
monk (died 1624), mentioned by
Palomino. (See Camón Aznar 1970.)

(Amsterdam), which is probably the one sent in 1639 to Brussels to the Cardinal-Infante Ferdinand, who in expressing his delight in the portrait referred to one of himself which he was sending to Spain but which was not yet ready as 'the painters here are more phlegmatic than Señor Velázquez.' Later in the same year portraits of the King and Queen and Prince Baltasar Carlos destined for England were delivered to the English Ambassador by the King's Painter, whose 'lazyness', according to the Ambassador, had been the cause of much delay. But if, as seems likely, they are the paintings now in the collection of Her Majesty The Queen (Plates 17, 18, 19), they are unquestionably studio works. The documents regarding these portraits reveal a further activity of Velázquez as adviser on the subject of some antique heads of which moulds had been requested of the King of Spain for Charles I, at the instigation of Inigo Jones, Surveyor of the Board

of Works. On arrival in England two of the heads were said to be the wrong ones – Francis I instead of Hannibal, and Caracalla instead of Marcellus! – but the English Ambassador on receiving the complaint explained that the heads he had sent 'were certified to be the right [ones] by Diego Velasques the kinges painter a man of great judgement'. He was to exercise this role of connoisseur of painting and sculpture on many future occasions.

Velázquez's appointment as Gentleman of the Bedchamber was conferred in January 1643. Pacheco had spoken of it in 1638 but possibly it was not until 1643 that he exercised the office, as Palomino explains. The appointment was the subject of a newsletter comment a year later: 'There is no other news except that Diego Velázquez, who is said to be the greatest painter in Spain, has been given the key of Gentleman of the Bedchamber.' The key was an additional honour, 'a thing which many knights of military orders covet', to quote Palomino.

In June 1643, Velázquez was appointed assistant to the Marqués de Malpica in the supervision of special works for the royal buildings, an appointment that

17 (*Far left*). Studio of Velázquez. *Philip IV*. 1638–9. Canvas, 93 × 57½ in (236 × 145 cm.), with additions. Royal Collection (Hampton Court Palace).
This portrait and those of the Queen and Prince (Plates 18, 19) were no doubt sent as a gift from Philip IV to the English court, in exchange for some English royal portraits sent to Spain in 1638. Though Velázquez was surely responsible for the original and grand compositions, the execution is not his, just as the English portraits were from the studio of Van Dyck, not by his hand. The two Queens were sisters and there was talk of a marriage between the Spanish Prince and Princess Mary.

18 (*Left*). Studio of Velázquez. *Queen Isabel*. 1638–9. Canvas, 100¾ × 57⅛ in. (256 × 145 cm.), with additions Royal Collection (Hampton Court Palace).
The English Ambassador in Madrid explained the delay in finishing the portrait: 'Partly by reason of the Queen's indisposition, and partly through the lazynesse of the Painter'.

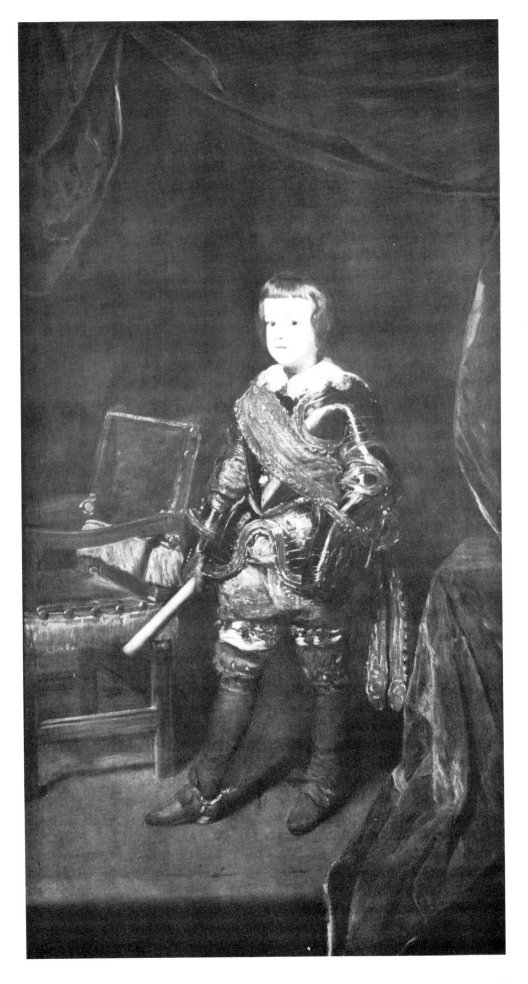

19. Studio of Velázquez. *Prince Baltasar Carlos*. 1638–9. Canvas, 83 × 43¼ in. (211 × 110 cm.). Royal Collection (Hampton Court Palace).
The Prince wears the *toison d or* which he received in October 1638. The portrait was dispatched by December 1639, 'in armour and full gala', as if h s marriage to the English Princess was imminent, according to the Tuscan Ambassador in Madrid.

involved him in a dispute a year later with Malpica, who complained to the King of his interference, because, he said, he always tried to avoid arguing with Velázquez. The King replied that Velázquez was to obey him, as his subordinate.

The respect paid by Velázquez to his early patron, the Conde-Duque de Olivares, after his dismissal and banishment in 1643, and his show of mourning on his death did not prevent Philip IV from continuing to honour Velázquez, and Palomino cites as an example the order for the artist to accompany the King on his journey to Aragon, which gives the title to a whole chapter. Palomino's story that Velázquez went with the King to Aragon in 1642 at the beginning of the French invasion is not confirmed, but there is evidence that he accompanied him there on his second expedition in 1644.

In his life of Jusepe Martínez, Palomino describes how on the occasion of Philip IV's visit to Saragossa in 1642 Martínez applied to be appointed honorary Painter to the King, who, after consulting with Velázquez, agreed. But the occasion could have been the later visit, since the appointment was made in April 1644. Martínez himself tells an anecdote about Velázquez when he was in Saragossa in attendance on the King but does not say in which year. He tells how a young lady who sat to Velázquez for her portrait refused to accept it because she liked nothing about it and in particular because he had not painted to her satisfaction the fine lace collar she had worn. Velázquez's visit to Aragon in 1644 is famous, however, for the portrait he painted of *Philip IV at Fraga* in the costume he had worn when he went out to meet his soldiers after the defeat of the French army and while awaiting his entry into Lérida (Plate 106). The portrait, painted hurriedly in difficult conditions – a carpenter was employed to make an easel and the artist's house had to be fitted with a window so that he could see to paint – was sent back to the Queen in Madrid and exhibited in the church where the Catalans celebrated the capture of Lérida. Palomino's description of this portrait is an example of how his account of paintings he saw in the royal collection and in private collections has helped to identify many of Velázquez's works, as well as providing a record of those that have been lost.

On his way back to Madrid, the King heard the news of the death of the Queen (6 October 1644). Two years later, while he was with the Prince and the court in Saragossa, accompanied by Mazo and possibly Velázquez, the 17-year-old Prince Baltasar Carlos was taken ill and died. The King was stricken by the death of his beloved wife and only son, and worried by the threat of military setbacks, as we learn from his correspondence with his confidante, the nun María de Agreda. Nevertheless, he did not pause in his programme of enlarging and improving his palace and his collection of works of art, a luxury the country could ill afford. Velázquez, his chief collaborator, was consequently increasingly occupied with duties other than painting; and though these were honours that he sought, they also brought trouble, involving him in arguments with colleagues over his status, and frequently resulting in difficulty in obtaining the money due to him. In January 1647 he was appointed supervisor and paymaster for the *pieza ochavada*, an octagonal room that was to be erected above a new staircase in the Alcázar. Yet four months later he was asking for arrears of salary that had been owing for the past two years, and a year later he had to apply for money due to him from a much earlier date. The royal finances were unable to keep up with the royal commitments. Velázquez's concern with the *pieza ochavada* was probably confined to its decoration and furnishing, and did not extend to its design.

It was for the purpose of enriching the royal collection, and of furnishing some of the rooms in the Madrid Alcázar with sculpture as well as paintings, that Velázquez was sent on his second journey to Italy. The conversation with Philip

IV that determined the journey, reported by his friend Jusepe Martínez, may not be a verbatim account, but it is quite credible and its gist is supported by other evidence. Velázquez, according to the report, when told by the King to find painters to decorate a gallery in the palace, suggested that rather than have paintings that anyone could have, he should go to Rome and Venice to look for works by the best Italian artists that were to be found, and he named Titian, Veronese, Bassano, Raphael and Parmigianino. He also suggested that the lower rooms should be decorated with antique statues and proposed getting moulds if necessary, to be cast in Spain. 'His Majesty gave Velázquez leave to return to Italy with all the necessary means and credit.'

So it was that Velázquez, now nearly 50 years of age, and at the height of his career, returned to Italy 20 years after his first visit. This time he went not as Court Painter but as Gentleman of the Bedchamber travelling on the King's business, and the royal order added that he was to be given a carriage corresponding to his status, and an extra mule to carry pictures – probably gifts from the King to Pope Innocent X, who was to celebrate his jubilee in 1650. Velázquez was to travel with the embassy of the Duque de Maqueda y de Nájera, who was going to Italy to meet and conduct back to Spain Mariana of Austria, niece of Philip IV. The King had decided to make her his new Queen after the death of his son, to whom she had previously been betrothed. The embassy left Madrid on 16 November 1648 for Malaga, where they arrived on 7 December and stayed until 21 January, when the expedition consisting of many ships sailed for Genoa, arriving on 11 March.

Palomino's detailed account of Velázquez's second Italian journey, embroidered though it is with digressions on classical sculpture, and on the principal sights in the places he visited, has been proved accurate in so many respects that it would appear to be based on first-hand information. Just as Pacheco's account of Velázquez's first Italian visit suggests that he may have been in correspondence with him, so Palomino's version of the second visit suggests that he may have had access to letters written by Velázquez from Italy, and possibly to the royal inventories made by Palomino's colleagues in 1701–3. As Court Painter, he would certainly have been admitted to the royal palace, where he must have seen Velázquez's purchases.

On this journey, Palomino says, Velázquez stopped in Genoa and Milan on his way, via Padua, to Venice, whose painters he had specially admired ever since his visit 20 years before. His arrival in Venice on 21 April 1649 is announced in a dispatch from the Marqués de la Fuente, Spanish Ambassador, which shows he lost no time in setting about his business. He is arranging for the artist to see as many paintings as possible, the Ambassador writes, but people in Venice were very cautious and would make difficulties. He adds that Velázquez wanted to go on to Modena as he had heard of something very much to his purpose there. This was evidently Correggio's famous painting *La Notte* (Dresden), which we know he tried to persuade the Duke of Modena to part with, from a later account by the Duke's Ambassador in Madrid, who met Velázquez in Genoa on his way home. Velázquez, he says, impressed on him that there was no better way to please the King – or his Prime Minister, Luis de Haro – than to present him with first-rate pictures, as his love of painting was now greater than ever. (Velázquez's purchases in Venice, which Palomino describes, were probably made, as we shall see, after he had been in Rome.)

On his way to Rome, Palomino says, Velázquez stopped in Bologna, Florence, Modena and Parma, and in Bologna he saw the two fresco painters, Angelo Michele Colonna and Agostino Mitelli, to arrange for them to go to Madrid. His route was more like to have been slightly different, and it is probable that his

meeting with the two Bolognese painters took place on his return journey, for Velázquez was first instructed in a letter dated 17 February 1650, many months after his arrival in Rome, to take back with him no less a master of fresco painting than Pietro da Cortona, one of the painters by whom Palomino says he was much favoured in Rome. It was because Pietro da Cortona was not available that he was ordered in June to take back another suitable painter in his stead; and it was no doubt after this that Velázquez approached Colonna and Mitelli. It was in December 1650, when he stopped again in Modena after he left Rome, that he told the Duke's secretary that he was taking the two Bolognese fresco painters with him to Spain and expected to meet them shortly in Genoa. Velázquez himself did not sail for Spain until several months later, and Colonna and Mitelli did not go there until 1658, for reasons that have not come to light. Their biographer Malvasia makes much of the several attempts to engage them for the King of Spain without, however, referring to any negotiations made by Velázquez.

That Velázquez stopped in Modena on his way to Rome, and was lodged in the Comedia, is mentioned in a letter from the Duke's secretary when the artist returned in December 1650. Velázquez reached Rome by 29 May 1649, the date of a letter from Cardinal de la Cueva, Bishop of Malaga, who was in Rome at the time, to his brother the Marqués de Bedmar in Milan, announcing the artist's arrival. He expressed in no uncertain terms his criticism of Velázquez's mission, on the grounds that this was not the time to spend money on such frivolous pursuits as the decoration of the royal palace.

Neither the troubled times – Spanish rule in Naples had only recently been threatened by the rising led by Masaniello – nor the country's economic condition deterred the King. His great concern for the success of Velázquez's mission and his interest in the details of the 'obra' on which he was engaged in Rome is revealed in a series of letters, some of them from the King himself, most of them from his Secretary of State, Fernando Ruiz de Contreras, to the Duque del Infantado, Ambassador in Rome, dating from 17 February 1650 to 24 July 1651. The letters stress Philip IV's impatience to see the results of Velázquez's mission and for his return. The enclosures addressed to Velázquez, mentioned in several of the letters, have not survived, nor have his or the Ambassador's replies. The Ambassador was ordered to urge Velázquez to finish his work and return with the utmost speed because His Majesty wanted to see him back; to hurry him and not allow him to delay another moment; 'to rouse him from the *flema*, which they say he has'. The 'obra' to which the letters refer was the ordering of moulds and casts of antique sculpture. But first Velázquez had to go to Naples, soon after his arrival in Rome, to get funds from the Viceroy, the Conde de Oñate. By 10 July 1649, he was back in Rome, where he remained, so far as we know, until November 1650, except for one other visit to Gaeta to meet the Viceroy, probably to get more money for what must have been an enormously costly undertaking.

Palomino's list of the selection Velázquez made of 29 antique sculptures, apart from portrait heads, includes many celebrated works. Velázquez, following the tradition of great collectors since the sixteenth century, chose to have casts made of the most famous statues in Rome rather than acquire inferior originals. François I had sent Primaticcio, and Charles I of England had sent Hubert Le Sueur (in 1631) on similar missions. We also know from Nicolas Poussin, who was engaged on the same pursuit, the difficulties in finding antiques and getting permission to export them and even in having casts made. The only modern sculpture in Palomino's list is the head of Michelangelo's *Moses*. From the correspondence between Madrid and Rome, it appears that some of the sculptures were cast in bronze in Rome under the direction of Giuliano Finelli, a pupil of Bernini,

20. Medals of Pope Innocent X (British Museum).
Velázquez, according to Palomino, was rewarded for his portrait of the Pope by a gold medal and chain with the Pope's portrait. Two such medals were in Velázquez's possession at his death; one with a Cross with two angels on the reverse, the other with a Roman obelisk on the reverse. The first was issued 1644–6, on the Pope's election; the second, with Bernini's obelisk, set up in 1648, was issued 1649–52.

among them the 12 lions and accompanying gilt bronze mirror frames surmounted by eagles which were to decorate the *Salón de los espejos*, and which are not mentioned by Palomino. Other casts were made in bronze and plaster after Velázquez's return, including no doubt those of statues in the Vatican Belvedere. For it was not until 8 March 1650 that the Viceroy, not the Ambassador, wrote to Cardinal Panciroli, the Pope's Secretary of State, asking for permission for Velázquez to make the moulds, and he had to repeat his request on 7 April. When the permission came is not known. Most of the long list of sculptures given by Palomino can be identified with bronze and plaster casts recorded in the inventories made in 1666 and 1686 of the royal palace, and several of the bronzes exist today in the Prado Museum and the royal palace in Madrid (Plates 139, 164). So, too, may some of the many portrait busts mentioned by Palomino, though they would be difficult to identify.

'Without neglecting his official business', as Palomino puts it, Velázquez painted many pictures while he was in Rome, chief of which was the portrait of Pope Innocent X, from whom he received many favours, including no doubt the permission to make copies of the Belvedere statues. Palomino also names more than half a dozen members of the papal court who sat to Velázquez, and mentions other sitters whom he says he does not name because their portraits remained unfinished. Several of the portraits that he records have been identified from his account, so that it can be assumed that the whole of his list is correct.

Palomino is also the source of the well-known story that in order to prepare for his portrait of the Pope by painting a head from life, Velázquez made the portrait of Juan de Pareja, his 'slave'. Pareja, a mulatto painter from Seville and probably Velázquez's assistant – if not his slave – had accompanied him from Spain, and is famous only for the portrait Velázquez painted of him in Rome. Another story about this portrait, Palomino says, was told him by Andreas Schmidt, a Flemish painter at the Spanish court (by 1663), who was in Rome at the time, and who may well have provided Palomino with other details about Velázquez in Rome, remembered more or less accurately. The portrait of Pareja, according to Schmidt, was exhibited in the Pantheon on Saint Joseph's Day and was so greatly admired that Velázquez was received as a Roman academician in the year 1650. In fact Velázquez was admitted to membership of two organizations of artists in 1650: in January he was made a member of the Academy of Saint Luke and in February of the Congregazione dei Virtuosi. Recognition could go no further. It was the Virtuosi who gave exhibitions in the Pantheon, and the portrait of Juan de Pareja, if it was exhibited there, must either have been exhibited after his election or well before Saint Joseph's Day, which falls on 19 March, since he had not yet reached Rome on that day in the previous year. As for his election to the Academy of Saint Luke, it is likely that the painting that won him this honour was the portrait of the most prestigious of all his sitters, Pope Innocent X. Lázaro Díez del Valle seems to imply this when he says that the Pope was so pleased with Velázquez's portrait of him that he offered 'to place the artist's portrait among those of the famous painters of Rome, renowned academicians', presumably a reference to the custom of academicians of giving a self-portrait to the Academy. The Pope, according to Palomino, rewarded Velázquez with a gold papal medal on a chain (Plate 20), and two gold medals of Innocent X are in fact recorded in the inventory of the artist's possessions at his death. Strangely enough, though, there is no record of how or exactly when the portrait of the Pope came to be painted. The earliest mention of it is in a letter from the Cardinal Secretary of State, Giovanni Giacomo Panciroli, to the papal Nuncio in Spain, dated 17 December 1650, expressing the Pope's satisfaction with

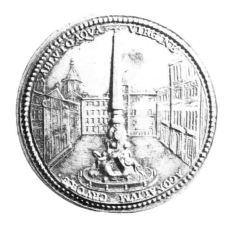

its 'extraordinary merit' and offering his support for Velázquez's application for membership of a Spanish military order, which is the first reference to this subject. It was not, however, until 1659, a year before his death, that he was made a Knight of Santiago.

Despite the letters from Madrid urging him to hurry back, which date from 17 February 1650, Velázquez does not appear to have left Rome before November, though he was expected to have departed much sooner, and even then he did not go home direct. He did, however, make some concession by obeying the royal command that he should go by sea rather than land, which might have delayed him further, 'apart from his inclination to linger'. Palomino attributes the artist's decision to go by sea, although he had wanted to see Paris and had obtained a French passport, to the fear of war. Although many of the details of his return journey can be pieced together from various documents, there are still several months that can only be tentatively accounted for.

In a letter dated 2 December 1650, the Viceroy in Naples wrote to inform the King that he had done everything necessary to help the artist and had arranged for the works he had ordered in Rome to be sent to Naples for shipment to Spain. This implies that Velázquez had left Rome shortly before, probably in November. But it was not until June 1651 that he arrived back in Madrid. After leaving Rome, it is possible that he stopped in Florence and almost certain that he stopped in Bologna on his way to Modena, where he arrived on 12 December 1650. In a letter to the Duke Francesco d'Este – who was away at the time – his secretary, Gennaro Poggi, announcing Velázquez's arrival, wrote that the artist expressed his intention of waiting for the Duke's return to pay his respects, but he suspected that his excessive '*puntualità*' concealed a wish to get the Duke to part with some of his paintings. Velázquez had asked to see them all but was told that only the Duke had the keys, and accepted instead the offer of a visit to Sassuolo, where there were frescoes by Colonna and Mitelli, which led him to say that he expected to meet these artists in Genoa in a few days' time.

It was perhaps the lack of transport that prevented Velázquez from sailing from Genoa at that time – the boat he was to take sailed from Naples without touching Genoa. But why he remained another six months in Italy and where he spent those months are questions that can only be partly answered. Some of the time was almost certainly spent in Venice. From letters from Madrid written in June and October 1650 it appears that he was expected to go to Venice on his way home with money to purchase a painting he had hoped to take back with him. Although Palomino refers his purchase of paintings in Venice to Velázquez's outward journey, we know that he was then in a hurry to go on to Modena, and it was probably on his return that he made the purchase. Marco Boschini, the Venetian painter, writer and guide, who was presumably there at the time, insists that it was in 1651 that Velázquez was in Venice and bought five Venetian paintings. He even adds that this visit took place after Velázquez had been in Rome, where he painted the portrait of Innocent X, and that he later returned to Rome from Venice as he wished to carry out various duties for the King. It was on his return to Rome that, Boschini says, Velázquez had a conversation with Salvator Rosa on the rival merits of Raphael and Titian in which he praised Titian above all other painters. Though there are no documents to support Boschini's story of Velázquez's return to Rome, there was plenty of time for him to do so.

As for the paintings Velázquez bought in Venice, Boschini says that he was only able to buy five: two by Titian, two by Veronese and the model for Tintoretto's *Paradiso*, on which he spent 12,000 scudi. Palomino adds to this list details of a ceiling decoration and the *Conversion of Saint Paul* by Tintoretto, a *Venus and*

Adonis by Veronese and some portraits. (With the exception of the *Conversion of Saint Paul* and the portraits, the paintings have been identified with pictures now in the Prado.) Curiously enough, however, the painting Boschini says Velázquez most admired, the model for Tintoretto's *Paradiso*, was either not acquired by him at the time or there was another version in Venice; for the Spanish Ambassador, in a letter to Philip IV's minister dated 12 July 1653, refers to a painting of this subject in the hands of a dealer and wants to know if it is the painting Velázquez had seen and listed in one of the memoranda of pictures he had left with the Ambassador.

Our knowledge of Velázquez's eventual departure from Italy is based on a letter from the Duke of Modena's Ambassador in Madrid, written several months later (13 January 1652), in which he says that he had met Velázquez while they were waiting to embark in Genoa. We know that the Italian arrived in Valencia after 19 days at sea on 13 June, and in Madrid at midnight on 23 June, which is also the date of a letter from Philip IV to his Ambassador in Rome announcing Velázquez's return. The fact that the King had to send Velázquez repeated instructions to leave Italy before he finally did so was evidently memorable enough to be recorded long afterwards by Palomino. His protracted stay was, he says, the reason why he was refused permission to return to Italy, as he wished to do in 1657.

The letter from the King to his Ambassador in Rome announcing Velázquez's return also mentions the arrival of part of his acquisitions, which had been shipped from Naples. A few days later, on 8 July 1651, the papal Nuncio, writing to Cardinal Pamphili, also reported the artist's arrival, saying that he had brought with him 'a great number of original paintings by the best artists and also a portrait, a very good likeness of Our Lord, with which the King appeared very pleased'. Not long afterwards he wrote again acknowledging the letter asking him to advance Velázquez's application for membership of a military order, saying that he would do all he could to support the Pope's '*benigna propensità*' towards the artist. Although most of the sculptures – the casts, moulds and busts – that Velázquez ordered in Rome, said to have numbered 300 pieces, did not arrive with him (they were probably brought to Spain by the Conde de Oñate when he returned from being Viceroy in 1653), Velázquez was soon able to display some of his acquisitions. Three bronze statues cast in Rome for the *pieza ochavada* were perhaps already *in situ* when the Florentine Ambassador wrote on 30 August 1651 of the '*bellissime statue*' in this room where the King kept his most precious objects.

In the following year, on 8 March, Velázquez took the oath as Palace Chamberlain, having been selected by the King himself from five other applicants. In his application for the office, Velázquez pointed out that he had been occupied with the decoration and maintenance of the King's apartments for many years. From now on his duties were to include the arrangement of the lodgings of the King when he travelled – and he had usually to accompany him – as well as the furnishing and decoration of his apartments; he was responsible for sheets and floor-covering as well as works of art, and for the supervision and payment of many of the palace servants. He also took part in the arrangement of festivals and was deputed to look after distinguished foreign visitors. As Palace Chamberlain as well as Gentleman of the Bedchamber, he was fully occupied; yet he still found time to create some of his greatest masterpieces.

Palomino devotes many lines to his reflections on Velázquez's appointment as chief Chamberlain, coming to the conclusion, in a very roundabout way, that it was a restriction of his talent, more of a punishment than a reward. He then goes on to say how well Velázquez carried out his duties and how highly the King

esteemed him. The King's friendly treatment of the artist, on the other hand, talking to him for hours on end, was a cause of envy. As Court Painter, Velázquez had a studio in the palace; now he was given apartments in the Casa del Tesoro, which was connected by a passage with the palace, a residence that corresponded to his new office (see Plate 22).

While Velázquez was in Italy, Philip IV had married his niece, Mariana of Austria, and the young Queen and her children provided the artist with new models during his last years. The Infanta Margarita (born 13 July 1651) is the central figure in the painting known today as *Las Meninas* (Plate 184), which is generally considered to be Velázquez's masterpiece. As with many of his court paintings, there is no record of it in Velázquez's lifetime, and it is Palomino who, in a whole chapter devoted to the picture, is our chief source of information about the subject, the people represented and the date, 1656, which he gives for its completion.

In the same year, 1656, Velázquez, according to Palomino, was ordered to take to the Escorial 41 paintings, some of them acquired at the sale of the collection of Charles I of England, others brought back from Italy by Velázquez, and others presented to the King by some of his noble subjects. An account of the King's visit to the Escorial in October 1656, recently brought to light, confirms Palomino's story. The writer, the King's chaplain, Julio Chifflet, tells how the sacristy was completely changed, with Pietro Tacca's *Christ* and Raphael's *Perla* (from Charles I's collection) now adorning the altar: 'Diego Velázquez, painter and Gentleman of the Bedchamber to His Majesty, has been busy for several months arranging everything and has ordered gilt frames to be made for the pictures.' The new arrangement of the sacristy is described by Francisco de los Santos in his book published in 1657, but without mention of Velázquez. This description, together with Palomino's mention of a memorandum of the paintings written by Velázquez, which he praised for the elegance of the writing as well as for proof of his learning, are the origin of a printed *Memoria* bearing Velázquez's name and purporting to have been published in Rome in 1658 by Juan de Alfaro (Plate 21). First discovered – or fabricated – in 1871, and subsequently translated into French and English, it is now generally considered to be a fake. That Velázquez did write a memorandum is, however, very likely – it is the term used for the notes he left with the Ambassador in Venice – and it may well have been known and used by de los Santos and seen by Palomino.

Velázquez's reason for wishing to return to Italy in 1657, if indeed it was his wish, is not known; possibly he wanted to see again the collection of statues and vases belonging to Ippolito Vitelleschi, a member of the papal court, which was now being offered for sale in Rome. The Ambassador in Rome, now the Duque de Terranova, writing to the King in March 1657, points out that Velázquez had seen the collection and could say whether or not it was good. Vitelleschi had, according to Palomino, been one of Velázquez's sitters when he was in Rome in 1650. In any case, there is little doubt that Velázquez did not go back, although one of his friends was later to say that he had been three times to Italy. He did, however, send his son-in-law Mazo there in 1657, partly on private business in Naples connected with his granddaughter, who had married a Neapolitan, and it is possible that he went on to Rome.

Velázquez himself must have been fully occupied during these years, in particular with the decoration of the Alcázar. In 1658 the two Bolognese painters Colonna and Mitelli arrived in Madrid to paint the walls and ceilings of some of the apartments there; they also worked in the Buen Retiro, in the garden house of the Marqués de Heliche, son of the Prime Minister, and in the church of La

21. Title-page of the pamphlet purporting to be Velázquez's *Memoria* mentioned by Palomino, listing all his titles. It was once thought to be what Palomino called 'proof of his learning and great knowledge of art'. The unique copy, belonging to the Spanish Academy, has since been pronounced a forgery.

MEMORIA
DE LAS PINTVRAS,
QVE LA MAGESTAD CATHO-
lica del Rey nuestro Señor Don Philipe
IV. embia al Monasterio de San Lau-
rencio el Real del Escurial, este
año de M.DC.LVI.
DESCRIPTAS, Y COLOCADAS,
POR DIEGO DE SYLVA
VELAZQVEZ,
Cauallero del Orden de Santiago, Ayuda de
Camara de su Magestad, Apofentador mayor de
su Imperial Palacio, Ayuda de la Guarda ropa,
Vgier de Camara, Superintendente extraor-
dinario de las obras Reales, y Pintor
de Camara, Apeles deste Siglo.
LA OFRECE, DEDICA, Y CONSAGRA
a la Posteridad,
D. IVAN DE ALFARO.
Impresa en Roma, en la Oficina de Ludouico
Grignano, año de M.DC.LVIII.

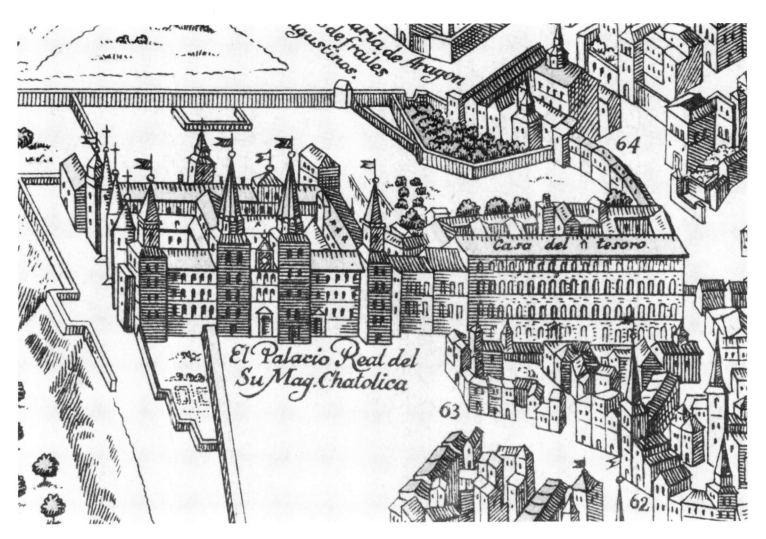

22. *The Royal Palace, Madrid, with the Casa del Tesoro*, where Velázquez lived when he became Palace Chamberlain, where later he lodged the Bolognese painters Colonna and Mitelli, and where he died. Detail of Plate 9.

Merced. Palomino's long description of their work at the Spanish court is explained by the fact that he was himself a fresco painter and probably owed much to the two Italians who had come to re-introduce the art of fresco painting in Spain. Their joint activity came to an end with the death of Mitelli in 1660, a few days before that of Velázquez. Colonna appears to have stayed on in Spain for another two years. Velázquez not only looked after the lodgings of these two visiting artists, in the Casa del Tesoro, where he himself now lived (Plate 22), and their salary; he also supervised their work. He made a detailed plan, Palomino says, of their major work in the palace, the decoration of the ceiling of the principal room, now called the *Salón de los espejos*, the Hall of Mirrors, which they carried out with the assistance of two Spanish painters, Juan Carreño and Francisco Rizi. Whether this means that Velázquez made rough sketches of the different scenes to be represented or only drew up the programme is not clear. But thanks to Palomino's vivid first-hand description of the ceiling, decorated with the fable of Pandora and enriched with elaborate architectural decorations, the *quadratura* for which Mitelli is famous, we have an idea of the richness of the setting chosen by Velázquez for some of his own paintings as well as for many of the earlier masterpieces in the royal collection.

The Bolognese biographer, Giulio Cesare Malvasia (1678), describing some of the contretemps that his fellow citizens had in Spain, says that they made a drawing for the painting of Pandora, and because it did not please Velázquez, 'still less did it find favour with His Majesty who referred everything to him, nor therefore did the Marqués de Heliche like it.' He also says that Colonna, because

31

of the lack of female models in Spain, made use of the antique Belvedere Venus, of which he found the cast as well as the mould in Madrid, together with casts of all the other famous statues of Rome.

Examples of modern sculpture as well as antiques from Italy were among the acquisitions of Philip IV, and Velázquez was in touch with sculptors as well as painters during his second journey to Italy: in Rome, Palomino says, he was befriended by Alessandro Algardi and Gianlorenzo Bernini, as well as by Mattia Preti, Pietro da Cortona and Nicolas Poussin. When he was in Rome, Velázquez apparently commissioned from Algardi a set of bronze fire-dogs representing the four elements. These are the subject of one of the only two extant personal letters in Velázquez's hand. From this letter, addressed to one of his Roman patrons, Monsignor Camillo Massimi, dated 28 March 1654, it appears that the fire-dogs had just reached Spain.

Nothing is known of Velázquez's contact with Bernini, but one of Bernini's assistants, Matteo Bonarelli, husband of his beloved Costanza, signed and dated in 1651 the bronze cast of one of the lions ordered by Velázquez in Rome. The lions were part of a commission given by Velázquez in 1650 to a pupil of Algardi, Giuliano Finelli. Finelli was also probably the sculptor commissioned to make the gilt bronze *Christ on the Cross*, which arrived in Spain in 1659 and is thought to have been finished after his death (1657) by his nephew Domenico Guidi (Plate 112). Palomino, who attributes the *Christ* to a nephew of Finelli, says it was commissioned by the Duque de Terranova, Ambassador in Rome (1653–7) for Philip IV. He mentions it for the part Velázquez played in taking it to the Escorial and supervising its placing in the sacristy of the Pantheon. The Pantheon, burial place of the Kings of Spain, begun 40 years earlier in the reign of Philip III, was only completed in 1654, when Philip IV sent 25 pictures from Madrid for its decoration, probably on the advice of Velázquez. According to his friend, Gaspar de Fuensalida, it was Velázquez who 'finished and perfected' the Pantheon.

Of the Roman sculptor Giovanni Battista Morelli, to whom Palomino devotes several paragraphs, little is known today. He was another pupil of Algardi, who came to Spain from Paris in 1659 and settled in Valencia. His works in Valencia and Madrid have perished, except for a clay figure of Saint John the Baptist (Plate 23), so that it is difficult to judge why Velázquez thought so much of him that he recommended him to the King. He did not come to the court until the year after Velázquez's death.

If Philip IV's avowed interest in the decoration of the Escorial was because his remains were going to rest there forever, the refurbishing of the Alcázar, the painted ceilings by Colonna and Mitelli, the re-hanging of pictures and the placing of Velázquez's purchases from Italy were intended not only for the King's pleasure but also to impress foreign visitors. In particular, the *Salón grande*, that had been rearranged some 30 years earlier for the visit of the papal legation of Francesco Barberini, was now redecorated anew and renamed the *Salón de los espejos*, in time for the arrival of the French emissaries who came to arrange the peace treaty and the marriage of Louis XIV with Philip IV's daughter, the Infanta María Teresa. The Maréchal Duc de Gramont, French Ambassador Extraordinary, who arrived in Madrid in October 1659, describes how he was received, in a large room hung with tapestries, by the King seated on a dais before Titian's equestrian portrait of Charles V. Possibly it was after his greeting of the Ambassador that the King took his place standing next to a side table, as Palomino describes him, in the pose of later portraits of Charles II in the *Salón de los espejos* (Plate 161). The Ambassador does not mention his tour of the royal palace, conducted by Velázquez, which Palomino records.

23. Giovanni Battista Morelli (died Madrid 1669). *The Infant Saint John the Baptist, with Gesture of Silence*. Clay, painted red, $20\frac{7}{8} \times 13\frac{3}{8} \times 8\frac{5}{8}$ in. ($53 \times 34 \times 22$ cm.). Madrid, Prado Museum.
This is the only work in Spain by Velázquez's Roman protegé that has survived or been identified. Yet the sculptor was considered important enough by Palomino to be named in the heading of his life of Velázquez.

Velázquez's increasing occupations as Palace Chamberlain partly account for the paucity of paintings recorded in his last years. Palomino says little of his paintings after the *Meninas*, mentioning only two portraits of Prince Philip Prosper and the Infanta Margarita made in 1659 (Plates 180, 181) to be sent to the Emperor Leopold I, and a miniature portrait of the Queen. He says nothing of the late portraits of the King. The portraits of the Prince and Infanta, which he must have known from replicas judging from his detailed description, were, he says, 'the ultimate in perfection' and much praised, but also the subject of envy, and it is here that he introduces the story, ascribed to a much earlier date by Jusepe Martínez, of Velázquez being accused of only being able to paint heads. To this the artist replied, in Palomino's version: 'they favour me greatly, for I do not know that there is anyone who can paint a head', an example of what Palomino calls his pithy repartee.

Velázquez's desire to crown the honours bestowed on him by the King with membership of one of the military orders of knighthood had been raised by him in Rome and had won papal support. But it was not until the spring of 1658, when he was on a visit to the Escorial with Philip IV, that he was offered, according to Palomino, the choice of three Spanish military orders and chose that of Santiago. Whether or not the delay in establishing the necessary proofs of nobility was due to jealousy, as Palomino had heard say, it was not for another year and only after 148 witnesses had been interrogated that Velázquez was installed as a Knight of Santiago, and then it was necessary for the King to request a special dispensation from the Pope because of the doubts that still existed about the nobility of one of his grandparents. On 27 November 1659, the birthday of Prince Philip Prosper, Velázquez's title was conferred by the King, who, on the next

24. *The Ceremony at the Isle of Pheasants: The Arrival of the Royal Parties.* From Leonardo del Castillo, *Viage del rey ... don Felipe quarto ... a la frontera de Francia,* Madrid, 1667.

day, made him a *hidalgo* so that he could receive the habit of the Order; and on 27 and 28 November, in consideration of his position in the royal service, he was granted exemption from the contribution, service in the galleys and profession in a convent of the Order, which were the normal obligations of a Knight.

The last act in Velázquez's life was performed in his capacity as Palace Chamberlain, when in March 1660 he preceded Philip IV and his entourage, preparing the route for the royal progress to the French frontier, where the King was to hand over his daughter in marriage to Louis XIV (Plates 24,25). Velázquez's duties were to prepare lodgings on the way and arrange the decoration of the Spanish pavilion on the Isle of Pheasants, where the ceremony was to take place,

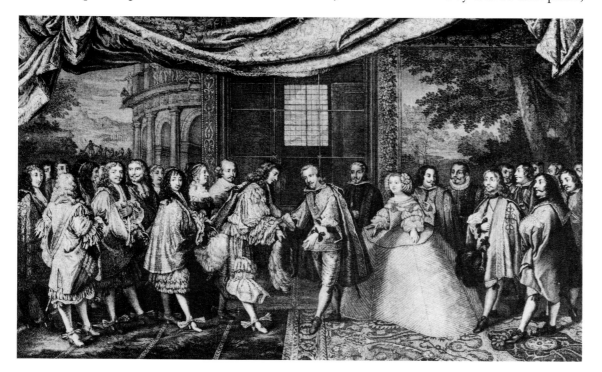

25. *The Betrothal Ceremony in the Conference Hall on the Isle of Pheasants: Philip IV Gives the Infanta María Teresa in Marriage to Louis XIV.* 1728. Engraving by E. Jeurat after a tapestry designed by Charles Lebrun. Velázquez, Palomino says, was in charge of the building of the Hall.

26. Attributed to Juan de Alfaro
(1643–80). *Study of Velázquez on his Death-
bed*. 1660. Black chalk, $8\frac{1}{16} \times 5\frac{1}{4}$ in.
(20.5 × 13.5 cm.). Paris, Frits Lugt
Collection, Institut Néerlandais.
Said to have belonged to Alfaro's widow,
the drawing was acquired in Madrid in
1856 by William Stirling-Maxwell, who
reproduced it in the second edition of his
Annals (1891) as 'a sketch taken from his
[Velázquez's] corpse as it appeared arrayed
in the habit of Santiago'.

to be in attendance on the King on his arrival there and accompany him on the
journey back. Palomino was undoubtedly acquainted with the first-hand account
of the journey and marriage ceremony written by Leonardo del Castillo and
published in 1667, and added the details of Velázquez's participation and of his
costume, also apparently from a first-hand source. Numerous documents relating
to the expenses of the journey for which Velázquez was responsible confirm the
range of his duties. A bullfight that was part of the festivals with which the royal
party was entertained in Valladolid on the way back to Madrid is recalled in a
letter from Velázquez to the painter Diego Valentín Díaz in Valladolid, written
a week after his return. In this letter, the second of his two surviving autograph
letters, Velázquez announces his safe arrival on 26 June, tired out from travelling

35

by night and working by day, but in good health. He praises the looks of the Queen and young Prince, and refers to a bullfight he attended a few days previously which reminded him of the one in Valladolid.

A month after his return to Madrid, on 31 July, Velázquez fell ill, and a few days later he died, probably of the same fever that carried off the Bolognese painter Mitelli a few days earlier, and his own wife Juana Pacheco a few days later. Velázquez died without making a will but had given power of attorney, as Palomino records, to his friend Gaspar de Fuensalida, Keeper of the Records, in whose family vault in the church of San Juan Bautista he was buried. During his illness the King is said not only to have sent him court physicians, but to have gone himself to visit him in the hour of his death.

As was the custom with Knights of Santiago, Velázquez's body was clothed in the robes of the Order and, if we can believe Palomino, the funeral rites were carried out with elaborate ceremonial, 'with the greatest pomp and at enormous expense, but not too enormous for so great a man', to quote Velázquez's epitaph, composed by the brothers Alfaro and published by Palomino. Juan de Alfaro was no doubt present at his master's funeral. A drawing attributed to him shows Velázquez in his funeral attire (Plate 26). Alfaro also probably provided Palomino with the list of offices held by Velázquez and the honours conferred on him, which have proved accurate in nearly every detail, including his emoluments.

Alfaro is also probably the source of Palomino's story of the calumnies against Velázquez after his death, which are so far unconfirmed. His son-in-law and executor, Mazo, who succeeded him as Court Painter in 1661, had difficulty in getting possession of his family's inheritance, but this was apparently because Velázquez owed money at the time of his death, no doubt in payment of the enormous expenses of the Proofs of his nobility, which led to the seizure of his belongings. Eventually, after several applications for money owing to Velázquez by the treasury, his debts were liquidated and his belongings released. Inventories were made soon after his death of the *Cuarto del Príncipe*, the room where he worked in the royal palace, and of his apartments in the Casa del Tesoro, where he and his wife lived and died. The list of his possessions, furniture, clothes, ornaments and jewellery, shows that Velázquez lived in great comfort, if not luxury, even though he had so often to plead for money due to him. The paintings in his room in the palace, some by Velázquez himself, belonged partly to the King and partly to the artist. There were also a few paintings in his home which are difficult to identify, and a library of 154 books, including several that Palomino cited in his account of Velázquez's early education, and some recent Italian and Spanish publications. In the room where Velázquez and his wife died was a trunk full of clothes not yet unpacked, which he must have brought back with him from his last journey to the Isle of Pheasants.

27. *Pendent Badge of Santiago*. 17th century. Gold enamelled. Height, 1⅛ in. (2.8 cm.). London, Victoria and Albert Museum.

2 Early Works in Seville: 1617-1623

Velázquez's oeuvre is by no means as well documented as his career. He seldom signed or dated his paintings and the number of works recorded in his lifetime is surprisingly small. Although some of his early works in Seville were doubtless commissioned, no contracts have come to light. The records of payment he received as Court Painter seldom refer to specific works, nor do they provide evidence of the date of execution, as payment was usually made in arrears. The only inventory of the royal collection made in the artist's lifetime is that of the Madrid Alcázar in 1636–7, when only three paintings by Velázquez were hanging there. The art of engraving was little practised in Spain before the eighteenth century, and the very few works by Velázquez recorded in engravings in his lifetime are restricted to portraits. Indeed, the first artist to make engravings after Velázquez's paintings for their artistic importance was Goya, who in 1778–9 recorded many of his works in the royal collection.

Pacheco makes general reference to drawings and *bodegones* made by Velázquez as part of his early training, but names no more than eight paintings, all dating from after he first went to Madrid, only two of which are known today. Nevertheless, Velázquez's youthful oeuvre as a painter in Seville presents fewer problems of identification and dating than his production as Court Painter. On the one hand, some of the early paintings are dated, and, on the other, with the exception of a few canvases of disputed authorship, they form a group so harmonious in style and character that they could hardly be mistaken for the work of any artist other than Velázquez or be attributed to a later period of his career. The existence of more than one version of some of these paintings does, it is true, raise questions of authorship that have not yet been satisfactorily solved. Did Velázquez himself make repetitions of his early compositions, as he probably did of later royal portraits; did he already have a studio when he was living in Seville; or was he from the beginning successful enough for his paintings to be copied as they came off the easel? As for the dating, the appearance of the same models and the same studio props in different pictures is of little assistance in arranging them in strict chronological sequence. This is of no great significance, however, since all the extant early works must have been painted within a period of no more than five or six years, from the time Velázquez qualified as a painter in Seville in 1617 until he moved to the court in 1623.

The earliest date on any of the paintings is 1618, the year of Velázquez's marriage to the daughter of his master Pacheco, and one year after he had completed his apprenticeship. This date appears on the *Old Woman Cooking Eggs* (Plate 28) and the date of which there are traces on the *Kitchen Scene with Christ in the House*

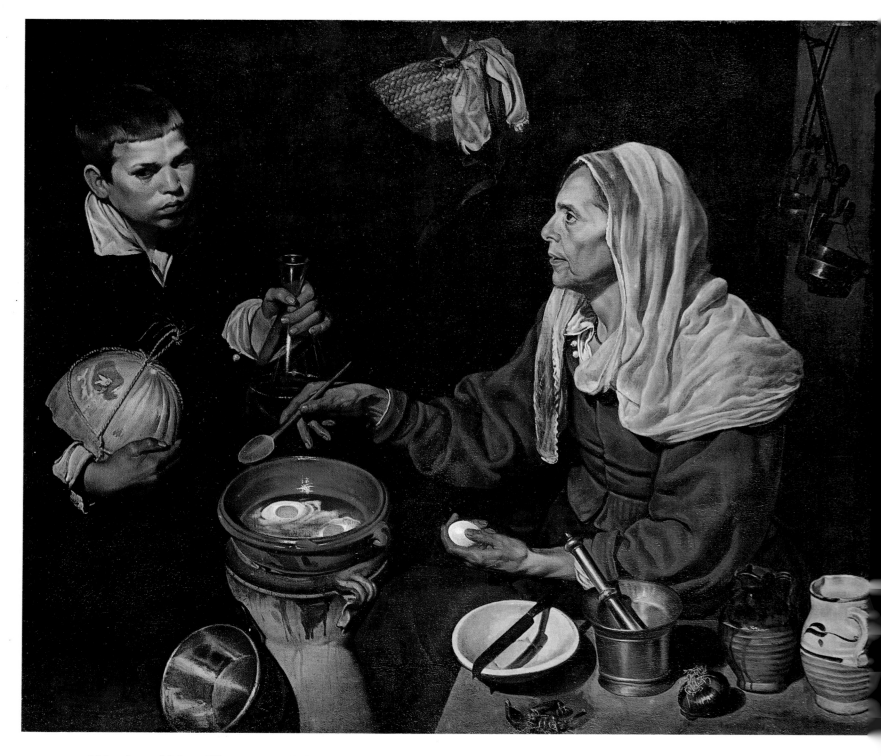

of *Martha and Mary* (Plate 34) probably also originally read 1618. The *Adoration of the Magi* (Plate 30) is dated 1619. The two versions of the portrait of the nun *Jerónima de la Fuente* (Plate 31) are signed and dated 1620, and one if not both versions can be dated more exactly to June of that year, when the sitter is known to have been in Seville. The date 1620 also appears, with a monogram, on the portrait of *Cristóbal Suárez de Ribera* (Seville Museum, on loan). The last datable work of the period is the portrait of the poet *Luis de Góngora* (Plate 29), which we know from Pacheco was painted at his request during Velázquez's first visit to Madrid in 1622.

Velázquez most probably began his career as a painter of religious subjects, and he was examined as such. Throughout the seventeenth century this was the chief

28. *An Old Woman Cooking Eggs.* 1618. Canvas, 39⅝ × 47 in. (100.5 × 119.5 cm.). Edinburgh, National Gallery of Scotland. The date 1618 uncovered during cleaning (1957) makes this and Plate 34 the earliest surviving dated works. Velázquez would have known the comparable scene of a woman cooking eggs for a young boy (the Sevillian rogue hero) described in detail in the picaresque novel by Mateo Alemán: *Guzmán de Alfarache* (I, 1599).

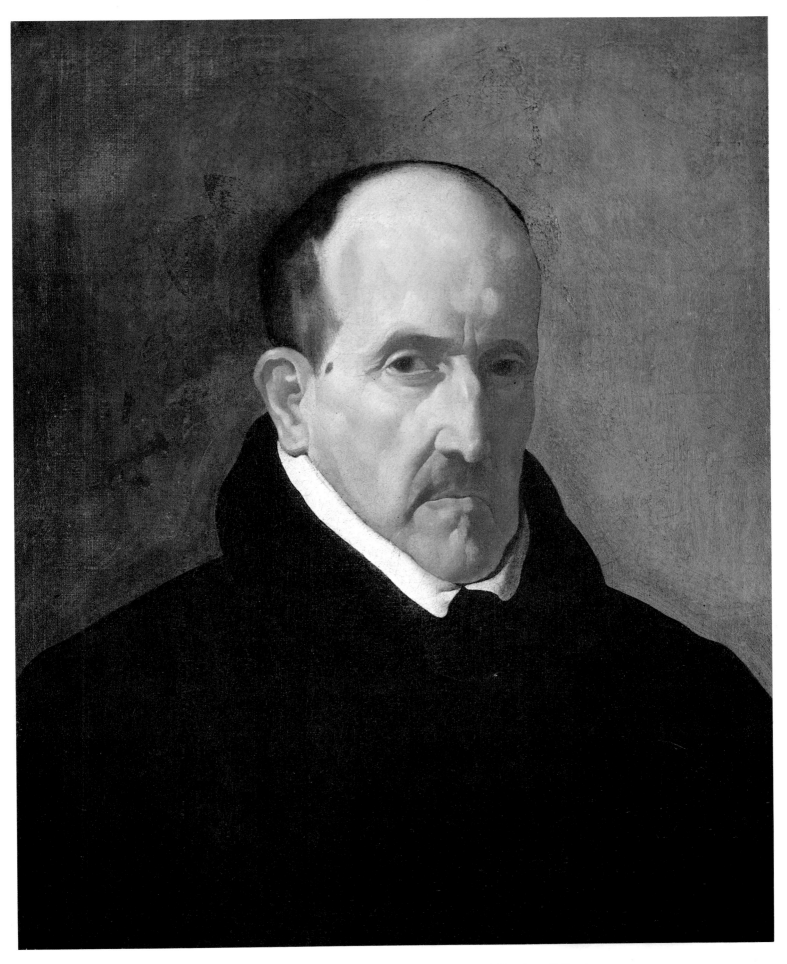

29. *Luis de Góngora* (1561–1627). 1622. Canvas, 20⅛ × 16⅛ in. (51 × 41 cm.). Boston, Museum of Fine Arts. (L-R 25)
Velázquez painted the celebrated poet, satirist and former chaplain to Philip III at the request of Pacheco on his first visit to Madrid. The poet originally wore a laurel wreath in the painting, which was no doubt made as a model for the *Libro de Retratos*, a collection of drawings of famous men that Pacheco was compiling, but it is not among the surviving drawings. Several copies of Velázquez's portrait were made in painting and engraving.

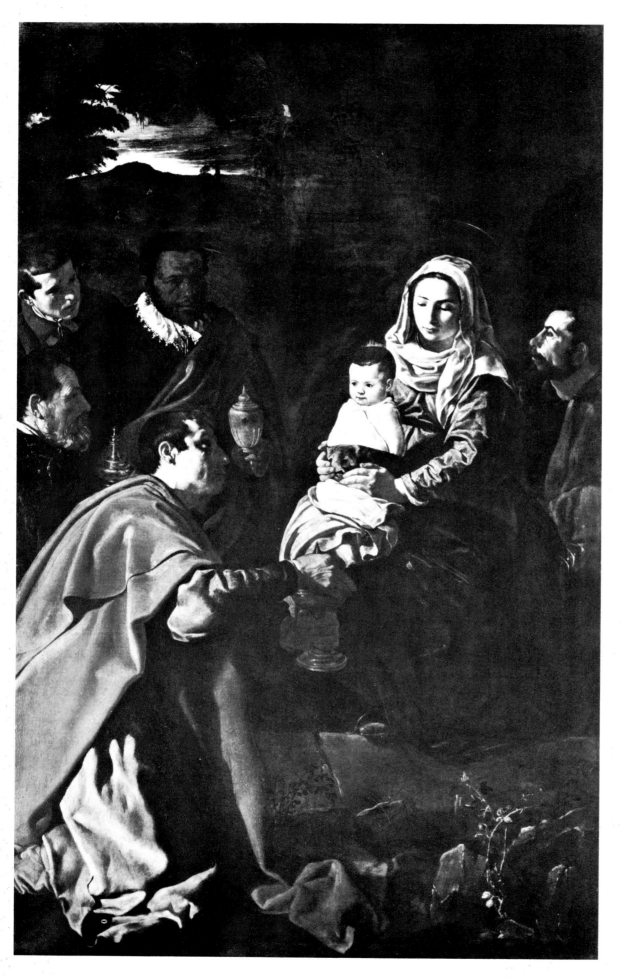

30 (Left). The Adoration of the Magi.
Dated 1619. Canvas, 78 × 49½ in.
(203 × 125 cm.). Madrid, Prado
Museum. (L-R 3)
Probably painted for the Jesuit
College of San Luis, Seville. The
composition, cut a little on all sides,
is the most elaborate of his early
works, but many of the same models
used in other paintings – The Virgin
of the Immaculate Conception (Plate 32),
the boy in some of the bodegones,
perhaps also the Water Seller (Plate
39)–appear here.

31 (Right). Sor Jerónima de la Fuente.
Signed: Diego Velasquez f. 1620.
Canvas, 63 × 43¼ in. (160 × 110 cm.).
Madrid, private collection. (L-R 21)
The inscription (added later) states
that this is 'a true portrait' of the nun
from the Franciscan Convent of
Santa Isabel, Toledo, who set out to
found a convent of the Order in
Manila at the age of 66, on 28 April
1620. Velázquez must have painted
her during her stay in Seville on her
way to the Philippines, 1–20 June
1620. Another version of the portrait,
with a few variations, also signed and
dated, is in the Prado Museum. Both
are considered autograph though it is
unclear which was painted first.

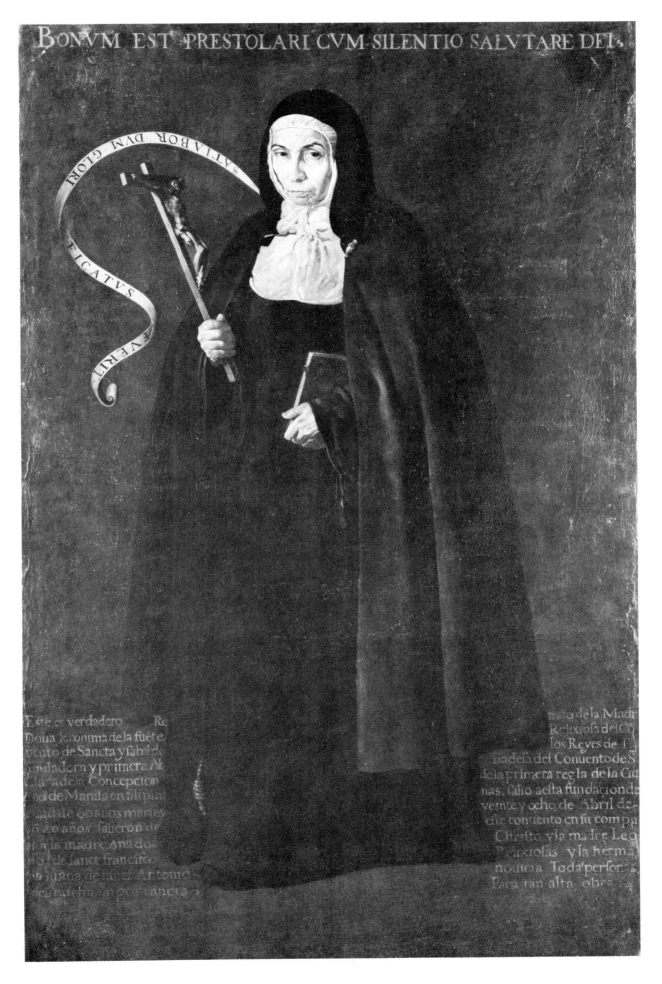

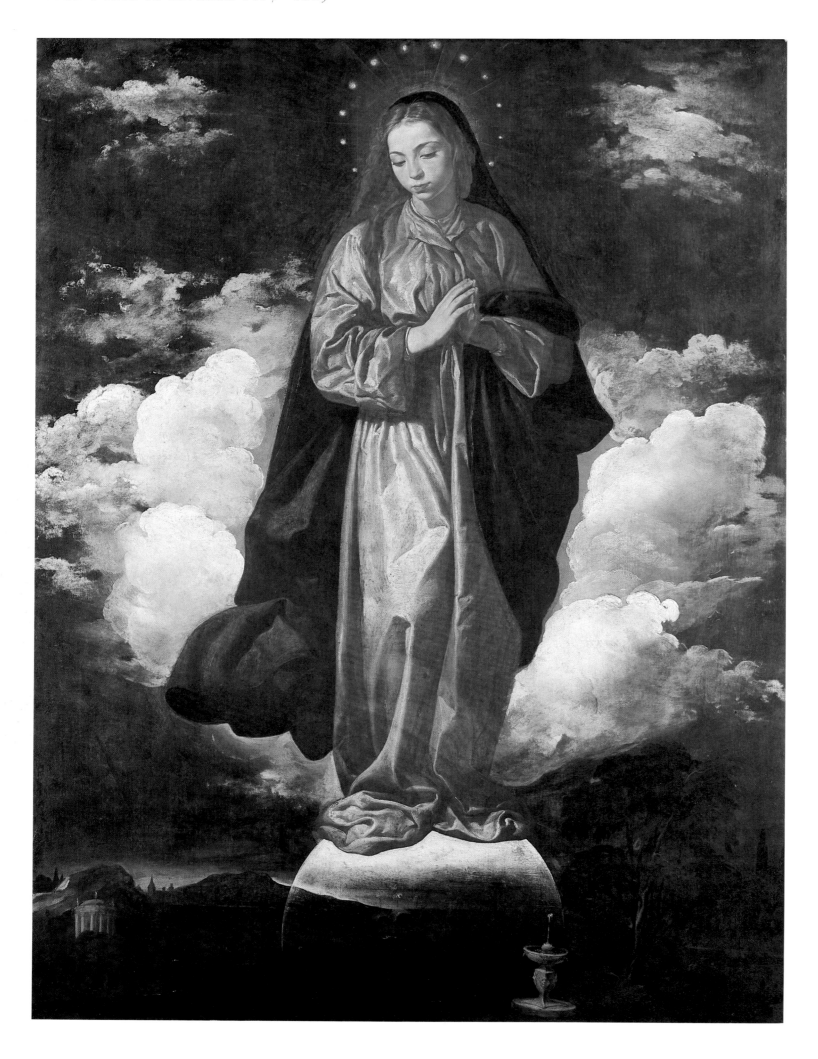

32 (*Left*). *The Virgin of the Immaculate Conception*. Canvas, 53 × 40 in. (135 × 101.6 cm.). London, National Gallery. (L-R 11)
Probably painted with *Saint John the Evangelist* (Plate 33) for the Convent of Shod Carmelites, Seville, where they are first recorded in 1800. Painted soon after the celebrations of the papal decree defending the mystery of the Immaculate Conception in 1617, the year in which Velázquez was examined as Master Painter. This is one of the earliest of innumerable Sevillian paintings of the subject. Velázquez has followed Pacheco's precept for its orthodox treatment, and the landscape is filled with traditional emblems from the Litany of the Virgin.

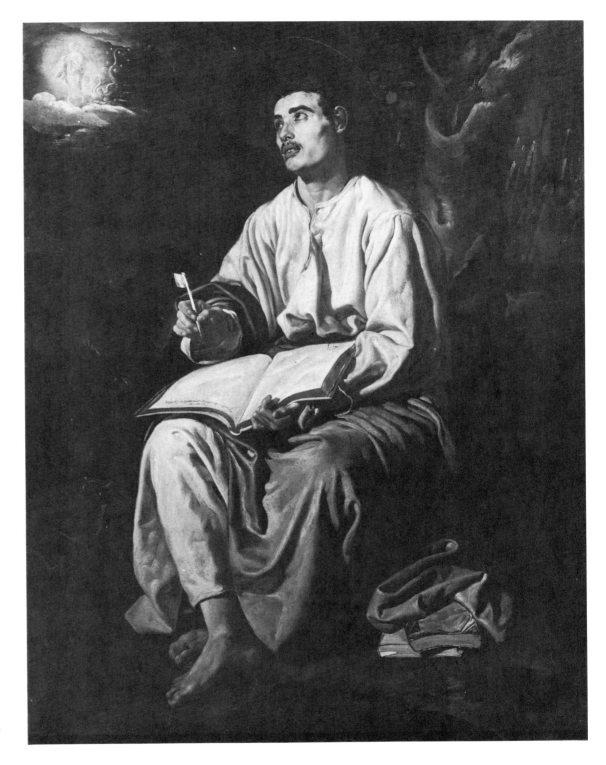

33. *Saint John the Evangelist on the Island of Patmos*. Canvas, $53\frac{3}{8} \times 40\frac{1}{4}$ in. (135.5 × 102.2 cm.). London, National Gallery. (L-R 12)
Probably painted as pendant to Plate 32. The subjects are closely related, Saint John's vision of the Woman of the Apocalypse, here represented on a tiny scale, was considered supporting evidence of the Immaculate Conception of the Virgin and was an iconographic source of her representation. Velázquez has represented Saint John as a young man, probably using one of the models that appear in his *bodegones*, despite the recommendation of Pacheco and others that he was an old man when he wrote the Apocalypse.

occupation of artists in Seville, and it was there that orthodox rules for the treatment of Christian mysteries were formulated by Velázquez's master. A large part of Pacheco's treatise is devoted to these rules, which were based, according to him, on Holy Scripture and on the writings of the Doctors of the Church. Velázquez closely followed Pacheco's precepts in his representation of the *Virgin of the Immaculate Conception* (Plate 32), one of his earliest extant works, but not in the companion piece *Saint John the Evangelist on Patmos* (Plate 33). Many years later he was to represent *Christ on the Cross* (Plate 113) crucified with four nails, following a tradition of which Pacheco was a keen apologist.

Neither Pacheco nor Palomino mentions Velázquez's early religious subjects,

but both speak of him as a painter of *bodegones*. The *bodegón*, the name given to kitchen or tavern scenes with prominent still-life, was a new type of genre subject in Spanish painting, and Velázquez was one of its earliest exponents in Spain as well as the most celebrated. (The term now refers simply to still-life.) As subject-matter, the *bodegón* apparently met with some criticism, judging from Pacheco's defence of it as being worthy of art, especially when painted by his son-in-law, and he adds that he himself ventured to paint such a subject when he was in Madrid in 1625, to please a friend. Palomino also praises the *bodegón*, citing as Velázquez's eminent predecessor Piraikos, a painter of antiquity who, according to Pliny, was nicknamed 'rhyparographos, painter of low and coarse themes'. Palomino singles out for detailed, if not altogether accurate, description several of Velázquez's *bodegones*, only two of which are known today. One, the *Water Seller* (Plate 39), must have been one of the first examples of Velázquez's painting to be seen and admired at the Court. In Palomino's time it hung in the Buen Retiro Palace. Of the other, *Two Young Men at Table* (Plate 38), he does not give the whereabouts. Both paintings were among those captured by the Duke of Wellington and are now at Apsley House. Both were attributed to Caravaggio when they arrived in London.

Some of Velázquez's early *bodegones* not mentioned by his biographers are also extant, two of which are distinguished by a religious scene represented on a small scale in the background: the *Kitchen Scene with Christ in the House of Martha and Mary* (Plate 34) and the *Tavern Scene with Christ at Emmaus* (Plate 35). The double scene with two episodes of the same story was a commonplace in late sixteenth- and early seventeenth-century painting and occurs, for instance, in Pacheco's *Saint*

35 (*Right*). *Tavern Scene with Christ at Emmaus*. Canvas, 21¾ × 44 in. (55.8 × 118 cm.). The canvas has been cut on the left, with the loss of one disciple. Blessington, the Beit Collection. (L-R 17) Similar in composition and character to Plate 34, here the trance-like air of the mulatto kitchen maid suggests awareness of the moment of recognition of Christ by the disciples, seen through the hatch in the background (Luke 24: 30–1). The religious scene was uncovered during cleaning (1933). A version without the religious scene is in the Art Institute of Chicago.

34. *Kitchen Scene with Christ in the House of Martha and Mary*. 1618. Canvas, 23⅝ × 40¾ in. (60 × 103.5 cm.). London, National Gallery. (L-R 7) The remains of a date, similar to that on Plate 28, were discovered during cleaning (1965). This and Plate 35 are the only known examples by Velázquez of *bodegones* with religious subjects. The scene of Martha and Mary (Luke 10: 38–42), on a small scale, is seen through a hatch in the background. The source is 16th-century Netherlandish compositions (cf. Plate 37). The subject would have been eminently suited to hang in a nuns' refectory.

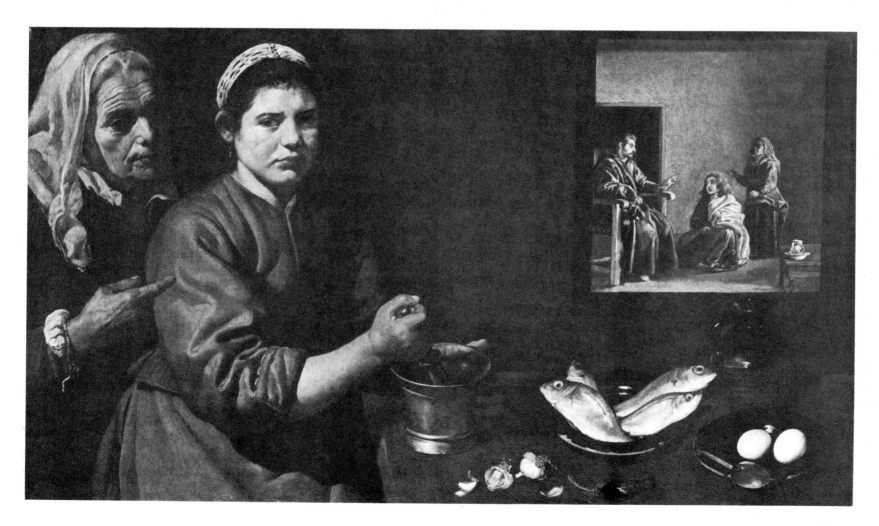

36 (*Below*). Francisco Pacheco (1564–1644). *Saint Sebastian attended by Saint Irene*. 1616. Canvas, 115 × 85 in. (292.2 × 216 cm.). Formerly Alcalá de Guadaira, Hospital of Saint Sebastian, destroyed 1936.

37 (*Below right*). Jacob Matham (1571–1631) after Pieter Aertsen (1508–75). *Kitchen Scene with Christ at Emmaus*. One of a set of engravings of homely scenes with biblical subjects that Velázquez may have known.

Sebastian Attended by Saint Irene, painted in 1616, with the main scene in the foreground and the Martyrdom of Saint Sebastian on a much smaller scale seen through an open window at the back (Plate 36). But closer sources for Velázquez's combination of kitchen scene and religious subject, in horizontal compositions, with half-length figures in contemporary costume in the foreground and a small-scale religious subject in the background, are the much earlier works of some Netherlandish painters, notably Pieter Aertsen (1508–75) and Joachim Beuckelaer (*c*.1530–*c*.1573), which Velázquez could have known through engravings (Plate 37), if not in the original. Velázquez, however, has produced his own

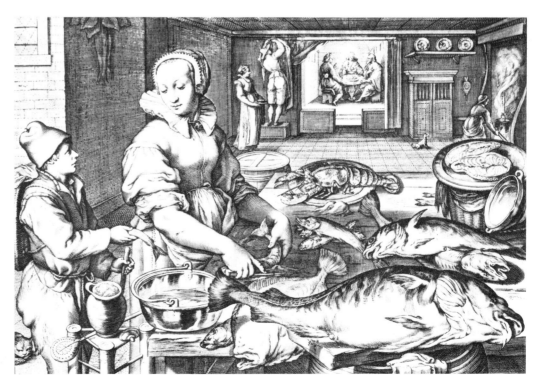

entirely Spanish version of the foreground scene: the kitchen maid and her companion are two of his regular local models, the kitchen utensils, the water jug, the mortar and pestle are typically Spanish, the garlic and pimento are basic ingredients of a Spanish meal. At the same time, the kitchen scene, as in some of the northern examples, is more than realistic genre. The gesture of the old woman and the pensive air of the young woman as she pauses in her work, as if they were addressing the spectator, suggest that they play a moralizing role relating them to the religious theme in the background. This role is not obvious, however. Possibly the allusion is to the contemplative and active lives for which Martha and Mary stand. Similarly, the rapt expression on the face of the servant in the tavern at Emmaus indicates her awareness of the miracle that is taking place behind her, even though she cannot see it.

The old woman in the kitchen scene appears again as the *Old Woman Cooking Eggs* (Plates 42, 43), probably painted in the same year, and some of the kitchen utensils also reappear in the painting. The young boy holding the carafe of water in the same picture is seen again in the *Water Seller*. In fact, not only the studio equipment (Plates 40, 41) but also many of the same models appear again and again in different poses and with varying expressions in these early religious and genre subjects, bearing out Pacheco's description of how Velázquez in his youth made studies from the life in drawings. Pacheco in his treatise takes credit for having set his pupil on the path of what he calls the 'true imitation of nature'. He himself, he writes, found it best to keep to nature not only for heads, hands and feet, but also for the draperies and everything else. For the female nude, however,

38. *Two Young Men at Table*. Canvas, 25⅜ × 41 in. (64.5 × 104 cm.). London, Apsley House, the Wellington Museum. (L-R 24)
First mentioned by Palomino, who describes it somewhat inaccurately and does not say where it was. Later in the royal collection, it was among the paintings captured in 1813 by Wellington.

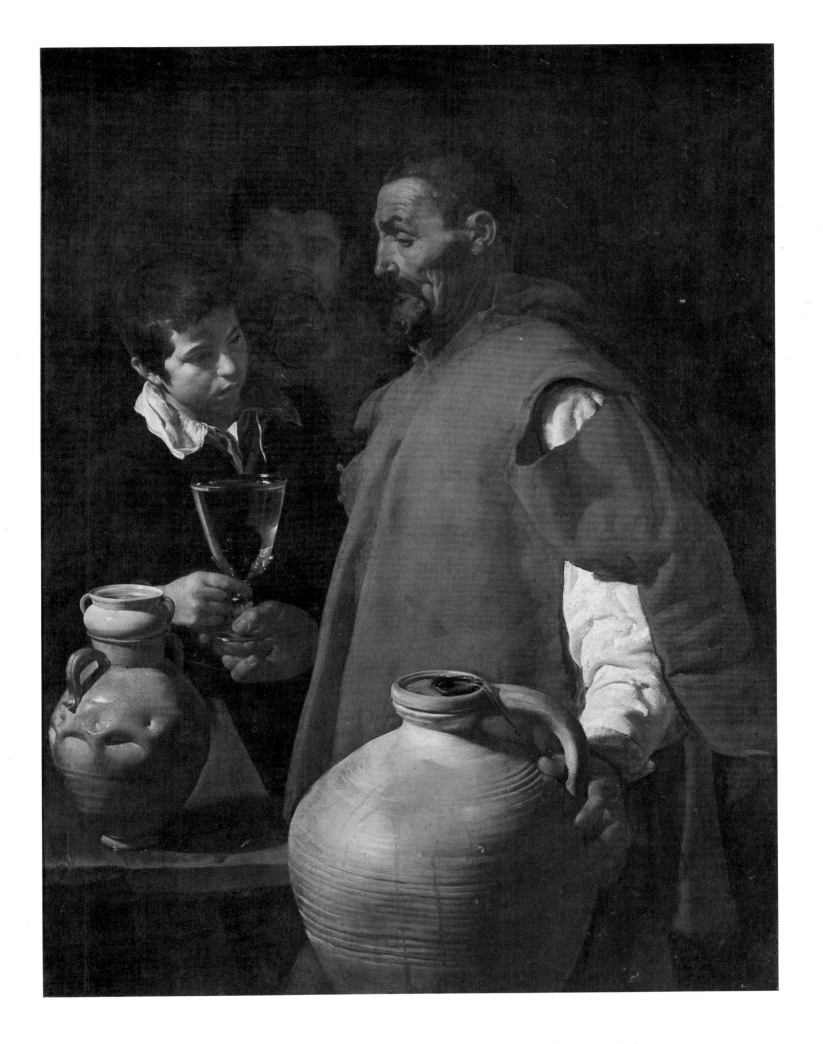

39. *The Water Seller of Seville*. Canvas, 42 × 31⅞ in. (106.7 × 81 cm). London, Apsley House, the Wellington Museum. (L-R 16)
The only work painted in Seville of which there is a record in Velázquez's lifetime; recorded in the collection of his friend and protector Juan Fonseca
y Figueroa, at his death in Madrid in 1627. Later, it entered the royal collection, where it is first recorded in 1701 in the Buen Retiro and where it was
in Palomino's time. The water seller was until recent times a familiar sight in Spain, especially in the south. In Seville, he figures in the picaresque
novel, *Vida y hechos de Estebanillo González*, 1646. Three variations of Velázquez's painting are known.

40 (*Left*). Detail of Plate 35.

41. Detail of Plate 28.
Examples of kitchen utensils, part of the artist's studio equipment that appear in different early works.

unavoidable in certain religious subjects, he advised copying from nature only the head and hands ('of chaste women') and for the rest using 'good pictures, engravings, drawings, models, and ancient and modern statues'. Pacheco's concern for truthfulness is also expressed in his rules for the representation of religious subjects, where he insists on accuracy – in the spirit of the Counter-Reformation – and the need, in the portrayal of saints, to take a faithful likeness, a portrait from life or a death mask, wherever possible.

Pacheco did not practise what he preached – at least not at the time when he was Velázquez's teacher – but his book was published, if not written, long afterwards. He was later to some extent influenced by his famous pupil. What is striking, therefore, about Velázquez's earliest known paintings is, first, the extraordinary accomplishment of an artist barely 20 years old and, second, that they

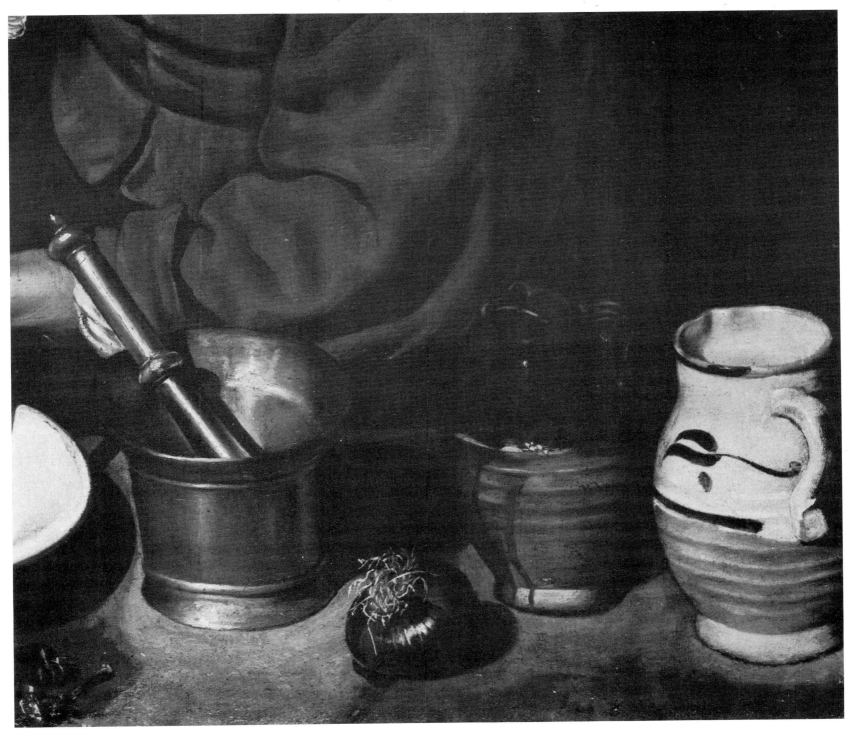

42. Detail of Plate 34.
The old woman shown in this Plate and in Plate 43 was evidently painted from the same model.

43. Detail of Plate 28.

are in a 'modern' style that distinguishes them not only from that of northern artists who inspired some of his compositions, but also from that of his teacher, the leading painter in Seville at the time. In his representation of the *Virgin of the Immaculate Conception* (Plate 32), to take an example, Velázquez with his simple pose and emphasis on the heavy folds of the drapery has created an effect of solid and natural form very different from the stiff, flat figures in Pacheco's versions of the subject (Plate 44). Indeed, this popular devotional image by Velázquez seems to owe less to Pacheco than to the polychrome wood sculptures of Juan Martínez Montañés (Plate 45), who had been active in Seville since the beginning of the century. The colouring of his carved figures was carried out by painters, including Pacheco, and increases their natural appearance, 'gives them life', as Pacheco puts it. Some of them, made to be taken out in Holy Week processions, were dressed and adorned, as they are today, like actors, to inspire public participation in the actions and emotions they portray.

Velázquez was the earliest exponent of this 'naturalistic' style in painting in Seville, where it nourished his contemporaries, Francisco Zurbarán and Alonso Cano, and also Murillo a generation later. The naturalistic style of the young Velázquez and of later Seville painters has a distinctive character, although its origins are almost certainly related to those of other forms of naturalism that appear elsewhere in Spain from the second decade of the seventeenth century

44 (*Above left*). Francisco Pacheco (1564–1644). *The Virgin of the Immaculate Conception, with the Poet Miguel Cid.* Signed and dated 1621. Canvas, 59 × 43 in. (150 × 109.2 cm.). Seville Cathedral.
One of several paintings of the subject by Pacheco. The donor, Miguel Cid, holds a verse he composed in honour of the Immaculate Conception that was set to music and chanted in the streets of Seville, becoming the battle-cry of the supporters of the mystery.

45 (*Above*). Juan Martínez Montañés (1568–1649). *The Virgin of the Immaculate Conception.* 1606–8. Polychromed wood. El Pedroso, Church of Nuestra Señora de la Consolación.
The first of several sculptures by Montañés representing the mystery that was soon to become a matter of passionate concern throughout Spain, but particularly in Seville. Montañés conforms to Pacheco's rules for the representation of the subject.

onwards: notably in Toledo, in the work of Maino and Tristán, and in Valencia in the paintings of Francisco Ribalta and his followers.

In genre subjects like Velázquez's *Water Seller* (Plate 39), Spanish naturalism can be related to the taste for low-life subjects popularized by the picaresque novel. In religious art it is associated with the popular piety prevalent in seventeenth-century Spain, and particularly in Seville. But its origin has been disputed. Some critics argue in favour of the autonomous character, the 'Spanishness' of Spanish naturalism, while others attribute most of its manifestations to

46. Jusepe de Ribera
(1591–1652). *The Sense of Taste*
c. 1614–16. Canvas, 44¾ × 34¾ in.
(113.6 × 88.3 cm.). Hartford,
Connecticut, Wadsworth
Atheneum.
One of the 'half-length figures
of the five senses' which
Mancini (writing about 1620)
says Ribera painted in Rome for
a Spanish patron (unnamed).
The originals of *Taste, Touch* and
Sight and copies and variants of
all five are known. Among the
names formerly given to one or
other is that of Velázquez, the
half-length figures behind tables
with still-life recalling his
bodegones.

the impetus of Caravaggio, whose influence had revolutionized painting in other European countries earlier in the century. That the young Velázquez evolved a style so different from his master's without outside influence is hard to believe, and the novelties he introduced, the use of commonplace models, the effect of volume and space created by means of modelling in light and shade, the emphasis on still-life and his genre subject-matter, must almost certainly be attributed to the influence, direct or indirect, of Caravaggio. 'They gave him the name of a second Caravaggio . . . because he imitated nature so successfully', says Palomino. He was writing with hindsight, but Pacheco also ranks Velázquez with Caravaggio and Ribera as an artist who always worked from the life.

The question of when and how the influence of Caravaggio first reached Spain is still difficult to answer. Whereas in other countries we have examples of artists who went to Rome in Caravaggio's lifetime and took back his influence to their native countries, the few Spanish painters who are known to have gone to Italy in the early seventeenth century did so after Caravaggio's death. As for Ribera, the recent identification of the *Five Senses* (Plate 46) which, according to Mancini, he painted in Rome for a Spanish patron (*c*.1614–16) supports the theory that he was one of the most important channels of Caravaggesque influence in Spain. We still do not know, however, when his works first began to reach his native country, only that from the 1620s onwards many of his paintings were taken or sent as gifts by the Viceroys, and were highly esteemed both in provincial centres and at the court. As for the *caposcuola* himself, one question of major importance remains unanswered. Did the Prior of the hospital where Caravaggio was nursed in Rome in 1596 (?) take the artist's gift of paintings back with him to Sicily or Seville? (The question arises out of the variants in two manuscript copies of the treatise by his early biographer, Giulio Mancini.) These paintings apart, the number of works by Caravaggio recorded in Spain at an early date is very small. The actual number in Spanish hands may have been considerably larger. Milan, where Caravaggio was born, and Naples and Sicily, where he lived, were under Spanish rule, and at his death it was the Spanish authorities who took charge of his belongings. Moreover, some of the copies of Caravaggio's paintings that exist in Spain today, and more besides, may well have come there in the early seventeenth century. These included in all probability the copies of the *Crucifixion of Saint Peter* (Plate 47) mentioned by Pacheco. There was presumably one or more in Seville in Pacheco's time since he claimed that they showed, despite their being copies, how the artist worked from life.

Velázquez, Palomino writes, was called a second Caravaggio because he was so successful in imitating nature. According to Pacheco, it was through the many studies he made of his models that Velázquez 'gained assurance in portraiture'. Caravaggio, Pacheco points out, although one of the great painters, was not a portraitist. In fact he painted very few portraits. Velázquez was undoubtedly exceptional among all the exponents of naturalism, in that he began as a painter of religious subjects and genre and developed into a master of portraiture. It was no doubt Pacheco who encouraged his former pupil to try his hand at portraiture, although only a few painted portraits by him are known, and these are nearly all of donors of religious pictures. Pacheco, however, was engaged for many years on making a collection of drawings of famous men, following the Renaissance tradition, which he accompanied with eulogies in verse, and which he evidently planned to publish. His drawings were mostly copied from models by other artists, and the portrait of the poet Góngora, which Velázquez made in 1622 at his request, was doubtless intended to provide such a model.

Velázquez's early portraits, like his figure subjects, illustrate the theory but not

47. Michelangelo da Caravaggio (1573–1610). *The Crucifixion of Saint Peter.* 1600–1. Canvas, 90½ × 68⅞ in. (230 × 175 cm.). Rome, Santa Maria del Popolo. Several copies have been recorded in Spain. A small copy by Francisco Ribalta (signed) may have been made in Rome. Even in copies of the painting that Pacheco saw he claimed he could admire Caravaggio's faithful rendering of nature, a procedure followed, he says, by Ribera and Velázquez.

the practice of Pacheco, showing how his youthful training in making studies from the life served him as a portrait painter. Indeed, the new naturalistic style of his *bodegones*, with its dark tones, strong modelling in light and shade and emphasis on detail, seems to give his portraits an effect of characterization as well as of faithful likeness, at least in the case of the two sitters whose identity is known: the 66-year-old Franciscan nun from Toledo, *Jerónima de la Fuente* (Plate 31), a sturdy figure with rugged features and penetrating glance, portrayed as she stopped in Seville on her way to Manila to found a convent, and the famous poet

and court chaplain, *Luis de Góngora* (Plate 29), at the age of 60, an impressive head with strongly marked features and severe expression, set off by his black costume. The portrait of Góngora, which Velázquez painted on his visit to Madrid in 1622, must have been seen by many people at the court before it was taken back to Seville to Pacheco, who had commissioned it. From the many copies that were made, it must have been much admired, and since it was the only portrait Velázquez painted on this occasion, it must also have played an important part in earning him an invitation to return to court in the following year.

3 At Court: The 1620s

Had Velázquez remained in Seville, instead of moving to Madrid, he would no doubt have won fame as a religious painter instead of as a master of portraiture. Outside the court, the Church was still the chief patron of art in Spain throughout the seventeenth century, and it was in Seville, where Velázquez was born and trained, that the most important religious painters flourished: Francisco Zurbarán (1598–1664) and Alonso Cano (1601–67), almost exact contemporaries of Velázquez; Bartolomé Esteban Murillo (1617–82), born nearly 20 years later; and Juan de Valdés Leal (1622–90), a few years younger than Murillo. Even at the court, two of the painters who had passed from the service of Philip III to that of his son were chiefly religious artists: Vicente Carducho and Eugenio Caxés, the younger brother and son respectively of Italians who had come to work for Philip II in the Escorial; and two were portrait painters: Bartolomé González and Rodrigo de Villandrando, pupils of Pantoja de la Cruz and followers of the tradition of court portraiture introduced by the Dutchman Anthonis Mor and continued by Alonso Sánchez Coello in the sixteenth century.

Although in Seville Velázquez had been occupied chiefly with religious and genre subjects, it was as a portrait painter that he made his first appearance at court in 1622, and although he was not to paint the King on this occasion, his call to the court in the following year by the Prime Minister soon gave him that opportunity. His portrait of the King painted in August 1623 won him his appointment as Painter to Philip IV in the following October, filling a vacancy created by the death of Rodrigo de Villandrando in December of the previous year. The portrait of Philip IV also won the young Sevillian artist the approval of Olivares who, according to Pacheco, promised him that in future he alone was to portray the King. If this is true, an exception was made in the case of Rubens. From now on Velázquez was to be occupied chiefly with portraiture, with recording the likeness of members of the royal family and of the court. Only occasionally was he to be called upon to paint religious, historical or mythological subjects, and he never, so far as we know, returned to genre. His most frequent sitter was to be Philip IV himself, with whom the artist lived in close contact, with a studio in the palace, to which the King used to come and watch his favourite painter at work.

Velázquez's move to the court opened up for him a new world, not because of his fellow artists, who were of modest stature, but because of the royal collection of paintings, rich in works of the Italian Renaissance, which Philip IV had inherited from his grandfather and great-grandfather, Philip II and Charles V. Both monarchs had employed Titian, the artist who was to have more influence

57

48. *The Conde-Duque de Olivares. c.* 1625.
Canvas, 95 × 51 in. (216 × 129.5 cm.). New
York, The Hispanic Society of America.
(L-R 32)
The inscription *el Conde Duque*, even if not
original, suggests that the portrait
represents the Conde de Olivares after he
was created Duque de Sanlúcar in January
1625. He wears the green cross of the
Order of Alcántara for which he had
renounced the red cross of Calatrava worn
in the São Paulo portrait. The riding whip
is the symbol of his office of Master of the
Horse.

than any other on Velázquez's later development, and most of Velázquez's royal
portraits were made to hang in the same palace, if not in the same room, as
Titian's.

Unfortunately, Velázquez's earliest court portraits have not survived: the
portraits of his host, Juan de Fonseca, Philip IV, and the Prince of Wales (the
future Charles I), all painted in 1623 (cf. Plate 6). Nor has the equestrian portrait
of the King, 'all painted from life, even the landscape', which was exhibited in the
Calle Mayor and won him the envy of his fellow artists and the admiration of all
the court, a financial award and several eulogies in verse. In 1626, soon after it

was painted, it was hung in a place of honour in the great hall of the palace opposite Titian's portrait of *Charles V at Mühlberg* (Plate 85). It was later replaced by Rubens's equestrian portrait of the King.

Only a small number of the paintings by Velázquez that can be dated with certainty between 1623 and 1629, when he left on his first visit to Italy, are known today. This makes for some difficulty in tracing the different stages of his development, all the more so in view of his habit of making alterations to his works, encouraged no doubt by the fact that they were always at hand.

The question of whether a painting is an original or a replica, an autograph or studio work, also arises at the outset of Velázquez's career as Court Portraitist, suggesting that from the beginning he had studio assistants. The portraits of the *Conde-Duque de Olivares* (São Paulo Museum) and *Philip IV* (Metropolitan Museum) are a case in point. Because of their pedigree, they have been identified with two of three portraits for which Velázquez received payment in December 1624. But because of their execution – they lack the hallmarks of undisputed autograph paintings – they have been classed by some critics as copies after lost originals. Their connection with the portraits documented in 1624 is supported by their relationship to portraits of the same sitters painted by Velázquez a year or two later: *Olivares*, *c*.1625 (Plate 48); *Philip IV*, *c*.1626 (Plate 52). It was apparently a version of the earlier portrait that provided Rubens with the model for his first design for an engraved portrait of the *Conde-Duque de Olivares* (Plate

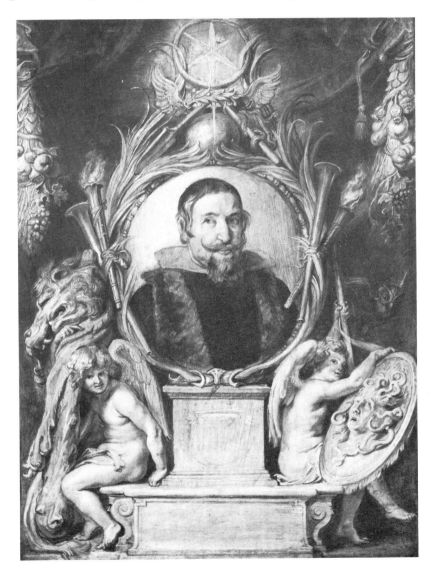

49. Peter Paul Rubens (1577–1640). *The Conde-Duque de Olivares*. Panel, 24¾ × 17⅜ in. (63 × 44 cm.). Brussels, Musées Royaux des Beaux-Arts. Rubens's first sketch for the engraved portrait is based on the likeness in the São Paulo portrait or a version of it.

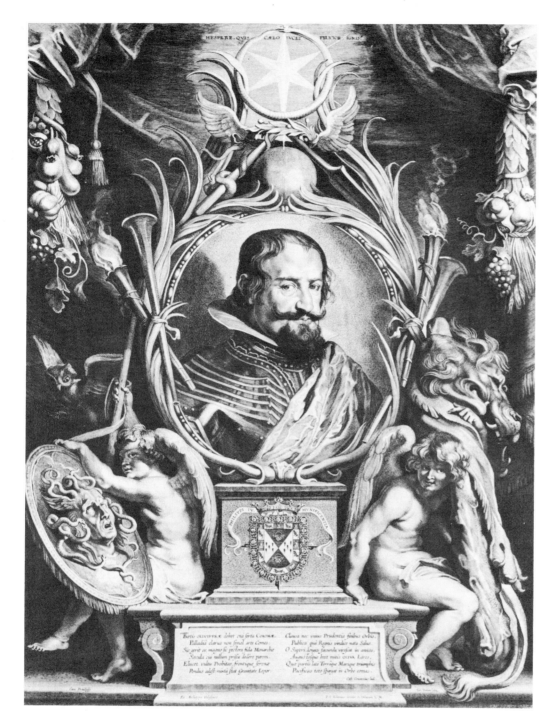

50. *The Conde-Duque de Olivares.* Engraving by Pontius after Velázquez and Rubens. Inscribed: *Ex Archetypo Velasquez. P.P. Rubenius ornavit et Dedicavit L.M. Paul. Pontius Sculp.* 1626. 24⅜ × 17½ in. (62 × 44.5 cm.).
The engraving was in Olivares's hands by 8 August 1626, when he wrote to Rubens in Antwerp, thanking him enthusiastically for this token of his friendship.

49). The finished engraving, sent to Madrid in 1626, presents a more recent likeness of him, with a different hairstyle and beard, based on what must have been a later portrait by Velázquez (Plate 50).

From the evidence we have, Velázquez's first court portraits were in the severe naturalistic style of his Seville paintings, like the portrait of Góngora and the portrait of a *Young Man Wearing a Golilla* (the new-style collar), which some critics believe to be a self-portrait (Plate 5). Indeed, the portrait of *Góngora* (Plate 29) and the *Water Seller* (Plate 39), which Velázquez took with him or sent to his patron in Madrid, Juan de Fonseca, and which later entered the royal collection, must have contributed largely to his good reception at court. And although he owed much to the support of influential friends and fellow citizens, especially Olivares, it says something for the perspicacity of the young Philip IV that he recognized the talent of the young painter, who brought with him from Seville a style very

different from that of the other Court Painters, adapting the naturalistic language of his youthful religious and genre compositions to his portraits of royalty.

The portraits of *Philip IV* (Plate 52) and his brother the *Infante Don Carlos* (Plate 54), painted a few years after Velázquez was established at court (*c*.1626) – the earliest surviving royal portraits of undisputed authenticity – are strikingly different from the royal portraits of his predecessors, with their emphasis on regalia and on the elaborate costumes of their sitters. In his portrait of the King, Velázquez, it is true, adopted the full-length figure and three-quarter view made fashionable by Titian, and preserved the stiff pose of Titian's *Philip II* (Plate 53). But in place of Titian's dark background, he has introduced a lighter, greyish ground that sets off the solid form of his figure, dressed from head to toe in black. The head and hands stand out carefully drawn and strongly modelled, creating an effect of real likeness, rather than an idealized image, of the solemn, timid young ruler, with his long face, thick red lips and prominent Habsburg jaw. What is remarkable about this royal figure is its severe and sombre appearance (the only note of colour is the red table cloth), and this is largely, but not entirely, due to Velázquez's style, his simple composition and subdued tones. The King's black suit and stiff white collar, the *golilla*, are the result of the laws of dress reform that he introduced at the beginning of his reign, in a vain attempt to curb extravagance at a time of economic crisis by prohibiting the wearing of rich materials and ornaments and the elaborate pleated linen ruffs which had been fashionable until then. Subject and style seem to belong together, and the King had reason to be pleased with his new Court Painter.

Velázquez's painting at this time was not to everyone's taste. The Italian connoisseur and art patron, Cavaliere Cassiano dal Pozzo, who visited Madrid in 1626 as a member of the Legation of Cardinal Francesco Barberini, begged the Cardinal to have his portrait painted by Juan Van der Hamen, a painter better known today for his still-life subjects than for his portraits, because of his dissatisfaction with the portrait Velázquez had painted of him. Velázquez's portrait of the Cardinal and a portrait of Olivares, made at the same time, which were to be exchanged by the sitters, have not survived (nor has the portrait of the Cardinal by Van der Hamen). But we can have some idea of the 'melancholy and severe air' to which Cassiano objected from the engraving of Olivares made by Paulus Pontius in Antwerp (Plate 50) and based, according to the inscription, on an 'archetype' of Velázquez, embellished by Rubens. Pontius's preparatory drawing of the head of Olivares (Plate 51) gives the impression of being a faithful rendering of Velázquez's model, which was transformed by Rubens, not only by the addition of a decorative frame and hieroglyphs but also by the alteration to the moulding of the head. From a description of the painting that belonged to Cardinal Barberini, a bust of Olivares in armour, this was presumably the original of the portrait by Velázquez that was sent to Rubens in Antwerp for the engraving, which was received with enthusiasm by Olivares in August 1626. The sash and armour in the engraving, usually attributed to Rubens, would therefore have belonged to Velázquez's original, which must have borne a close resemblance in style to his portrait of *Philip IV in Armour* (Plate 55). Here, the armour and sash serve to enliven the royal figure, and show the first fruits of Velázquez's study of Titian. The head of the King, however, is almost identical with that in the full-length portrait of the King in black (Plate 52). Although both portraits are unquestionably by Velázquez's hand, it is hard to say which is the earlier of the two and the one most likely to have been painted from life. The problem recurs frequently.

The style of painting that won Velázquez his royal appointment was early the

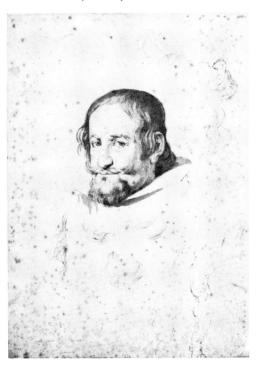

51. After Velázquez. *The Conde-Duque de Olivares*. Drawing by Paulus Pontius (1603–58). 1626. Pen and ink, 12¾ × 8⅞ in. (32.5 × 22.5 cm.). Rotterdam, Museum Boymans-Van Beuningen.
Pontius's preparatory study for the head of Olivares, later to be embellished by Rubens, appears to be a faithful copy of a model by Velázquez.

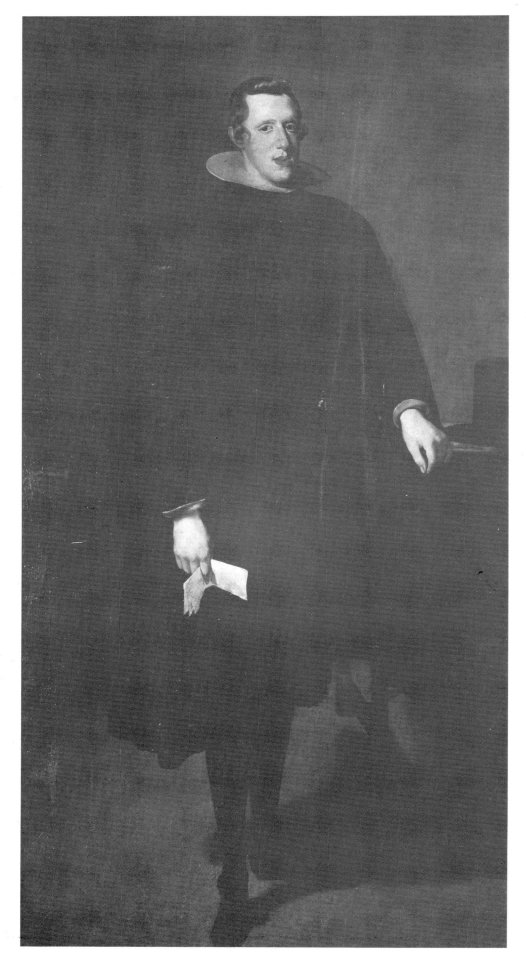

52. *Philip IV Dressed in Black. c.* 1626.
Canvas, $79\frac{1}{4} \times 40\frac{1}{8}$ in. (201 × 102 cm.).
Madrid, Prado Museum. (L-R 36)
Lopez-Rey's contention that the painting
conceals the portrait (visible in
radiographs) which Pacheco says
Velázquez completed on 30 August 1623
is disputable. In any event, the painting of
the head of the King in the present
portrait is very close to that in his bust
portrait in armour (Plate 55), datable
c. 1626.

53. Titian (c. 1488/90–1576). *Prince Philip,
later Philip II, in Armour*. 1550–1. Canvas,
76 × 43¾ in. (193 × 111 cm.). Madrid, Prado
Museum.

The portrait of the young Prince
(1527–98), painted at Augsburg was sent
to his aunt, Mary of Hungary, Governess
of the Netherlands, who took it with her
to Spain in 1556. There it was prized and
taken as a model for state portraits until
Velázquez's time. It was among the
Titians copied by Rubens in Madrid in
1628–9.

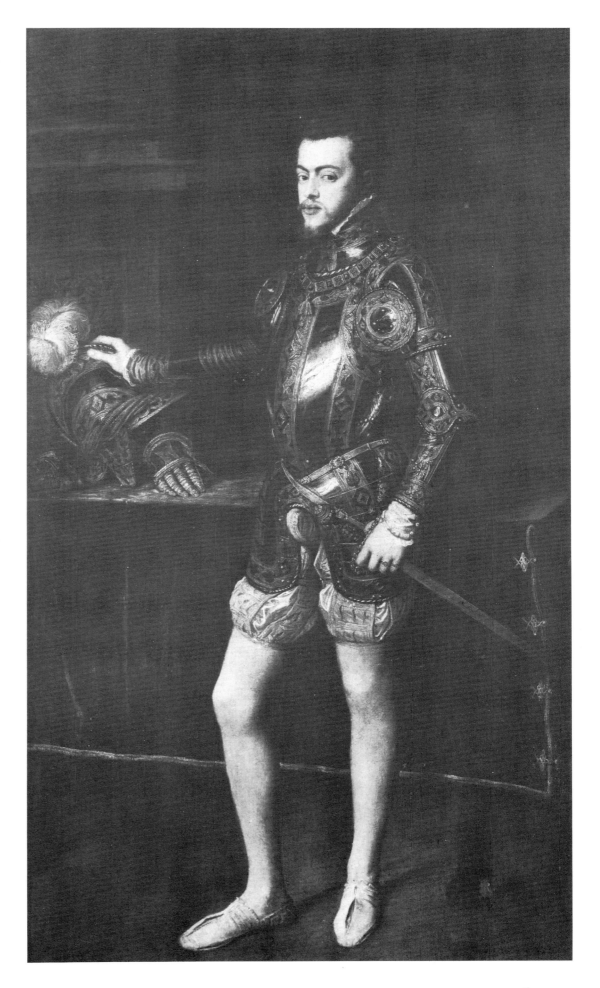

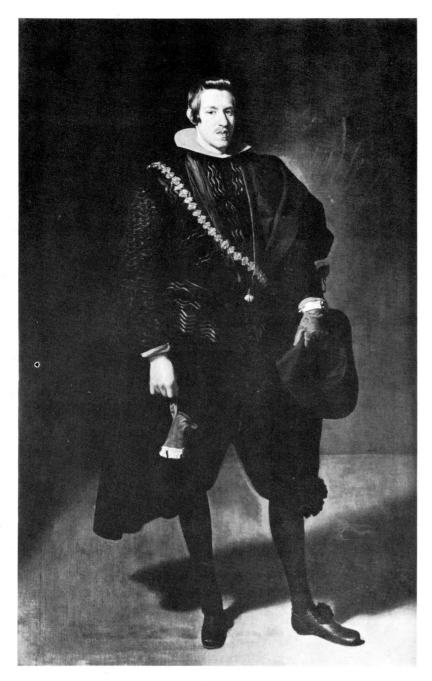

54. *The Infante Don Carlos Dressed in Black.*
c. 1626. Canvas, 82¼ × 49⅝ in.
(209 × 126 cm.). Madrid, Prado Museum.
(L-R 37)
Philip IV's brother (1607–32) was
portrayed by Rubens as well as Velázquez
but this is the only extant autograph
portrait of him by either artist. Although
he is said to have been 'black-haired and
of a Spanish hue' (Hopton in Howell,
Epistolae, I, p. 155), he is portrayed here
with similar colouring to his brother's.
From all accounts, including Cassiano dal
Pozzo's, he dressed like the king; the
fashion for the *fanfarone* or large chain that
he wears had been recently revived in
Spain.

subject of a violent attack by one of his older colleagues. Evidently acceptable to the young King at the beginning of a reign during which he was constantly subject to an inward and outward conflict between austerity and laxity, the style had been censured by Cassiano dal Pozzo. (Cassiano evidently later revised his opinion, since he owned an unfinished portrait by Velázquez.) In 1633, Vicente Carducho in his *Diálogos de la Pintura* fiercely and comprehensively condemns the new realism, the 'new dish' prepared by Caravaggio, who worked without precepts by copying nature. He deplores the influence of this 'Anti-Christ', who threatened the ruin of painting. Carducho also denigrates the portrait painter because he has to subject himself to the imitation of his subject, whether it is good or bad, and stresses the moral purpose of art. Although he does not mention Velázquez by name in either connection, his attack on portrait painters suggests that he was among the jealous rivals of Velázquez who accused him of only being able to paint heads, the circumstance that led to the painting in competition with Carducho and others of *Philip III and the Expulsion of the Moriscos*. The loss of this

55. *Philip IV in Armour. c.* 1626. Canvas,
22¼ × 17⅜ in. (57 × 44 cm.). Madrid, Prado
Museum. (L-R 38)
Because the canvas has been cut and the
King wears armour the portrait has been
thought by some critics to be a fragment
of an equestrian portrait. But the fact that
the King is bare-headed and the
background apparently not that of an
outdoor setting makes this unlikely. It is,
however, close in date and possibly related
to the equestrian portrait that hung in the
salón nuevo in the Alcázar in 1626.

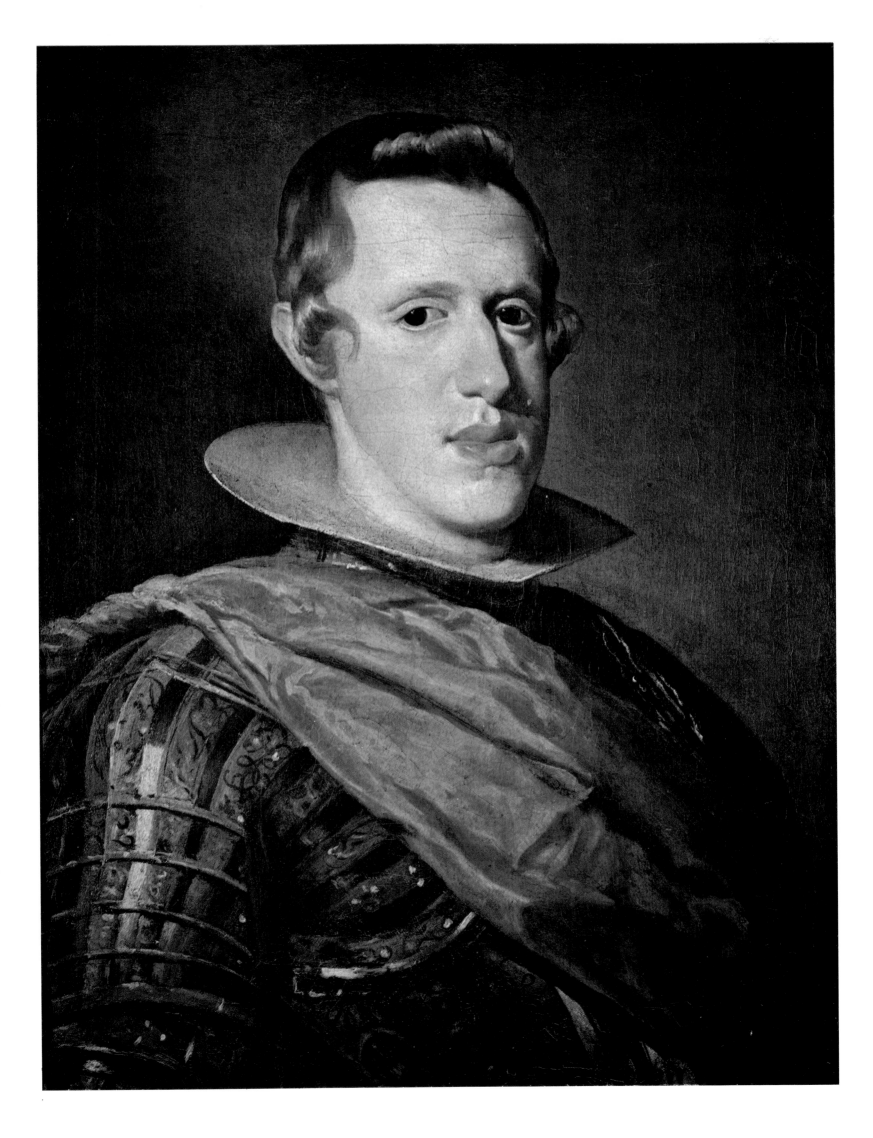

painting is all the greater since it is one of only two history pieces by Velázquez that are recorded and the only known work to include what Palomino calls a '*figura moral*', the figure of a majestic matron wearing Roman armour and holding a shield and arrows and ears of corn, a traditional form for the personification of Spain. The only visual record that survives of the competition is a drawing by Carducho (Prado) (Plate 56), without the figure of Philip III or of Spain.

Two other paintings of the 1620s which have disappeared were examples of another and a very different aspect of Velázquez's art of which we have today little or no idea. These were the *ritrattini* (small portraits or miniatures?) of Philip IV and Olivares made for the Duke of Mantua's Ambassador in Madrid in 1627. Olivares, on being shown two equestrian portraits that the Duke's Ambassador had had painted by an unnamed artist, told him that the King's painter Velázquez would have done them much better and at the Ambassador's request ordered Velázquez, who was at work on a portrait of the Queen, to stop what he was doing and make the two little pictures for the Duke. It is not clear from the correspondence whether or not they were equestrian portraits, and whether they were small paintings or miniatures, only that the King gave sittings so that his portrait would turn out all the better, and that the portrait of Olivares was very like him. The Duke of Mantua, announcing their arrival, declared how much he treasured them.

Strangely enough, the severe style of Velázquez's surviving early court portraits seems to have appealed to the one great contemporary painter whose opinion is recorded. In 1628, when Velázquez was 29, Rubens, then at the height of his mastery and reputation, made his second visit to Spain in his capacity as diplomat. Rubens, Pacheco recalls, admired Velázquez's paintings for their *modestia*; the word is not easily translatable but can perhaps be illustrated by the comparison of Pontius's drawing of Olivares after Velázquez's model and the engraving designed by Rubens (Plates 51, 50). The assertion made many years later by a friend of Velázquez, that Rubens acknowledged him to be the greatest

56. Vicente Carducho (1576–1638). *The Expulsion of the Moriscos*. 1627. Pencil, pen and blue wash drawing, 15 × 19⅞ in. (38 × 50.4 cm). Madrid, Prado Museum. Study for the painting made in competition with Velázquez and other court painters, mentioned by Pacheco and Palomino. The competition was won by Velázquez. The only surviving record is this drawing.

57. Peter Paul Rubens (1577–1640). *Philip IV in Outdoor Dress. c.* 1628–9. Black and red and touches of white chalk, pen and sanguine wash drawing, 15⅛ × 10⅜ in. (38.3 × 26.5 cm.). Bayonne, Musée Bonnat. This informal sketch is a testimony of the close contact Rubens says he had with the King. Traces of the moustache he was beginning to grow are just visible.

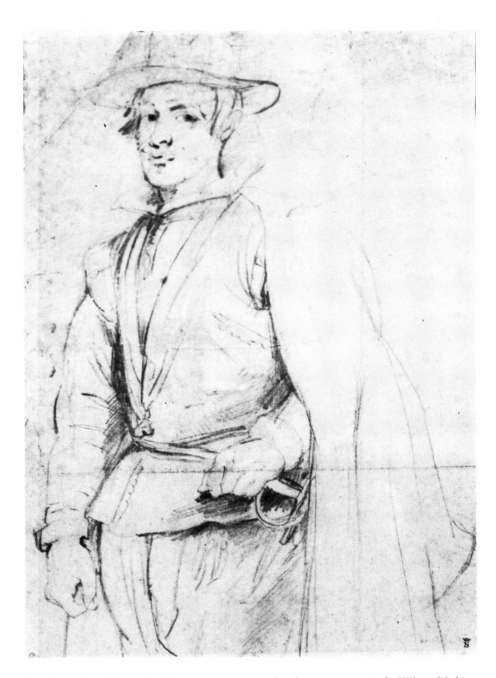

painter that there had been in Europe, was no doubt exaggerated. What Veláz-quez thought of Rubens is not recorded, but his admiration for him is reflected, though not immediately, in the gradual lightening of his tones, richer colouring and more fluent technique. The two artists must have lived and worked in close relationship to one another throughout Rubens's nine-month stay at the Spanish court, and Velázquez had plenty of opportunity to watch Rubens at work, even to watch him painting the very sitters that he himself was painting. For Rubens, despite his many other occupations and although, according to Pacheco, he was suffering from gout, was busy with portraits of all the members of the royal family, as well as making copies of paintings by Titian. 'Here I keep to painting, as I do everywhere,' he wrote to his friend Peiresc on 2 December 1628, 'and already I have done the equestrian portrait of His Majesty, to his great pleasure and satisfaction. He really takes an extreme delight in painting, and in my opinion the prince is endowed with excellent qualities. I know him already by personal contact, for since I have rooms in the palace, he comes to see me almost every day. I have also done the heads of all the royal family, accurately and with great

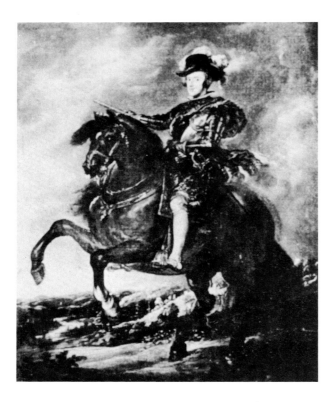

58. After Rubens. *Philip IV on Horseback. c.* 1628. Canvas, 39⅜ × 31½ in. (100 × 80 cm.). Whereabouts unknown. The horse and rider derive presumably from the lost Rubens (cf. Plate 59), but the absence of allegorical additions suggests it is a Spanish copy, probably made in the studio of Velázquez.

convenience, in their presence, for the service of the Most Serene Infanta, my patroness.'

Rubens's account of the king's interest in watching him at work and of his appreciation of painting echoes Pacheco's remarks apropos of Velázquez, whom he must have rivalled, even outshone, in the eyes of the King. His equestrian portrait of Philip IV was hung in place of Velázquez's in the *Salón nuevo*, a monumental image that has survived through a copy, with a later head of the King, and also in a small copy – apparently a contemporary work from the studio of Velázquez, judging from the elimination of the allegorical embellishments so foreign to the Spanish artist (Plates 58, 59).

In the autumn of 1628, Rubens was occupied with portraits of the royal family for his mistress, the Infanta Isabel Clara Eugenia, in Brussels. At the same time, Velázquez was working on a similar series of portraits for the special envoy to take with him to Vienna to the King of Hungary, to precede the arrival of Philip IV's sister, the Infanta María, who was to become Queen of Hungary. Rubens, who had arrived in Madrid at the end of August or beginning of September, working with his customary speed, had already finished his portraits (which Pacheco describes as half-lengths), as well as the equestrian portrait of the King, by the beginning of December. Velázquez, from all accounts, worked slowly; there are several references to his phlegmatic nature and to the need to hurry him. Yet he was certainly much more productive than his extant oeuvre suggests. The number of lost works still grows, witness the commission for this series of royal portraits, only recently brought to light. All that is known of the commission is a note from Olivares's secretary dated 21 October 1628 recommending that the envoy should take with him portraits of the King and Queen and the Infantes, particularly that of the Queen of Hungary to present to the King, and Olivares's reply: 'I consider this desirable and the painter Velázquez will be ordered to hurry and finish the portraits as soon as possible.'

Until the discovery of this note, it was always believed that the bust portrait of the Infanta María (Plate 61), the only known painting of her by Velázquez's hand, was the portrait that Pacheco says he made in Naples on his way back from Italy in 1630, when the Infanta stopped there on her way to Vienna. From her appearance and from the style of the painting, closer to that of the bust portrait

59. After Rubens. *Philip IV on Horseback.* Canvas, 132¾ × 105 in. (339 × 267 cm.). Florence, Uffizi. (L-R 101)
This copy of Rubens's lost portrait of the King, for which he was given harness and armour in the autumn of 1628, shows the head of the King at a later date (*c.* 1650). The portrait has been identified with a copy recorded in the collection of the Marqués del Carpio in 1651 with the head by Velázquez; but a close view of the head convinced me that either this is not the same portrait or that the attribution of the head to Velázquez was incorrect.

60. Peter Paul Rubens (1577–1640). *The Infanta María, Queen of Hungary*. 1628. Canvas, 43¼ × 32½ in. (110 × 82.5 cm.). Private collection.
Philip IV's sister, wooed by Charles Prince of Wales in 1623, was betrothed to the King of Hungary, son and heir of the Emperor Ferdinand II, in 1626, and married by proxy in Madrid in April 1629. She was one of the members of the Spanish royal family whose heads Rubens announced in December 1628 he had already done 'accurately and with great convenience, in their presence' (Magurn, p. 292). The costume was possibly finished by a follower.

of Philip IV than to any paintings he made in Italy or after his return, it now seems more probable that this was the portrait painted by Velázquez in 1628, perhaps as a model for the portrait to be sent to Vienna. Though it would be tempting to think that Velázquez and Rubens painted the Infanta at the same sitting, their portraits show that she was turned in a different direction and wore a different dress for each artist. But a more striking difference between the two portraits is the '*modestia*' of Velázquez's painting, the simplicity and stillness of the pose and the subdued tones, compared with the movement, liveliness and splendour of the seated figure of Rubens's Infanta (Plate 60). Whether Velázquez completed the series of royal portraits, as Rubens did, is not known. No others have yet come to light.

Although there is little evidence of Rubens's influence on Velázquez's portraiture of the time, it was no doubt Rubens's presence in Madrid and their

61. *The Infanta María, Queen of Hungary*. 1628(?). Canvas, 22⅞ × 17⅜ in. (58 × 44 cm.). Madrid, Prado Museum. (L-R 48)
Painted probably in 1628 with other portraits of the royal family intended to be taken to Vienna, but there is no evidence that any of them were completed or left Madrid. As this is the only extant autograph portrait of the Queen, it may have served as a model for portraits sent abroad. Some critics believe this to be 'the beautiful portrait of the Queen of Hungary' that Pacheco says Velázquez painted in Naples in 1630 on his way back from Rome.

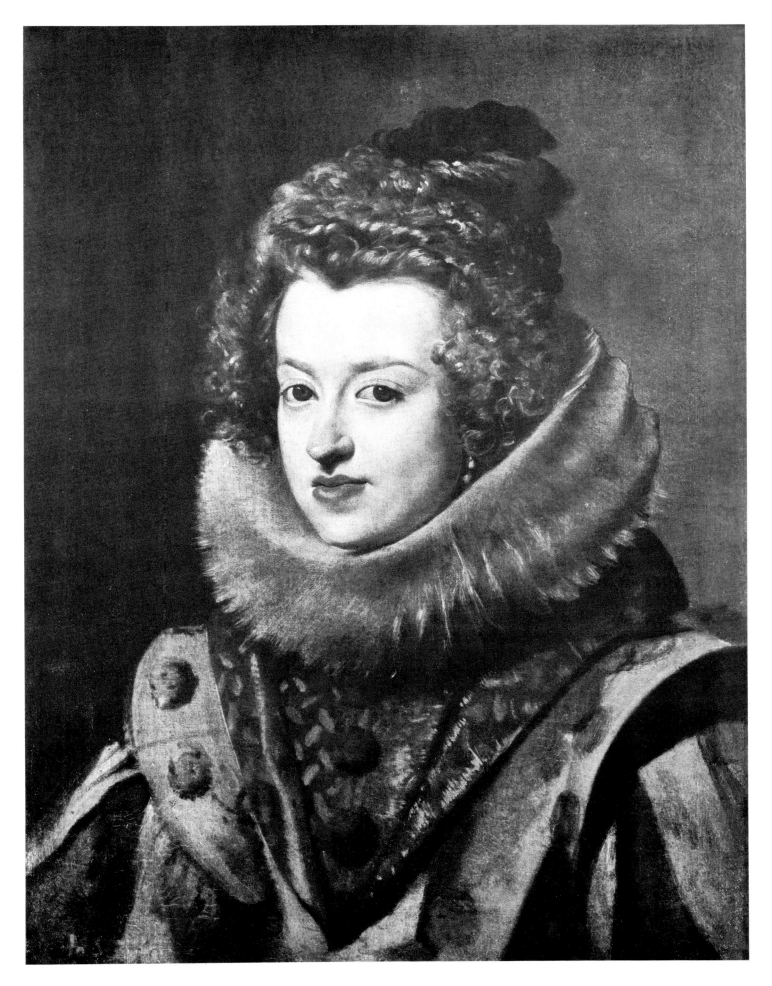

62. Jusepe de Ribera (1591–1652). *The Drunken Silenus*. Signed and dated 1628. Etching, $10\frac{7}{8} \times 13\frac{3}{4}$ in. (27.6 × 35 cm.). Ribera's etching and the painting of 1626 on which it is based (Naples, Capodimonte) are in marked contrast to Velázquez's nearly contemporary *Bacchus*: the former inspired by antique sculpture, Velázquez portraying the god and his companions as contemporary human beings.

63. Michelangelo da Caravaggio (1573–1610). *Bacchus*. *c.* 1590–5. Canvas, $37\frac{3}{8} \times 33\frac{1}{2}$ in. (95 × 85 cm.). Florence, Uffizi. Described by Caravaggio's biographer Baglione as the first of an early series of small pictures 'drawn from his own reflection in a mirror'.

64. *Bacchus and his Companions* (*Los Borrachos* or *The Drinkers*). *c.* 1628. 65 × 88½ in. (165 × 225 cm.). Madrid, Prado Museum. (L-R 41)
In the record of payment (Doc. 42, 22 July 1629) called 'a painting of Bacchus'; in the inventory of the Alcázar 1636/7: 'Bacchus seated on a barrel crowning a drunkard . . .' Gaya Nuño, *Bibliografía*, no. 725, suggests that the description of a carnival float in the picaresque novel, *Vida y hechos de Estebanillo González*, 1646, may be related to Velázquez's painting.

shared love of Titian that inspired the Spanish artist to paint, or the King to commission, his first mythological subject, the *Bacchus*, known today as *Los Borrachos* or *The Drinkers* (Plate 64). It was Rubens, however, not Velázquez, who in future was chosen to provide most of the pagan subjects for the Spanish royal palaces. Velázquez's painting of Bacchus, as it was called in the record of payment made in July 1629, also owes something to the many Venetian Bacchanals in the royal collection. Here, in the only figure composition – apart from the *Expulsion of the Moriscos* – that he is known to have painted after his appointment at court and before his departure for Italy, the naturalism of Velázquez's early religious and genre compositions has been somewhat modified by the influence of Titian and Rubens. This is an outdoor scene with an attempt at natural rather than studio lighting. But it is still, like the Seville paintings, a close-up view of a compact group of figures, seen individually and posed as for a snapshot against a landscape backcloth. The individual heads, the draperies and the still-life are painted in a naturalistic style not very different from that of the *Water Seller* (Plate 39), and the figure of Bacchus is even more naturalistically portrayed than that of Caravaggio's *Bacchus* (Plate 63), which was based on a mirror image of himself, not to mention the figures in Ribera's *Silenus* (Plate 62).

Velázquez's individual interpretation of the subject, his life-like portrayal of the figures, has led to the suggestion that it may be based on a theatrical performance or festival. It has also been taken to be a parody, a mocking of the gods of antiquity, partly by analogy with contemporary burlesque Spanish poetry and partly because it was so described in the eighteenth century by Antonio Ponz. But Ponz, who called it 'the triumph of Bacchus in burlesque, which was engraved by Goya', was probably looking at the etching (Plate 65), in which Goya had subtly transformed Velázquez's painting, rather than at the original. The most convincing interpretation is that Velázquez's treatment of the theme echoes that of a late sixteenth-century Flemish engraving (Plate 66), in which, according to the inscription, the peasants beseech Bacchus to assist them in forgetting their sorrows; in the engraving the group of Bacchus and satyr is based on an antique sculpture group. Velázquez, trained in the naturalistic tradition, rejecting heroic language and idealized models, sees his subject entirely in terms of everyday life of his time, making only the necessary concessions for the subject to be identified. In other words, he represents the god of wine as a human bestowing his joys on ordinary mortals, making them forget the miseries of their humble lives. This approach to pagan themes was to vary little throughout Velázquez's life, even when the direct language of the story of Bacchus is transformed into the veiled language of the fable of Arachne. Nor does this attitude appear to have been affected by either of his two journeys to Italy.

65 (*Above left*). Francisco Goya (1746–1828) after Velázquez. *Bacchus* Titled: '... un BACO fingido coronando unos borrachos ...' ('a feigned Bacchus crowning some drunkards'). 1778. One of the series of etchings after paintings by Velázquez in the Spanish royal collection. 12⅝ × 17¾ in. (32 × 44 cm.). Manet included Goya's etching, partly covered, in the background of his portrait of *Zola*.

66 (*Above*). Jan Saenredam (*c.* 1565–1607) after Hendrik Goltzius (1558–1617). *The Worship of Bacchus.* 1596. Engraving, 17½ × 12⅝ in. (44.5 × 32.2 cm.). Inscribed with a Latin verse by the Dutch poet Cornelis Schonaeus (1540–1611) – a prayer to the god of wine to relieve the pains and worries of the humble suppliants – the suppliants being peasants and a soldier.

4 First Visit to Italy: 1629-1631

Italy, when Velázquez eventually achieved his ambition to go there, had long been a place of pilgrimage for artists from Spain as from elsewhere in Europe. And Rome was the goal, with her threefold attractions, as treasure-house of antique sculpture and of Renaissance painting and the centre of developments in modern art. Spain's artistic relations with Italy were, indeed, particularly close, thanks to her possessions there and to her many art-loving representatives. She had, moreover, a tradition of patronage of Italian art. Velázquez's fellow painters at court were nearly all of Italian origin, and Philip IV continued throughout his reign to employ Italian artists and artisans as well as adding many works by modern artists and Old Masters to the remarkable collection of Italian paintings that he had inherited.

Velázquez was one of several Spanish painters to visit Italy during the first half of the seventeenth century; another was his friend, the writer on art, Jusepe Martínez. Nor was Velázquez the first Spanish painter of his time to win recognition there. In Pacheco's chapter on famous contemporary painters who were specially honoured, Velázquez comes third, after Rubens and an otherwise unknown artist, Diego de Rómulo Cincinnato (son of Rómulo Cincinnato, one of the first Italian artists to work in the Escorial), who went to Rome in the service of the Duke of Alcalá, Ambassador Extraordinary to Pope Urban VIII. There, he painted a portrait of the Pope, who not only rewarded him with a gold medal and chain – as Velázquez was later to be rewarded by Innocent X – but also with membership of the Order of Christ (1625). Ribera, too, was made a Knight of the same Order (1626), having already become a member of the Academy of Saint Luke (1616) by the time he established himself in Naples. He chose to remain in Italy, he told Jusepe Martínez, who visited him in Naples in 1625, because there he was highly esteemed. Spain, he added, was a good mother to foreigners but a cruel stepmother to her own sons – a judgement he perhaps revised when Velázquez came to Naples.

Velázquez at 30 was older than most artists who went to Italy to study – though no older than Nicolas Poussin on his first visit. He was also in a very different position from that of other artists in Rome, foreign or Italian. His status was comparable only to that of Rubens, who travelled abroad with the dual function of painter and diplomat. Velázquez, secure in his office as Painter to the King and holding, besides, the first of his appointments as courtier, travelled with a servant and with money in his pocket, carrying letters of introduction from the Papal Nuncio and Italian Ambassadors in Spain. He was received by Spanish Ambassadors and by Cardinals and presented to kiss the Pope's toe; he lodged in the

Vatican Palace by courtesy of Cardinal Francesco Barberini and in the Villa Medici with permission of the Florentine Grand-Duke.

As a full-time servant of the King of Spain, Velázquez was looking neither for patronage nor financial reward from Italy. On the contrary, it seems that he was occupied not only with his studies but, like other Spanish representatives, with keeping a look-out for works of art for the royal collection and with making purchases. The record of payment made to him in 1634 for his own two canvases painted in Rome refers to 18 pictures, among them works by Cambiaso, Bassano and Titian, which he almost certainly acquired in Italy. Although the story of the 12 pictures 'ordered by Velázquez' for the King of Spain in 1630 has been proved false, Velázquez is likely to have known the artists concerned and their work. It was possibly on his recommendation that one of these artists, Nicolas Poussin, was commissioned with Claude Lorrain and other landscape painters in Rome a few years later for paintings for the Buen Retiro Palace. Another of the twelve painters was Pietro da Cortona, whose latest frescoes in Rome in 1630 may well have led Velázquez later to suggest to Philip IV that he should be invited to decorate the ceilings in the Alcázar. When the invitation was finally given in 1650, by Velázquez himself on a second visit to Rome, it was unsuccessful. On the other hand, Poussin and Cortona, together with Mattia Preti, Alessandro Algardi and Gianlorenzo Bernini, who were also active in Rome in 1630, were the artists who, according to Palomino, favoured Velázquez when he returned to the city 20 years later.

Velázquez's interest in antiquity, which was stimulated if not first aroused during his first stay in Rome, was to have a delayed effect in Madrid. One result was the plan to decorate the Alcázar with casts of ancient statues, which he himself was to implement on his second visit. In all likelihood, the choice of statues was influenced by his earlier studies in Rome, at a time when artists were busy copying antique marbles for Cassiano dal Pozzo, Velázquez's former acquaintance and critic in Madrid. Velázquez may well have made notes as well as drawings of the sculptures he admired; possibly he took back with him some of the volumes of engravings available in Rome; and some of the casts or copies of antiques that were in his own possession at his death may have been acquired at this time. It was presumably because of his experience in Italy that a few years after his return to Spain Velázquez was considered to be something of an authority on antiques, so that he was consulted when doubts were raised in London about the authenticity of certain moulds of busts made in Spain for Charles I.

Since the main purpose of Velázquez's journey was to study, it is more than a pity that he left no Italian sketch-book as Van Dyck did, or even a diary on the lines of the one that Carl Justi, the German art historian and author of the famous work on the artist, invented for him. As it is, the documents relating to his stay in Italy are lamentably few. There is the royal permit allowing him to make the journey and to draw his salary while he was away, and there are letters of recommendation from the Ambassadors of Venice, Parma and Florence in Madrid. There is also the exchange of letters between the Florentine representative in Rome and the secretary to the Grand-Duke Ferdinand II regarding permission for the artist to move from the Vatican to the Villa Medici. Not a word has survived from Velázquez himself during an absence from the court of 18 months or more, though he must have sent reports to his royal master as well as letters to his former master Pacheco and to family and friends. We have to make do with the account of the journey given by Pacheco and the supplementary information provided later by Palomino. While these are in some respects very detailed, they give little information about Velázquez's artistic activity, or his response to the

works of art he saw. In Genoa, where he landed, he could have seen portraits by Van Dyck, which may have had some influence on his later portraiture; in Cento, where he stopped on his way to Rome, he must have seen paintings by Guercino and probably met the artist; in Naples, on his way back to Spain, he would certainly have met his compatriot Ribera, who was eight years his senior, as well as the Viceroy, the Duke of Alcalá, former Ambassador in Rome and famous patron and collector. It was possibly on Velázquez's recommendation as well as the Duke's that during the next decades many paintings by Ribera were acquired for the royal collection. But what influence, if any, the two artists had on one another is hard to see. In 1630 they probably had more in common through their shared Caravaggesque beginnings than they were to have later in their careers.

As for the works that Velázquez made in Italy, few are recorded and fewer still survive. Palomino's description of the paintings Velázquez admired in Venice reads like an entry in a guide book but is quite credible; his stay there must have strengthened his taste for Venetian painting. But the reference he makes to Velázquez's copy of Tintoretto's *Communion of the Apostles* may have been inspired by the fact that a *Last Supper* attributed to Velázquez was in the royal collection in his time. While this small copy of Tintoretto's *Last Supper* in the Scuola di San Rocco (Academy of San Fernando) has been convincingly identified with the painting which had been in the royal collection since 1666, and hence with the copy mentioned by Palomino, it is hard to believe that it is by the hand of Velázquez. As for the other copies that Velázquez is said to have made in Italy, drawings after Michelangelo and Raphael in the Vatican and possibly of antique statues in the Villa Medici, there is no trace today. The two small *Views of the Villa Medici Gardens* (Plates 143, 144), with statues very sketchily recorded, have been thought by some critics to have been painted during the artist's stay there in 1630, but there is now evidence to show that they must have been painted during his second visit to Italy.

Although Velázquez, on the present occasion, came with the reputation of a portrait painter, he seems to have had little opportunity to practise his art. No Italian is recorded as having sat to him, though he was to paint many eminent members of the papal court on his return. The Florentine Ambassador in Madrid, who recommended Velázquez to the Grand-Duke as the favourite painter of Philip IV and Olivares, advised the Grand-Duke to have his portrait painted by Velázquez and to reward him not with money but with a chain and medal. But Velázquez did not stop in Florence, in his haste to reach Rome. It is possible that he made sketches of Spinola on the journey to Italy, which he used for his portrait in the *Surrender of Breda* (Plate 122), since no other portrait of the general shows him in profile. It is also possible that while he was in Rome he painted the portrait of the Condesa de Monterrey, sister of Olivares and wife of the Ambassador, who looked after the artist when he fell ill. The large portrait he painted of her, which she mentions in a letter in 1652, has possibly survived in a copy, which has been attributed both to Velázquez and to Ribera.

The only portraits that Velázquez is recorded to have made in Italy and the only paintings that Pacheco mentions are a *Self-Portrait* painted in Rome and a portrait of the Queen of Hungary painted in Naples on his way home, to take to the King. The *Self-Portrait* has not survived. The portrait of Philip IV's sister, the Infanta María, future Queen of Hungary (Plate 61), which until recently was thought to be the portrait mentioned by Pacheco, has now been connected with that made before Velázquez went to Italy.

The *Self-Portrait* painted in Rome that Pacheco describes (but not Palomino) was, at the time he wrote, in his possession; possibly he intended to reproduce

67. Gianlorenzo Bernini (1598–1680). *Self-portrait. c.* 1640. Canvas, 20⅞ × 16½ in. (53 × 42 cm.). Rome, Borghese Gallery. The 'darker colours and more unified tone values' of this and a similar self-portrait in the Prado have been attributed to the influence of Velázquez. The earlier self-portrait in the same Gallery was once attributed to Velázquez.

68. Attributed to Velázquez. *An Ecclesiastic.* Canvas, 24¾ × 19⅝ in. (63 × 50 cm.). Rome, Capitoline Gallery. The painting was for long considered to be the self-portrait painted in Rome in 1630 that belonged to Pacheco until it was pointed out that the sitter wears an ecclesiastical collar. It had also been thought to be a portrait by or of Bernini. The painting came to the Gallery in 1750 from the collection of Prince Pío di Savoia as by Velázquez. Although the sitter bears a slight resemblance to Velázquez and the style is similar to his in 1630, neither the attribution to him nor the likeness to him is wholly convincing.

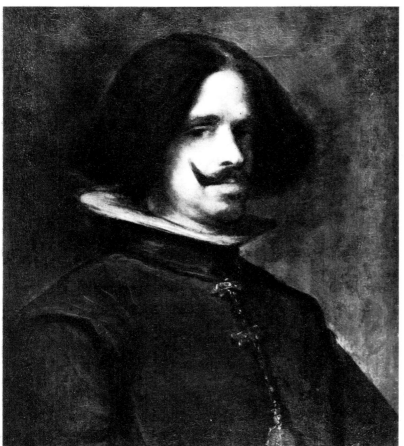

69 (*Above*). After Velázquez. *Self-portrait.*
Canvas, 24 × 20½ in. (61 × 52 cm.).
Munich, Alte Pinakothek.
One of many replicas and variants of a
self-portrait that is probably lost, although
the original is thought by some critics to
be the dark fragmentary bust in Valencia
(L-R 96). The original was probably
painted in 1639 (see Plate 70). Most of the
versions represent Velázquez wearing the
badge of the Order of Santiago, and
therefore date from after his investment in
November 1659.

70 (*Above right*). After Velázquez. *Self-
portrait.* Inscribed (in brown ink): *D.ⁿ
Diego Velazqᶻ dibujado|en el año 1639. pᵗ el.*
Black chalk drawing, 4⅛ × 3⅜ in.
(10.5 × 8.7 cm.).
New York, private collection.
From the collection of Sir William
Stirling-Maxwell, reproduced as
frontispiece to his *Essay towards a Catalogue
of Prints engraved from the works of
Velázquez and Murillo*, 1873. Though not
by the hand of Velázquez, in spite of the
inscription, it is a copy after the *Self-
portrait* that is known in many painted
versions (cf. Plate 69); if the date on the
drawing is correct, this is the earliest
certain likeness of the artist.

it in his *Libro de Retratos*. In preferring it to no fewer than 150 of his own portraits
in colour, Pacheco praises it for being 'painted in the manner of the great Titian
and (if I may be permitted to say so) not inferior to his heads'. This painting was
once thought to be the portrait in the Capitoline Gallery in Rome (Plate 68); such
was its reputation, that it appeared as frontispiece to Justi's *Velazquez* and to
Walter Gensel's *Klassiker der Kunst* volume (1905). Later, it was pointed out that
the sitter wears the collar of an ecclesiastic and cannot, therefore, be Velázquez.
The authorship of the painting is also now in question. The other artist to whom
the portrait in Rome has been attributed is Bernini, who has also been identified
as the sitter; but his name has since been withdrawn. It is interesting to note,
however, that a certain similarity between the style of Velázquez at the time of
his visit to Rome and that of Bernini as painter resulted in the attribution to
Velázquez of paintings now considered to be self-portraits by Bernini (Plate 67),
a fact that has been explained by one critic as the influence of Velázquez on
Bernini. Later, when portraying the same sitters (the Duke of Modena and
Innocent X), Bernini as sculptor was to produce effects strikingly different from
those of Velázquez.

Although Palomino says that Velázquez portrayed himself on several
occasions, the only certain self-portrait known today, apart from the one in *Las
Meninas*, is a painting that exists in more than a half-dozen versions, some bust
only, others half or three-quarter length. The original, sometimes thought to be
the almost invisible fragmentary bust in Valencia, has probably not survived. The
number of replicas (Plate 69) speaks for its having been famous. But although the
Valencia painting was once identified with the *Self-Portrait* painted in Rome,
Velázquez's appearance is that of an older man. This view is supported by the
inscription on the pencil sketch of the same likeness with the date 1639 (Plate 70).

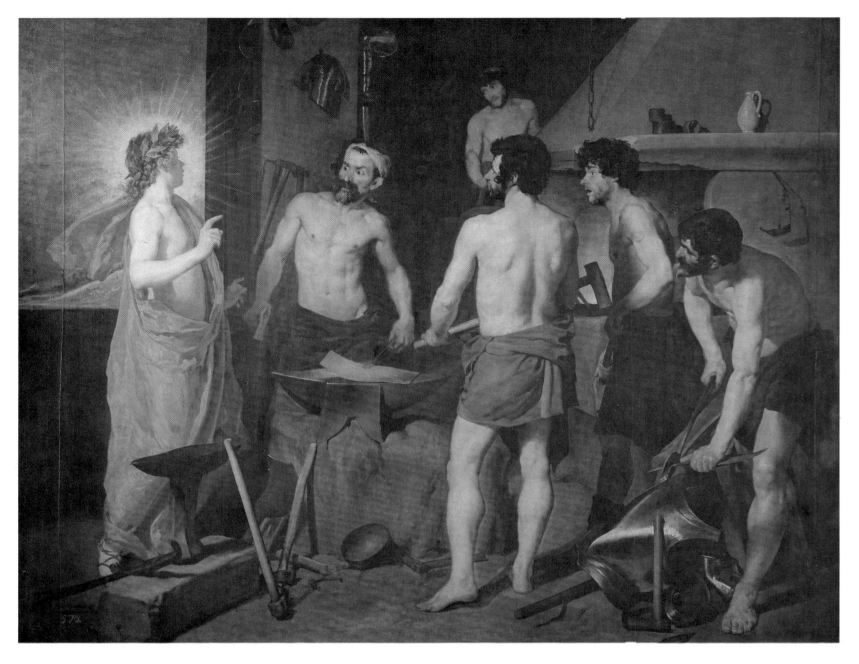

All things considered, it seems that the only surviving works that can be said indisputably to have been painted by Velázquez in Italy are the two large canvases representing *Apollo in the Forge of Vulcan* (Plate 71) and *Joseph's Blood-stained Coat Brought to Jacob* (Plate 72) – indisputable, even though the authority for their Roman origin is Palomino, not Pacheco. Velázquez, Palomino says, took them back to Spain and offered them to His Majesty, 'who regarded them with the esteem they deserved and ordered them to be placed in the Buen Retiro'. The two paintings were among the 18 for which Velázquez was paid in 1634 from special funds devoted to purchases for the Buen Retiro. That they were painted in Rome has never been questioned, not only because of Palomino's statement but also because in style and character and even in scale they are unlike any of Velázquez's earlier works. Because they are nearly the same size and seem to balance one another in composition, the two paintings have often been taken as pendants. Since it was customary, especially in Italy, for subject pictures to have more than one meaning, attempts have been made to interpret them. Justi, for instance, considered them to be illustrations of detected and successful betrayal. A Christian meaning with Apollo as a symbol of Christ and Joseph's coat as a prefiguration of the death of Christ has also been suggested, but no really convincing interpretation has been found. Whatever led Velázquez to treat these unusual

71. *Apollo in the Forge of Vulcan.* 1630. Canvas, $87\frac{3}{4} \times 114\frac{1}{4}$ in. (223 × 290 cm.). Madrid, Prado Museum. (L-R 44) Not mentioned by Pacheco but said by Palomino to have been painted in Rome together with *Joseph's Blood-stained Coat* (Plate 72) and taken to Spain to be offered to the King. Both paintings were bought from the artist (with other works) for the Buen Retiro, as Palomino says. *The Forge* is recorded there in 1701. The subject, Apollo announcing to Vulcan the adultery of his wife Venus with Mars, is an unusual choice for illustrating the story of Mars and Venus.

subjects from Ovid and the Old Testament, the fact that the King of Spain's portrait painter chose subject pictures at all is probably because these rather than portraiture were the main occupation of painters in Rome at the time. He may also have painted them as a challenge to his rivals at the Spanish court, as a demonstration of his ability to paint other things than heads.

Even though Velázquez has represented both subjects in what was already his characteristic manner, as actual scenes with living models, the effect of his Italian sojourn is quite striking. Firstly, there is a new ability to portray a number of nearly life-size figures in a spacious setting and disposed in various attitudes of arrested movement. Then there is a new interest in human anatomy, in the study of nude torsos and limbs, rather than faces, many of which are turned away. Compared with the *Bacchus* of a year or two earlier (Plate 64), the only mythological subject Velázquez had previously attempted, the *Forge of Vulcan* creates a much more natural impression. Instead of a close-up view of a crowded group of motionless figures, there is space and air around the blacksmiths, as they are poised for action, and as if halted by the appearance of a draped figure identified as Apollo by his crown and sunburst. The less detailed modelling of the figures and their apparently casual arrangement combine with lighting and perspective to create a more life-like impression than in the *Bacchus* or any other earlier work.

In the painting of *Joseph's Blood-stained Coat Brought to Jacob*, his first religious

72. *Joseph's Blood-stained Coat brought to Jacob.* 1630. Canvas, 87¾ × 98⅞ in. (223 × 250 cm.). El Escorial. (L-R 43) Painted in Rome and taken to Spain and purchased for the Buen Retiro with *The Forge* (Plate 71); recorded there in the poem by Manuel de Gallegos, 1637. Moved to the Escorial between 1657 and 1668, when it is mentioned there and described in detail by Francisco de los Santos. The whole composition (now cut at both sides) is recorded in old copies. A painting of the subject by Juan de Alfaro is also recorded.

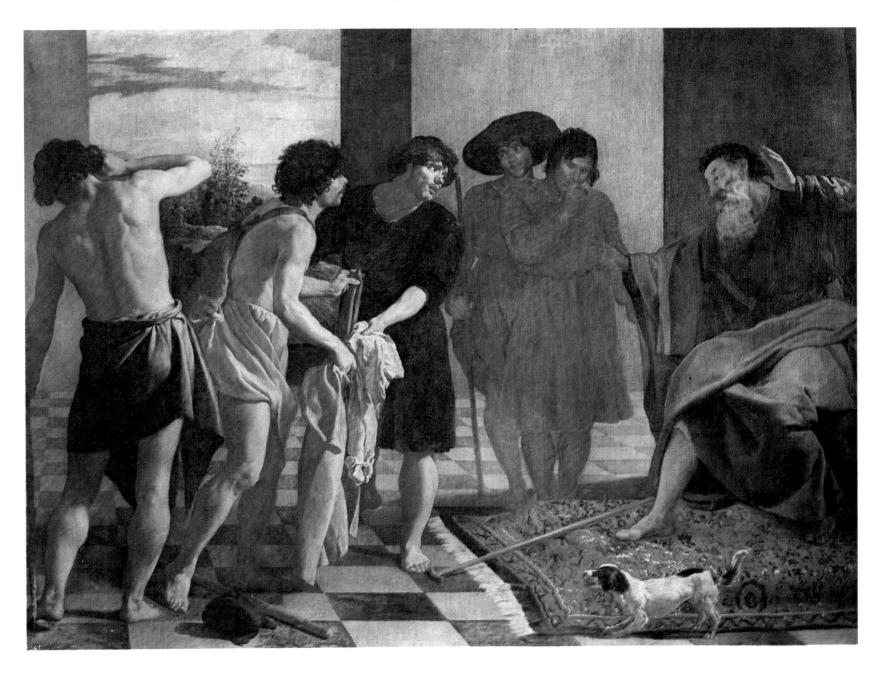

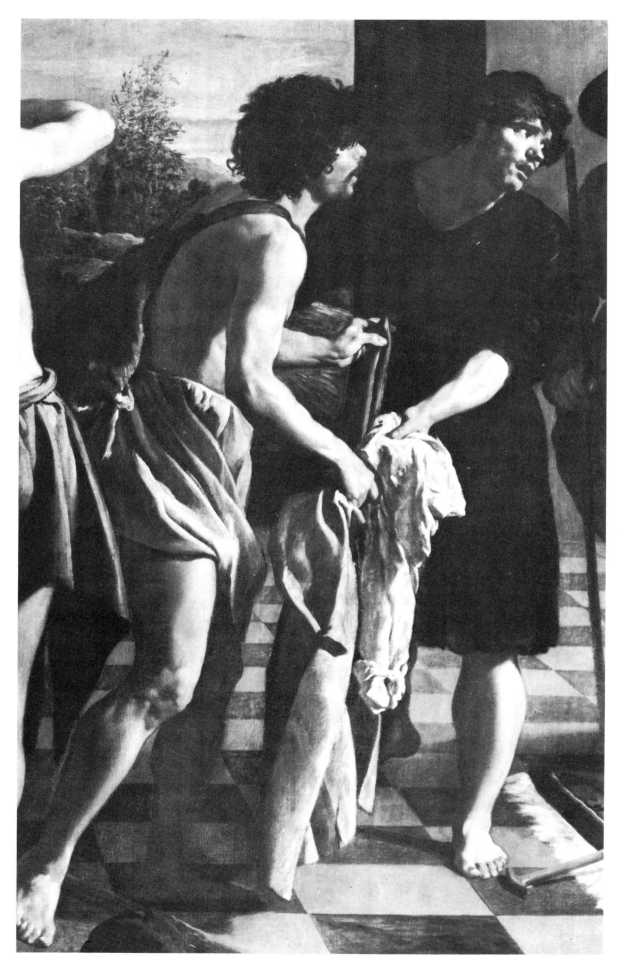

73. Detail of Plate 72.

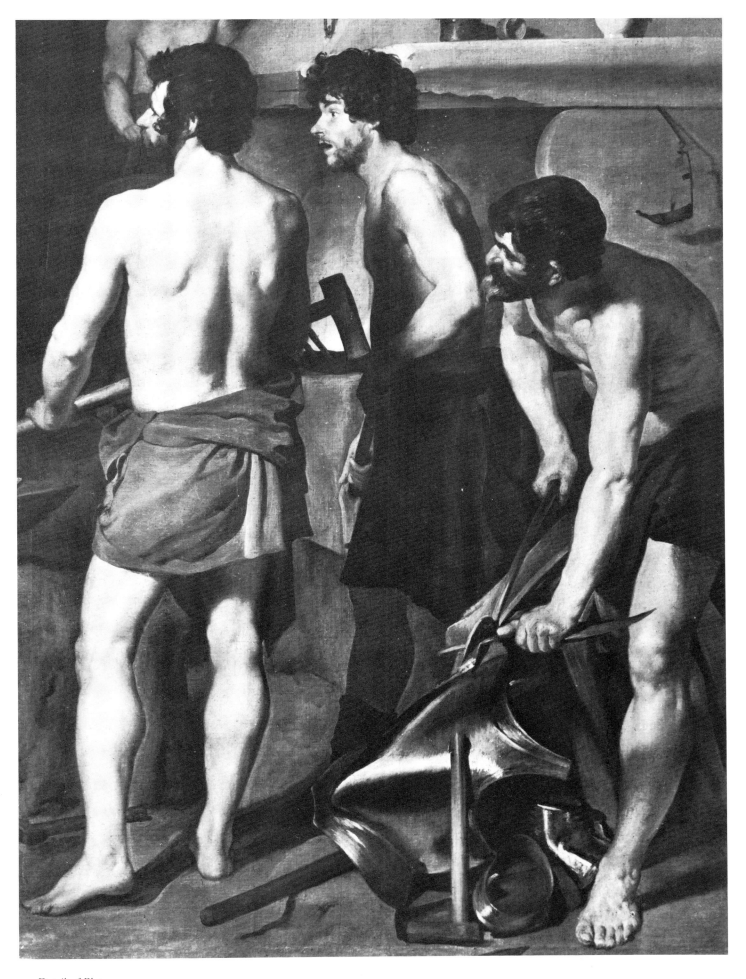

74. Detail of Plate 71.

75. *Vulcan and the Cyclopes Forging the Shield of Achilles*. Marble relief, Hadrianic period. Rome, Palazzo dei Conservatori. The arrangement of the figures in Velázquez's Roman paintings suggest that he studied antique reliefs as well as sculpture in the round.

subject after his appointment as Court Painter, Velázquez has used some of the same models as he used for the blacksmiths, while the two figures in the background, presumably Joseph's brothers, only sketchily portrayed with their feet half concealed by the carpet, appear to have been added as an afterthought. In the setting of a large hall, with a view beyond, the figures here are posed in attitudes that emphasize the drama of the story they illustrate. Here, too, Velázquez has added to his earlier studies of facial expression a knowledge of the language of gesture. The figure on the left raises his arms to tear his hair and the brother nearest to Jacob holds his fist to his mouth, displaying grief and horror, while Jacob himself has his arms outstretched in a classic expression of mourning. For Francisco de los Santos, who first described this painting after it had been moved from the Buen Retiro to the Escorial towards the end of Velázquez's life, its most notable feature was the dramatic quality which, he says, Velázquez had heightened by ignoring scripture and introducing Joseph's brothers in place of shepherds to bring the bloody garment to Jacob. He also admired the way in which Velázquez had arranged the figures to be seen front view, back view and in profile, with such artistry that they could serve as a model for an anatomy lesson (cf. Plates 73, 74).

Velázquez was said by his friend Jusepe Martínez to be 'much improved by his study in Rome of ancient and modern paintings, statues and reliefs', especially so far as perspective and composition were concerned. This is obviously true, judging from these two novel and remarkable works. But the lessons Velázquez learnt in Italy were so quickly absorbed and adapted to his own dedicated pursuit of the

84

imitation of nature that it is difficult to point to particular studies or influences. Antique statues and reliefs undoubtedly aroused his interest in the representation of nude torsos (Plate 75). At the same time, the figures have the appearance of living models, and moreover of the same models in different guises and poses. Indeed, Justi went so far as to say they must have been Spaniards, from the Ambassador's household, rather than Italians. Yet it must be remembered in dealing with seventeenth-century artists that what we see as a figure of flesh and blood may have been portrayed from some clothed classical marble. The measure of the painter is how well he transforms and conceals his debt. As for the gestures in the painting of Jacob, which for Velázquez are used to unusually dramatic effect, these were learnt possibly from Tintoretto, whose works in Venice he is said to have copied. Tintoretto may also have given him the idea for the chequered floor, a device that creates the effect of space, and even for the introduction of the dog. The great masters of the sixteenth century, Raphael, Michelangelo, Titian and Tintoretto, may all have contributed to his development of composition, light and colour. But there seems to be little influence from any living Italian artist. Velázquez's naturalism, stemming directly or indirectly from Caravaggio, still has more affinities with that of the *caposcuola* than with any of his followers in Rome or Naples. Yet beside Velázquez's Roman masterpieces, Caravaggio's once revolutionary imitation of nature (Plate 76) now looks theatrical.

76. Michelangelo da Caravaggio (1573–1610). *The Calling of Saint Matthew.* 1598–1600. Canvas, 126¾ × 133¾ in. (322 × 340 cm.). Rome, San Luigi dei Francesi, Contarelli Chapel. Caravaggio's first public commission, finished after many difficulties, which involved the repainting of this altarpiece, and the replacement of another, considered indecorous.

5 Madrid, 1631-1649: Portraits

Immediately after his return from Italy early in 1631, Velázquez entered on the most productive period of his career. At the same time, the range of his activities was expanding in various directions. The next years saw the realization of the two major artistic projects of Philip IV's reign: the completion of the building and decoration of the new royal palace on the outskirts of Madrid, the Buen Retiro (Plate 12), and the refurbishing of the Torre de la Parada (Plate 13), a nearby hunting lodge. For these, Velázquez contributed most of the royal portraits. Apart from the *Surrender of Breda*, the history pieces for the Buen Retiro were painted by his Spanish colleagues, and the mythologies for the Torre were ordered from Rubens in Antwerp. But Velázquez must have played an important role not only as artist but also as connoisseur and adviser concerned with the arrangement of the quantities of paintings and other works of art coming from Flanders and Italy, including some of his own recent purchases. This was a role that was to occupy him more and more during the rest of his life.

Velázquez's own output in this period, between his two Italian journeys, was more varied than at any other time. Portraits, however, were as always his speciality, his chief task being to record the likeness of living people, the members of the royal family and of the court and also of visiting nobility. His portraits were painted either to hang in the various royal establishments or to be sent as gifts to the King's relatives and friends abroad; others were commissioned by visitors to Madrid – distinguished prototypes of the modern signed photographs of royalty. Some of these portraits were by his own hand but others were from his studio, like the portraits of Philip IV, Queen Isabel and Prince Baltasar Carlos which were sent to Charles I of England about 1639. An indication of the position Velázquez had attained as an authority on the subject is his appointment in December 1633, with his senior colleague Vicente Carducho, to examine a number of portraits of members of the royal family and decide whether they passed the test of likeness and decorum.

If the separation of Velázquez's portrait production during the 1630s and 1640s is artificial, it has the advantage of providing a framework for a chronological survey. So few of his paintings are documented that his portraits assume a greater importance for such a survey, since they can often be dated, more or less accurately, by the age and appearance of the sitter or the occasion for the painting. The separation also serves to illustrate the great variety of Velázquez's genius in one particular field and underlines the way in which his gift for portraiture dominates his whole oeuvre, investing with a quality of living likeness not only his human subjects but also the protagonists of history and fable.

Because of his fame, in his own time and later, as the King of Spain's portrait painter, Velázquez's name has been given to a large body of paintings that present one of the problems of Velázquez scholarship. For instance, the entries for portraits of Philip IV in the most recent catalogue of works by and attributed to Velázquez number more than 80, and those of Baltasar Carlos no less than 30. Relatively few of these are autograph. Some are copies or studio replicas of known or lost originals, others probably designed by Velázquez and executed by assistants, like the portraits sent to England, others wholly by pupils and imitators. The quantity of royal portraits not by Velázquez's hand points to a number of pupils and assistants. Unfortunately, we know little or nothing about the organization of his studio. We have, mostly from Palomino, the names of more than a dozen painters who worked with Velázquez, and a few are documented as his apprentices. Though some are known for their independent works, there is no evidence of the part they played in the studio. Juan de Pareja and Juan Bautista Martínez del Mazo, the best-known of Velázquez's 'pupils', were certainly closely connected with him. Pareja was probably one of his assistants in the 1630s and 1640s, and no one has ever questioned Palomino's story that he accompanied Velázquez on his second visit to Italy and there sat for his celebrated portrait. Pareja's own paintings, all dating from after his return to Spain, are, however, at best a feeble reflection of Velázquez's style (Plate 77).

As for Mazo, whose name has been given to the majority of portraits after Velázquez or in his style, he probably entered the Master's studio not long before 1633, when he is first recorded on the occasion of his marriage to Velázquez's daughter. Thereafter, he enjoyed his father-in-law's protection and patronage, taking over his office of Gentleman Usher in 1634. He was appointed Painter to Prince Baltasar Carlos in 1646 and succeeded to the post of Court Painter vacated by Velázquez on his death. He remained attached to the court until his own death in 1667. Mazo is said to have specialized in copying and in painting small figures. His copies after Titian and Rubens are recorded in the royal collection and some

77 (*Below*). Juan de Pareja (*c.* 1610–70). *The Calling of Saint Matthew*. Signed and dated 1661. Canvas, 88½ × 128 in. (225 × 325 cm.). Madrid, Prado Museum.
The self-portrait on the left appears to be based on Velázquez's famous portrait of Pareja painted in Rome (Plate 149). The execution, however, hardly justifies Palomino's praise of his portraits, so close to the style of Velázquez that they could be mistaken for his.

78 (*Below right*). Attributed to Juan Bautista del Mazo (*c.* 1612/16–1667). *Don Adrián Pulido Pareja*. Inscribed (above, left): *Did. Velasq.ᶻ Philip. IV. acrbiculo. | eiusqu.ᶻ pictor. 1639*; (below): ADRIAN | PVLIDOPAREJA. Canvas, 80¼ × 45 in. (204 × 145 cm.). London, National Gallery.
The signature and date correspond to those that Palomino says Velázquez put to his celebrated portrait of the naval commander Adrián Pulido Pareja (1606–60). The portrait, formerly attributed to the Master, is no longer considered autograph. Some critics believe it to be an original by Mazo painted after 1647, since the sitter wears the badge of the Order of Santiago awarded him in that year, and that it was mistaken by Palomino for a Velázquez. A more likely solution is that it is a copy of Velázquez's portrait made after 1647, possibly by Mazo, with the inscription added later.

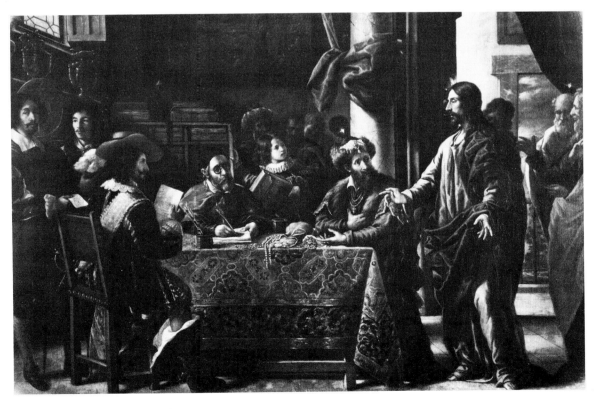

79 (*Left*). *Philip IV in Brown and Silver. c.* 1631–2. Signed on the paper in his right hand (see Plate 1). Canvas, 78½ × 44½ in. (199.5 × 113 cm.). London, National Gallery. (L-R 52) The first known portrait of the King painted after Velázquez's return from Italy shows him with a fully grown moustache, of which the drawing made by Rubens in 1628–9 (Plate 57) shows only a trace. The unusually elaborate costume suggests that the portrait was painted to commemorate a special occasion.

80. *Prince Baltasar Carlos with an Attendant Dwarf.* 1632. Inscribed: .TAT.S ANN./ MEN. Canvas, 53½ × 41 in. (136 × 104 cm.). Boston, Museum of Fine Arts. (L-R 51) This is Velázquez's earliest known portrait of the Prince (1629–46), born 17 October 1629, while the artist was in Italy. It has been convincingly claimed that it commemorates the ceremony of taking the oath of allegiance to the heir to the throne, which took place on 7 March 1632, when Baltasar Carlos was two years and four months old, the age presumably recorded in the incomplete inscription. The identification of the dwarf with Francisco Lezcano (Plate 102) is in doubt, despite the resemblance, as he did not enter the Prince's service until 1634. A portrait of the Prince in similar pose and elaborate costume, about a year older, is in the Wallace collection. (L-R 60).

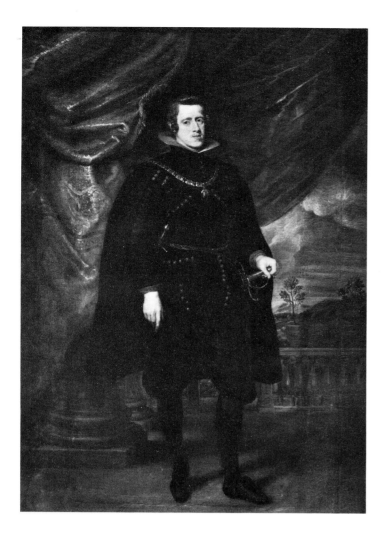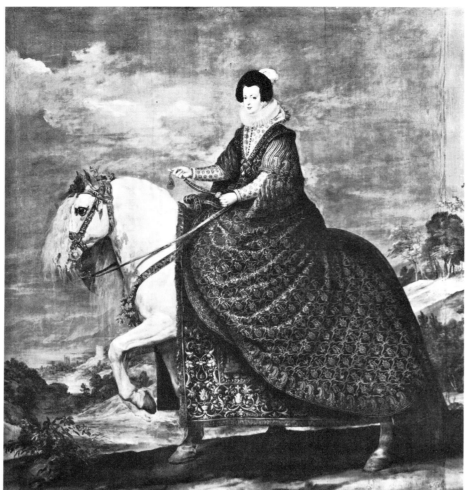

have survived, but there are no documented copies after Velázquez, which, according to Palomino, were so good that they were difficult to distinguish from the originals. His observation raises the question whether the portrait of *Adrián Pulido Pareja* (Plate 78), attributed to Mazo, is a copy of a lost original or whether Palomino mistook it for a painting by the Master.

Juan de Alfaro (1643–80), whom Palomino acknowledges as his chief source of information about Velázquez, describes himself as the latter's pupil, presumably during his last years. The few paintings attributed to Alfaro today owe nothing to the master, but the drawing said to portray Velázquez on his deathbed, of credible authenticity, is a document of considerable historical interest (Plate 26).

To return to Velázquez's own production as a portrait painter, what can he be said to have gained from a first visit to Italy made at an age when his style had already begun to form itself into something assured, individual and dignified? The question is complicated by the fact that even without leaving Spain, Velázquez had access to portraits by Titian and Rubens which can hardly have been surpassed by anything he saw in Italy. Rubens himself had copied Titian's portraits of the King's ancestors when he was in Madrid in 1628, as well as painting the living members of the royal family. After the appointment of Philip IV's brother Ferdinand as Governor of the Netherlands (1633), Rubens was increasingly occupied with commissions for the Spanish court, which must have kept alive his professional relationship with Velázquez. The part played by Velázquez in the orders for paintings to decorate the Buen Retiro and the Torre de la Parada is not known, but he was certainly at the receiving end of the canvases (100 or more for the Torre were sent from Rubens's studio in Antwerp). Velázquez's royal portraits probably provided Rubens with guides to the likenesses of the

King and Queen that he painted after he left Spain, while the change in style of the portraits he himself painted after his return from Italy seems to owe more to the influence of Titian and Rubens than to his recent Italian studies.

For his royal sitters, Velázquez for the most part went back to models that he found at home. *Philip IV in Brown and Silver* (Plate 79) is in the traditional pose followed in his earlier portrait in black – a pose that Velázquez was to use again and again. The position of the head, the eyes directed towards the spectator, is as constant as in some artists' self-portraits. The changing physiognomy of the King from youth to age is illuminated by the subtly changing style of the artist, which distinguishes the autograph works from the numerous studio replicas. In this work, painted soon after Velázquez's return from Italy, there is a notable change in the appearance of the King, compared with his earlier portraits in black, that is not only due to his festive costume. The moustache that had begun to grow when Rubens was in Madrid is now fully developed, and there is a tuft of hair on the chin. The more adult look of the sitter is matched by the stylistic development. For one thing, there is what Velázquez's friend Martínez called an improvement in perspective: the King now seems to stand in the room instead of being silhouetted against the background. There is also a lightening of tones and a more fluent technique which may partly derive from Rubens's recent portraits of the King (cf. Plate 81). But beside Rubens's Philip IV, with its slightly tilted head, there is a stillness, an air of natural simplicity about Velázquez's figure which is perhaps the *modestia* that Rubens admired in the younger man. We can see this *modestia* growing into something much subtler in the succession of portraits Velázquez painted of Philip IV, the King whose friend as well as servant he became, serving him as Court Painter from the time he was 24 and the King a boy of 18. Subject and style seem to mature together, each, as it were, acting on the other.

The birth of Baltasar Carlos during Velázquez's absence in Italy, the longed-for heir to the throne and the only child of Philip IV to have survived infancy, provided the artist with an important addition to the small number of his regular sitters. His portraits of the Prince were the first of a series of paintings of royal children that culminated in *Las Meninas*. The earliest version, painted soon after Velázquez's return from Italy, probably to commemorate the ceremony of taking the oath of allegiance to the heir to the throne, shows the young *Prince Baltasar Carlos with an Attendant Dwarf* (Plate 80), the first of Velázquez's portrayals of the dwarfs, idiots and entertainers that were a notable feature of the Spanish court. Here convention and invention are combined to create a remarkable effect of originality, with the royal Infante standing stiffly like his father, baton in hand, while the dwarf prominent in the foreground turns towards him, holding a rattle and an apple, suggestive of the royal attributes of orb and sceptre. Each figure bears witness to the small stature of the other.

As heir to the throne, Baltasar Carlos appeared in a prominent position in the decoration of the *Salón de Reinos* of the new Buen Retiro Palace. His portrait on horseback hung over the door between the equestrian portraits of the reigning King and Queen and opposite the dais flanked by those of his grandparents, Philip III and Margarita. Of the five portraits (see Plates 82, 83, 84), only those of the King and Prince are wholly autograph, and that of the Prince – if not of the King – was painted for the place where it was to hang. The pentiments and additions to the others are evidence that they were adapted for a scheme of decoration for which they were not designed, and they were almost certainly begun – probably by another hand – before Velázquez left for Italy. The scheme, which Velázquez probably designed and carried out with his Spanish colleagues, is in many respects original. At either end of the great hall were the life-size

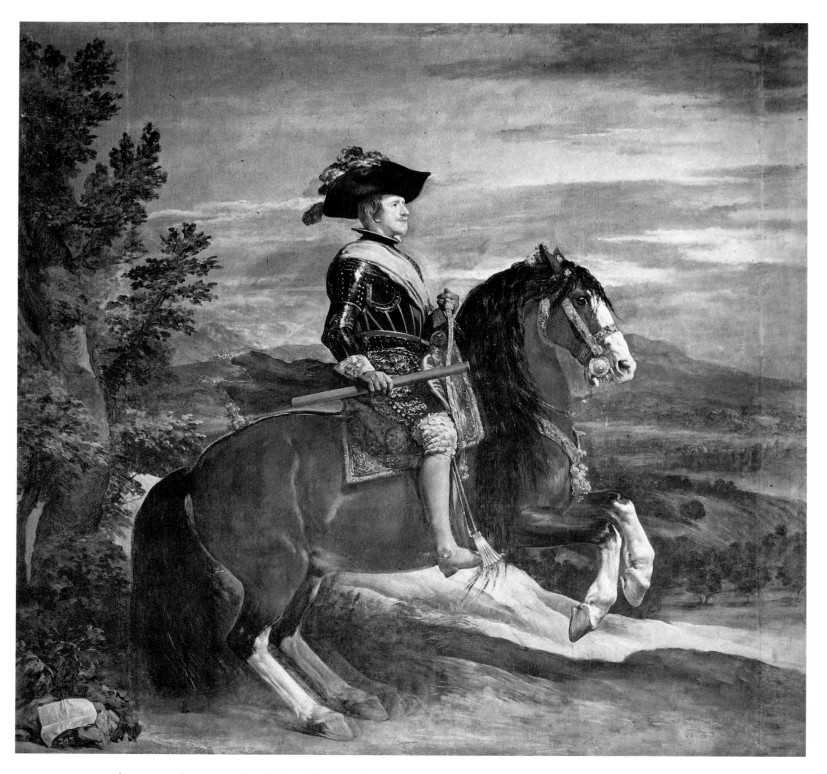

equestrian portraits not only of the ruling monarch, his predecessor and his heir, but also of the two Queens, while the long side walls were hung with 12 history pieces celebrating the military successes of the reign and 10 Labours of Hercules, the mythical ancestor of the Spanish kings. Thus, at the very time when Rubens celebrated the entry into Antwerp of Philip IV's brother, Ferdinand (April 1635), with triumphal arches, decorated in a traditional way in allegorical and symbolical language, the King himself was honoured in a relatively solemn and real setting, with portraits and military scenes, with scarcely any allegorical references, but accompanied by the Hercules series. It was also a world apart from any of the frescoed rooms Velázquez may have seen in Rome. This was the setting of

83 (*Left*). *Philip IV on Horseback*. 1634–5. Canvas, 118½ × 125¼ in. (301 × 318 cm.). Madrid, Prado Museum. (L-R 71)
The idea for the equestrian portraits of Philip III and Philip IV may have originated in 1628 when Velázquez was given armour for use in his portraits of the two kings, but while that of Philip III (and that of his Queen) may have been begun then and finished (?) by another hand, the portrait of Philip IV appears to have been wholly executed by Velázquez after his return and painted for the *Salón de Reinos*, where it was installed by April 1635.

84. *Prince Baltasar Carlos on Horseback*. 1634–5. Canvas, 82¼ × 68⅛ in. (209 × 173 cm.). Madrid, Prado Museum. (L-R 72)
The portrait of the Prince, born while Velázquez was in Italy, is possibly the only one of the five royal equestrian portraits painted for the place where it was to hang, over the doorway in the *Salón de Reinos*. The exaggerated curve to the pony's barrel indicates that it was designed to be seen from below. With the other paintings in the *Salón* it was installed by April 1635.

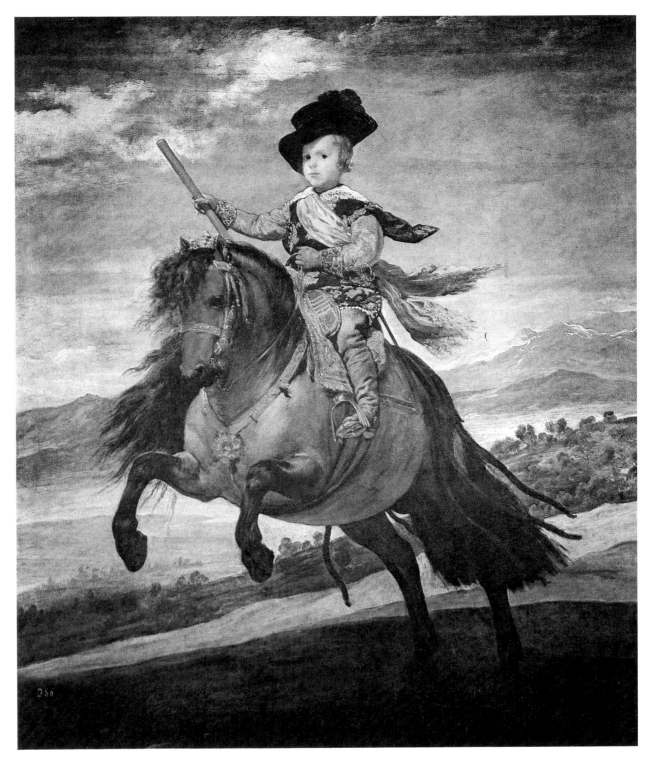

unusually light-hearted entertainments over which the King was to preside in this palace built primarily for recreation, a place of retreat from the problems of monarchy.

Velázquez had painted equestrian portraits of the King and Olivares before he went to Italy, but they have not survived. For these and for the portraits for the Buen Retiro, he followed a tradition that went back in Spain to Titian's *Charles V at Mühlberg* (1548) (Plate 85), a tradition that was continued by Rubens, who painted the first equestrian portrait of the seventeenth century for the Spanish court, *The Duke of Lerma* (1603, Prado). In his portrait of Philip IV on horseback, Velázquez's almost classical composition is close to Titian's but its larger scale

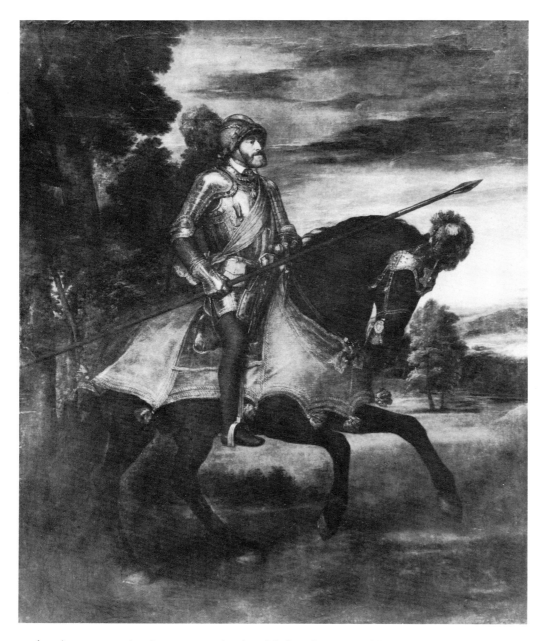

85 (*Left*). Titian (*c.* 1488/90–1576). *The Emperor Charles V on Horseback, at Mühlberg.* 1548. Canvas, 130¾ × 109⅞ in. (332 × 279 cm.). Madrid, Prado Museum. Titian's portrait commemorating the victory over German Protestants in April 1547 provided a model for later state equestrian portraits. It hung in a place of honour in the Madrid Alcázar in the 17th century with Velázquez's and later Rubens's *Philip IV on Horseback* facing it.

makes it more majestic, more poised, with less bravura. The rearing or galloping horse is derived from Rubens, who had painted an equestrian portrait of Philip IV in Madrid in 1628 (cf. Plate 59), which was given a place of honour in the Alcázar in the same room as Titian's *Charles V*. But the pose of Velázquez's horse and rider, looking straight ahead, the impression that the horse's movement has been momentarily checked, create an effect of stateliness, of royal dignity, that is very different from the pomp and dash of Rubens's group, with its characteristic allegorical accessories. Here, too, Velázquez has transformed the timid young ruler, dressed in black, of his early portrait (Plate 52), the first gentleman of the land, in brown and silver, of the early 1630s, only a little more regal (Plate 79), into the proud, confident monarch (Plate 83). And this transformation is matched in Velázquez's style. The monumental group of horse and rider has a new three-dimensional quality; the head of the King, now with a more lively, vigorous expression, is painted with strong, broad brush strokes, but without outline or detail or strong contrasts of light and shade. The natural lighting and the setting give an impression of an outdoor scene painted *in situ*.

Though Velázquez frequently followed traditional compositions, particularly for his royal sitters, it was from no lack of ability to invent or compose. For the

86. Philip IV in 1634–5. Detail of Plate 83. Unlike Velázquez's other portraits of the King which repeat the same three-quarter view of the head, the profile view in this portrait is unique.

Torre de la Parada he created a new type of informal royal portrait with his figures of the King, the Cardinal Infante Ferdinand and Prince Baltasar Carlos in hunting dress (Plates 87, 88, 89), and although all three appear to have been painted from the life, the head of Ferdinand must have been copied from an earlier portrait painted before Velázquez went to Italy, when he also sat to Rubens (1628). By the time of the Torre portrait Ferdinand, like Philip, had lost his boyish look and had grown a good-sized moustache, as we know from his portraits painted in the Netherlands by Van Dyck and Rubens.

87. *Philip IV as Huntsman. c.* 1635–6. Canvas. 75¼ × 49⅝ in. (191 × 126 cm.). Madrid, Prado Museum. (L-R 63)
A far cry from Van Dyck's romantic image of Charles I at the hunt (Louvre), Velázquez's portrait was copied by Goya in a drawing for an etching not executed (as were those of the other royal huntsmen) and inspired his *Charles III as Huntsman* (Prado). The three royal huntsmen were probably among the works for the Torre for which the artist applied for payment in 1636 (Doc. 66); they are recorded there in 1701, and the portraits of the King and his brother are mentioned there by Palomino.

88. *The Cardinal Infante Ferdinand as Huntsman. c.* 1635–6. Canvas, 75¼ × 42⅛ in. (191 × 107 cm.). Madrid, Prado Museum. (L-R 64)

Philip IV's second brother Ferdinand (1609–41) was made a Cardinal in 1619. He left Madrid in 1632, and on the death of Carlos in 1634 left Spain to become Governor of the Netherlands. This is the only extant portrait of the Infante by Velázquez. Despite the frequent exchange of family portraits, the artist evidently did not have an up-to-date likeness and used an earlier one, possibly one by Rubens or a version of the portrait he himself was to have made to send to Vienna in 1628. According to portraits of Ferdinand made by Van Dyck and Rubens in 1635, he had by then grown a moustache like the King's.

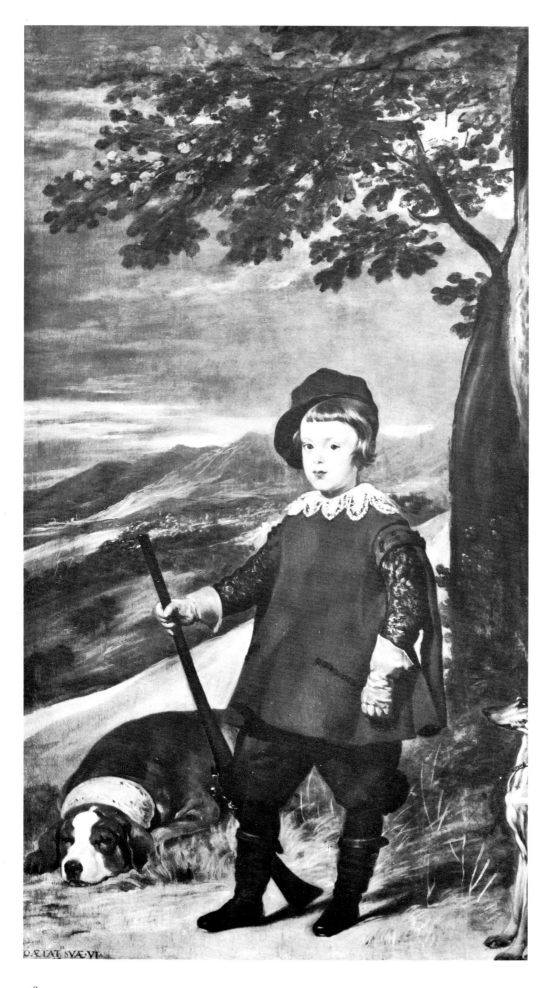

89. *Prince Baltasar Carlos as Huntsman.*
c. 1635–6. Inscribed: *Anno aetatis suae VI.*
Canvas, 75¼ × 40½ in. (191 × 103 cm.).
Madrid, Prado Museum. (L-R 77)
With the portraits of his father and uncle
the painting is recorded in the Torre de la
Parada in 1701, but was overlooked by
Palomino. According to the inscription it
was painted between October 1635 and
October 1636, shortly after his equestrian
portrait (Plate 84). Judging from the many
replicas this was one of the most popular
images of the young Prince and was
originally wider on the right to include
three dogs.

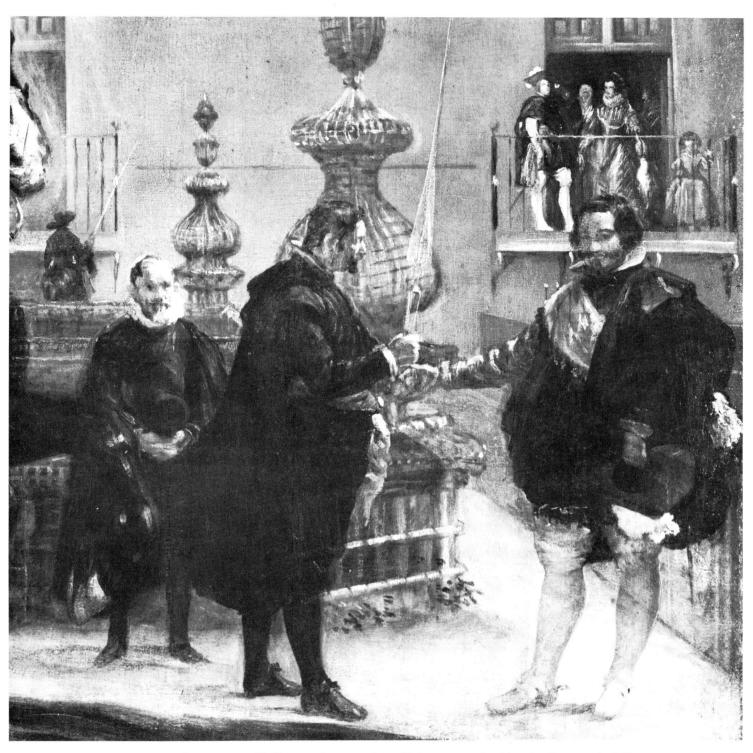

90. Detail of Plate 91. The jousting lance, held out to Olivares by the Prince's valet, suggests that Baltasar Carlos, who is not in armour, is about to receive a lesson in tilting or jousting, one of the many aspects of horsemanship that were part of the education of a Prince.

Velázquez's portraits of his patron the Conde-Duque de Olivares were mostly formal compositions, of which the most notable is the grandiose equestrian portrait of him as victorious general at the battle of Fuenterrabía (1638) (Plate 92). But Olivares also appears in a less conventional setting in the portrait of *Prince Baltasar Carlos in the Riding School* (Plates 90, 91). Here the young Prince is portrayed as horseman executing one of the feats of *haute école*, an attendant dwarf at his horse's tail. Olivares stands in the middle ground receiving a jousting lance from the Prince's valet, in the presence of the Master of the Hunt. The figures are painted with a diminishing degree of detail as they recede into the background so that the group standing on the balcony, spectators of the main scene, are hardly distinguishable; yet two of them can be recognized as the King and Queen. The

99

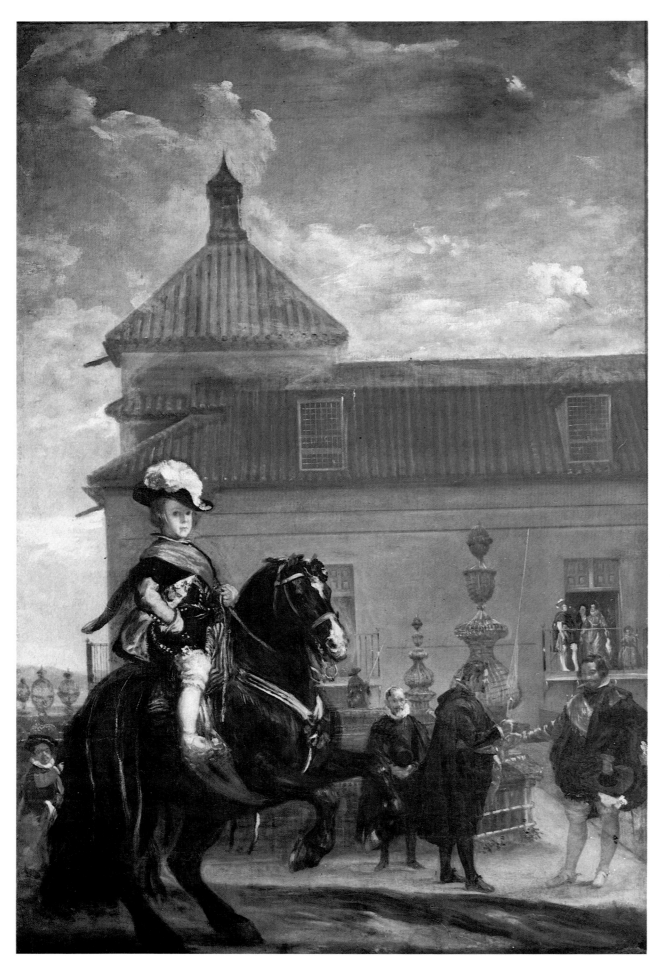

91 (*Left*). *Prince Baltasar Carlos in the Riding School.* c. 1636. Canvas, 56¾ × 35⅞ in. (144 × 91 cm.). The Grosvenor Estate. (L-R 78) The young Prince, already an accomplished horseman, is executing one of the movements of *haute école*, in the presence of Olivares, Master of the Horse, Alonso Martínez de Espinar, the Keeper of Arms and valet to the Prince, and Juan Mateos, Master of the Hunt. On the balcony (of the Buen Retiro Palace) in the background are the King and Queen and other figures. The painting was probably made for Olivares and inherited by his nephew in whose collection it is first mentioned by Palomino. A variant, possibly by Mazo, is in the Wallace collection.

92. *Gaspar de Guzmán, Conde-Duque de Olivares, on Horseback.* 1638. Canvas, 123¼ × 94⅛ in. (313 × 239 cm.). Madrid, Prado Museum. (L-R 66) First mentioned by Palomino but he does not say who owned it and his references to a panegyric in verse by Salcedo Coronel must be mistaken as this was published in 1627. Because the horse's pose in Jusepe Leonardo's *Conquest of Breisach* painted for the *Salón de Reinos* is similar, López-Rey dates Velázquez's painting before 1635. More probably the pose is dependent on a common source. There is little reason to doubt that this portrait of Olivares in armour as a General, with sash and baton, commemorates the victory over the French at Fuenterrabía (the battle represented in the background), for which he received the credit although he was not present.

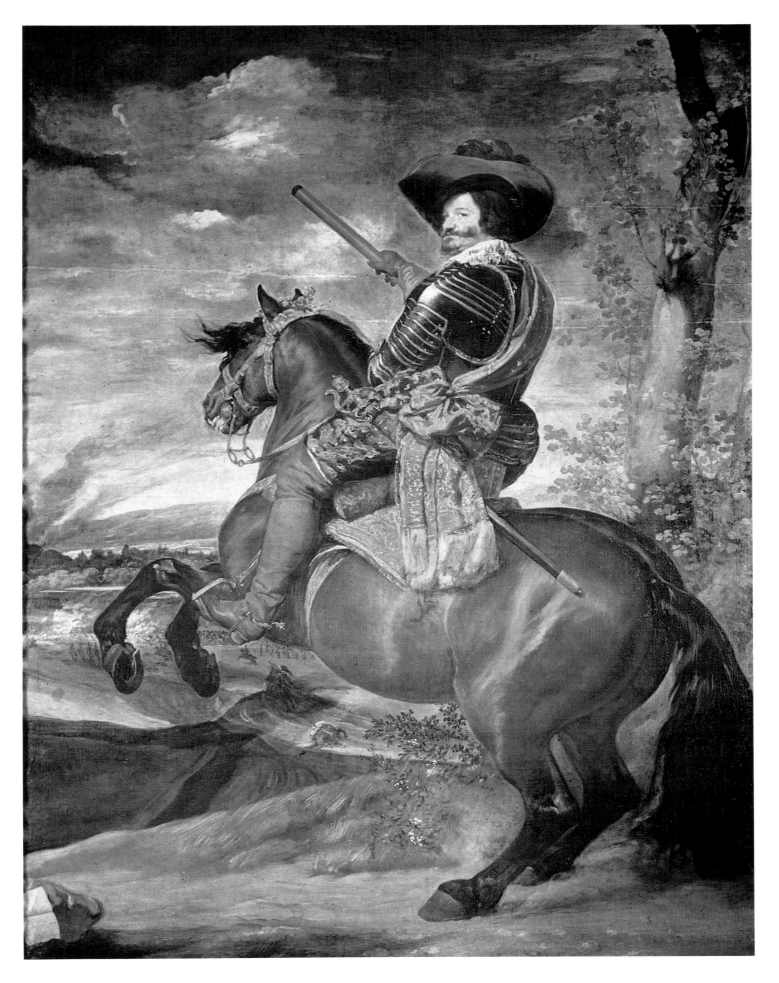

93. Spanish School, 17th century. *The Gardens of the Casa de Campo, with the Equestrian Statue of Philip III.* Canvas, 45¼ × 66⅞ in. (115 × 170 cm.). Madrid, Prado Museum (on loan to the Municipal Museum).

The statue, begun by Giovanni da Bologna and completed by Pietro Tacca, was first erected in the garden of the Alcázar, and moved to the Casa de Campo in 1617. It is now in the Plaza Mayor.

94. Pietro Tacca (1557–1640). *Equestrian Statue of Philip IV.* 1634–40. Signed and dated 1640 on the horse's reins. Bronze. Madrid, Plaza de Oriente.

The statue was made in Florence, at the request of Philip IV, to ornament the gardens of the Buen Retiro. Sketches of the King, his costume and armour were requested by the sculptor. A version of Velázquez's *Philip IV on Horseback* (Plate 83) was probably sent as well as a bust of the King by Montañés, who was summoned from Seville to make it. Galileo is said to have advised on how to overcome (for the first time) the technical problem of casting a life-size self-standing galloping or rearing horse, on which the King, an accomplished horseman, had insisted. The statue was taken to Madrid by the sculptor's son and set up in the Buen Retiro in 1642. In 1844 it was removed to its present location facing the Royal Palace.

building is the Buen Retiro Palace, the scene of most of the court tournaments and jousts, as well as other festivities. The combination of portraiture and narrative, a scene that Palomino described as '*grandemente historiado*' (with many figures) is rare in Velázquez's oeuvre. A royal equestrian portrait in an informal setting, it is also highly original as a court scene and has been aptly acclaimed as a predecessor of *Las Meninas*, painted some 20 years later.

Mainly through Velázquez as well as Rubens, the equestrian portrait became fashionable in the seventeenth century everywhere in Europe. It was Velázquez who must have provided the model for a statue of Philip IV that played the important role of introducing the rearing horse in Italian Baroque sculpture. For his bronze statue of Philip IV (Plate 94), executed in Florence for the garden of the Buen Retiro Palace, Pietro Tacca was sent models from Madrid. The statue was at first to be based on portraits by Rubens and the life-size equestrian group of Philip III that had been begun by Giambologna and finished by Tacca 20 years before (Plate 93). Later, however, it was decided that the horse was to be shown in the attitude of galloping or rearing rather than '*di passeggio*' like Philip III's. As for the paintings sent to Florence, Rubens had left Madrid long before the statue was ordered. From the copy of the lost equestrian portrait of the King he left behind (Plate 59), it is clear that it was not this but almost certainly a copy of Velázquez's Philip IV on horseback that the sculptor used. Velázquez's fellow Sevillian, the sculptor Martínez Montañés, also provided a model of the King's

95. Gianlorenzo Bernini (1598–1680). *Equestrian Statue of the Emperor Constantine.* 1654–70. Marble. Vatican, Scala Regia. The monumental, animated group of horse and rider, made for its position on the staircase which Bernini himself had rebuilt, is at the same time a symbolic composition: a representation of the Emperor at the moment of his conversion.

96 (*Left*). *Francesco I d'Este, Duke of Modena* (1610–58). 1638. Canvas, 26¾ × 20⅛ in. (68 × 51 cm.). Modena, Galleria Estense. (L-R 89)
During his visit to Madrid in 1638 for the baptism of the Infanta María Teresa, the Duke was lodged in the Buen Retiro. The portrait shows the Duke wearing armour, the Spanish *golilla* and the toison d'or with which he and Prince Baltasar Carlos were decorated on 24 October 1638. The Duke rewarded the artist liberally, according to Palomino, and presented him with a gold chain. Among the gifts presented to the Duke by Philip IV was a diamond eagle with a miniature portrait of the King on the back by Velázquez, described by the poet Fulvio Testi, the Duke's Ambassador, as 'so beautiful and so life-like that it is amazing'. He also said that Velázquez was expensive but that his portraits ranked 'as highly as those of any other most renowned master, old or modern'.

97 (*Above*). Gianlorenzo Bernini (1598–1680). *Francesco I d'Este, Duke of Modena*. 1650–1. Marble, height 39⅜ in. (100 cm.). Modena, Galleria Estense. Bernini's bust was executed in Rome without the sculptor ever having seen the sitter. Yet, on the basis of painted portraits, he achieves his usual lively effect.

head, presumably the head that appears in sketched form in his portrait by Velázquez, painted when he came to Madrid in 1635 (Plates 98, 99). But the pose of horse and rider, looking straight ahead, and the impression that the horse's movement has been momentarily checked are clearly derived from Velázquez and very different from Rubens's horse and rider, which seem to be in motion and are related more closely to the heroic equestrian monuments of Bernini (Plate 95).

The fundamental difference between the naturalness and poise of Velázquez's portraiture and the dynamic, sensational manner of his great Roman contemporary is well illustrated by their versions of the same sitter. Velázquez's portrait of the handsome young *Duke of Modena* (Plate 96), painted during his visit to Madrid in 1638, hangs today in the Modena Gallery close to Bernini's marble bust made in 1650 (Plate 97). Though the bust was not made from the life, the pose gives credence to the story told by Baldinucci that when portraying anyone, Bernini did

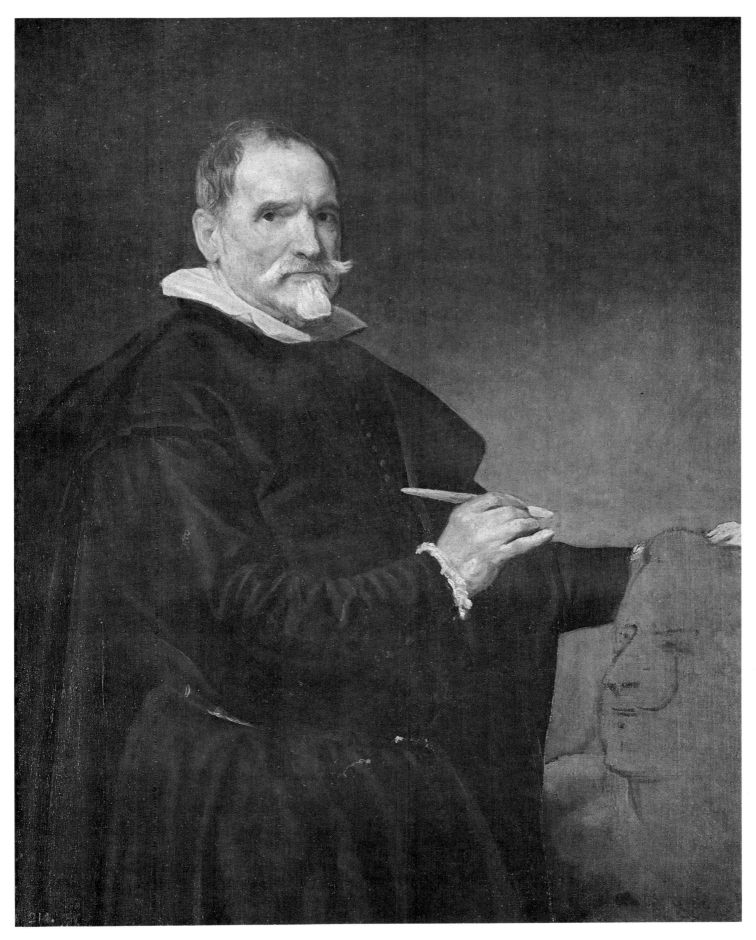

98. *Juan Martínez Montañés* (1568–1649). 1635–6. Canvas, $42\frac{7}{8} \times 32\frac{7}{8}$ in. (109 × 83.5 cm.). Madrid, Prado Museum. (L-R 76)
The sculptor was summoned to Madrid from Seville to make a bust in clay of the King to be sent to Florence as a model for Tacca (see Plate 94).
Velázquez has portrayed him at work on the bust, with which the King is said to have been very satisfied. It was celebrated in Madrid in a sonnet in
which Montañés is called the 'Andalusian Lysippus'.

not like his sitter to stay still but to move and talk; the best moment to choose for the mouth, he is quoted as saying, is when the sitter has just spoken or is about to speak. Velázquez, on the other hand, according to Pacheco, 'when he painted the King on horseback had him seated for three hours at a time, with all that vigour and greatness in abeyance.'

The equestrian portraits are supreme examples of how Velázquez could transform and transcend traditional subjects in traditional poses. The sitter, however,

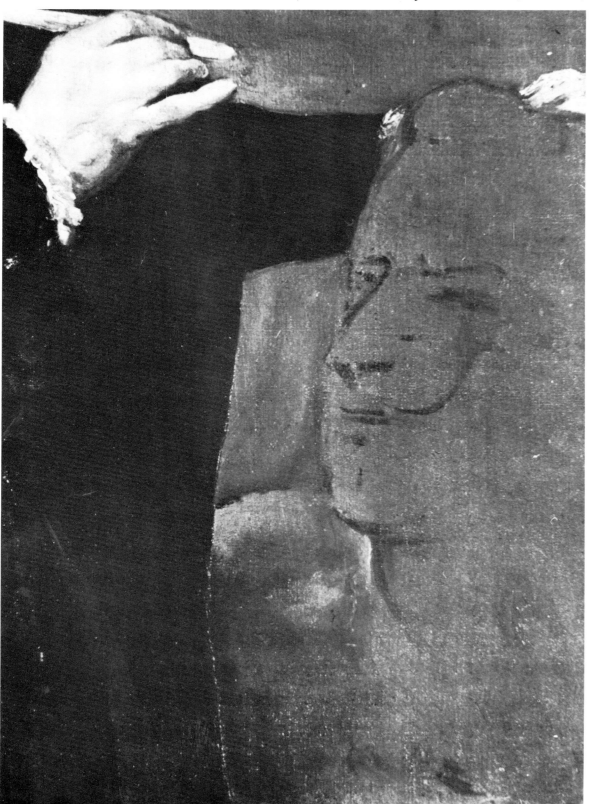

99. Detail of Plate 98.
Velázquez's sketch of the head of Philip IV probably represents the sculptor's first sketch and illustrates the painter's style as draughtsman.

100 (*Right*). *The Buffoon Cristóbal de Castañeda y Pernia, called 'Barbarroja'*. *c*. 1635–45. Canvas, 78 × 47⅝ in. (198 × 121 cm.). Madrid, Prado Museum. (L-R 84)
First documented in the Buen Retiro Palace in 1701, and described as unfinished, it was presumably one of the 'court entertainers' that Palomino mentions hanging on the staircase there. Nicknamed '*Barbarroja*' (Red-beard) after a 16th-century Algerian pirate, renowned for his military prowess, whose portrait was in the royal collection, he is recorded at court from 1633 to 1649. On the problem of dating, see page 108; here the unfinished state and the cloak added by another hand make it specially difficult to date.

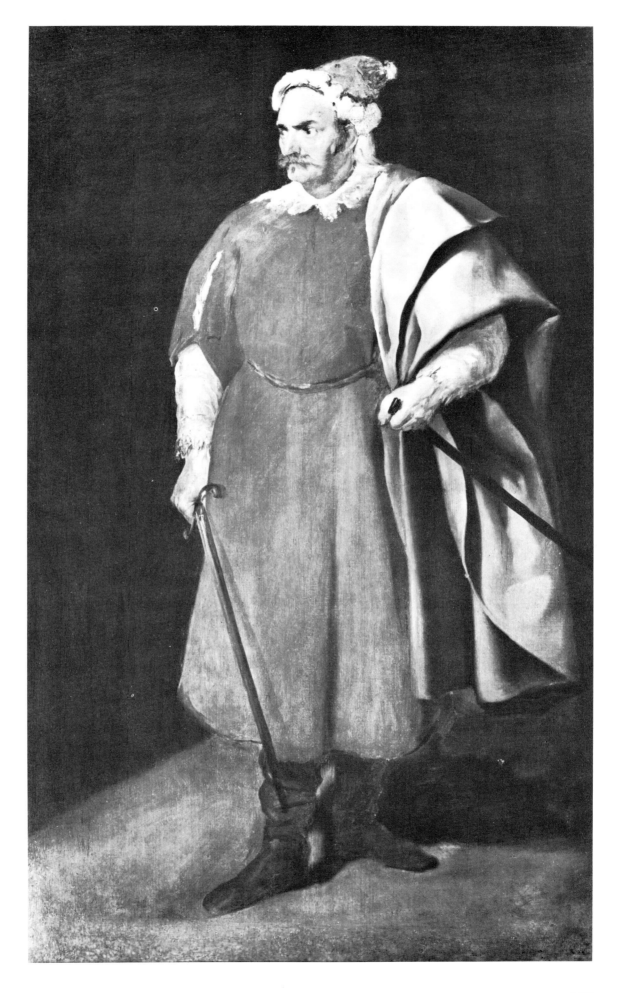

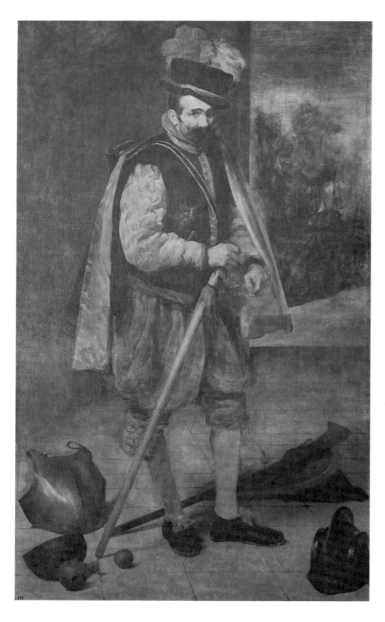

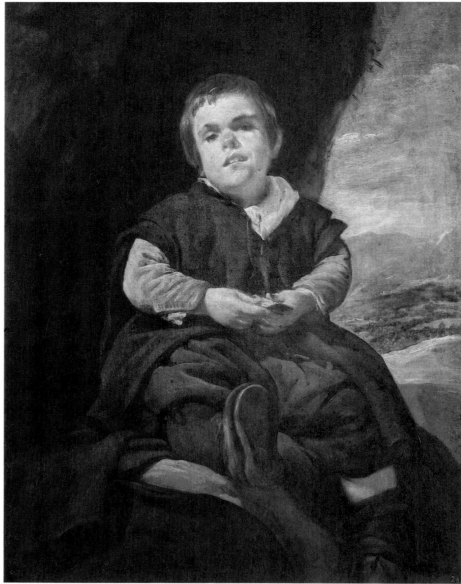

did not need to be royal or noble for him to display all his powers of sympathetic observation. In the series of court dwarfs and jesters dating from the 1630s and 1640s, the apparently natural and unconventional poses serve to demonstrate the individual characteristics of these unusual models (Plates 100–5). The seated figures reveal more clearly than any standing pose their dwarfish stature and stunted limbs, and bring closer their remarkable heads, with varied expressions: serious, jovial, imbecile. In the case of *Francisco Lezcano* (Plate 102), for instance, the awkward position of the deformed legs and short arms with large hands exposes without obvious distortion the details of the dwarf's malformation. In the painting of these portraits, the bold technique and broad brush strokes match the originality of the compositions; a close-up view shows how the artist without any clear definition of form has vividly brought to life the vacant expression or the idiot smile on the face of his sitter (Plate 203).

The way in which Velázquez seems to match his style to his subject is one of the reasons why his works are often difficult to date. The dwarf known as *el Primo* (Plate 103) has a strongly modelled head which stands out in contrast to the summary treatment of the hands and body and the sketchy mountain scene in the background. His pensive expression tells of the administrative function he held,

101 (*Above left*). *The Buffoon called 'Don Juan de Austria'*. *c.* 1635–40. Canvas, 82⅝ × 48⅜ in. (210 × 123 cm.). Madrid, Prado Museum. (L-R 65)
First documented in the Buen Retiro Palace in 1701. The buffoon, nicknamed after the hero of Lepanto (represented in the background), is recorded at court from 1624 to 1654.

102 (*Above*). *The Dwarf Francisco Lezcano*. *c.* 1644. Canvas, 42⅛ × 32⅝ in. (107 × 83 cm.). Madrid, Prado Museum. (L-R 99)
Possibly painted for the Torre de la Parada, where it is first recorded in 1701. Plates 102–5 form a homogeneous series almost certainly painted around 1644 (see Plate 103). Lezcano, also known as the *Niño de Vallecas* and the *enano vizcaino*, entered the service of Prince Baltasar Carlos in 1634.

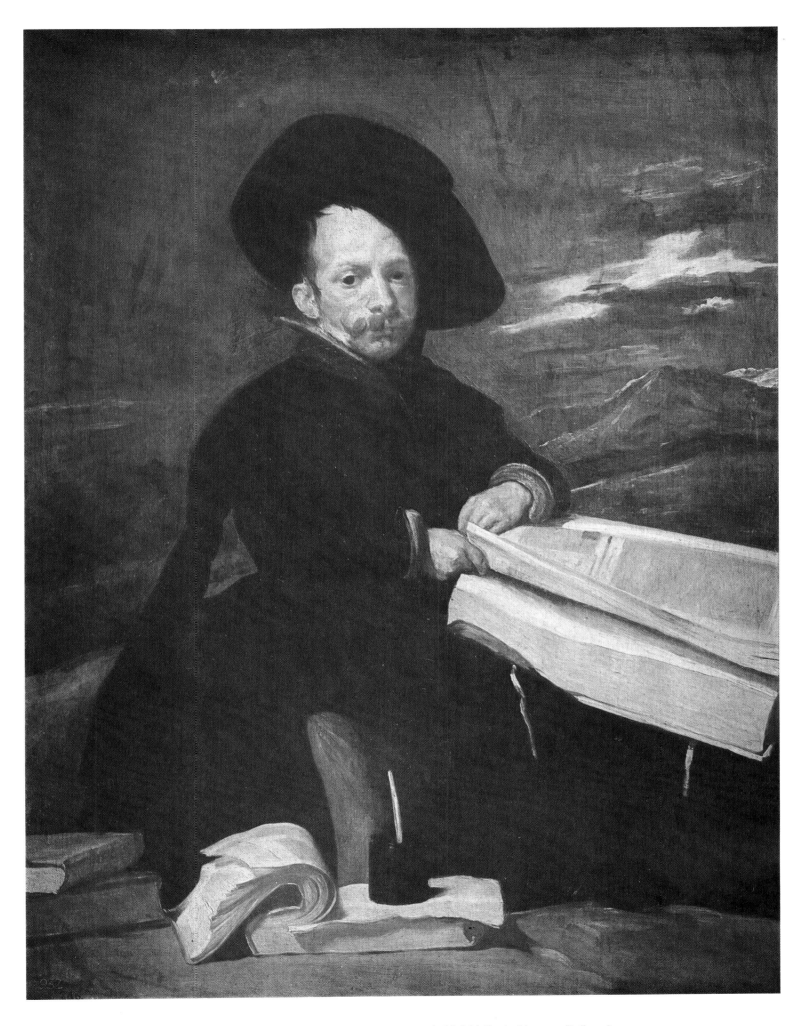

103. *The Dwarf Diego de Acedo, 'El Primo'*. 1644. Canvas, 42⅛ × 32¼ in. (107 × 82 cm.). Madrid, Prado Museum. (L-R 102)
The dwarf is recorded at court from 1635 until his death in 1660. The books and writing materials are references to his office in the court secretariat. The portrait was painted at Fraga in June 1644 at the same time as the portrait of the King (Plate 106). A portrait of 'El Primo' is recorded in the inventory of the Alcázar from 1666 onwards. López-Rey questions the identification of this portrait because a dwarf with an open book (but not named) is recorded in the Torre de la Parada in 1701. Probably the explanation is that there were two versions in the royal collection.

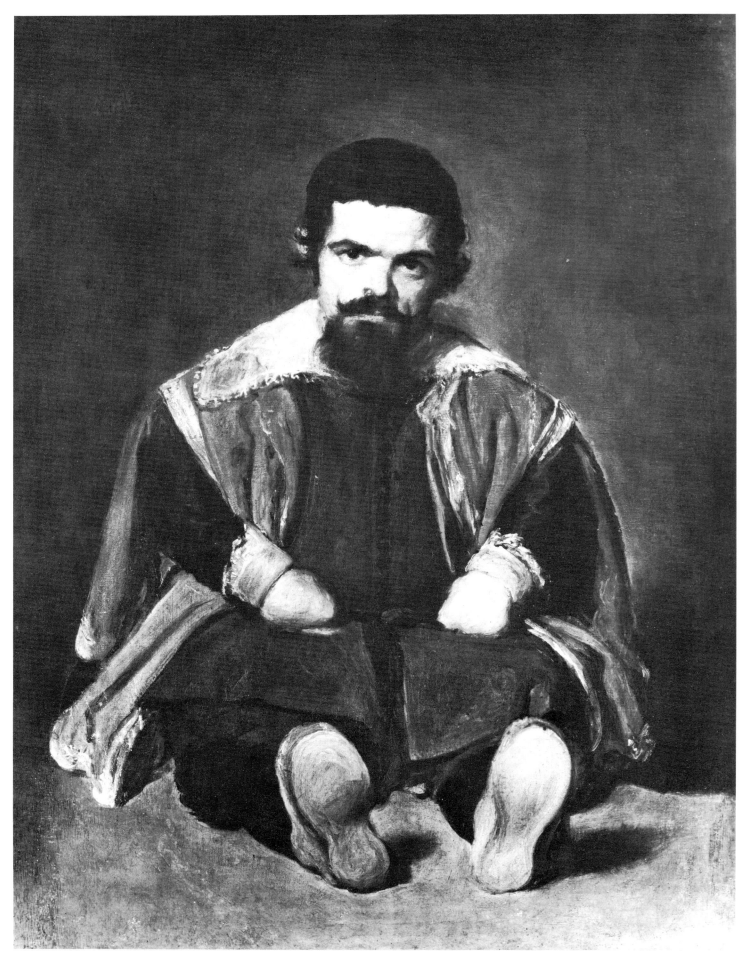

104. *The Dwarf Sebastián de Morra. c.* 1644. Canvas, 41¾ × 32 in. (106 × 81 cm.). Madrid, Prado Museum. (L-R 103)

The dwarf came to Madrid in 1643 from the service of the Cardinal Infante Ferdinand to attend Prince Baltasar Carlos, and died in 1649. The portrait is recorded in the Madrid Alcázar from 1666.

105. *The Buffoon Juan de Calabazas or Calabazillas. c.* 1639. Canvas, 41¾ × 32⅝ in. (106 × 83 cm.). Madrid, Prado Museum. (L-R 83)
The sitter, identified by the gourds ('calabazas') on either side of him, came from the service of the Cardinal Infante Ferdinand to
that of Philip IV in 1632 and died in 1639. Though he was not a dwarf, in pose, style and format the portrait is very close to those
of the three dwarfs (Plates 102–4), but must have been painted a few years earlier, at latest the year of the sitter's death. Probably
one of the four paintings of dwarfs and others in the Torre de la Parada in 1701.

106 (*Left*). *Philip IV at Fraga*. 1644.
Canvas, 53¼ × 38½ in. (135 × 98 cm.). New
York, Frick Collection. (L-R 100)
The portrait, described by Palomino, was
painted at Fraga in June 1644, in three
days, to commemorate the victory of the
Spanish army over the French at Lérida. It
was sent to the Queen in Madrid, where at
the request of the Catalan residents it was
exhibited under a canopy in the church of
San Martín on 10 August, the day the
victory was celebrated. Several copies
were made, one of which is in the
Dulwich Picture Gallery.

107. Anthony Van Dyck (1599–1641). *The
Cardinal Infante Ferdinand*. 1634. Canvas,
42⅛ × 41¾ in. (107 × 106 cm.). Madrid,
Prado Museum.
In taking Velázquez with him to Fraga,
Philip IV evidently had in mind the
practice of his brother, whose victories in
the Netherlands were commemorated by
Rubens and Van Dyck. The portrait of
Ferdinand, dressed in red and gold and
holding a commander's baton, as he
appeared after the Battle of Nördlingen,
was in Spain by 1636, and may have given
Philip the idea for his own portrait by
Velázquez (Plate 106).

which is also indicated by the books and inkwell on the ground in front and the
enormous folio on his knees, that accentuates his smallness. Without the evidence
of documents, there would be no reason to relate this portrait to that of *Philip IV
at Fraga* (Plate 106). In fact, it is recorded that both portraits were painted in June
1644 and were sent back to Madrid within a few weeks of one another. Following
the tradition of his great-grandfather Charles V, who had Titian paint him as he
appeared at the Battle of Mühlberg, and his brother Ferdinand, whose entries and
victories in the Netherlands were recorded by Rubens and Van Dyck, Philip IV
had Velázquez – and the dwarf – accompany him to the battlefield and portray
him in the costume he wore, after the defeat of the French, for his entry into
Lérida. Velázquez's portrait was evidently inspired by Van Dyck's portrait of
Ferdinand (Plate 107), as he appeared for his entry into Brussels after the Battle
of Nördlingen, which was in the Spanish royal collection at the time (by 1636).
The similarity serves to emphasize the difference in style between the two royal
portrait painters: the detailed description of Van Dyck and the more summary
treatment of Velázquez, which so eloquently portrays the King's dignified bear-
ing as a general. Compared with the more solid structure of the dwarf's, the head
is softly modelled, without shadows. The costume, partly concealed by the enor-
mous hat, is freely painted to give an impression, without detail, of the richness
and glamour of the red and silver field dress that the King wore on this occasion.

108. *The Lady with a Fan*. 1638–9 Canvas,
37¼ × 27½ in. (94.6 × 69.8 cm.). London,
Wallace Collection. (L-R 79)
Nothing is known of the early history of
the portrait, one of Velázquez's most
beautiful paintings, and attempts to
identify the sitter of one of the very few
he made of women outside the royal
family have failed. From her costume, the
kid gloves, fan, garnet necklace and long
gold rosary with silver pendant, she was
obviously a lady of quality. The
suggestion that it was painted shortly
before the royal decree published in April
1639 proscribing, among other details of
dress, the low-necked bodice, except in
the case of licensed whores, can be
supported on stylistic grounds. Compare,
for instance, the portrait of the *Duke of
Modena* (Plate 96).

The unknown and unrecorded *Lady with a Fan* (Plate 108) dates from a few
years before the Fraga portraits, about 1638–9. Here, the painting of the head is
different from that of the King or the dwarf, softer and more delicate in the
rendering of detail, a style that sensitively portrays the personal charm of the
sitter. At the same time, the accessories, the white glove, transparent white cuff,
the gold rosary and blue bow are painted with a freedom that recalls the story told
by his friend Jusepe Martínez about a portrait Velázquez painted of a lady in
Saragossa. In order not to tire the sitter, the artist after painting the head finished
the portrait without her. When she saw the painting she refused to accept it,
complaining that the collar she wore when she sat for the artist was of fine Flemish
lace. Presumably, Velázquez had sought to create an impression of the lace
without representing the details of its design. Earlier, the poet Quevedo had
admired this very aspect of the artist's style, praising the 'distant blobs of colour'
with which, he said, the great Velázquez had achieved truth rather than likeness,
a form of praise that was to prove more and more appropriate with the passage
of time.

6 Madrid, 1631-1649: Subject Pictures

Work on the building of the Buen Retiro Palace was already in progress before the end of 1631. Velázquez no doubt knew of the project while he was still in Italy, and was on the look-out for works of art and talent for his royal master as well as competing with artists in Rome in painting large figure compositions. Whether or not he had the new palace in mind at the time, several paintings by other hands that he brought back from Italy were purchased by the King for the Buen Retiro when it was nearing completion, as well as his own *Apollo in the Forge of Vulcan*

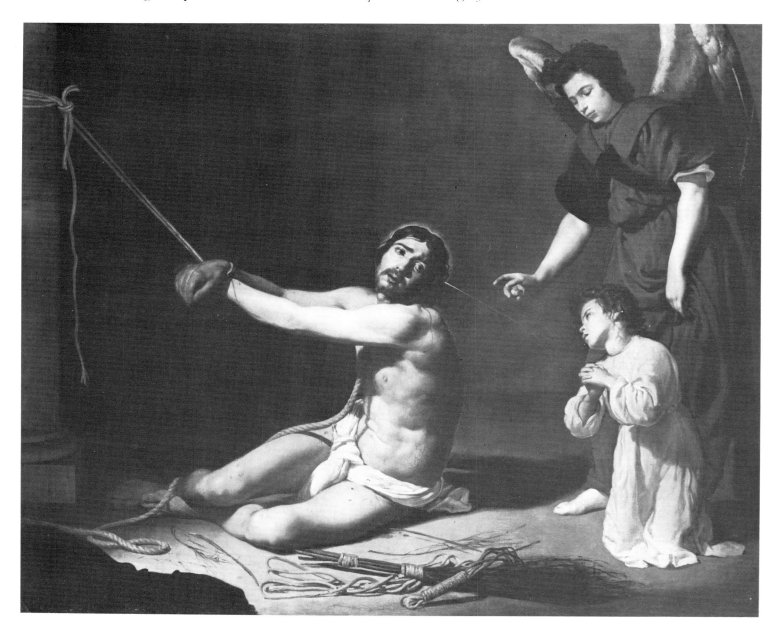

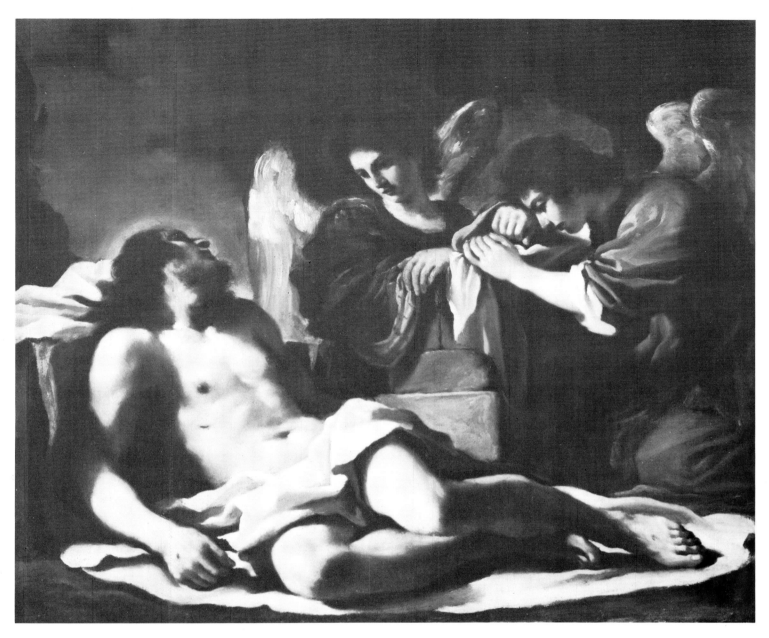

110 (*Above*). Giovanni Francesco Barbieri, called Guercino (1591–1666). *Angels Weeping over the Dead Christ. c.* 1618. Copper, 14½ × 17½ in. (36.8 × 44.4 cm.). London, National Gallery.
Velázquez, on his visit to Cento in 1629, 'where he spent a short but very enjoyable time' (Pacheco), would have seen examples of Guercino's early works, such as this. He evidently admired them and recalled them in, for example, Plate 109.

109 (*Left*). *Christ and the Christian Soul. c.* 1631–2. Canvas, 65 × 81¼ in. (165 × 206 cm.). London, National Gallery. (L-R 35)
The subject of Christ after the flagellation contemplated by the Christian soul in the form of a child, accompanied by a guardian angel is unusual. Velázquez's rendering of the mystical theme is characteristically naturalistic. In style it seems to be influenced by his Italian visit and datable after his return. The history of the painting is not known.

(Plate 71) and *Joseph's Blood-stained Coat Brought to Jacob* (Plate 72). The latter was later moved to the more suitable setting of the Escorial.

It was probably due to the success of these two canvases that the career of the King of Spain's portrait painter was now interrupted more frequently than before by commissions for religious, mythological and other subjects. Their relative scarcity, however, their independence of one another and the fact that – as usual – hardly one of them is documented, makes them more difficult to place in Velázquez's oeuvre than the portraits.

Neither the *Christ and the Christian Soul* (Plate 109) nor the *Christ on the Cross* (Plate 113) has an early history. They have sometimes been dated before Velázquez's visit to Italy, but since it was there that he became seriously occupied with the study of anatomy and of the male nude, they are more likely to have been painted shortly after his return. The body of Christ in both paintings is in a manner closer to that of the blacksmiths and Joseph's brother than to that of *Bacchus* (Plate 64), the only earlier example of a nude. Indeed, more than any of Velázquez's portraits, they reflect the influence of his Italian studies. Because of the Italianate Christ in *Christ and the Christian Soul*, it has been suggested that it was painted in Italy: the head has been compared with the work of Guido Reni, and the style in general is evidence of his visit to Guercino at Cento (cf. Plate 110). Against this is the 'Spanish' character of the two other figures and the unusual

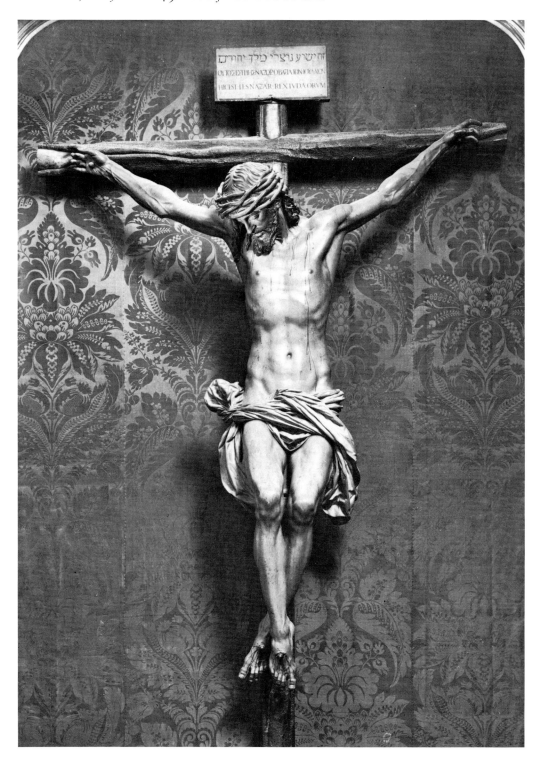

111 (*Left*). Juan Martínez Montañés (1568–1649). *Christ on the Cross* (the 'Christ of Clemency'). 1603. Polychromed wood, painted by Francisco Pacheco. Seville Cathedral.
Montañés conforms to Pacheco's rules for the Crucifixion with four nails, though unlike Velázquez he has crossed the feet. The sculpture was commissioned by a canon of the Cathedral.

112 (*Below*). Domenico Guidi (1625–1701). *Christ on the Cross*. c. 1659. Bronze, height 49¼ in. (125 cm.). El Escorial, altar of the Pantheon of the Kings.
Probably begun by Guidi's uncle Giuliano Finelli (with whom Velázquez was in touch in Rome in 1650) and finished after his death (1657). Palomino attributes it to a nephew of Finelli, and says Velázquez was ordered to take it to the Escorial and place it where it is today.

subject-matter, which has a mystical significance that seems to be peculiar to Spain. The *Christ on the Cross* has a similar Spanish flavour. Here Velázquez has followed the precept of his former master, Pacheco, as to the number of nails with which Christ was crucified. The painting has also been related to the mystical theme represented some years before by the Sevillian Juan Martínez Montañés in a sculpture that, according to the contract of 1603, was to show 'Christ alive before His expiry with head inclined, looking at the person praying at His feet as if to say it is for him that He suffers thus' – the so-called *Christ of Clemency* (Plate 111), which Velázquez would have known in Seville Cathedral. Many years later it was probably through the influence of Velázquez that the Italian sculptor Domenico Guidi adopted a similar attitude for the figure of his bronze *Christ on*

113. *Christ on the Cross*. c. 1631–2. Canvas, 97⅝ × 66½ in. (248 × 169 cm.). Madrid, Prado Museum. (L-R 59)
First mentioned by Palomino, in the Benedictine Convent of San Plácido. Palomino notes that Velázquez followed the precept of his master Pacheco in representing Christ crucified with four nails instead of three. Pacheco is said to have been the first authority in Spain to revive the tradition.

the Cross executed for the Escorial (Plate 112). Though the style is later, the religiosity of Velázquez's crucified Christ, the placing of the figure so as to bring the spectator close to the subject of his devotion, is in the tradition of his early religious works, a tradition that still flourished in the School of Seville. The painting is first recorded in the eighteenth century in a Madrid convent where, according to legend, it had been placed by Philip IV as one of his many acts of expiation for his sins.

The two devotional subjects that have more serious claim to being royal rather than ecclesiastical commissions are very different in character, and seem to owe little to Velázquez's early training as a religious artist in Seville. The *Saint Anthony Abbot and Saint Paul the Hermit* (Plate 115), with small-scale figures set in a large landscape, is more or less unique in Velázquez's oeuvre. The various dates put forward for its painting range from the early 1630s to the late 1650s. It was fairly certainly painted for the altar of an oratory in one of the hermitages in the grounds of the Buen Retiro Palace, where in fact it is first recorded in 1701. It is therefore reasonable to suppose that it was painted in the 1630s, at the time when Philip IV was acquiring similar subjects of hermit saints and anchorites from Italy, from the two leading landscape painters in Rome, Claude and Poussin (Plate 114), among others. If, as seems likely, it was painted as an altarpiece for the Hermitage of Saint Paul, where it was in Palomino's time, there is evidence to suggest that it may have been painted as early as 1633, before Velázquez had completed the series of equestrian portraits with landscape backgrounds for the *Salón de Reinos* in the same palace. Because Velázquez had followed an earlier tradition in representing various scenes from the legend of Saint Anthony and Saint Paul, it is possible that

115 (*Right*). *Saint Anthony Abbot and Saint Paul the Hermit. c.* 1633. Canvas, 101⅛ × 74 in. (257 × 188 cm.) (formerly framed with semi-circular top). Madrid, Prado Museum. (L-R 116)
Recorded in the inventory of the Buen Retiro Palace, 1701, in the hermitage of Saint Anthony. Palomino, however, describes it in the oratory of the hermitage of Saint Paul (Plate 118), for which it was most probably painted.

114. Nicolas Poussin (1594–1665). *Landscape with Saint Jerome. c.* 1637–8. Canvas, 61¼ × 92⅛ in. (155 × 234 cm.). Madrid, Prado Museum.
Painted for the decoration of the Buen Retiro Palace, this was among the many examples commissioned from Poussin, Claude and other artists working in Rome for one of the largest series of landscape paintings ever to be assembled. First recorded in the 1701 inventory of the Buen Retiro as by '*el italiano*', like many others of the series.

116. Detail of Plate 115.
The landscape background is one of the rare examples of a detailed landscape setting – more detailed than those of the royal equestrian portraits and royal huntsmen.

117. *The Coronation of the Virgin by the Trinity. c.* 1640. Canvas, 69¼ × 52¾ in. (176 × 134 cm.). Madrid, Prado Museum. (L-R 105)
Formerly in the oratory of the Queen's apartment in the royal palace, according to Palomino, who is the first to mention it. The
Queen's apartments are not included in the 17th-century inventories. Although his chronology is not reliable, Palomino's mention
of the painting before Velázquez's second visit to Italy supports the view that it was for the oratory of Philip's first wife Isabel that
it was painted, and must therefore be dated before her death in 1644. The composition is closely dependent on a painting by
Rubens which Velázquez could have known through the engraving by Pontius (Plate 119).

VEVE DE LHERMITAGE DE SAINCT PAVL DANS LE RETIR DE MADRID *Vista de la Hermita de San Pablo que esta en el buen retiro de Madrid*

he used an earlier model. It has also been suggested that the landscape setting is taken from paintings or engravings. The mountain view in the background, however, appears to be a view of the Guadarrama, with which the artist was familiar and which he represented in his equestrian portraits and portraits of royal huntsmen. The high rocks in the middle ground are very like the rocks that are a feature of the landscape of the Escorial, which Rubens had recorded in a drawing, now known only from a painted copy, where he also sketched the hermit living there at the time (Plate 11). The setting of the two saints is clearly contrived – the tree in the foreground was a device that Velázquez often used in portraits as a foil to his sitter or to establish his position – but also reflects a concern for natural forms, for effects of distance and lighting. Velázquez was later to bring this concern to perfection in his only two independent landscapes, the little views of the Villa Medici gardens (Plates 143, 144).

The *Coronation of the Virgin by the Trinity* (Plate 117), one of the rare subjects by Velázquez that required a setting in heaven rather than on earth, is also one of the few instances where he undoubtedly used a composition by Rubens, which he probably knew from the engraving by Pontius (Plate 119). Though it is not documented, there is no reason to doubt that Velázquez's painting was made for the Queen's oratory in the Alcázar, where Palomino says it hung, and the Queen for whose worship it was designed was almost certainly Philip IV's first and dearly beloved wife, Isabel of Bourbon, who died in 1644. Velázquez has adapted his source in a characteristic way. The three figures are firmly seated as if on chairs and sit still; the Virgin, with her solemn dignified air, might have been based on a living model and her clothing copied from real draperies. In some respects, Velázquez's treatment of the subject is less orthodox than that of Rubens. While he appears to have followed the precept of Pacheco that the Virgin, since she suffered no illness or accident to mar her beauty, should be portrayed at the moment of her Assumption as no more than 30 years old, he has disregarded Pacheco by representing the first Person of the Trinity nearly bald-headed, and he has further departed from tradition in fully clothing the figure of Christ, who usually appears in this scene half-robed, showing His wounds. The crown of flowers is also unconventional, as is the position of the Virgin's hands, normally crossed on her breast or clasped in prayer. Perhaps her outstretched hand is to be interpreted as a gesture of the protection she is offering to her royal suppliant.

118. *The Hermitage of Saint Paul, Buen Retiro Gardens*. Etching by Louis Meunier, *c.* 1665.
This was the first hermitage to be built, finished in 1633. Like other hermitages in the gardens, there was a secular part, which was decorated, according to Palomino, by Colonna and Mitelli, including probably the façade. It was in an oratory of this hermitage that he saw Velázquez's altarpiece (Plate 115).

119. Paulus Pontius (1603–58). *The Coronation of the Virgin by the Trinity*. Engraving after the painting by Rubens (1626, Brussels, Musées Royaux), followed quite closely in Velázquez's painting (Plate 117).

The three figures, enveloped in voluminous and colourful robes, create an effect of splendour that is rare in Velázquez's work, but which is specially fitting to a painting of the Coronation of the Queen of Heaven that was to decorate the altar of the oratory of Her Most Catholic Majesty.

Before he went to Italy, Velázquez had already distinguished himself as a history painter with the *Expulsion of the Moriscos*, and his ability to compose large figure subjects must have been confirmed by the two paintings he brought back from Rome. It may therefore seem somewhat surprising that he contributed only one of the 12 military victories painted to hang in the *Salón de Reinos* in the Buen Retiro, while Carducho, one of the artists whom he had previously vanquished with his *Expulsion of the Moriscos*, contributed three. Velázquez was undoubtedly more fully occupied than his fellow painters with the decoration of the *Salón*, with his equestrian portraits that hung in the same room, and with other royal works. Whatever the role played by Velázquez in planning the decoration, it must in some ways have been governed by the architecture of the *Salón* (now the Army Museum, one of two portions of the Buen Retiro Palace still standing). The windows and balconies on the long walls allowed for 12 large history paintings but only 10 Labours of Hercules, while the only large area available, the ceiling, lent itself to decoration with the arms of the Kingdoms of Spain, which gave the

120. *The Salón de Reinos, Buen Retiro Palace.* Reconstruction by Philip Troutman of the wall decorations: the history paintings, including Velázquez's *Breda*, between the windows, Zurbarán's *Labours of Hercules* above them, Velázquez's equestrian portraits of the reigning monarchs and the heir to the throne beside and above the door. The equestrian portraits of Philip III and his Queen flanked the throne on the opposite wall.

room its name 'Salón de Reinos (Plate 120). As for the choice of subjects illustrating Spain's successes in the Thirty Years War, this was partly dependent on events, three of them occurring in 1633 while the work was still in progress. The battle of Nördlingen (September 1634) happened too late to be included, according to the Florentine Ambassador in Madrid in a despatch dated 28 April 1635, whose account of the treasures of the new palace describes the subjects of the paintings in the Salón but not the artists. It fell to Rubens to commemorate the victory of Nördlingen in one of the paintings for a triumphal arch erected for the entry of the Cardinal Infante Ferdinand in Antwerp in April 1635 (Plate 121).

Velázquez's contribution to the series of Spanish triumphs records one of the earliest and and also one of the most famous military successes of Philip IV's reign, the *Surrender of Breda* (Plate 122). On 2 June 1625, Breda, the bulwark of the Orange party in Flanders, surrendered to the Spanish army led by the Genoese general, Ambrogio Spinola. In view of his valiant defence, the governor, Justin of Nassau, was allowed to march out with all his men, armed, with flags flying and drums beating, 'as became a famous foe'. For his view of the besieged city in the background, Velázquez no doubt used the engraving made by Jacques Callot after visiting the place. The central scene, however, with the surrender of the keys, is not recorded in the history of the siege, but it is represented in the last scene in the play by Calderón written soon after the event.

The figures of the two great commanders, united by the sympathetic gesture of Spinola, implying that 'in the courage of the vanquished lies the fame of the victor' (Calderón), represent one of the most human expressions of feeling in Velázquez's art. Velázquez had met Spinola on the journey to Genoa in 1629, but it seems that for this portrait, made after his death in 1630, the artist drew not on any sketches he himself may have made – no such sketches have ever been known – but on the portrait painted by Rubens in Antwerp in 1625 after the victory at Breda, a portrait known in several versions and also engraved (Plate 123). Veláz-

121. Peter Paul Rubens (1577–1640). *The Meeting of Ferdinand King of Hungary and the Cardinal Infante Ferdinand at Nördlingen.* 1634–5. Canvas, 129⅛ × 152¾ in. (328 × 388 cm.). Vienna, Kunsthistorisches Museum.
Rubens painted the meeting of the two Ferdinands before the Battle of Nördlingen (September 1634) for the decoration of one of the arches celebrating the Cardinal Infante's entry in Antwerp in 1635. Their gestures of friendship are not very different from those of victor and vanquished at Breda.

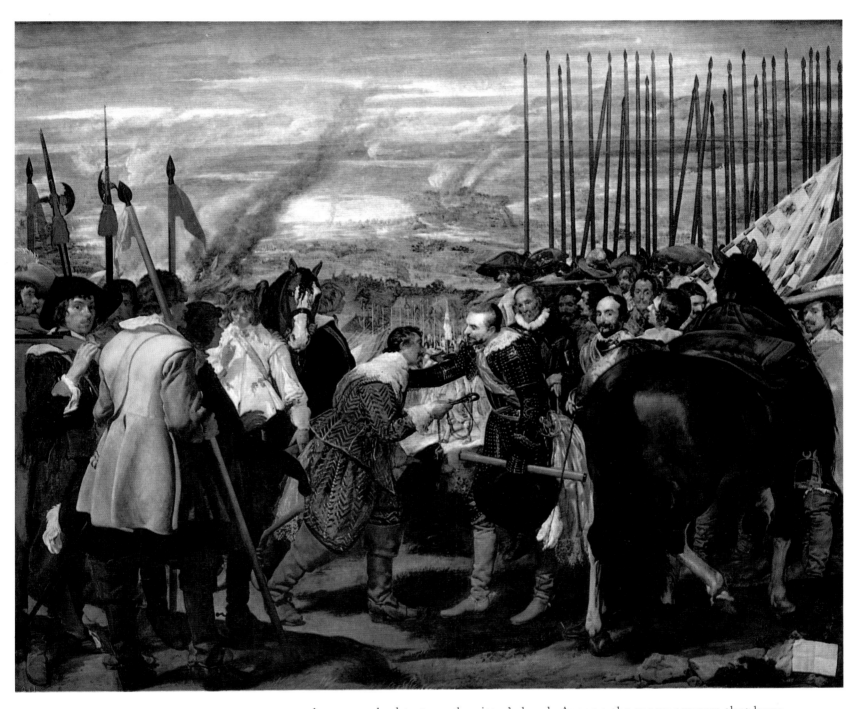

122. *The Surrender of Breda.* 1634–5.
121 × 144½ in. (307 × 367 cm.). Madrid,
Prado Museum. (L-R 73)
The only history painting in Velázquez's
surviving oeuvre, popularly known as *Las
Lanzas* because of the row of lances on the
victors' side. Like the lost *Expulsion of the
Moriscos*, it was painted many years after
the event it records. The surrender of
Breda in June 1625 was one of the major
Spanish victories in the Thirty Years War.
Velázquez's painting was made for the
Salón de Reinos in the Buen Retiro Palace,
and exhibited there in April 1635. Two
years later Breda was recaptured by the
Dutch.

quez, however, had to turn the sitter's head. Among the many sources that have
been proposed for the composition of the *Surrender of Breda* is Rubens's *Meeting
of Ferdinand King of Hungary and the Cardinal Infante at Nördlingen* (Plate 121). But
Rubens's painting cannot have been earlier than Velázquez's, and the similarity
of pose between his group of victor and vanquished and Rubens's is either
fortuitous or due to a common source. For the rest, the difference between the
two great artists as history painters is more striking than any resemblance. While
Rubens adopted the time-honoured device of myth and allegory to embellish and
glorify victor and victory, Velázquez and his colleagues in the *Salón de Reinos*
sought to reconstruct and record historical events, giving prominence to acts of
surrender and peace-making, with the battle scenes for the most part relegated to
the background. Juan Bautista Maino alone introduced allegorical figures in his
Recapture of Bahía de San Salvador (Plate 124), where they appear, however, in the
tapestry in the background.

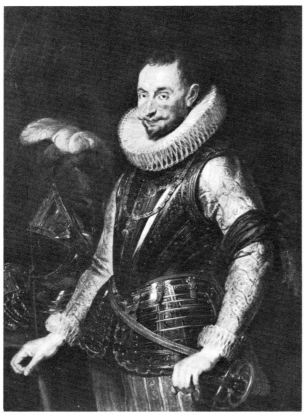

123. Peter Paul Rubens (1577–1640). *The Marquis Ambrogio Spinola. c.* 1627. Panel, 46 × 33½ in. (117 × 85 cm.). Brunswick, Herzog Anton Ulrich-Museum.
Rubens painted his friend and patron 'from life' in 1627 and at other times. He admired him for being 'worthy and wise', though 'not very communicative' and with 'no taste for painting, and understands no more about it than a street-porter' (Magurn, p. 234).

125 (*Right*). Detail of Plate 122. Although the Dutch General, Justin of Nassau, and the Spanish Commander, Ambrogio Spinola, had both died before Velázquez painted the scene, Velázquez has portrayed the handing over of the keys as if he had been a compassionate witness, and created on the face of Spinola an expression that matches his sympathetic gesture. Yet he probably had to base his likeness of Spinola on a version of a portrait by Rubens (cf. Plate 123). The handing over of the keys is not mentioned in the history of the siege and Velázquez probably based the scene on Calderón's play written soon after the event.

What distinguishes Velázquez's *Breda* from the other paintings of the series, and also from Rubens's histories even of contemporary events, is the way in which the historical scene is transformed by the art of the portrait painter. Executed long after the event it records, even after the hero had suffered humiliation and death, at most only some minor characters can have been painted from life. Yet it is notable how Velázquez has re-created the scene, as if he had been there, and how he has given the central figures the appearance of living likeness.

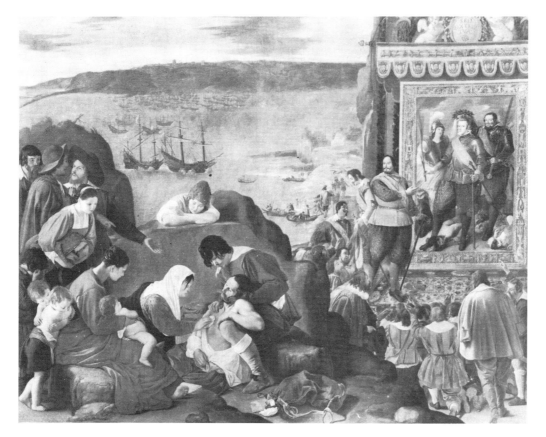

124. Juan Bautista Maino (1578–1641). *The Recapture of Bahía de San Salvador.* 1634–5. Canvas, 121⅝ × 150 in. (309 × 381 cm.). Madrid, Prado Museum. Painted for the *Salón de Reinos*, Buen Retiro Palace. The recapture of the Brazilian port and city from the Dutch took place on 1 May 1625, the feast of Saint Philip. Maino, one of the judges who had awarded Velázquez the prize for his *Expulsion of the Moriscos*, has, like Velázquez, represented the aftermath of the battle. Like Velázquez, too, he has taken his scene of surrender – the defeated foe kneeling before a portrait of the King – from a literary source, Lope de Vega's *El Brasil restituido*, which he presents in the form of a tapestry of allegorical composition.

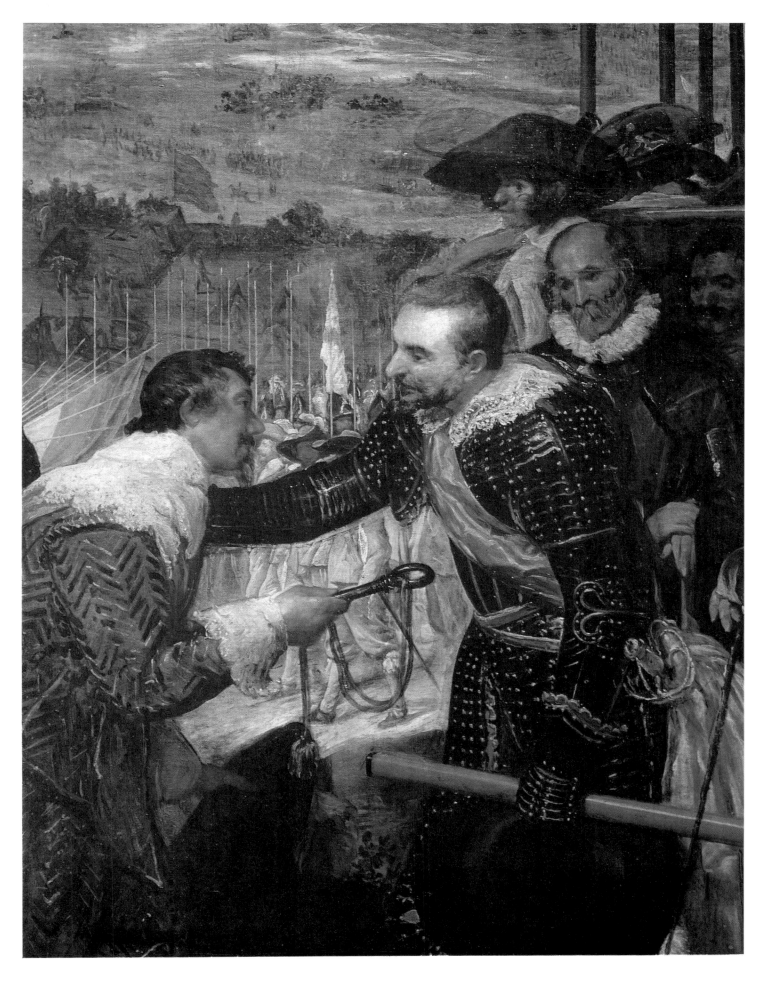

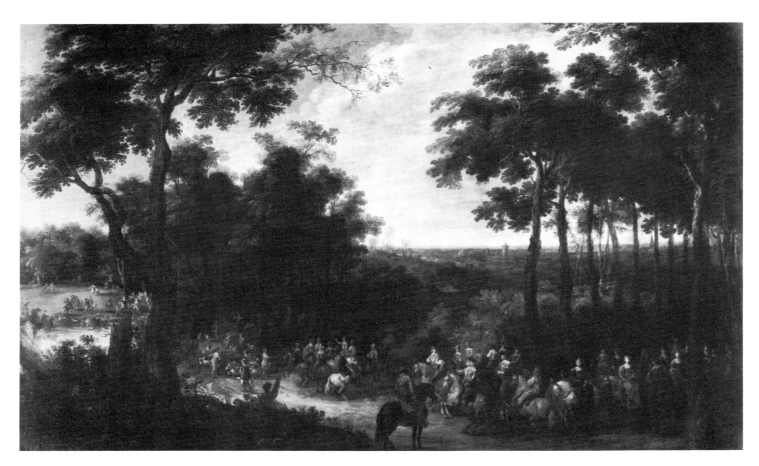

There is, too, a courtly elegance in the attitude of conqueror to conquered that anticipates the attitude of the Infanta in *Las Meninas*, painted some 20 years later. Not long after the painting was completed, in October 1637, Breda fell again after another notable siege, this time to the Swedish army, the Cardinal Infante having failed to relieve the city, and many other victories on the walls of the *Salón* were soon to be turned into defeat.

The military theme of the decorations of the great hall in the Buen Retiro was replaced in the main room of the Torre de la Parada by illustrations of the more peaceful pursuit of hunting, more appropriate to the country retreat and a traditional favourite sport of Spanish kings. The walls of other rooms were covered with mythological scenes by Rubens and his School. Velázquez himself painted a royal boar hunt to hang with his portraits of the King, his brother and his son in hunting costume. Similar subjects were commissioned by the Cardinal Infante Ferdinand from Flemish artists, for which detailed instructions were sent from Madrid, to ensure their accuracy. Among the surviving large canvases painted for the Torre in Antwerp by Peeter Snayers are a *Court Hunt* (Plate 126) and several scenes of specific incidents which were evidently based on illustrations in a hunting manual. Velázquez would also have known this manual (Plate 128), but his painting of *Philip IV Hunting Wild Boar* (Plate 127) is an accurate view of this particular form of hunt, based largely on observation. The poor and uneven condition of the painting today makes it difficult to judge its original quality. The subject and composition, however, are notable and make it unique in Velázquez's surviving oeuvre: a combination of landscape, genre and narrative, with the protagonists seen at a distance and on a tiny scale. In style, the painting that perhaps comes closest to the *Boar Hunt* is the portrait of *Prince Baltasar Carlos in the Riding School* (Plate 91). The narrative character of *Philip IV Hunting Wild Boar* recalls the secondary scene behind the equestrian group in the

126. Peeter Snayers (1592–*post* 1667). *A Court Hunt*. Signed. *c.* 1638. Canvas, 76¾ × 118⅞ in. (195 × 302 cm.). Madrid, Prado Museum.
Among the figures on the right setting off for the hunt is that of the Cardinal Infante Ferdinand.

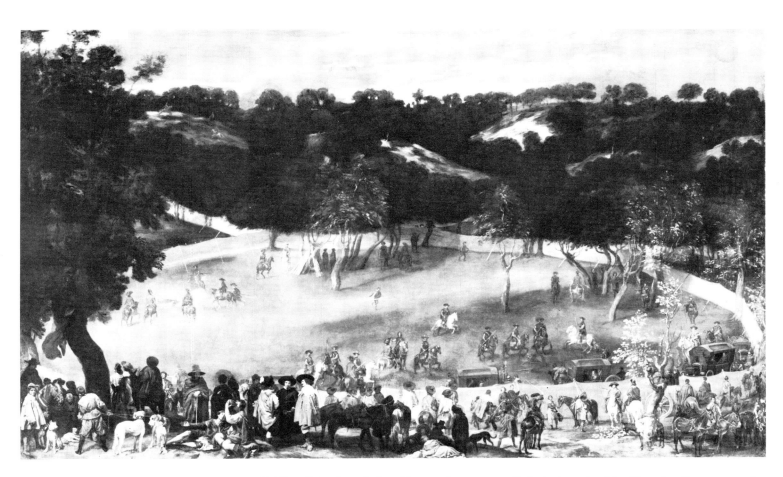

127. *Philip IV Hunting Wild Boar.*
c. 1635–7. Canvas, *c.* 71⅝ × 118⅞ in.
(*c.* 182 × 302 cm.). London, National
Gallery.
Almost certainly painted for the Torre de
la Parada and first recorded there, 1701,
under the title *Tela Real* (royal enclosure).
Velázquez gives an accurate picture of the
peculiar kind of hunt practised by the
Spanish King, and it is possible that he
has depicted an actual hunt. Philip IV and
Olivares are recognizable, and so,
possibly, are Juan Mateos, Master of the
Hunt, and Queen Isabel (in a carriage).
Though the authorship has been
questioned, owing probably to the uneven
state of preservation, the invention and
much of the execution are undoubtedly
the Master's.

Riding School, and the distant figures are lightly brushed in like the figures on the balcony, yet in both cases the King and Queen are recognizable despite their tiny scale. If, as seems likely, the *Boar Hunt* was painted for the Torre, it is to be dated about 1636–8, a little after the *Riding School*. Several copies testify to the popularity of Velázquez's composition; a version of the same dimensions hung in the Alcázar.

Since the earliest inventory of the paintings in the Torre de la Parada dates only from 1701, there is no certainty about the paintings made specially for it by

128. *A Boar Hunt.* Illustration to Juan
Mateos, *Origen y Dignidad de la Caça,* 1634,
showing the canvas enclosure (*tela real*)
and forked sticks used in the kind of hunt
painted by Velázquez. The author appears
in Plate 90.

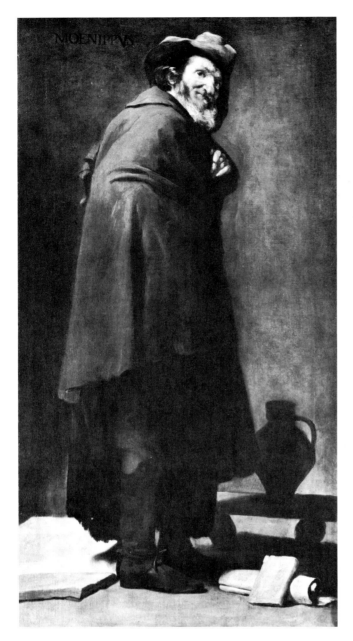 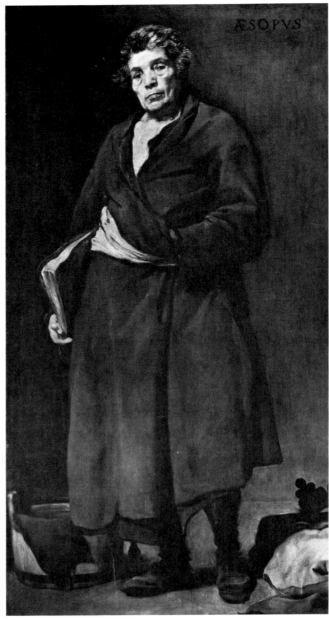

Velázquez. No record is extant of any commissions or payments such as we have for the paintings from Rubens's studio. While it can be assumed that the royal huntsman and the royal hunt were painted for the Torre, the portraits of dwarfs are less obviously suitable subjects. There is, however, a better case for believing that the three classical subjects by Velázquez in the Torre in 1701 were among the original decorations, which included two portrayals of classical philosophers by Rubens: *Democritus* and *Heraclitus*. It is true that Velázquez's two 'philosophers', *Aesop* and *Menippus* (Plates 129, 130), are less familiar subjects in painting, and but for the inscriptions they might prove difficult to identify, despite the prominence of their still-life attributes. In character they probably owe less to Rubens than to Ribera, whose many versions of ragged philosophers and beggars (Plate 131) Velázquez would have known in the royal collection as well as in Naples. In style they are close to the portraits of dwarfs that may have hung in the Torre with them. The date of the Flemish paintings for the Torre, 1636–8, or a year or two later, would fit them well.

The third classical subject, *Mars* (Plate 132), the god of war, seated at rest, is an obviously appropriate subject for the Torre, where the King was to lay aside

129 (*Above left*). *Menippus*. Inscribed MOENIPPVS. *c.* 1636–40. Canvas, 70½ × 37 in. (179 × 94 cm.). Madrid, Prado Museum. (L-R 93)
Probably painted for the Torre de la Parada, where it is first recorded (together with Plates 130 and 132) in 1701. A pendant to the *Aesop*, but the choice of this cynic philosopher for the decoration of the Torre is hard to explain. Like the dwarfs and buffoons, these figures appear to be portraits of living models. The figure appears as a spectator in Mazo's *Hunt* (Prado).

130 (*Above*). *Aesop*. Inscribed AESOPVS. *c.* 1636–40. Canvas, 70½ × 37 in. (179 × 94 cm.). Madrid, Prado Museum. (L-R 92)
A pendant to the *Menippus* (Plate 129), the presence of Aesop in the Torre, where there were many paintings illustrating his fables, is easier to explain.

131 (*Below*). Jusepe de Ribera (1591–1652). *The Club-footed Boy*. Signed and dated 1642. Canvas, 64⅝ × 36¼ in. (164 × 92 cm.). Paris, Louvre.

Ribera's beggars and beggar philosophers, popular as types rather than individuals, appear to have been painted from models. The deformed boy is obviously a portrait, like Velázquez's dwarfs, but in sentiment it is very different, with the appeal to charity through the inscription pleading for 'alms for the love of God'.

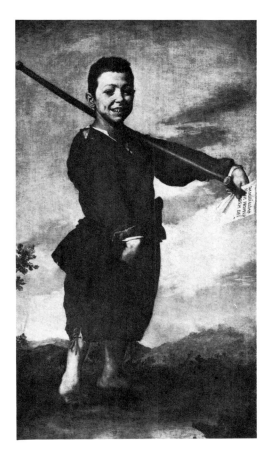

132. *Mars at Rest*. *c*. 1636–40. Canvas, 70½ × 37⅜ in. (179 × 95 cm.). Madrid, Prado Museum. (L-R 94)

The same dimensions as the *Menippus* and *Aesop* and recorded with them in the Torre in 1701, the image of Mars at rest is more eminently suited to decorate a hunting lodge. The moustache is a common attribute of military valour in literature and art, not, as has been suggested, a sign of ridicule.

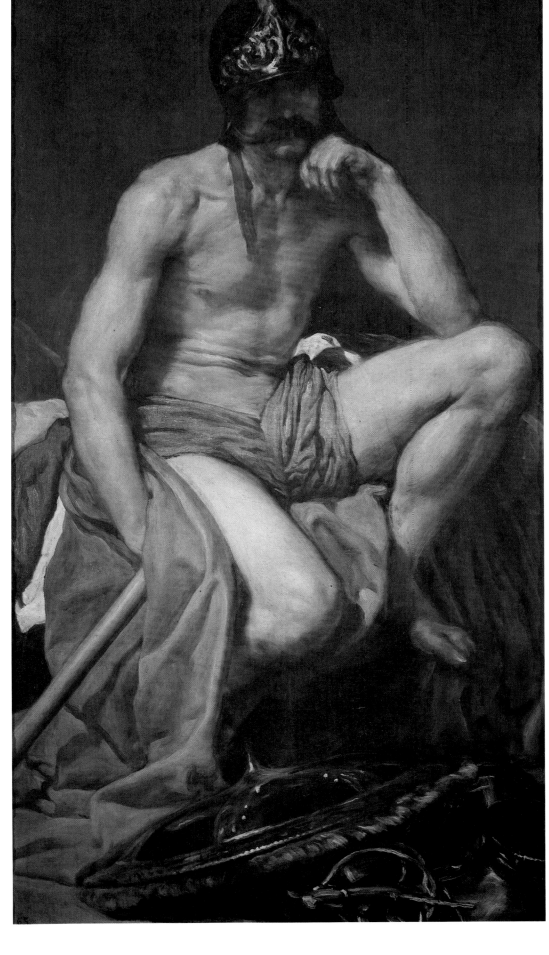

the art of war in the enjoyment of the hunt. The seated figure in melancholy pose is a grandiose variant of the seated dwarfs, while the thick and flowing draperies that partly cover and set off his nakedness are as rich in colour and texture as the draperies in the *Coronation of the Virgin* (Plate 117). It has been suggested that this unusual portrayal of the god of war reflects the serious reverses suffered by the Spanish armies at the time when it was probably painted – in the late 1630s or early 1640s. But since it was made for a royal residence it is unlikely that it was meant to allude, even indirectly, to military disasters. By those critics who take the view that Velázquez parodied the pagan gods, it has been described as burlesque and compared to Quevedo's reference to Don Quixote as the celestial Mars. The moustache in particular has been taken as a sign of ridicule. Yet it is by no means unique in seventeenth-century portrayals of Mars and is even a common attribute of military valour (cf. Plate 133). Furthermore, Velázquez, as we know from his biographer and his library, was educated in a tradition that respected rather than denigrated the ancient world, and was trained, moreover, as a naturalist painter. Is there any reason, then, to doubt that his Mars, like his Bacchus, is other than a portrayal of the god in a human body? The figure can also be said to illustrate Velázquez's admiration for antiquity. The pose and quiet attitude of his resting Mars must have been based on the memory or possibly on drawings and engravings, not only of Michelangelo's *Lorenzo de' Medici* in Florence (Plate 135), but also of the famous antique statue of the seated Mars which he had known in the Ludovisi collection in Rome (Plate 134) and which was one of the antiques of which he was to order casts when he returned to Italy.

133. Hendrick Terbrugghen (1588–1629). *Mars at Rest*. Signed and dated 1629. Panel, 41⅞ × 36⅝ in. (106.5 × 93 cm.). Utrecht, Centraal Museum. Terbrugghen, like Velázquez, portrayed the god of war at rest, the picture's frame carved with symbols of war. His moustache, too, belongs to the image of a military figure.

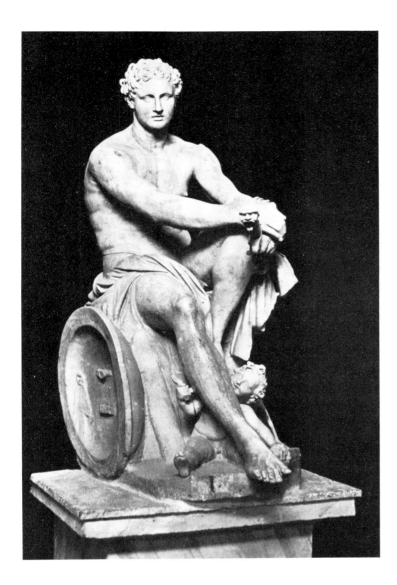

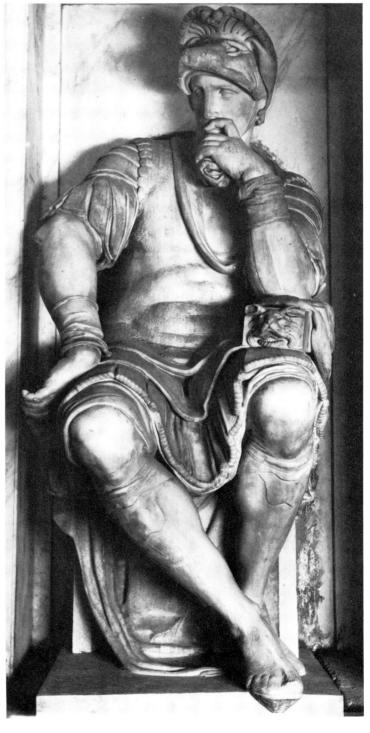

135. Michelangelo Buonarroti
(1475–1564). *Lorenzo de' Medici*. 1521–34.
Marble, 70⅛ × 25¾ × 28¾ in.
(178⅛ × 65.4 × 73 cm.). Florence, San
Lorenzo, Medici Chapel.
The melancholy pose of Michelangelo's
tomb figure was probably reflected in
Velázquez's Mars, although he probably
knew it only in an engraving. The only
mention of Michelangelo's sculpture in
Palomino's biography is of his *Moses*, of
which he says Velázquez ordered a cast.

134. *Seated Mars*. Antique marble. Height,
61⅜ in. (156 cm.). Rome, Museo delle
Terme.
Velázquez could have seen the statue
during his first visit to Rome, when it was
already in the Ludovisi collection. Prince
Ludovisi was one of the Romans who
were very friendly to him on his second
visit to Italy when he ordered a cast of the
Mars (Palomino calls it a Gladiator).

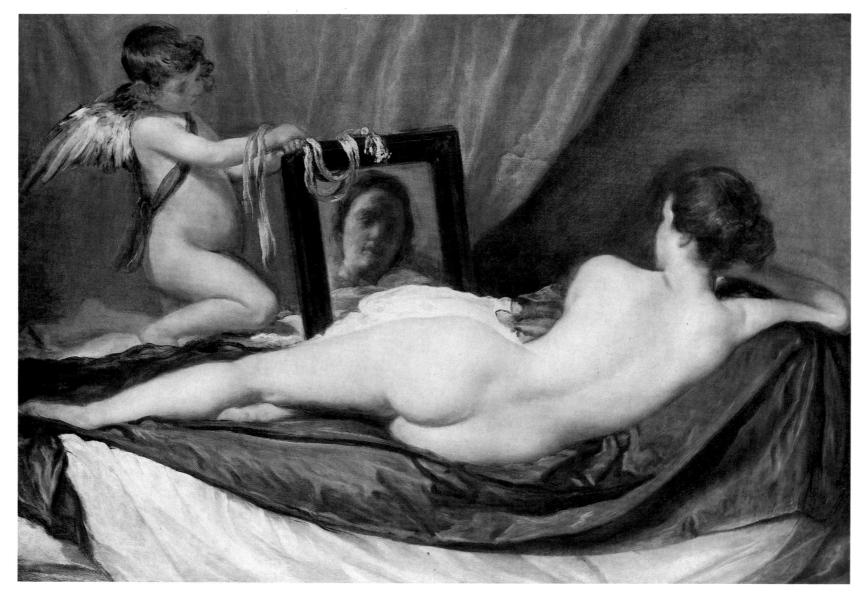

In the case of the famous 'Rokeby' *Venus* (Plate 136), there has, surely, never been any doubt that Velázquez portrayed the goddess of love as a living woman. In fact, when it was first recorded in an inventory made in June 1651, it was described as 'A painting of a nude woman lying on a cloth . . . showing her back, leaning on her right arm and looking at herself in a mirror held by a child'. It is only because the child is winged that we recognize the popular Renaissance theme *The Toilet of Venus* (cf. Plate 137). Until quite recently this painting was considered on stylistic grounds to be one of Velázquez's last works, but the discovery of a mention of it in 1651 means that it must have been painted either before Velázquez left for Italy in 1648 or while he was there. Without further evidence the matter cannot be settled. The fact that the painting was in the collection of a Madrid nobleman in 1651 argues for its earlier Spanish origin. But there are perhaps more reasons for believing it to have been painted in Italy and sent or taken back to Spain by the artist. For one thing, the female nude was, for religious reasons, rarely represented in Spanish art, although the royal collection was rich in nude goddesses from Renaissance Italy and from Flanders. Velázquez's master Pacheco, who was Inspector of Art for the Inquisition, advised the artist to copy only the hands and faces of chaste women – he saw no harm in that. Although Velázquez himself is known to have painted a few similar subjects, this is the only

136. *The Toilet of Venus* (the '*Rokeby Venus*'). 1649–51. Canvas, 48¼ × 69¾ in. (122.7 × 177 cm.). London, National Gallery. (L-R 106)
The only surviving female nude by Velázquez, the *Venus* was probably painted for the young man in whose collection it is first recorded: the great-nephew of Olivares and son of the Prime Minister, Don Gaspar Méndez de Haro, Marqués del Carpio and de Heliche (see Plate 160). He was to become an avid collector and owner of many other paintings by Velázquez. In an unofficial commission from a nobleman, the artist would no doubt have been allowed more licence than would have been permitted with a royal commission. Nevertheless, the view of the naked goddess was perhaps a concession to modesty.

137. Titian (*c.* 1487/9–1576). *The Toilet of Venus. c.* 1552–5. Canvas, 49 × 41½ in. (124.5 × 105.5 cm.). Washington, National Gallery of Art, Andrew Mellon Collection, 1937.
One version of the subject by Titian was in the royal palace in Velázquez's time as well as many other Venuses and other female goddesses by Venetian artists. Cassiano dal Pozzo records in the diary of his visit to Madrid in 1626 that the mythologies had to be covered if there were nudes in them every time the Queen passed through.

surviving example by him of the female nude and the only known Spanish painting of its kind before Goya. The lack of female models in Spain was commented upon by the Bolognese fresco painter Angelo Michele Colonna when he was in Madrid in 1658; he complained that he was therefore obliged to use a cast of an antique statue of Venus for his figure of Pandora.

Another reason for attributing this painting to Velázquez's stay in Italy is its associations with the works of art with which he was occupied there – paintings and sculptures to be acquired for the royal palace. Among his purchases were works by Titian, Tintoretto and Veronese, as well as casts of famous statues in Rome, including some Venuses and other nudes.

It has often been noted that the unusual view of Velázquez's Venus was

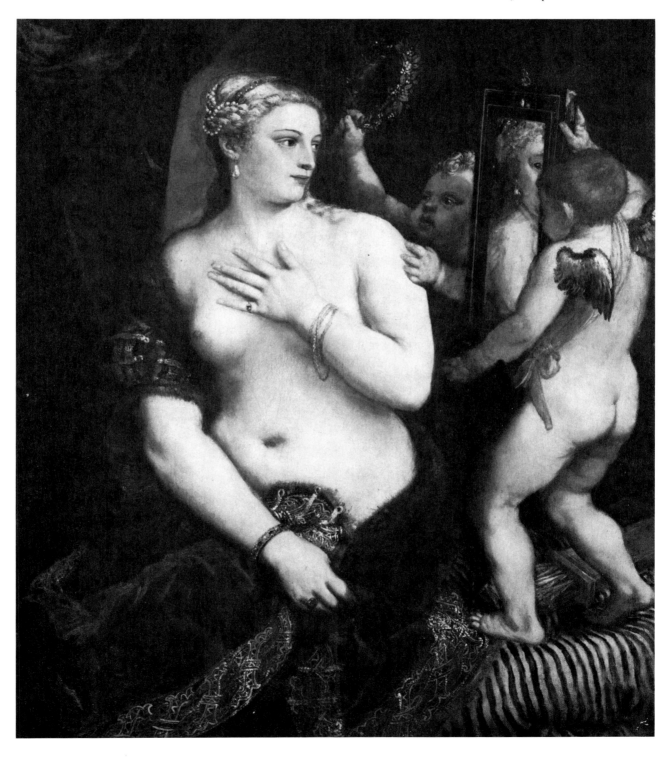

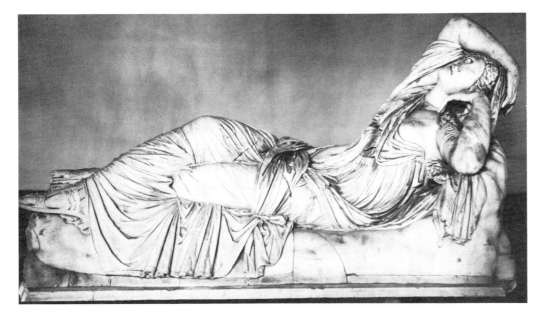

138. *Cleopatra*, now called *Ariadne*.
Antique marble, length 87¾ in. (223 cm.).
Florence, Museo Archeologico.
In the Villa Medici gardens when
Velázquez stayed there in 1630, the statue
is the centre-piece of one of his *Views*
painted on his second visit to Italy (Plate
143). It was probably of this version
rather than the one in the Vatican that he
had a cast made.

probably suggested by the classical statue of a sleeping Hermaphrodite, one of the
antiques of which Velázquez ordered a bronze cast (Plate 139). The pose has also
been compared with that of the draped Ariadne, then called Cleopatra, of which
he also ordered a cast for Madrid. This was one of the antiques, probably the
version in the Villa Medici (Plate 138), which Velázquez studied when he was first
in Rome, and which was to appear later in his *View of the Villa Medici Gardens*
(Plate 143).

Antique statues may well have given Velázquez the idea for his highly original
view of a reclining Venus, and it may well have been the many nudes which
abounded in Italy, ancient and modern, sculptures and paintings, that inspired
him to paint one himself. In particular, his Venus is reminiscent of sixteenth-
century Venetian paintings, above all Titian's. But if it seems likely that his Italian
experience enriched and deepened his understanding of the great Venetians,
especially Titian, and helped him to the assured mastery of their painterly lan-
guage and the confident modifications of it that the Venus displays, it is also true
that he had examples of these at home as well as in Italy and could have taken
inspiration from them without leaving Spain. The rich colouring of the red
curtain, Cupid's blue sash, and the pink ribbons on the mirror, the flesh tones and

140 (*Right*). Detail of Plate 136.
Without regard for the rules of
perspective, the face of Venus is only
dimly reflected although the mirror is held
close to her.

139. *Hermaphrodite*. Signed: M.B. (Matteo
Bonarelli). Bronze, length 61 in. (155 cm.).
Madrid, Prado Museum.
Cast of the antique statue in the Villa
Borghese, Rome (now in the Louvre),
ordered by Velázquez in Rome in 1650–1,
one of the antiques that he found
important enough to have cast in bronze.
The mattress, with gilt bronze fringe, is
not copied from the mattress by Bernini,
on which the original marble lies.
Probably one of the sources of inspiration
of his *Venus*.

painting of the draperies are close to Titian. But the body itself is modelled almost in full light, with hardly perceptible brush strokes; and no Venetian Venus ever lay on a dark grey drapery with black shadows, which brings out the brilliant softness of her flesh. Though Cupid and mirror are important elements of the composition, this Venus gives the impression, even from the back of her head, that she is a living woman. There can be no doubt that Velázquez has followed his custom of using a model; and though other seventeenth-century painters may have used living models, this Spanish Venus is unique in her time, in the way that the artist has characteristically made no attempt to disguise or idealize his model. It is hard to believe that the artist who painted this living Venus, her face only a dim reflection in the mirror (Plate 140), was once accused of only being able to paint heads. At the same time, there is an ambivalence about this woman, an uncertainty whether she is a human being or goddess of myth. We are all, each one of us, left to fill in the features of the face in the mirror.

7 Second Visit to Italy: 1649-1651

The *Toilet of Venus* shows us Velázquez already at the height of his powers, his debt to the great Italians assimilated and transcended in a supremely individual mastery of his medium. The rich variety of his brushwork already defies exact dating and even placing in Spain or Italy. Italy must have provided fresh inspiration when he returned there in 1649, but the splendour and complexity of his achievement, his own transformation of what he had already learned, in Spain or on the spot, from Italian painting make the effect of his second visit even more difficult to define than before. There is still occasional dependence on Italian settings and Italian models, but the pictures are clearly marked by Velázquez's special qualities. They could have been painted by no one else.

The two little *Views of the Villa Medici Gardens* (Plates 143, 144) are, like the *Toilet of Venus*, unique for their subject-matter in Velázquez's surviving oeuvre: the only Velázquian examples of pure landscape that are indisputably autograph. There has never been any doubt that the views were painted in Rome and hardly any that they were painted on the spot. What has been in question is whether they were painted during Velázquez's first or second visit to Italy – a difference of no less than 20 years and an extreme example of the difficulty of dating the artist's work on style alone. Carl Justi, who took the views to be sketches, ascribed them to the first visit, declaring that 'as unfinished works they may have been charming pictures, whereas now much is left to the imagination'. Some later critics have agreed with Justi's dating either on stylistic grounds or because it was during his first visit to Rome that Velázquez is known to have stayed in the Villa Medici. On the other hand, the argument for the later dating is strengthened by the fact that it was on his second visit to Italy that Velázquez ordered casts and moulds of some of the antiques in the Villa Medici, including most probably the Cleopatra/Ariadne that is the centre-piece of one of the *Views* and was probably – as we have seen – one of the sources for the pose of his Venus.

As for the style, although the *Views* are sketchily painted, they are not studies for larger paintings but independent works. There is no reason to consider them unfinished. Here, the sketchiness is the style, and comparable to details in the background of some of Velázquez's large paintings but to no other composition as a whole. For this reason, it is hard to believe that the *Views* were painted before the royal equestrian portraits of the 1630s with their 'sketchily' painted landscapes or before the *Saint Anthony Abbot and Saint Paul the Hermit* (Plate 115) in a landscape setting, with narrative scenes on a small scale, of about the same date. Recently, evidence has come to light that makes it virtually certain that the *Views* were painted in 1649–50 rather than in 1630. In 1648–9 extensive repairs to the

141. View of the 'Pavilion of Cleopatra' in the Villa Medici Gardens, Rome. The Cleopatra, removed to Florence in 1787, has been replaced by a statue of Venus.

house and gardens of the Villa Medici were being made. These repairs included the restoration of the very grotto that is seen boarded up and is the principal feature of one of the *Views*. Why Velázquez chose to paint this prosaic and temporary scene in a famous beauty spot is hard to say, especially since the other painting combines a view of the 'incomparable prospect' and one of the 'incomparable statues' praised by John Evelyn. Possibly his choice of scenes was inspired by the varying effects of light – on the trees, the marble, the wooden boards and the figures, human and sculptured – which he so marvellously re-creates. From the distance at which he must have placed himself to paint the *Views*, the strong sunlight in reality creates deep shadows, blurs the outline of arches and columns and gives the trees that grow there today a speckled look (Plates 141, 142).

The faithfulness with which Velázquez has portrayed the scenes makes it almost certain that they were painted from nature. As open-air studies in oils, they

are not only exceptional in Velázquez's oeuvre, but also for their time. Though some landscape artists in Rome, including Claude, are known to have made outdoor sketches in oils, few if any have survived. Nor do the *Views* reflect any influence from the two leading landscape painters in Rome at this time, Claude and Poussin (the latter, Palomino says, befriended Velázquez), whose works he already knew in Spain and may have helped to acquire for Philip IV. Nor, for that matter, is there any echo of the lesser landscape painters in Italy, the Netherlands and Spain, who contributed to what in 1650 was the largest collection of landscape paintings in Europe that decorated the Buen Retiro Palace in Madrid. Like other works of Velázquez's maturity, the *Views of the Villa Medici Gardens* foreshadow the achievements of much later artists, in this case the *plein-air* painters of the nineteenth century. These rare examples of uncommissioned works were taken back to Spain and entered the royal collection, where they are first recorded in 1666, placed not among the landscapes in the Buen Retiro but in a passage in the Alcázar, where they were valued at a fraction of the price put on the plaster cast of the statue of Cleopatra/Ariadne.

It was possibly because of their inconspicuous position in the palace that the *Views* escaped the notice of Palomino. His account of Velázquez's Italian acquisitions, the paintings and sculptures that were his 'official business' in Italy, is, however, very detailed. So, too, is the information he gives about the portraits Velázquez painted in Rome, even though they nearly all remained in Italy. In this case one of his informants, as he says, was the Flemish painter Andreas Schmidt, who was in Rome in 1650 and later at the Spanish Court, where Palomino knew him. Velázquez's sitters in Rome range from his mulatto assistant Juan de Pareja, a number of important ecclesiastics, to the Pontiff himself. Several of these portraits have survived.

As portrait painter to the papal court at the time of the Jubilee, Velázquez

142. View of the Grotto-Loggia in the Villa Medici Gardens, Rome.
As in the other view, little has changed, apart from the disappearance of the hoarding, the different trees and statues and details of the pilasters.

143. *The Villa Medici Gardens, Rome: 'Pavilion of Cleopatra'.* 1649–50. Canvas, 16⅞ × 15 in. (43 × 38 cm.). Madrid, Prado Museum. (L-R 46)
The statue of Cleopatra that is the centre-piece of the view chosen by Velázquez, one of the possible sources of the pose of his *Venus*, was probably one of the statues of which he had a cast made while he was in Rome (see Plate 138).

144. *The Villa Medici Gardens, Rome: Grotto-Loggia Façade*. 1649–50. Canvas, 18⅞ × 16½ in. (48 × 42 cm.). Madrid, Prado Museum (L-R 47)
Records of extensive repairs to the villa and gardens in 1648–9 include work on the grotto-loggia seen boarded up in Velázquez's painting, providing a very different centre-piece from the Cleopatra. The records confirm the dating of both views during the artist's second visit to Italy.

appears to have had no rival. The great masters of portraiture in Rome were the sculptors Gianlorenzo Bernini and Alessandro Algardi, who were friendly to the visitor from Spain, if we are to believe Palomino. But Velázquez's sitters at the time far outnumber theirs.

Among the lost or unidentified Roman portraits listed by Palomino are two of Velázquez's rare portraits of women, other than royalty. One of the sitters, named Flaminia Trionfi, 'excellent painter', has not been identified. The other was Donna Olimpia Pamphili, the widowed sister-in-law of Pope Innocent X, a powerful domineering woman, who fell temporarily from favour in the autumn of 1650. Her portrait, possibly the painting by Velázquez, is reported to have hung in the Cardinals' waiting-room, as if she were royalty. A marble bust by Algardi (Plate 145) records her imposing presence, and engravings of her may reflect Velázquez's painting, a bust portrait wearing a black veil (Plate 146), as it is described when it came into the possession of Cardinal Camillo Massimi, another of Velázquez's Roman sitters. It is last heard of when it was acquired after Massimi's death by the Marqués del Carpio, Velázquez's Spanish patron, who already owned the *Toilet of Venus* and was to become the most important private collector of his paintings. He acquired some in Spain, and others in Italy, where he was Spanish Ambassador in Rome and Viceroy in Naples.

The chronology of Velázquez's Roman portraits is not recorded, but they must all have been executed in a relatively short period, between his arrival in May 1649 and November 1650. (His stay there was interrupted only by visits to Naples and Gaeta in June/July 1649 and March 1650.) He probably returned to Rome in 1651 but only to conclude his official business. He had come to Rome with presents for Pope Innocent X on the occasion of his Jubilee, which began on 25 December 1649. It is likely that the portrait of the Pope was one of the first, and perhaps it was painted at the King's request. There is, however, no certain knowledge of when or how this famous likeness of Velázquez's most eminent sitter came to be made. Velázquez had no doubt met the future Pope in Madrid when, as Giovanni Battista Pamphili, he had accompanied Cardinal Francesco Barberini as datary on his mission to Spain in 1626. Not long afterwards, as Monsignor Pamphili, Papal Nuncio in Spain, it was he who forwarded to Cardinal Barberini, at the request of Velázquez's Spanish patron, the Prime Minister Olivares, a 'memorial' from the artist appealing for papal dispensation for him to enjoy an ecclesiastical benefice to supplement his salary as Court Painter. This was, of course, a matter of official business and no evidence of any personal interest in Velázquez on the Nuncio's part.

That Velázquez, before painting the Pope, made a portrait of his mulatto assistant *Juan de Pareja* (Plate 149), who had accompanied him to Rome, is quite credible. No doubt, as his first portrait in Rome it was intended as an exercise in painting a portrait from life. So Palomino says, at any rate. Possibly it was also made to provide a sample of his powers to prospective sitters. For unless the paintings he took with him to Italy as a gift to the Pope were by his own hand (and there is no knowledge of what they were), there can have been few if any examples of Velázquez's portraits in Rome at the time, apart from the bust of Olivares that he had painted for Cardinal Barberini in Madrid in 1626. Unlike the portrait of Olivares, that of Juan de Pareja won enthusiastic approval. The story of the painting being mistaken for the sitter himself is an ancient one, which Palomino tells of other portraits as well as this one, including the portrait of Innocent X. Palomino has another story about the portrait told him by the Flemish painter Andreas Schmidt, which purports to be an eye-witness's account. It is a variation of the old artist's legend on the theme of life and imitation: the

145. Alessandro Algardi (1598–1654). *Donna Olimpia Pamphili*. Before 1650. Marble bust, height 27½ in. (70 cm.). Rome, Galleria Doria-Pamphili. At the time this bust was made Algardi had temporarily eclipsed Bernini in favour at the papal court.

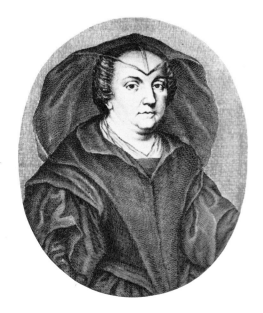

146. *Donna Olimpia Pamphili*. Anonymous engraving. From its description, Velázquez's bust portrait of her may be reflected in this engraving.

147 (*Above*). Titian (*c.* 1488/90–1576). *Pope Paul III*. 1543. Canvas, 41¾ × 33½ in. (106 × 85 cm.). Naples, Gallerie Nazionali, Capodimonte.

148 (*Above right*). El Greco (1541–1614). *Cardinal Fernando Niño de Guevara. c.* 1600. Canvas, 67¼ × 42½ in. (171 × 108 cm.). New York, Metropolitan Museum of Art. According to Palomino, Velázquez in his portraits imitated El Greco. Certainly Velázquez's *Innocent X* has much in common with this portrait. Both artists owed much to the inspiration of Titian.

painters of various nationalities who came to see the portrait exhibited in the Pantheon judged that it alone was truth – all other paintings were imitations.

The story is well chosen, whether or not it has any foundation in fact. Even for Velázquez, the effect of familiar and living likeness in this exceptional unofficial portrait is unusually striking. There is nothing to remind us of Titian or Rubens and nothing comparable in Italian, Flemish or Spanish painting. The pose, the steady glance, the greenish-grey background are Velázquez's own. The black hair, dark eyes and copperish complexion are the colouring of the sitter, which is set off by the white collar and dark grey doublet. Examined closely, there is very little detail in the painting of the face or costume; but from a distance everything takes shape to create the appearance of solid flesh and blood dressed in a cloth doublet, with lace-edged linen collar. It was probably this portrait – if not that of the Pope – that won Velázquez election to the Congregazione dei Virtuosi in February 1650, shortly after his election to the Academy of Saint Luke, for it was the Virtuosi who held their exhibitions in the Pantheon, on Saint Joseph's Day, 19 March.

In contrast to the portrait of Juan de Pareja, Velázquez's portrait of *Pope Innocent X* (Plate 150), for him the most important sitter in the world, is the most official-looking of all his paintings. As in the earlier portraits of his royal master, he here once again follows a famous tradition, the three-quarter length seated figure created by Raphael and used by Titian in his portrait of *Pope Paul III* (Plate 147) and by El Greco in his portrait of *Cardinal Niño de Guevara* (Plate 148). Here again, as in his *Venus*, Velázquez seems to have been revitalized by a renewed study of Titian; his painting could be described as more Titianesque than Titian's

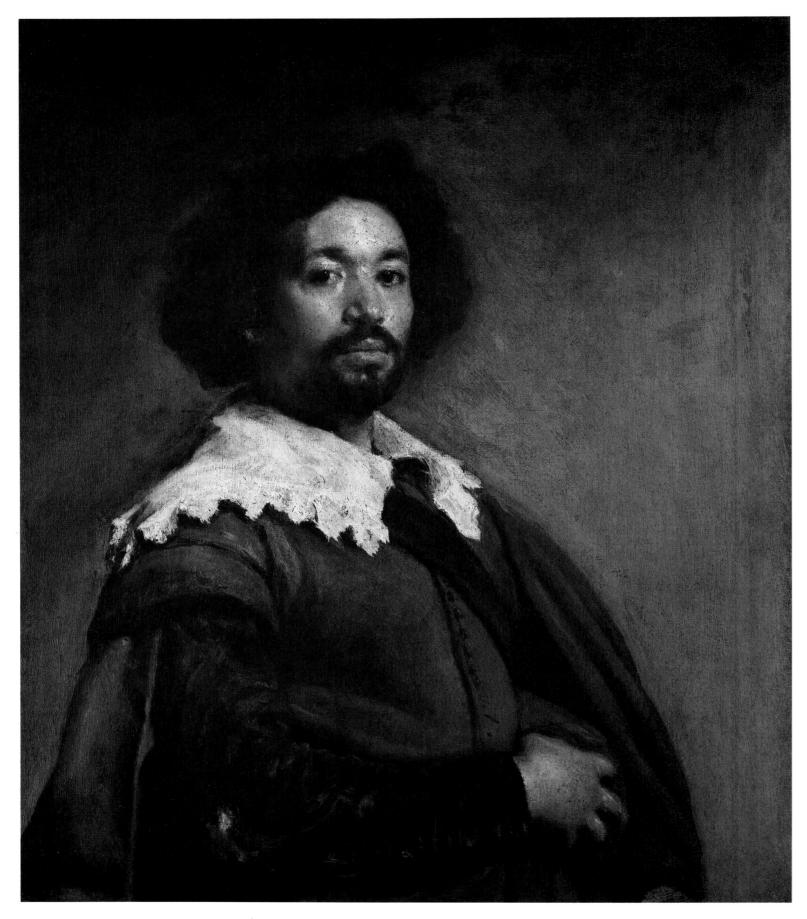

149. *Juan de Pareja.* 1649–50. Canvas, 32 × 27½ in. (81.3 × 69.9 cm.). New York, Metropolitan Museum of Art. (L-R 112)
According to Palomino, Velázquez made the portrait of his mulatto 'slave' as an exercise in painting a head from life before portraying the Pope. It was, he says, exhibited in the Pantheon and won universal acclaim for its lifelike quality. The exhibition in the Pantheon on Saint Joseph's Day (19 March) was held by the Congregazione dei Virtuosi, to which Velázquez had been elected a member in February 1650. Velázquez's portrait appears to have been the model for the self-portrait in Pareja's *Calling of Saint Matthew* (Plate 77).

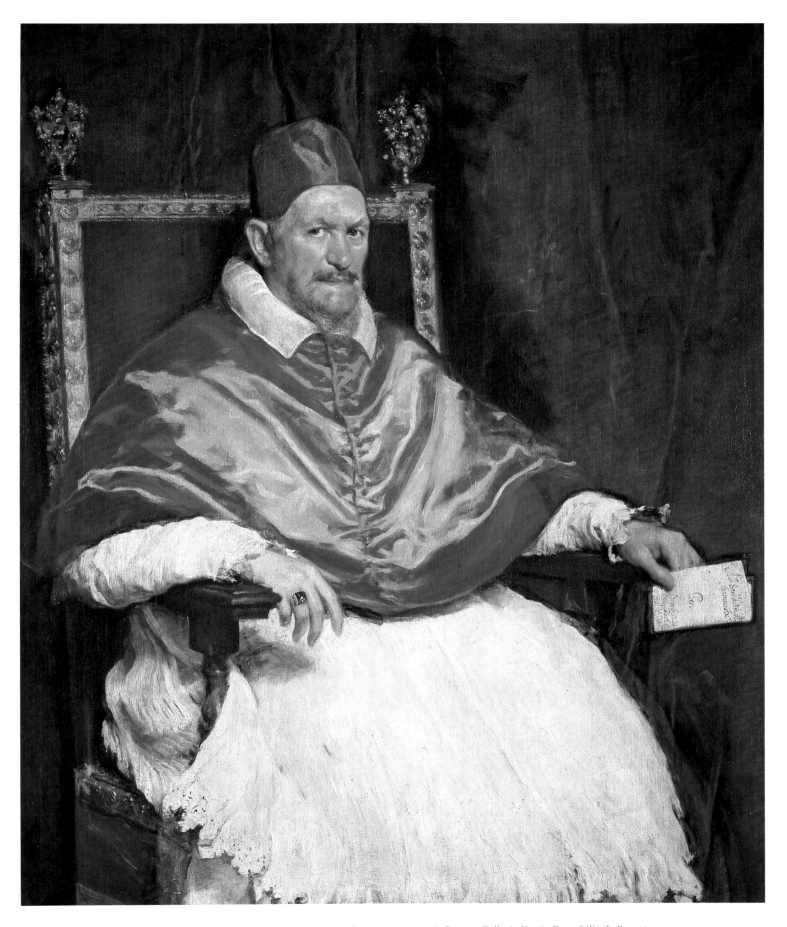

150. *Pope Innocent X.* 1649–50. Signed (see Plate 2). Canvas, 55⅛ × 48 in. (140 × 120 cm.). Rome, Galleria Doria-Pamphili. (L-R 114)
It was probably the portrait of the Pope painted on the occasion of his Jubilee that earned Velázquez admission to the Academy of Saint Luke in January 1650. The Pope himself rewarded Velázquez with a gold medal and chain (cf. Plate 20) and support for his ambition to become a member of a Spanish military order. The portrait, greatly admired and copied in Velázquez's time, is today regarded, as it was by Reynolds, as 'one of the first portraits in the world'.

149

own painting. This portrait of a Pope is at the same time one of the most powerful evocations of person and personality ever achieved by Velázquez, even in the portraits of his most regular royal sitter, King Philip IV. No reproduction can convey the almost physical impact of the original painting of this stern, ugly, old man, seated in an enormous chair; or give an idea of the brilliant combinations of various shades of crimson of the curtain, the chair, the cape and biretta; even the Pope's complexion is ruddy, and the crimson is broken only by the dazzling white of the surplice, painted almost without shadows. And even in the original it is difficult to see how the strong modelling of the head has been achieved with hardly visible brush strokes.

Not surprisingly, this portrait brought Velázquez immediate and lasting fame. Palomino's praise of his compatriot's achievement – the wonder of Rome, copied and admired by everyone – is echoed by the Venetian, Marco Boschini, who commends it for its true Venetian touch and its perfect and noble manner. Reynolds, 100 years later, called Velázquez's *Pope Innocent X* 'one of the first portraits in the world'; few would quarrel with this judgement. Many copies of the portrait were in fact made, and Velázquez himself took a version of it with him to Spain. This was probably the painting seen by Boschini in Venice. The portrait, indeed, gives credence to the extent of Velázquez's admiration for Titian expressed in the alleged conversation with Salvator Rosa in Rome, as reported by Boschini. When asked if he did not think that Raphael was the best of all

151 (*Below left*). Detail of Plate 147.

152 (*Below*). Detail of Plate 150.

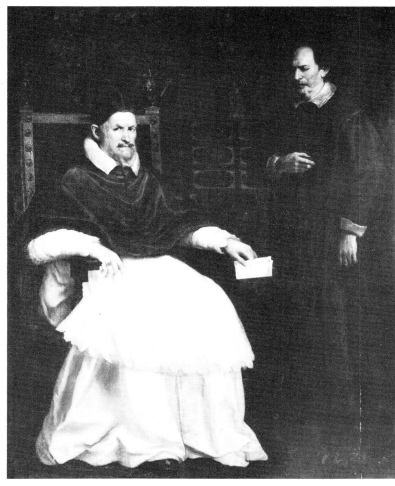

153 (*Above*). *Pope Innocent X.* 1650. Canvas, 32¼ × 28¼ in. (82 × 71.5 cm.). London, Apsley House, the Wellington Museum. (L-R 115)
This is almost certainly the 'copy' of his portrait of Innocent X that Palomino says Velázquez took back with him to Spain and the portrait described by the Papal Nuncio in Madrid as 'very like' the sitter, with which the King was very pleased. It was also probably this painting that was seen and praised by Boschini in Venice. Although some critics have questioned its authorship, there is little doubt that it is an autograph replica of the portrait in Rome.

154 (*Above right*). Pietro Martire Neri (1591–1661). *Pope Innocent X with an Attendant Cleric*. Signed. Canvas, 83⅞ × 65¾ in. (213 × 167 cm.). El Escorial. The signature on the paper in the Pope's hand is in the form of Velázquez's signature on his portrait of the Pope (Plate 150). The attendant cleric has not been identified. The portrait on the wall is that of Saint Philip Neri. When and how the painting came to Spain is not known.

painters, Velázquez replied that to tell the truth he did not like him at all. It was in Venice, he went on to say, that he found 'the good and beautiful. I give the first place to her painters and Titian is the standard-bearer.' The Pope rewarded Velázquez with a gold medal (Plate 20), and in appreciation of the portrait's 'extraordinary merit' offered to support the artist's cherished ambition to be admitted to one of the Spanish military orders.

Of the many copies of Velázquez's *Pope Innocent X* (nearly 20 are recorded) that bear witness to the painting's fame, one is probably autograph – the painting that the artist took back with him to Spain, now identified with the bust portrait at Apsley House (Plate 153). For the rest, only one painter's name is connected with the copies made in Rome: Pietro Martire Neri (1591–1661). Neri signed two versions, one a close copy, the other showing the seated Pope as a full-length figure accompanied by a cleric (Plate 154). Neri's name also appears, this time with that of Velázquez, on a portrait of the Pope's Maggiordomo, *Cristoforo Segni* (Plate 155). Segni, a member of the Bolognese family who gave Velázquez hospitality when he was in Bologna in 1649 (Count di Segni or 'Conde de Sena', as Palomino calls him), friend and patron of Algardi, is seated in a pose similar to that of Innocent X, in reverse. The execution, however, owes little or nothing to Velázquez. The question is whether this is the portrait of the Pope's Maggiordomo recorded by Palomino or whether it is a copy of a lost original by Velázquez. Apart from these portraits, nothing is known of the relationship between Velázquez and Neri. A religious painter of mediocre talent from Cremona, Neri was in Rome in 1650 and a fellow member with Velázquez of the Congregazione dei Virtuosi in March of that year. The only other portraits by him that are known

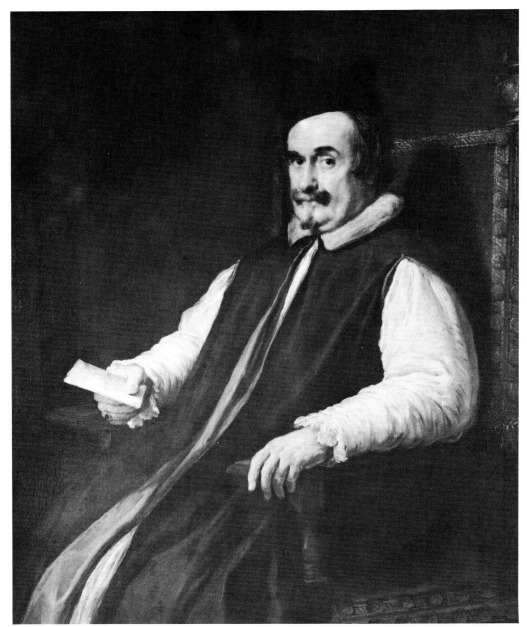

155. Pietro Martire Neri (1591–1661).
Cristoforo Segni, the Pope's Maggiordomo.
Signed: Alla Santa di Nro Sigre/Inozencio
Xo/ Monsre Maggiordomo / ne parli a S.
S.ta/ Per Diego di Silva y Velazq./ e Pietro
Martire Neri. Canvas, $44\frac{7}{8} \times 36\frac{1}{4}$ in.
(114×92 cm.). Private collection.
Despite the inclusion of Velázquez's name
in the signature (partly hardly legible,
partly reinforced in 1960), and the pose
recalling that of his *Innocent X*, the
execution seems to be entirely by the
author of Plate 154.

PETRVS S·R·E· PRESB. CARD. VIDONVS.
CREMONENSIS. CREAT. DIE
· V. APRILIS. MDCLX.

156 (*Far left*). *Cardinal Pietro Vidone*.
Engraving by A. Clouwet after Pietro
Martire Neri.

157 (*Left*). After Velázquez. *Cardinal
Camillo Astalli, known as Cardinal Pamphili.*
Canvas, $23\frac{1}{4} \times 16\frac{1}{2}$ in. (59×42 cm.).
Leningrad, Hermitage.
Called a portrait of Cardinal Portocarrero
by Mateo Cerezo, this is probably the oval
portrait of Cardinal Astalli attributed to
Velázquez in the collection of the Marqués
del Carpio, shipped from Naples to
Madrid in 1686, and presumed lost.

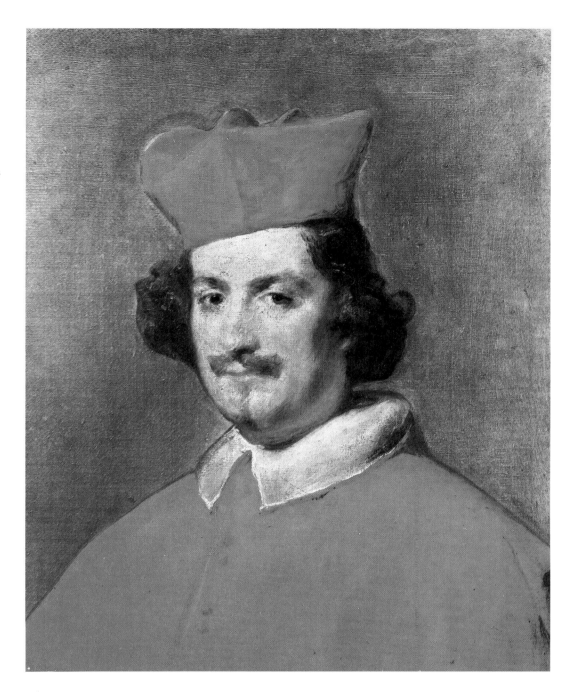

158. *Cardinal Camillo Astalli, known as Cardinal Pamphili.* 1650–1. Canvas, 24 × 19⅛ in. (61 × 48.5 cm.). New York, The Hispanic Society of America. (L-R 117)
An engraving confirms the identification of the Cardinal as the Pope's adopted nephew and not his real nephew, who was no longer Cardinal in 1650, and confirms also Palomino's dating of his portrait.

are models for a series of engravings of cardinals (Plate 156), only one of them related to Velázquez or his sitters.

The only portrait by Velázquez that might have served as a model for an engraving in the series is that of Camillo Astalli (Plates 157, 158), an adopted nephew of Innocent X, who was known as Cardinal Pamphili (the name given him by Palomino). Velázquez's portrait must have been painted soon after the sitter was raised to the purple in September 1650, when he was in his early 30s. With a greenish-grey background similar to that of Juan de Pareja, the head of the Cardinal is closer in style to that of the Pope, but the less impressive appearance of the sitter makes for a less powerful characterization than either of those two masterpieces.

Monsignor Camillo Massimi, as Velázquez's portrait of him suggests (Plate 159), was a more important person as well as a more imposing figure than the Cardinal. Palomino names him as one of Velázquez's sitters in Rome and also among the important prelates and artists who befriended him there. Camillo Massimi (1620–77), Papal Chamberlain, a Roman, a man of learning, art patron and collector and an amateur artist, owned at his death no fewer than six portraits

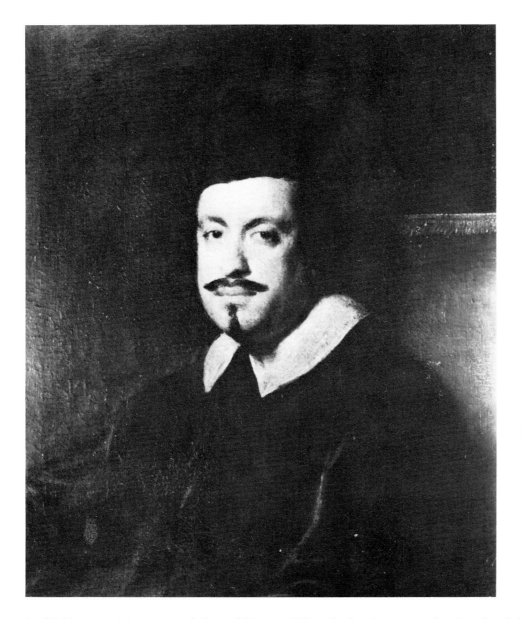

159 (*Left*). *Monsignor Camillo Massimi.*
1649–51. Canvas, 29⅜ × 23⅜ in.
(74.5 × 59.5 cm.). The National Trust,
Bankes Collection, Kingston Lacy.
(L-R 116)
The sitter, more renowned as art patron
and collector than as prelate, is one of the
members of the papal court who,
according to Palomino, befriended
Velázquez when he was in Rome and sat
to him for his portrait. Velázquez's
portrait of him, aged about 30, wearing
the blue cassock of a *camariere segreto*, must
have pleased Massimi, since he became the
owner of five more portraits by the
Master, renewing his friendship with him
when he went to Madrid as Nuncio in
1654.

160. *Don Gaspar Méndez de Haro, Marqués
del Carpio and de Heliche* (1625–87).
Engraving by J. Blondeau after Giuseppe
Pinacci.
Great-nephew of Olivares and son of his
successor as Prime Minister, Don Gaspar,
after a stormy youth, became Ambassador
in Rome (1677) and Viceroy in Naples
(1682). One of the great collectors of his
time, he owned several paintings by
Velázquez but apparently never sat to him
for his portrait.

by Velázquez: his own and that of Donna Olimpia (both acquired at his death by Velázquez's Spanish patron, the Marqués del Carpio) and portraits of the Spanish King and Queen and the two Infantas, which he probably obtained when he was in Madrid as Papal Nuncio (1654–8). His friendship with Velázquez is recorded in a letter to him from the artist (one of only two extant personal letters) welcoming him to Spain, at a time when the Nuncio was awaiting official recognition at the Spanish court. Velázquez's portrayal of this far from handsome man is masterly. The massive head is constructed with hardly any modelling; without outline or drawing, the artist creates the impression of prominent features, of large, heavily-lidded dark eyes and thick red lips beneath a dark brown moustache. The complexion is only a little less ruddy than the Pope's. The chair, dull crimson with gold braid, is set against a greyish-brown background. Though the painting is dark with dirt, a surprising feature is the colourful costume worn by Massimi, the costume of a *camariere segreto* in the papal court: a rich blue sleeveless cassock, with sleeves of a lighter blue under-cassock, which is visible also at the opening below the white collar, and the collar itself is shaded with a reflection of the blue garment. Velázquez was later to use similar shades of blue for the dress of one of his portraits of the Infanta Margarita (Plate 180), one of the most brilliantly colourful of all his paintings.

8 Last Years: 1651-1660

Can we, after all, say what was the effect of Velázquez's second visit to Italy? The destruction by fire in 1734 of the Alcázar, the royal palace in Madrid, has left us with only a partial idea of his last activities which, in his role as decorator if not as painter, must have been inspired directly by his Italian experience. Some of the paintings, sculptures and objets d'art that he acquired or commissioned in Venice and Rome have survived, but we have no means of reconstructing the splendours of the rooms where they were placed, other than bald inventories and glimpses of them in portraits by Velázquez's successors. A corner of the *pieza ochavada* appears in portraits of Philip IV's widow, *Queen Mariana*, by Juan Bautista Martínez del Mazo (Plate 162), but it gives little idea of the room 'designed and arranged by Velázquez' that housed many of the King's most precious treasures, a room compared by the Tuscan Ambassador in Madrid to the Tribuna in Florence – than which he could have found no higher praise. Similarly, portraits of the Queen Mother and of the young *Charles II* by Juan Carreño de Miranda (Plate 161) give only a tantalizingly limited view of the *Salón de los espejos*: a side table supported by a gilt bronze lion (see Plate 164) and surmounted by mirrors

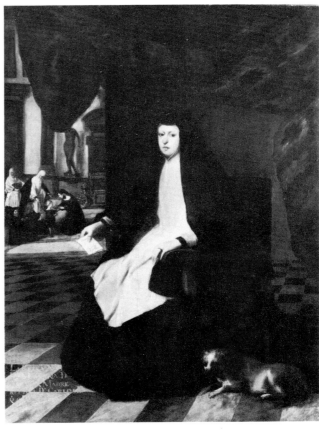

163. Juan Carreño de Miranda (1614–85). *The Marriage of Pandora and Epimetheus*. 1659–60. Inscribed 'de J. Carreño'. Black and red chalk, 13½ × 9¾ in. (34.3 × 24.8 cm.). Madrid, Academy of San Fernando.
A study for part of the ceiling of the *Salón de los espejos*. Carreño, according to Palomino, began painting the marriage scene, but was struck down by a serious illness, and it was finished by Francisco Rizi.

with gilt bronze eagle frames, and above a painting by Tintoretto, representing only a portion of the acquisitions made by Velázquez in Italy, which once adorned this 'Hall of Mirrors'. For the ornate ceiling of the hall, decorated under Velázquez's direction by the Bolognese *quadratura* artists Colonna and Mitelli, we have only Palomino's description and a drawing by Carreño, who was one of their Spanish assistants (Plate 163). A few drawings and a modello for a ceiling in the

164. Gilt bronze lions supporting a porphyry table. Madrid, Prado Museum. Four of the twelve lions, probably based on the 'Medici Lions', one antique, the other by Flaminio Vacca, which Velázquez ordered and had cast in Rome together with the mirror frames seen in Carreño's painting (Plate 161). The lions supported six porphyry side tables, with two eagle-framed mirrors above each. Eleven of the lions survive; four now decorate the throne in the Royal Palace, the others support tables in the Prado Museum.

165. *Mercury and Argus. c.* 1659. Canvas,
50 × 97⅝ in. (127 × 248 cm.). Madrid, Prado
Museum. (L-R 127)
The only surviving painting of four
mythological subjects that were hung in
the *Salón de los espejos,* redecorated under
Velázquez's direction during the last years
of his life. From their unusual dimensions,
they were presumably painted for the
place where they were to hang, between
the windows, a position against the light
that probably explains the accentuation of
what has aptly been described (by
Lafuente) as 'one of the most
characteristic examples of the intangible
and impressionistic technique of
Velázquez's last years'.

Buen Retiro (Plate 166) are all that survive to give an idea of the work carried out
by the Bolognese artists in Madrid. But from the many examples of their work
in Italy – in Florence and Modena – their illusionist combination of paint and
gilded stucco on the ceiling of the *Salón* must have provided an otherwise un-
known witness to this aspect of Velázquez's taste in decoration.

Of Velázquez's own paintings, hung round the walls of the *Salón* together with
works by Titian, Rubens and other old and modern masters – all in black frames
– the *Expulsion of the Moriscos,* painted years before, and three of the four
mythologies made for the *Salón* when it was redecorated all perished in the fire.
The *Mercury and Argus* (Plate 165), his only surviving painting from the *Salón,*

166. Agostino Mitelli (1609–60) and
Angelo Michele Colonna (1600–36). *Sketch
for a Ceiling in the Buen Retiro.* 16 9–60.
Canvas, 73⅝ × 110⅝ in. (187 × 281 cm.).
Madrid, Prado Museum.
The corner medallions illustrating the
story of Cephalus and Aurora served to
identify the ceiling as that of a loggia in
the Buen Retiro Palace, mentioned by
Italian biographers. The colourful oil
sketch gives an idea of the rich effect that
the frescoed ceilings of the Bolognese
artists must have produced.

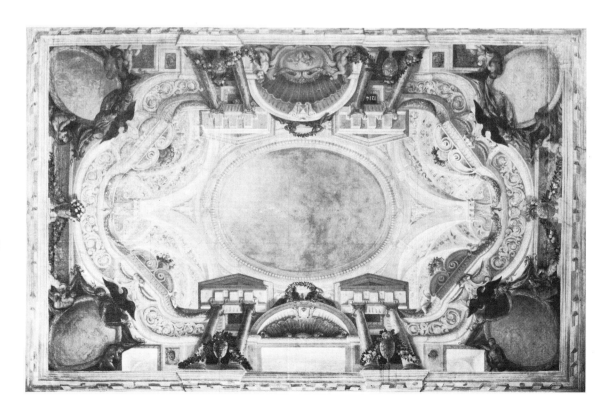

167. *Dying Gladiator*. Antique marble. Length of plinth, 73⅜ in. (186.5 cm.). Rome, Musei Capitolini.
One of the statues of which Palomino records Velázquez having a cast made in Rome; a plaster cast is recorded in the 1666 inventory of the Alcázar. In Velázquez's time the statue, with the Mars, was in the Ludovisi collection (see Plate 134).

owes its format and dimensions to the position of all four mythologies between the windows. The horizontal composition, designed for the long, narrow space, is emphasized by the outstretched body of Io, transformed into a cow, lying behind the crouching figure of Mercury and the sleeping Argus. Both figures seem to have been inspired by the pose of the Dying Gladiator (Plate 167), one of the famous antique statues in Rome of which Velázquez ordered a cast. Instead of showing one of the more usual scenes with Mercury putting Argus to sleep with his music or about to behead him, as in Rubens's painting for the Torre de la Parada (Plate 168), Velázquez depicts a moment before the beheading. Mercury's action is threatened, not portrayed; the drama implicit in the poses of the two protagonists, their faces half hidden, is painted in sombre tones against a background of dark clouds. Of the three lost mythological subjects, the *Apollo Flaying Marsyas* may have been similar in style and character, but the *Venus and Adonis* and *Cupid and Psyche* were surely more Italianate, like the *Toilet of Venus*.

None of these paintings can have had the startling originality of the *Fable of Arachne* (Plate 171), the most striking of Velázquez's extant mythological paint-

168. Peter Paul Rubens (1577–1640). *Mercury and Argus*. c. 1638. Canvas, 70½ × 117 in. (179 × 297 cm.). Madrid, Prado Museum.
One of the large series of scenes from Ovid's Metamorphoses painted by Rubens and his school in Antwerp for the decoration of the Torre de la Parada.

169. Titian (*c.* 1487/9-1576). *The Rape of Europa*. Inscribed TITIANVS P.
1559-62. Canvas, 70 × 80¾ in.
(178 × 205 cm.). Boston, Isabella Stewart Gardner Museum.
Painted for Philip II, this was one of the many Titians in the royal collection of which Rubens made a copy (Prado), when he was in Madrid in 1628-9.

170 (*Right*). Detail of Plate 171.
Though the *Rape of Europa* is the subject of the tapestry in the background of Velázquez's painting, providing a clue to the subject-matter, it is identified only by a few sketchy details taken from Titian's composition.

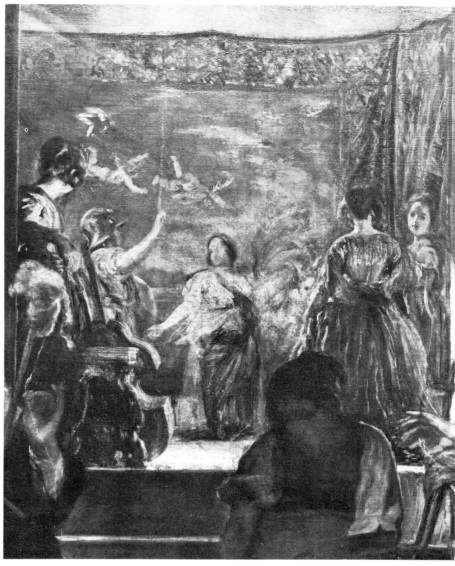

ings. This elaborate and monumental composition is usually dated on stylistic grounds to the decade after Velázquez's return from Italy, within a year or two of his last great royal commission, *Las Meninas*. It was apparently painted not for the King but for a member of the court, Pedro de Arce, in whose collection it first appears in 1664. Again there is a regrettable lack of documentation. Pedro de Arce was a fellow executor with Palomino of the will of Alfaro, his chief informant about Velázquez, yet Palomino makes no mention of this painting. Until modern times, the picture was called *Las Hilanderas* (*The Spinners*), a title given to it in the eighteenth century after it had entered the royal collection, and was taken to be of a genre subject, a scene in a tapestry factory, with women winding and spinning in the foreground and a group of ladies inspecting a tapestry on the wall in the background. The tapestry which is the focal point of the painting has now been shown to play a role similar to that of the mirror in *Las Meninas*, both compositionally and in the interpretation of the subject. The figures standing in the foreground of the tapestry have been identified as Pallas Athene and Arachne, the mortal who dared to challenge the goddess to a competition in the art of weaving and, being the loser, was metamorphosed into a spider. Behind them, we can just detect the head of a bull and some fluttering drapery. Because we share with Velázquez – and probably members of the court – a knowledge of Titian's *Rape of Europa* (Plate 169), we are able to identify the theme of the tapestry. Europa

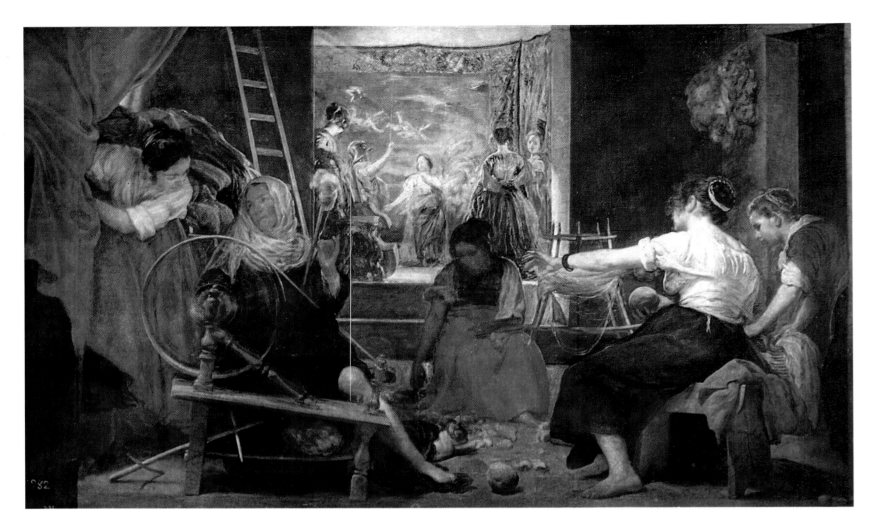

carried off by Jupiter in the form of a bull was, according to Ovid, the first subject woven by Arachne in her contest with Pallas Athene. Titian's painting was among the many paintings by him in the Spanish royal collection copied by Rubens during his visit to Madrid in 1628. Later, Rubens painted his own version of the contest between Pallas Athene and Arachne for the Torre de la Parada. We know it today only from a sketch (Plate 172) and from the copy by Mazo just visible on the wall in the background of *Las Meninas*. Once again, Velázquez treats the subject very differently from Rubens. The Flemish master illustrates the action of Ovid's story, with Athene angrily threatening Arachne, after throwing her to the ground. Velázquez, as in the *Mercury and Argus*, is less direct, more subtle, allusive and individual. The goddess is imperious and dignified as she confronts her mortal opponent. The punishment she inflicts is at most only hinted at by the musical instrument placed prominently in front of the tapestry. Music was the traditional antidote to the bite of the giant spider, the tarantula.

Despite the peculiar obliqueness of the allusion to Ovid's story, Velázquez's canvas was recognized as the *Fable of Arachne* in his own time; it is given this name only four years after his death. As an interpretation of a mythological subject it stands alone, not only in Velázquez's oeuvre, but in a wider context. No similar treatment of the subject is known, or any source for the composition, except for the detail after Titian. There exists no tapestry with the scene represented. There is, therefore, something to be said for the traditional view of the painting, that it was based on or inspired by a scene in the tapestry workshop in Madrid, the tapestry being introduced as an allusion to Pallas Athene, the patron of weaving and spinning. Both formally and in its allusive mode of reference, this is a late

171. *The Fable of Arachne*, known as *Las Hilanderas* (The Spinners). *c.* 1656–8. Canvas, *c.* 65¾ × 98⅜ in. (*c.* 167 × 250 cm.); with additions 86⅝ × 113¾ in. (220 × 289 cm.). Madrid, Prado Museum. (L-R 172)
First recorded in the collection of Pedro de Arce in 1664. Since it is not mentioned in the Arce inventories of 1657 (or earlier), it is presumed to have been acquired, and was possibly painted, after that date. López-Rey, however, dates it with the *Venus* to the years before Velázquez's second Italian journey. Called *Las Hilanderas* by Mengs, in his letter to Ponz, praising it as an example of Velázquez's last manner and painted 'as if his hand took no part in the execution, only his will'. And Renoir declared that of all the paintings by Velázquez he knew 'nothing more beautiful than the Spinners'.

172. Peter Paul Rubens (1577–1640). *The Fable of Arachne*. c. 1636. Panel, 10½ × 15 in. (27 × 38 cm.). Richmond, Virginia, the Virginia Museum of Fine Arts.
Rubens's sketch for one of the canvases with scenes from Ovid painted for the Torre de la Parada. The finished painting is lost and so is the copy by Mazo which hung on the wall in the room where Velázquez painted *Las Meninas* and is just discernible on the wall in the background (Plate 184). In contrast to Velázquez, Rubens has represented the moment of angry action in the story of the contest between Pallas Athene and Arachne.

development of the kind of composition that Velázquez had painted nearly 40 years before, at the beginning of his career, in Seville – for example, the *Kitchen Scene with Christ in the House of Martha and Mary* (Plate 34). As in the early composition, the figures in the foreground – the woman at the spinning-wheel and the woman winding wool – are probably references to the scene in the background. Ovid tells us how the goddess disguised herself as an old woman when

173. Detail of Plate 171.
'It needed the imagination and skill of a Velázquez to invent a means of suggesting that "uncertain glimpse" in the spinning wheel of the *Hilanderas*, which appears to catch the ... streaking after-image that trails its path across the field of vision when an object is whizzing past.' E.H. Gombrich, *Art and Illusion*, 5th ed. 1977, p. 187.)

she went to visit her young and low-born rival. There could be no clearer index of the transformation of Velázquez's art from its early to its late phase than these conceptual similarities between the religious-cum-genre subject and the mythological piece. The transformation is as remarkable in his figure subjects as in his portraits. The naive composition in the *bodegón*, where the style and scale of the scene through the hatch separate it from the foreground figures and still-life, is metamorphosed into something much richer and more inventive: a general impression of a roomful of figures, with a less distinct view of the scene in the alcove behind. Now there is no clear distinction between the world of myth and reality. Here, in place of the still-life laid out on the table before us, it is the spinning-wheel in motion that catches the eye (Plate 173). Movement is rendered without a single line or detail.

The *Mercury and Argus* and the *Fable of Arachne* are the supreme achievements of Velázquez's final period in their kind. As Court Painter, however, his first duty was to paint portraits, and he ended his career in the office, as he had begun, a specialist in portraiture. The early critics who dared to accuse him of only being able to paint heads would have been shamed before the mastery, the inventiveness and the controlled technical audacity of the images of these last years. A new sitter had come to court during his absence in Italy, a new Queen, Mariana of Austria, whom Philip IV had married in 1649. For her, for her step-daughter and for her two children, Velázquez virtually invented new modes of portraiture. His Roman masterpiece, *Pope Innocent X*, was patently a grand descendant of Titian's papal portraits; his late representations of the Spanish royal family seem to have no precedents. It is true that the pose of the full-length portrait of *Queen Mariana* painted in 1652–3 (Plate 175) is conventional. Indeed, the stiff figure in its fantastically elaborate costume, the huge farthingale, massive coiffure, outsize feather and handkerchief combine to create an effect of extreme formality. This formal effect, however, is produced by unconventional, almost intangible means, in a free 'sketchy' style that ignores detail yet achieves an impression of form and texture, of character even. For the *Infanta María Teresa*, the King's daughter by his first Queen, painted at about the same time (Plate 174), Velázquez used the same compositional formula and the same broad technique. The family likeness between the two young women and their similar doll-like figures makes it the more remarkable that the little that can be seen in their faces through their make-up distinguishes them one from another.

The royal children, the Infanta Margarita and Prince Philip Prosper, are portrayed in similar traditional poses, their childishness behind the façade of royal dignity revealed with profound sensitivity. The Infanta Margarita, born a few weeks after Velázquez's return from Italy, was for several years the only child of the young Queen to survive. In a notable series of paintings of her from the age of two or three to the age of eight, Velázquez chronicles the gradual changes in her appearance and demeanour from those of a baby to those of a young princess. In the first of these portraits (Plate 176), the innovations of Velázquez's late style counteract the formality of the royal pose. Curtain, floor and table are daringly suggested with no attempt at conventional perspective; the vase of flowers, seen in isolation (Plate 178), could be mistaken for a nineteenth-century flower-piece. The Princess's pose changes hardly at all, the variety derives from the wide and sophisticated range of colours in her setting and, above all, in her costume. This changes from silvery pink to white and silver (Plate 177) and finally to the blue and silver of her grown-up farthingale and the brown of her huge muff (Plate 180). According to Palomino, this last portrait was painted in 1659 to be sent to the German Emperor Leopold I – her cousin, uncle and future husband –

174. *The Infanta María Teresa*. 1652–3. Canvas, 50 × 39 in. (127 × 99 cm.). Vienna, Kunsthistorisches Museum. (L-R 119) María Teresa, the only surviving child of Philip IV and Queen Isabel (1638–83), was no more than four years younger than her step-mother and cousin Queen Mariana, and very like her in appearance. Her portrait, originally full-length, was sent by Philip IV to the Emperor Ferdinand III in Vienna in February 1653. In the absence of a male heir, her marriage was a matter of European concern, and other portraits of her were sent to Brussels and Paris.

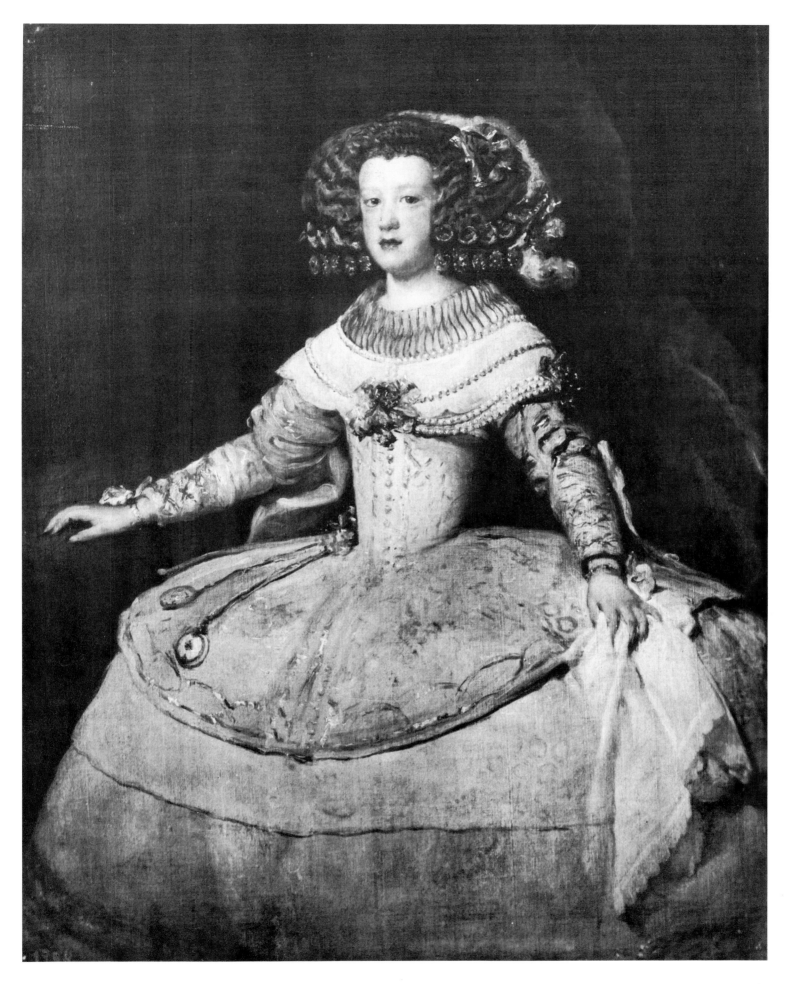

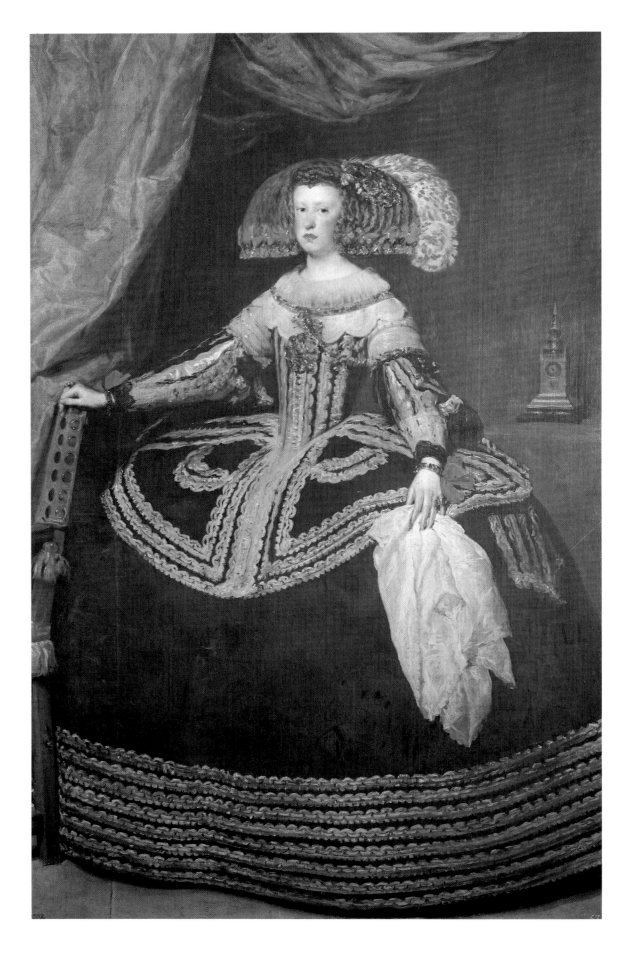

175 (Left). *Queen Mariana*. 1652–3. Canvas, *c*. 82¼ × 49¼ in. (*c*. 209 × 125 cm.). Madrid, Prado Museum. (L-R 177)
Philip IV's second wife Mariana of Austria (1634–96), daughter of his sister María and the Emperor Ferdinand III of Austria, arrived in Spain to marry her uncle in October 1649, when Velázquez was in Italy. A replica of this portrait was sent to the Emperor in Vienna in February 1653. This is the first of a series of royal portraits of the young Queen, her half-sister and her children, in which Velázquez was to display the brilliance of his late technique in a new and wide range of colours. The Queen is seen in mourning, thirteen to fourteen years later, in Plate 162.

176 (Right). *The Infanta Margarita in Pink*. *c*. 1653. Canvas, 50½ × 39½ in. (128 × 100 cm.). Vienna, Kunsthistorisches Museum. (L-R 122)
The daughter of Philip IV and Mariana, the Infanta Margarita María was born on 12 July 1651, shortly after Velázquez's return from Italy, married the German Emperor Leopold I in 1666 and died in 1673. Velázquez's first portrait of her when she was little more than two years old is one of the most enchanting child's portraits ever painted.

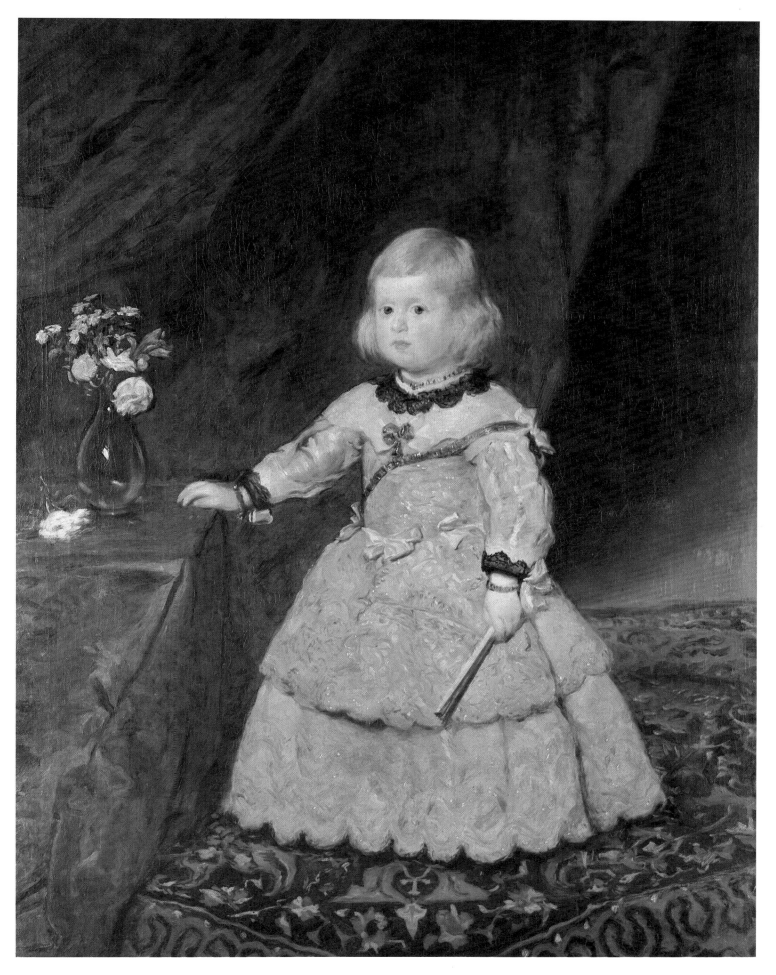

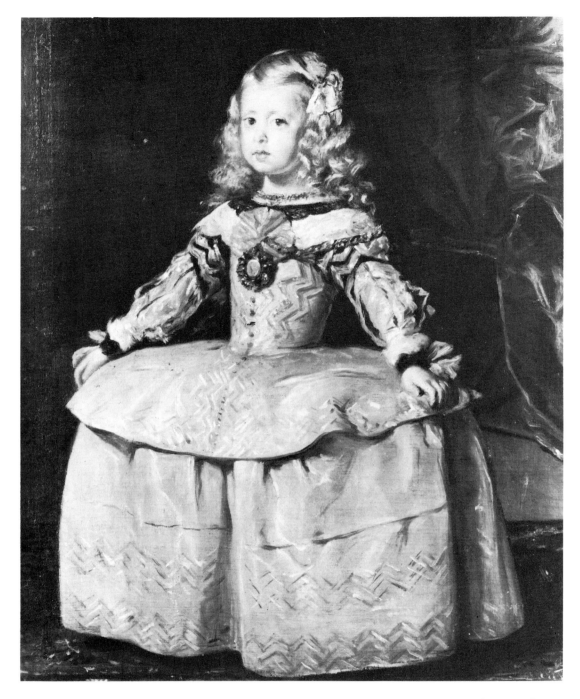

177. *The Infanta Margarita in White and Silver*. 1655–6. Canvas, 41½ × 34½ in. (105 × 87 cm.). Vienna, Kunsthistorisches Museum. (L-R 123)
The Infanta appears to be a little younger than in *Las Meninas*. She wears the same or a similar dress, her hair is curlier and parted on the other side. From an early age there were prospects of her marriage to the Emperor, and portraits of her were sent at intervals to Vienna.

together with a portrait of her brother, the longed-for but short-lived son and heir to the throne. Velázquez's only portrait of *Prince Philip Prosper* (Plate 181) shows him in his second year, apparently a little younger than his half-brother was in the painting of *Prince Baltasar Carlos with an Attendant Dwarf* (Plate 80), and in a similar pose. Philip Prosper's costume is less ceremonial – he wears an apron, like that of Baltasar Carlos's dwarf companion, over a red and white dress. Instead of the toy symbols of kingship in the dwarf's hand, the royal child himself is adorned with traditional amulets and charms – a fig-hand of jet, a piece of coral, a bell – as protection against the evil eye and sorcery. They hang as baubles on the child's dress, though they were probably the outward signs of apprehension for his survival. A dog lying on the chair (Plate 179) introduces an intimate note to intensify the contrast between the babyish figure and his conventional setting. These two portraits of the Infanta and the Prince are Velázquez's last recorded paintings – in the words of Palomino, 'the last, and the ultimate in perfection'.

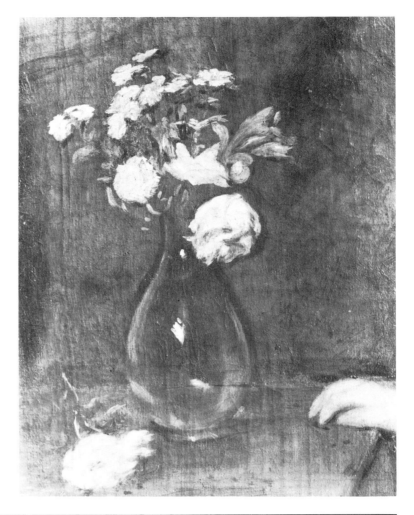

178. Detail of Plate 176.
The vase of flowers, placed as if to
complement the loveliness of the child, is
the only still-life of flowers in Velázquez's
oeuvre.

179. Detail of Plate 181.
Unlike the Infanta's vase of flowers, the
Prince's dog is one of several paintings by
the artist of dogs in royal portraits; this
one, Palomino points out, was a young
bitch that seemed to be alive and which
Velázquez had immortalized — an excuse,
perhaps, to quote a classical precedent.

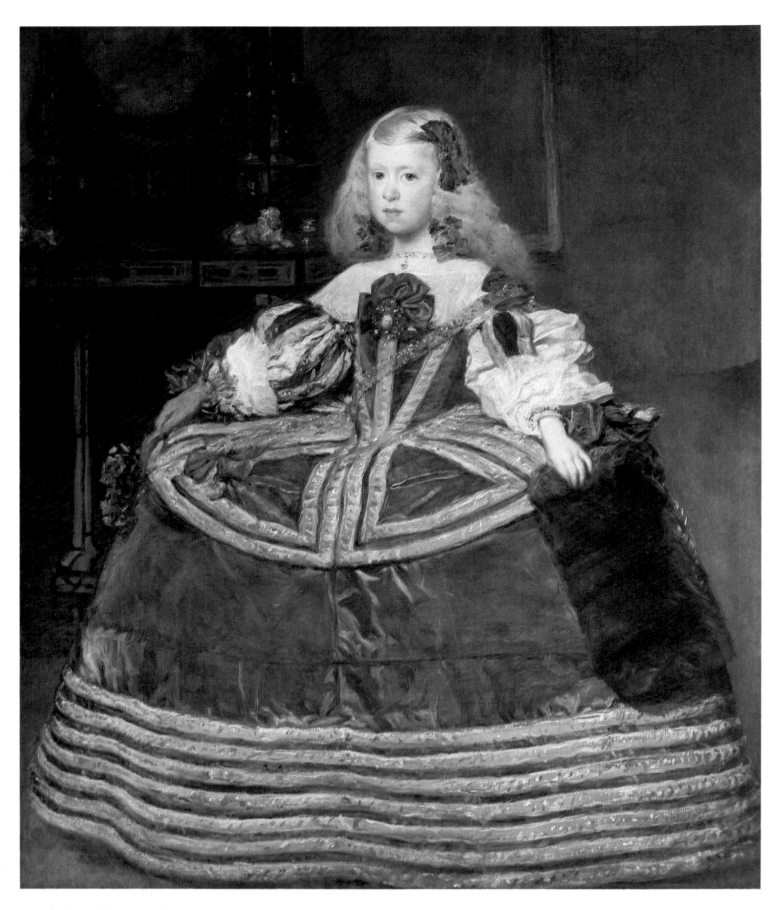

180. *The Infanta Margarita in Blue.* 1659. Canvas, 50 × 42 in. (127.5 × 107.5 cm.). Vienna, Kunsthistorisches Museum. (L-R 128)
Velázquez painted the portraits of the Infanta and her brother Philip Prosper in 1659, according to Palomino, to be sent to the Emperor Leopold I,
whom she was to marry in 1666. He says nothing of her colourful dress but describes in detail the remarkable clock behind her. The painting was
made into an oval in the 18th century and was evidently not restored to its original size as only the lower part of the clock is (barely) visible. A replica
in Budapest with the Infanta dressed in green is no more complete. Palomino must have seen a version showing the whole of the clock.

168

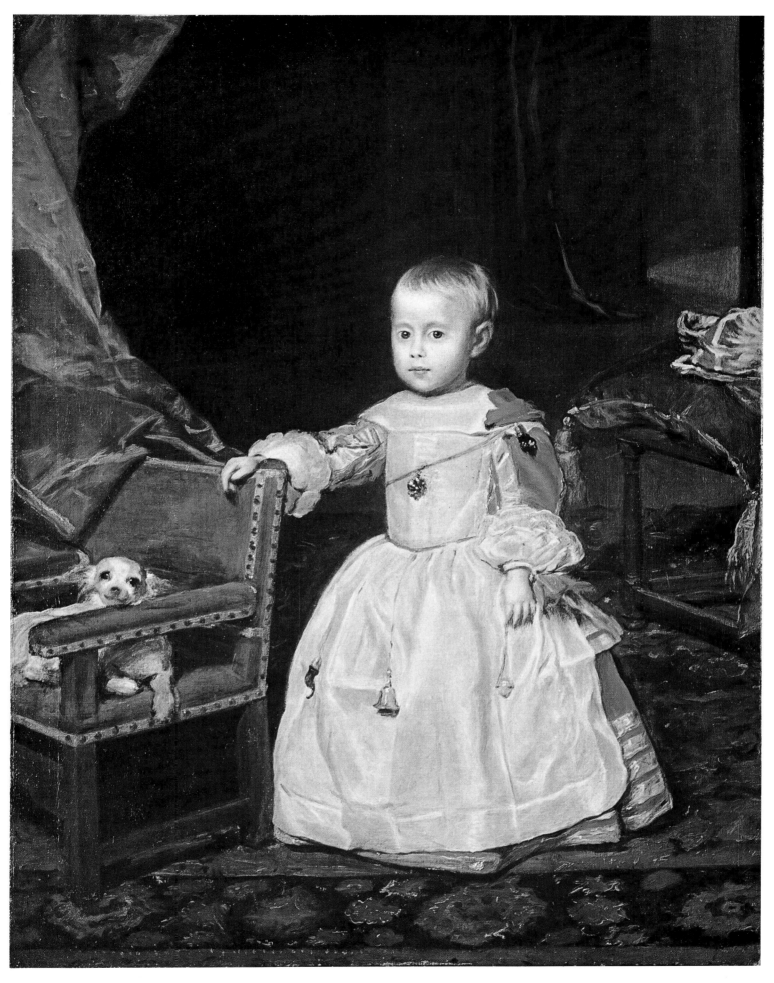

181. *Prince Philip Prosper*. 1659. Canvas, 50½ × 39 in. (128.5 × 99.5 cm.). Vienna, Kunsthistorisches Museum. (L-R 129)
Born 28 November 1657, the short-lived, sickly heir to the throne died on 1 November 1661. Velázquez painted this portrait together with that of the Infanta in 1659 to be sent to the German Emperor. Palomino describes the painting, as he does that of the Infanta, as if he had known it or a version of it, though one is not known, and in praising it remarks on the difficulty of painting children. The Prince is represented in his second year, possibly in celebration of his second birthday, the feast of Saint Prosper, the day Velázquez was invested with the habit of the Order of Santiago, according to Palomino. In place of the commander's baton and sword in the hands of Baltasar Carlos at a similar age (Plate 80), the child is bedecked with amulets to ward off the evil eye, echoing the fears that had replaced the earlier hopes of the ageing King.

These late, more or less ceremonial portraits of royal women and children are – the latter at least – the most colourful of all Velázquez's works. By contrast, his last portraits of Philip IV are simple busts in sombre tones, exceptional as royal images for their informal appearance (Plates 182, 183). Close-up views of the sad, ageing monarch, painted towards the end of the artist's life, they are his most intimate characterizations of any sitter, even of the King he had known and served for more than 30 years. Here again the transformation of Velázquez's style matches that of the King's appearance: the heavy head with its melancholy expression, drooping eyes and sagging cheeks is rendered with an amazing economy of modelling, outline and detail.

To judge from these impressions of Philip IV in his latter years, the King would no doubt have been less at ease in the *Salón de los espejos*, the sumptuous setting for official occasions, than in the intimacy of the room which Velázquez chose as the setting for the supreme masterpiece in portraiture of his last years – *Las Meninas* (Plate 184). Here in the apartment that had belonged to Baltasar Carlos, where Velázquez now had his studio, this image of the King – together with the Queen – is seen reflected in the mirror on the wall in the background of a lofty, gloomy room, furnished only with mirrors and with paintings in black frames. Strangely enough, given the acclaim with which later generations have greeted it, this painting is not recorded in Velázquez's lifetime – at least, no mention of it has so far come to light. It must nevertheless have been highly valued, for it hung in a room of some splendour, the ceiling of which was decorated by Colonna and Mitelli. *Las Meninas* (*The Maids of Honour*), the title by which the painting is known today, was not given it until the mid-nineteenth century, some time after it came to the Prado Museum from the royal collection. When it was first recorded in the inventory of the royal palace made in 1666, after the death of Philip IV, it was described as 'The Empress with her ladies and a dwarf'; and 20 years later, a little more fully, as 'A portrait of the Infanta of Spain with her ladies in waiting and servants by the Court Painter and Palace Chamberlain Diego Velázquez, who portrayed himself in it in the act of painting'. Ten years later a Portuguese writer on painting, Felix da Costa, remarks on the fact that the artist has introduced his own portrait in a painting of royalty, thus testifying to the high honour in which he was held by his King. The picture, he says, seems more like a portrait of Velázquez than of the Princess.

These are the only seventeenth-century mentions of the painting. For the makers of the inventories and probably for its original owner, it was a portrait of the Infanta Margarita, the future Empress, with her attendants – no more, no less – painted by a member of the royal household, who had the remarkable notion of showing himself actually at work. Da Costa, himself a painter, chose to emphasize the testimony to the standing of the artist implied by his presence in the picture. The earliest detailed description of *Las Meninas* is that of Palomino, who, as Court Painter to Philip IV's successor, Charles II, in 1688, was not only familiar with the painting but may also have known some of the people portrayed in it. The date he gives for the completion of the picture, 1656, is likely to be correct. The young Princess would then have been five and her appearance accords with this, as we can deduce from the other portraits of her by Velázquez. It is from Palomino that we know the identity of all but one of the Infanta's attendants: two *meninas* standing on either side of the Infanta, one handing her with a curtsey an earthenware vessel of water, the other appearing, he says, about to speak; and the two dwarfs, one treading on a dog dozing in the sunlight. Even the dog, says Palomino, stayed motionless while it was being painted. Behind stands an attendant to the ladies-in-waiting and a male escort – the only person

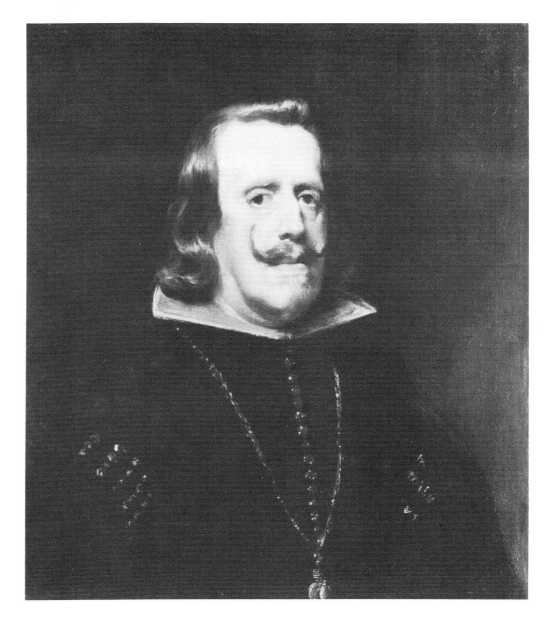

182. *Philip IV*. 1656–7. Canvas,
25¼ × 21⅛ in. (64.1 × 53.7 cm.). London,
National Gallery.
Very similiar in composition to Plate 183,
but the King looks a year or two older.
The costume, chain and toison d'or appear
to be by a studio assistant, but the head,
despite contrary opinions, is surely
autograph. This is the last known likeness
of Philip IV by Velázquez and even more
replicas were made of it than of the earlier
one. It was the model for Pedro de
Villafranca's engraved portrait in
Francisco de los Santos, *Descripción breve
... del Escorial*, 1657 (a book in
Velázquez's library) and used in later
publications.

not named by Palomino – and in the doorway, the Queen's Palace Marshal, said
to be a good likeness, despite the distance and the small scale of the figure. For
Palomino, too, this was Velázquez's most illustrious work. With this picture, he
foretold, Velázquez's name would live as long as the Infanta's. He was too much
the child of an age and a country of absolute monarchy to see that later ages would
reverse his verdict: the Infanta lives today only because Velázquez painted her.

The room in the royal palace where the scene takes place and where it was
painted, according to Palomino, was one of the apartments in the part of the
palace where Velázquez had his studio. It was decorated with 40 paintings after
Rubens and his school by Velázquez's pupil Mazo. The two canvases seen dimly
on the wall in the background – and seen only dimly even in Palomino's time –
can be identified with paintings of the *Fable of Arachne* and *Apollo and Midas* after
originals by Rubens and Jordaens (Plates 172, 186). The half-length figures of
Philip IV and Queen Mariana are seen in a mirror below. The suggestion that this
is not a mirror but a third picture is belied by the fact that no double portrait of
the King and Queen is recorded in this room or elsewhere and still more by the
way in which the artist has created the shimmering surface of a mirror reflection.

The scene is completed by the figure of the artist himself standing before an
enormous canvas, brush and palette in hand. Velázquez is dressed as a courtier,
with the key of his office as Palace Chamberlain at his waist (Plate 188). The cross
of the Order of Santiago on his breast must have been added later – according

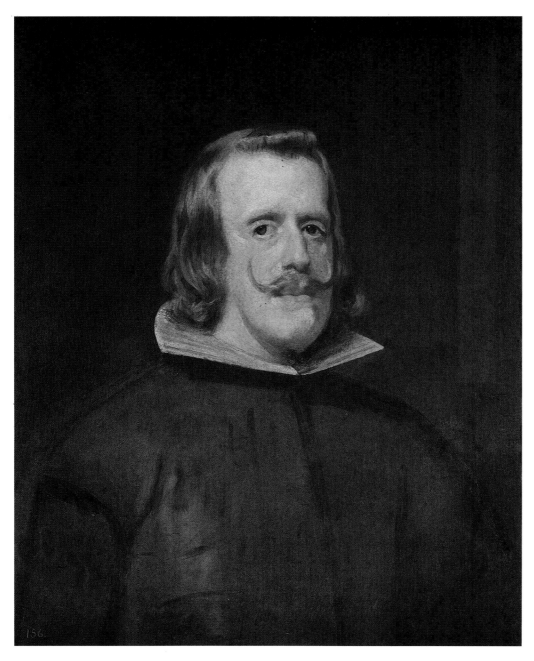

183. *Philip IV*. 1654–5. Canvas, 27 × 22 in. (69 × 56 cm.). Madrid, Prado Museum. (L-R 120)
The head was the model for an engraving by Pedro de Villafranca (a bust in armour), published as frontispiece to the *Regla y establecimientos* of the Order of Santiago in 1655. Velázquez's friend Lázaro Díez del Valle (1656) mentions a portrait of the King that Velázquez had just finished which he admired more than anything else he had seen by him in the palace, praising it for its 'lifelike' quality, 'a great spirit in living flesh'. Though there is no evidence that he referred to this portrait, it is the first known likeness of the King painted after Velázquez's return from Italy.

to legend it was painted by the King himself – since Velázquez was not awarded this honour until 1659, the year before he died. This is the only surviving self-portrait and one of the few certain likenesses that we have of him.

Since we know the setting of the scene and the identity of the people portrayed in it, the only unknown factor is the canvas on which the artist is at work. We see only its back. This has given free rein to conjecture. Some believe that Velázquez has represented himself working on *Las Meninas* itself; it has even been suggested that the whole picture was painted with the mechanical aid of a mirror. Among the many arguments against this suggestion is the fact that the Infanta and her *meninas*, as well as the artist, are seen to be right-handed, and the paintings on the wall are not in reverse. Another theory is that Velázquez is about to paint the Infanta, who is being cajoled by her attendants to pose, and that the King and Queen have come to visit him while he paints. Palomino thought that Velázquez had cunningly revealed the subject of the canvas on the easel by showing a reflection of it in the mirror. The most widely held and most convincing explanation is slightly different. This is that Velázquez has represented himself at work on a full-length portrait of the King and Queen, though no such double portrait

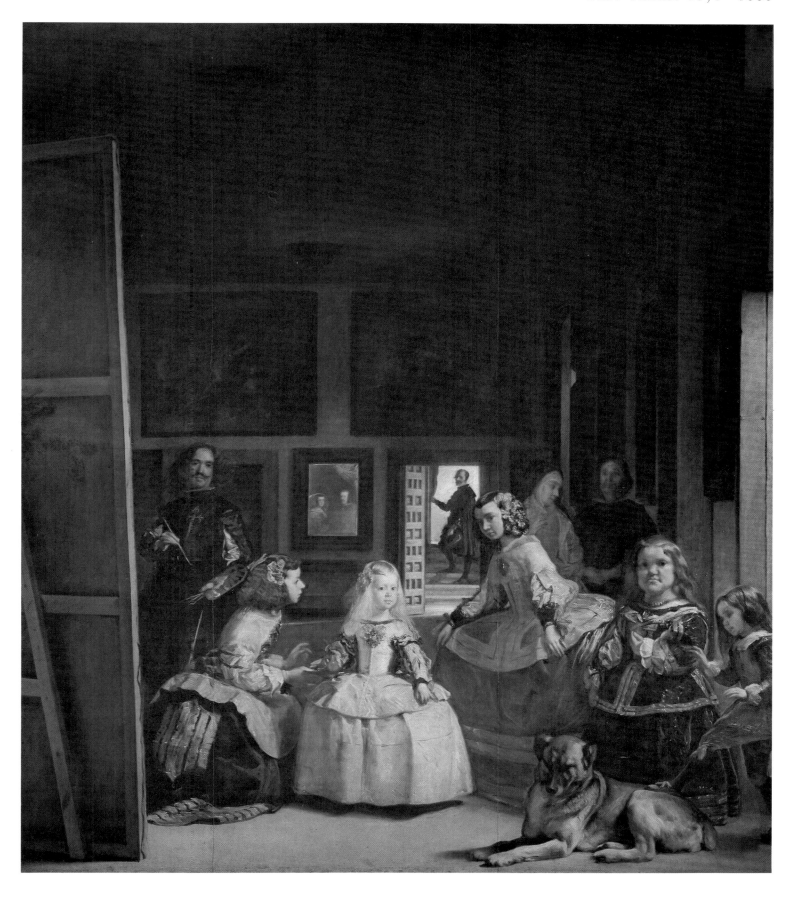

184. *Las Meninas (The Maids of Honour)*. 1656. Canvas, 125 × 109 in. (318 × 276 cm.). Madrid, Prado Museum. (L-R 187)
Since Palomino's time, *Las Meninas* has remained 'the most illustrious' of Velázquez's works, highly original in conception and unequalled in execution. The scene takes place in the apartment in the palace where the artist had his studio, a room decorated with 40 paintings after Rubens; two of them are dimly visible on the wall behind (cf. Plates 172, 186). The Infanta Margarita, accompanied by her *meninas* and dwarfs and dog and other members of the royal household, is being ceremoniously offered a drink of water. like the artist standing at his easel she looks towards the spectator, at the imagined figures of the King and Queen, whom Velázquez is presumably painting and whose images are dimly reflected in the mirror in the background. One cannot but agree with E.H. Gombrich that the painting is perhaps 'the most daring case of drawing the beholder into a composition, and also artistically the most perfect' (*Symbolic Images*, p. 211).

has ever been known, and that it is not his canvas but the royal couple themselves who are reflected in the mirror. We must imagine them standing where we stand to look at the picture. It is at the King and Queen that the Princess and some of her attendants seem to be looking, and on them – or us – that the artist's gaze appears to rest as he steps back from his large canvas. It is their imagined presence looking at their own reflection that completes the composition and puts the spectator artfully in the picture (Plate 187).

Velázquez had only once before used the mirror as a compositional device, as distinct from a portrait painter's aid. In his *Venus* (Plate 136), the mirror dimly reflects the features of the nude model. But Venus's mirror is part of her usual equipment, and there serves chiefly to create an effect of depth. The only other painting before *Las Meninas* where the mirror is introduced not only to draw the eye inwards but also to bring the spectator into the picture is Jan van Eyck's *Marriage Portrait of the Arnolfini* (Plate 185). There the mirror on the wall in the background reflects not only the backs of the married couple but also two figures in front of the picture, one of whom is thought to be the artist, who signs himself: *Johannes de Eyck fuit hic – 1434.* Van Eyck's painting may even have given Velázquez the idea for his far more elaborate and sophisticated composition, since it was in the Spanish royal collection in his time.

As a group portrait that is at the same time a court scene, *Las Meninas* is not only unique in Velázquez's oeuvre: it is also exceptional in the history of painting. Perhaps the artist owes something to the tradition of seventeenth-century Dutch cabinet pictures, though beside a northern interior *Las Meninas* has an air of courtly elegance. Beside an English royal group by Van Dyck, on the other hand, it has something of the informality of a conversation piece.

Until modern times *Las Meninas* was admired by painters and critics alike as a masterpiece of composition and portraiture, above all for the remarkable way in which Velázquez has created the illusion of reality, the impression of a momentary glance at an actual scene. In recent years, however, attempts have been made to interpret the painting, to see it, for instance, as a roomful of allegories and symbols based on the mirror and the subjects of the paintings on the wall in the background. Some, with more restraint, have discovered reference to the question of the painter's standing, to the repeated demand for the recognition of painting as one of the liberal arts, and it has been described as 'not only an abstract claim for the nobility of painting, it is also a personal claim for the nobility of Velázquez himself' – at the time the picture was painted he had set in motion the machinery for his membership of the Order of Santiago. These attempts to find a hidden significance in *Las Meninas* are less than satisfying. If there must be an occasion or motive for the painting, a political explanation is perhaps the most likely. This would in no way conflict with the traditional view of it as a court scene. The Infanta could then take the centre of the stage as heir to the throne, the only living child of Philip IV and Mariana and the only hope at the time of perpetuating the Spanish branch of the Habsburgs. Philip IV's daughter by his first marriage, the Infanta María Teresa, who is absent, was to renounce the throne when she married Louis XIV, and although the marriage did not take place until 1660, it was in 1656 that it was first proposed. After the birth of a male heir to the Spanish throne, the Infanta Margarita was betrothed to the Emperor Leopold I.

Both in invention and execution, *Las Meninas* is the ultimate solution of problems that had occupied Velázquez from the beginning: problems of composition and perspective, of likeness and visual truth, problems of light and colour and distance, of aerial perspective, that were not to become the subject of

185. Jan van Eyck (*d.* 1441). *The Marriage of Giovanni Arnolfini and Giovanna Cenami(?)*. Signed and dated: *Johannes de Eyck fuit hic – 1434.* Panel, 32¼ × 23½ in. (81.8 × 59.7 cm.). London, National Gallery.
Taken to Spain by Mary of Hungary in 1556, the painting presumably remained in the royal collection, but the first mention of it is in an inventory of 1701, when it was in the Alcázar. The form of the signature: 'Jan van Eyck was here' has been taken to mean that he was a witness to the marriage and is one of the figures reflected in the mirror.

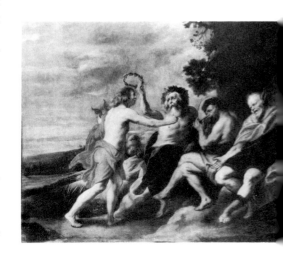

scientific study before the nineteenth century. Palomino saw the foundation of Velázquez's mature style in a technical peculiarity – his use of specially long brushes to enable him to keep his distance. He added (in the words of Vasari about Titian) that seen close to his portraits are unintelligible, but seen from a distance they are miraculous. Although Velázquez must have placed his easel at a distance from which he could take in the whole scene of *Las Meninas*, the brush in his hand in the painting is not particularly long. But his hand seen close to is, indeed, unintelligible (Plate 188). Only at a distance and in relation to the rest of his body does it take shape. Similarly, the figures and faces of his other sitters take form and definition according to their position in the composition. The female dwarf in the foreground, nearer to the spectator than the central figure, for instance, stands out, her dress boldly but sketchily painted, her ugly face indistinct in the strong light from the window. The Infanta herself, the central figure, in fuller and more even light, is more delicately painted with diffused brush strokes and soft shadows that sensitively portray the childish expression on her face.

187. Detail of Plate 184.
As in the case of the mirror reflecting the face of Venus (Plate 136), it is with artistic licence that the mirror on the far wall in *Las Meninas* reflects only the half-length figures of the King and Queen. Here again the reflection is dim, though the royal couple are easily recognized from the portraits by Velázquez of the young Queen and the ageing King (Plates 175, 183). Their mirrored reflection produces an extraordinary awareness of their presence.

186 (*Left*). Juan Bautista Martínez del Mazo (*c.* 1612/16–67) after Jacob Jordaens (1593–1678). *Apollo and Midas.* After 1637. Canvas, 71¼ × 87¾ in. (181 × 223 cm.). Madrid, Prado Museum.
The canvas by Jordaens (Prado) after a sketch by Rubens was painted for the Torre de la Parada. Mazo's painting, one of the many copies he made after Rubens and his school for the room in the Alcázar that is the scene of *Las Meninas*, is dimly seen, together with his copy of the *Fable of Arachne* (cf. Plate 171) on the wall at the back of Velázquez's masterpiece

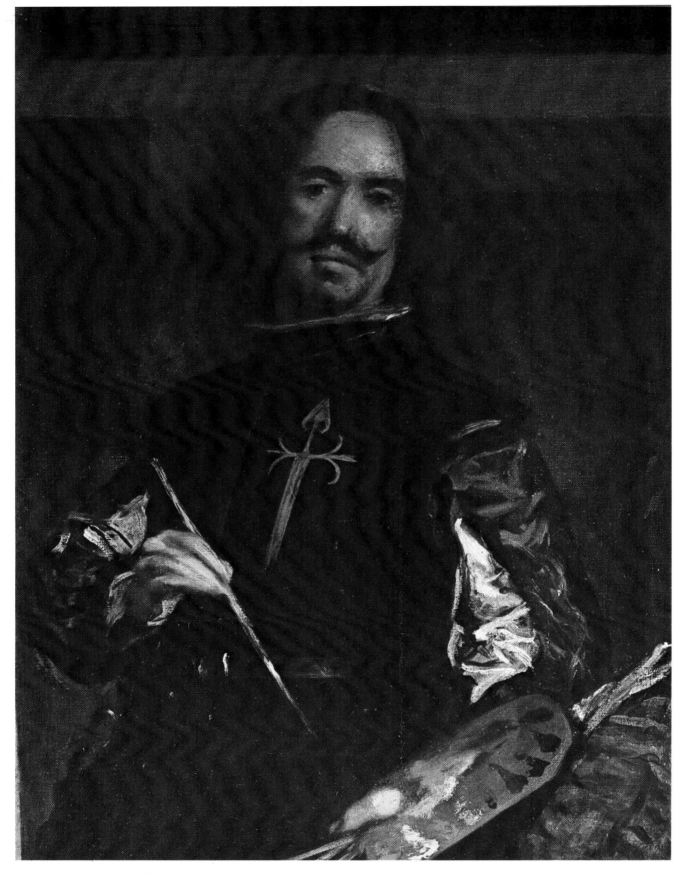

Kenneth Clark has vividly and eloquently described how he stalked *Las Meninas*, as if the painting were alive, in an attempt to find out how it was done. 'I would start from as far away as possible,' he writes, 'when the illusion was complete, and come gradually nearer, until suddenly what had been a hand, and a ribbon and a piece of velvet dissolved into a fricassée of beautiful brushstrokes. I thought I might learn something if I could catch the moment at which this

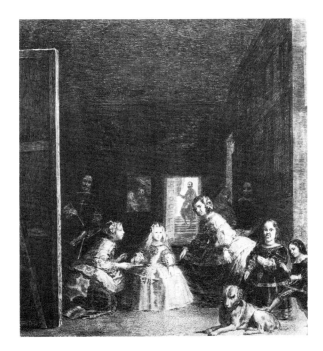

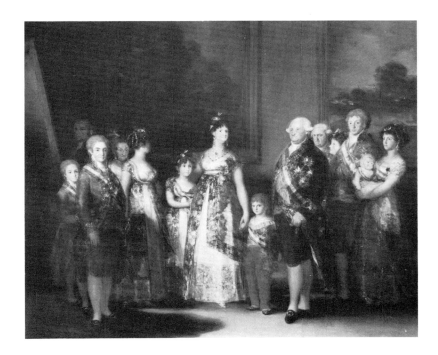

189 (*Above*). Francisco Goya (1746–1828) after Velázquez. *Las Meninas. c.* 1778. Etching, 16 × 12¾ in. (40.5 × 32.5 cm.). An unpublished etching (only rare proofs are known) after the painting by Velázquez.

190 (*Above right*). Francisco Goya (1746–1828). *Charles IV and his Family.* 1800–1. Canvas, 110¼ × 132¼ in. (280 × 336 cm.). Madrid, Prado Museum. Goya was obviously inspired for the composition of his royal group by *Las Meninas*, which he had copied in etching many years before. Like Velázquez, he stands at an easel behind the royal family but, unlike Velázquez, he makes no attempt to create an illusion of space and his group was probably composed in his studio from sketches made from life.

transformation took place, but it proved to be as elusive as the moment between sleeping and waking.' Velázquez himself would probably have found it difficult to explain how he brought about this magical triumph of communication from eye to hand. But his own position in the composition, behind the Infanta and her maids-of-honour, and his attitude as he steps back thoughtfully to view his sitters, seem to invite the spectator also to step back and put himself in the position of the King and Queen, the position from which they could see themselves dimly reflected in the mirror in the background, and from which they could take in the whole scene before them.

It is hardly surprising that *Las Meninas* was a source of inspiration not only to Velázquez's immediate followers, Mazo, Juan Carreño and Claudio Coello, but also to much later artists. Goya, the first painter fully to appreciate the innovations of Velázquez's style, copied his painting in an etching (Plate 189) and made it the source of his own *Charles IV and his Family* (Plate 190). In modern times *Las Meninas* inspired Picasso to paint a dazzling series of 44 variations on its theme, exploring the enigmatic relationship between artist, subject and spectator (Plate 191).

191. Pablo Ruiz Picasso (1881–1973) after Velázquez. *Las Meninas.* 1957. Canvas, 76⅜ × 102⅜ in. (194 × 260 cm.). Barcelona, Museo Picasso.
Painted in Cannes on 17 August 1957, this is the first of a series of 44 variations on the theme of *Las Meninas* which occupied Picasso for two months. 'He had taken possession of *Las Meninas* ... The realism of Velázquez that he had so much admired had been transformed into the life of Picasso and his surroundings' (R Penrose, *Picasso*, 1981, p. 422).

9 Summing Up

To modern eyes, it is clear that Velázquez had already at an early stage in his career eclipsed his rivals in Spain. Nor, looking at his oeuvre as a whole, do we have any difficulty in seeing that he stands with Rembrandt as one of the two great painters of the age. What is less easy to bear in mind is that we have to judge Velázquez on a relatively small surviving total autograph production – fewer than 150 paintings, next to no drawings and no engravings or etchings, as against some 500 paintings, nearly 2,000 drawings and over 300 etchings by Rembrandt. This situation is partly due to Velázquez's famous 'phlegm' and 'slowness' – real or alleged – partly to the demands of the offices he held at court, and partly to loss and destruction both of the works themselves and of the settings for which they were intended. This last loss makes more serious difficulties for us in forming our view of Velázquez than of Rembrandt. Royal Madrid and bourgeois Amsterdam were (and are) very different ambiences, Madrid perhaps, as more distant from ourselves, the more difficult to understand and appreciate. The royal and noble patrons for whom Velázquez was working were very different from the businessmen who commissioned and bought paintings from Rembrandt. Enough survives in Amsterdam and elsewhere in Holland for us to form an estimate of the original backgrounds to Rembrandt's paintings. Velázquez is perhaps better represented in his native country than Rembrandt in his, but nowhere, even there, do his paintings hang in the place for which they were made. The Royal Palace, scene of *Las Meninas*, the Buen Retiro Palace and the Torre de la Parada – the buildings for which most of Velázquez's canvases were painted – have all long been nearly totally destroyed. Such destruction makes it less easy to bring to life the Court – even the age – of Philip IV, despite a certain amount of surviving evidence in the form of written documents, drawings, engravings and paintings of the palaces, much of it put to excellent use by modern scholars. We have of course the paintings of Velázquez himself, *Las Meninas* for example, and the many portraits of the King, his family, his courtiers, dwarfs and jesters, which are more vivid and direct than any description. There is, too, the indirect evidence of royal and court tastes and predilections in his other works, notably the enthusiasm for horsemanship and hunting.

The age of Velázquez – and of Philip IV – was an age of many changes and great contrasts. The death of Philip II, only a year before Velázquez was born, marked at the same time the beginning of the decline of the great empire bequeathed to him by Charles V and the dawn of a Golden Age of Spanish painting. The city of Seville, the commercial capital of Spain in Velázquez's youth, was obliged on the death of Philip IV to postpone his funerary honours

for lack of funds. The series of economic, political and military disasters that
Spain suffered during Philip IV's reign culminated, on the death of his heir, the
mentally and physically feeble Charles II, in the final collapse of Habsburg rule
in Spain. The court that was the background to these events was a scene of
continual conflict: the conflict between strict etiquette and lax morals, religious
zeal and personal indulgence, poverty and prodigality. The many sumptuary laws
introduced by the King and his ministers were flouted by lavish displays of
opulence on every possible occasion. The canonization of saints, the birth of royal
children, the arrival of distinguished visitors from abroad, were celebrated with
festivities that lasted for days, if not weeks, with processions, bullfights, jousts,
pageants, theatrical performances and other entertainments. From the visit of
Charles, Prince of Wales, in 1623 to the arrival of the French embassy in 1659 to
negotiate the Peace of the Pyrenees, the opportunities for such celebrations were
numerous, and their extravagance astonished foreigners and earned the censure
of Spaniards. At the same time, the King's personal conflict between love of
pleasure and reforming zeal is revealed in his correspondence with the nun, María
de Agreda. From 1643 until her death in 1665, shortly before that of the King,
he sought her counsel and prayers in his attempt to save Spain from the calamities
which he feared were the punishment for his own sins and for the corruption of
the court, which he tried in vain to curb.

Philip IV failed to save his country from loss of its power and prestige. His
reign, paradoxically, saw the late flowering of letters as well as the visual arts in
Spain. The picaresque novel, established as a genre in the sixteenth century,
survived to enjoy wide popularity abroad as well as at home. The most celebrated
seventeenth-century example, *El Buscón*, was first published in 1626. The author,
Francisco de Quevedo y Villegas (1580–1645), famous novelist, poet and satirist,
courtier and art collector, was an admirer of Velázquez and one of his sitters (Plate
192). A critic of the 'corrupt' style of Luis de Góngora (1561–1627), who had also

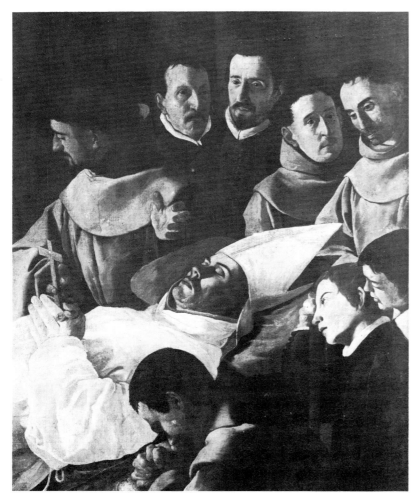

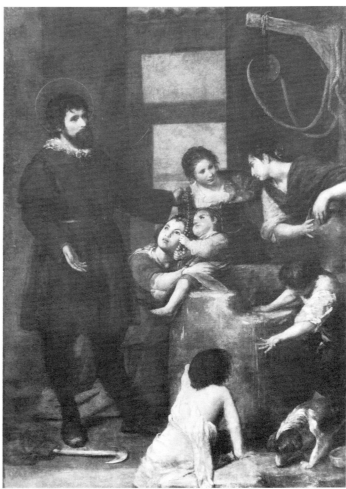

sat to Velázquez (Plate 29), as well as of the corrupt life of the court, Quevedo's attacks on Olivares led to his imprisonment in 1639 until the latter's downfall in 1643. Velázquez's likeness of Quevedo inspired the portrait in the frontispiece designed by Alonso Cano for his *Parnaso español*, first published in 1648 (Plate 193). Many writers less outspoken than Quevedo sought and won favour at court. Literary contests were among the palace entertainments, poets celebrated public events, and several of Velázquez's portraits, his *Surrender of Breda*, and the decoration of the *Salón de Reinos* were the subjects of eulogies in verse; a panegyric on the painter, composed on his death, appeared in the *Lyra de Melpómene* in 1666 by Enrique Vaca de Alfaro, co-author with his brother Juan of the epitaph published by Palomino.

Of all the literary arts, it was in the field of drama rather than of poetry that Philip IV's patronage was most productive. The enthusiasm of the King and court for theatrical performances rivalled even their devotion to the hunt. The court theatres rather than the public *corrales* were the chief settings for Spain's most prestigious and influential dramatists, Lópe de Vega Carpio (1562–1635) and Pedro Calderón de la Barca (1600–81), as well as for numerous lesser playwrights. Lópe de Vega and Calderón took part in the fight for painting to be declared a liberal art, a fight that began in El Greco's time and was only finally won in 1677, Calderón, in his plea, citing the honours bestowed on Velázquez by Philip IV. Both Lópe de Vega and Calderón wrote plays performed at court celebrating military victories that were later to be the subjects of paintings in the *Salón de Reinos* in the Buen Retiro. Calderón's *El sitio de Breda* was to inspire Velázquez's *Surrender of Breda*. Calderón also wrote an allegorical drama on the

194 (*Above left*). Francisco de Zurbarán (1598–1664). *Saint Bonaventure on his Bier*. Detail. *c.* 1629. Canvas, 98½ × 87½ in. (250 × 225 cm.). Paris, Louvre.
The Saint (died 1274) lies in state mourned by Emperor, Pope and Archbishop of Lyons and a group of Franciscans and two clerics, all painted as if from life.

195 (*Above*). Alonso Cano (1601–67). *The Miracle of the Well*. *c.* 1646–8. Canvas, 85 × 58¾ in. (216 × 149 cm.). Madrid, Prado Museum.
Cano's painting of Saint Isidore the Labourer (patron of Madrid) rescuing a child was much admired by his contemporaries and by Palomino, who called it a miracle of draughtsmanship and colouring. More than almost any other work of Cano, it reflects his admiration of the mature style of Velázquez.

new Buen Retiro Palace, to be performed there in 1634, and many of his later plays were written specially for the new theatre in the palace, opened in 1640, with its modern stagecraft and machinery introduced from Italy. Calderón, like Velázquez, had the King as his patron, and he too was rewarded with membership of the Order of Santiago, in 1637, but unlike Velázquez he was not exempted from military service. Until the end of his life, even though he was ordained priest (after the repeated closure of theatres in periods of national crisis during the 1640s), he continued to write plays for the palace as well as *autos sacramentales* (religious dramas) for Philip IV and for his heir.

While he played an important role as patron of the theatre, it was as patron of artists that Philip IV was unrivalled in his time, not only in Spain but in the whole of Europe, and no doubt his greatest claim to fame is the recognition and admiration he accorded Velázquez. In Seville, it was in the service of the Church that the arts flourished in the seventeenth century until the deaths of Bartolomé Esteban Murillo (1617–82) and Juan de Valdés Leal (1622–90). In Madrid, it was in the service of the King that the great painters of the age flourished, from Velázquez to Juan Carreño de Miranda (1614–85) and Claudio Coello (1642–93). In both centres Velázquez played an important role in artistic development.

There are, as we have already seen, certain obstacles to a precise definition of this role, chief among them the relative smallness of Velázquez's oeuvre. Moreover, many of his works have perished or disappeared. Despite these losses, Velázquez's surviving autograph oeuvre is sufficient to cover nearly every phase of his career, from his beginnings as a provincial painter of religious and genre subjects to his triumph as Court Painter *par excellence*. Smallness need not imply poverty and it is the richness of his achievement in every genre that he attempted which contributes largely to Velázquez's deserved reputation as one of the great masters of European painting.

As the first and also the foremost exponent of the naturalistic style in Seville, Velázquez was in all probability the chief influence on the beginnings of his two major contemporaries, Francisco Zurbarán (1598–1664) and Alonso Cano (1601–67), both primarily religious artists. For Zurbarán, naturalism was a language that lent itself to the expression of religious devotion, for the representation of saints and other holy persons with portrait-like realism (Plate 194), and his style was little modified in the course of his career, despite his visit to the court to take part in the decoration of the *Salón de Reinos* in the Buen Retiro. Cano, on the other hand, who had been a fellow pupil with Velázquez of Pacheco, after leaving Seville for Madrid in 1638, came under other new influences at the court, including that of Velázquez, which gradually transformed his style before he settled in Granada (Plate 195). Both Zurbarán and Cano, when testifying in Madrid in 1658 for Velázquez in his application for membership of the Order of Santiago, declared that they had known him and his family for 40 years and more, since their youth in Seville. As a painter of *bodegones*, Velázquez was one of the earliest and certainly the most accomplished exponent of the genre, and his master Pacheco was not alone in admiring and imitating them. A generation later, Murillo, trained in the same naturalistic style, must have been attracted not least by the humble models in Velázquez's Seville paintings, forerunners, like the heroes of the picaresque novel, of Murillo's own idealized beggar children in religious subjects and genre (Plates 196, 197).

At court, Velázquez's influence dominated portraiture in his lifetime and, in one form or another, until the end of the seventeenth century. Religious and profane painting owed less to him than to the examples of Rubens and Van Dyck, while the Bolognese painters Colonna and Mitelli had a lasting influence on their

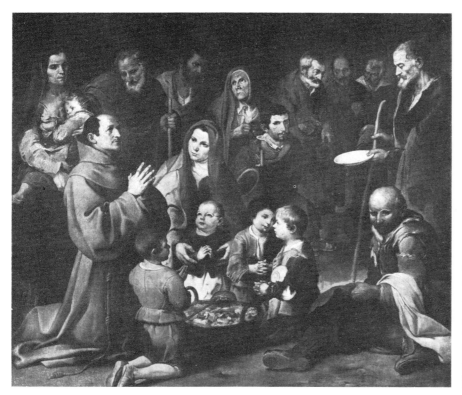
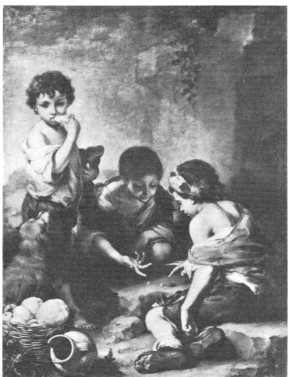

few Spanish colleagues and successors who practised painting in fresco. Chief of the painters in Velázquez's area of influence was his son-in-law and successor Juan Bautista Martínez del Mazo (1612/16–1667), a specialist in painting small figures and in copying Titian and Rubens as well as Velázquez. The *View of Saragossa* (1647, Prado), despite the inscription with Mazo's name, is thought by some critics to be partly by Velázquez. More probably, it gives credence to the attribution to Mazo of some other landscapes that have been wrongly ascribed to Velázquez. Mazo's documented portraits date from after his master's death and are indebted to Velázquez's painting of the 1630s and 1640s as much as to his style

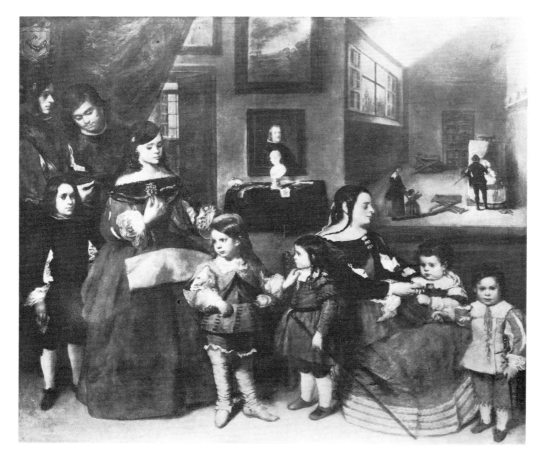

198. Juan Bautista Martínez del Mazo (1612/16–67). *The Artist's Family.* *c.* 1664–5. Canvas, 58¼ × 68¾ in. (148 × 174.5 cm.). Vienna, Gemäldegalerie. Formerly attributed to Velázquez, Mazo's authorship was established from the shield in the top left corner with a mailed fist holding a mallet (*mazo*). The artist's second wife is represented on the right with her young children; Velázquez's grandchildren are on the left (Mazo's first wife, Velázquez's daughter, had died in 1654). The setting is apparently the Court Painter's studio in the palace, with a portrait of Philip IV, similar to Velázquez's last portraits of him, on the wall; in the background a painter (Mazo or Velázquez?) is seen at work on a portrait of the Infanta Margarita. Inspired by *Las Meninas*, as a family group, Mazo's homage to Velázquez is unusual and original.

in the last period of his life. His group portrait of *The Artist's Family* (Plate 198), once attributed to Velázquez himself and directly inspired by *Las Meninas*, uses a studio setting in which the artist is able to incorporate a tribute to the master, which in turn reflects his pride in his illustrious connection. On the background wall to the left hangs one of Velázquez's royal portraits, while to the right a figure – either Velázquez or Mazo – seen from behind as he stands before an easel, is working on a portrait of the Infanta Margarita. Mazo's talent for imitating the work of his master makes him the most likely candidate for authorship of many of the numerous copies and variants of Velázquez's portraits. He also made some modest innovations in portraiture. It was he who originated the composition of *Queen Mariana* in mourning, after the death of Philip IV, seated at a table in a room in the Alcázar, with a view of a second room in the background (Plate 162) – another echo of *Las Meninas*.

Mazo's successor Juan Carreño de Miranda (1614–85), who was appointed Painter to Charles II in 1669, chose as his setting for portraits of the Queen Mother and the young King the *Salón de los espejos*. Though he had collaborated in the decoration of the ceiling of the *Salón*, under the direction of Velázquez,

there is no glimpse of it in his portraits. What is notable is his debt to the master in the style and pose of the sitter in his portraits of *Charles II* (Plate 161) and in his settings of paintings and sculptures seen reflected in the mirror behind the sitter.

Another painter who, like Carreño, owed much to the late fluent technique of Velázquez as well as to Colonna and Mitelli was Claudio Coello (1642–93), the last important Spanish painter of the century in Madrid. Coello's masterpiece, the *Adoration of the Sacred Host* (Plate 199), painted in 1685–90 for the sacristy of the Escorial, an addition to the paintings hung there earlier by Velázquez, openly exploits the illusionistic effects of *Las Meninas*. The painting commemorates the installation of a famous reliquary with the Host in the altar of the sacristy, which took place in 1684 in the presence of the King and members of the court and clergy. The lighting and perspective are designed to create the impression that the view of the sacristy in the painting is a continuation of the walls, windows and painted ceiling of the sacristy itself. An illusion of actuality is heightened by the canvas serving as a screen to the altar in which the relic was installed.

The final tribute paid to Velázquez in the seventeenth century was that of a foreigner. Luca Giordano came to Spain from Naples at the invitation of Charles II in 1692 and remained for 10 years, covering the walls and ceilings of the palaces and churches of Madrid and the Escorial with elaborate Baroque fresco decorations. His enthusiasm for Velázquez, on the testimony of Palomino, who knew him personally, was expressed in his praise of *Las Meninas*, which he proclaimed the 'theology of painting' – the greatest of paintings. Further, in a canvas once attributed to Velázquez but now accepted as by Giordano, he portrayed himself in a way that reflects his admiration for Velázquez's most dazzling and sophisticated composition. Nothing could be more apt than the title usually given Giordano's painting: *Homage to Velázquez* (Plate 201).

Nearly every painter at the court of Philip IV and Charles II owed something to the example of Velázquez. Such was his pre-eminence, however, that he had no immediate followers. It is hardly too far-fetched to say that the first artist to appreciate fully the innovations and mastery of his style was Francisco Goya (1746–1828). Goya, in the words of his son, 'looked with veneration at Velázquez and Rembrandt, but above all he studied and looked at Nature, whom he declared his mistress'.

Goya's study of Velázquez began with his copies in etching of 16 paintings in the royal collection, which are among his earliest works in this medium. Goya's royal equestrian portraits are descendants of Velázquez's, his *Family of Charles IV* (Plate 190) was obviously inspired by the composition of *Las Meninas*, his *Naked Maja* (Prado) by Velázquez's *Toilet of Venus* (Plate 136) in its lifelike portrayal of the female nude. Velázquez not only influenced Goya's approach to nature, he also provided him with an exemplar of the 'impressionistic' style which Goya was to develop further than any artist of his age, the style in which he creates the blind eyes and jovial expression on the face of *Tío Paquete* (Plate 202), that goes back to Velázquez's vivid portrayals of the faces of dwarfs and idiots. Goya recognized his debt to Velázquez even in his most extreme examples of the style, the series of small paintings on ivory made in his old age when he was in exile in Bordeaux (Plate 200). They were, he wrote to a friend, 'original miniature painting such as I have never seen, for it is not done with stippling and they look more like the brushwork of Velázquez than of Mengs'.

From his own time until the present, Velázquez has been admired by painters and writers in Spain above all as a master whose art was based on the observation of nature, whose genius lay in the power to re-create on canvas his impressions of the visible world. We find his teacher, Francisco Pacheco, in the early 1630s

200. Francisco Goya (1746–1828). *A Man looking for Fleas in his Shirt*. 1824–5. An individual technique employing carbon black and red wash on ivory, 2⅛ × 2⅛ in. (5.5 × 5.5 cm.). Los Angeles, private collection.
One of the collection of 'some 40 experiments' made by Goya, which he described as 'original miniature painting ... more like the brushwork of Velázquez than of Mengs'.

201. Luca Giordano (1634–1705). *Homage to Velázquez*. Canvas, 90¾ × 71¾ in. (205 × 182.3 cm.). London, National Gallery.
Presented to the Gallery in 1895 as by Velázquez, the painting is now convincingly attributed to Giordano, who portrayed himself in it (bottom right). Though the exact meaning is not clear, the painting reflects in style and composition Giordano's admiration of the Spanish master, in particular of *Las Meninas*, as recorded by Palomino.

when Velázquez was only approaching the height of his fame, already praising him for just this. Pacheco singles out Velázquez's life studies of a peasant model in different poses and with different facial expressions, and he thinks it important that when Velázquez painted the King on horseback he did it all from life – 'even the landscape'. Palomino especially admired the lifelike effect of the portraits, invoking apropos of some of them the familiar classical legend of the painting being mistaken for the original. Earlier, the poet Quevedo had praised the 'distant blobs of colour' with which, he said, the great Velázquez had achieved truth rather than likeness: his lifelike images, he adds, are more like reflections in a mirror than paintings. As for Anton Rafael Mengs, the German neoclassical artist and theorist, the first foreigner to rediscover Velázquez in the eighteenth century, when he visited Madrid in 1761, he acclaimed him as the first exponent of the natural style. Goya's admiration we have already seen; Picasso's was, in its own way, as pronounced.

Outside Spain, however, Velázquez was little known or regarded – the portrait of Pope Innocent X apart – until the early nineteenth century, when the Peninsular War brought about the wide dispersal of many collections. The opening of the Prado Museum in 1819 made his work more generally accessible to those who came to Spain as tourists or as students. Most important of these was Edouard Manet (1832–83), whose debt to Velázquez is obvious and revolutionary. His

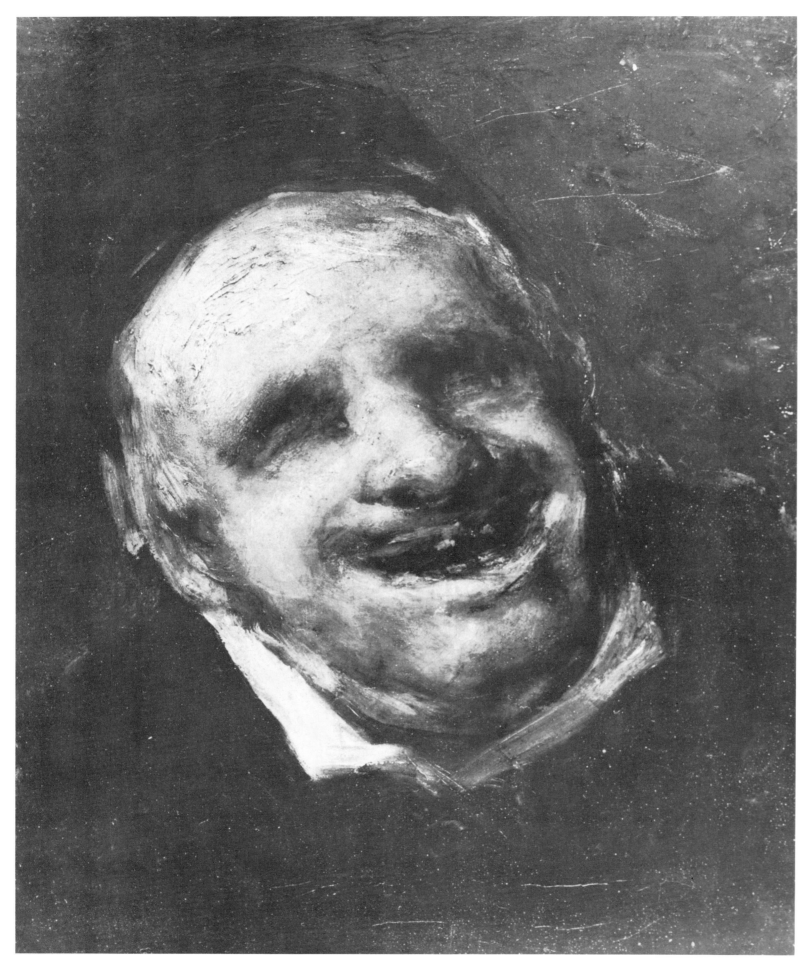

202. Francisco Goya (1746–1828). *Tío Paquete*. *c*. 1820. Canvas, 15⅜ × 12¼ in. (39.1 × 31.1 cm.). Lugano, Thyssen Collection.
The sitter was a famous blind beggar, who is said to have sat on the steps of the church of San Felipe (where Velázquez exhibited his first equestrian portrait of Philip IV). Goya creates the impression of blind eyes and jovial expression in a manner similar to that of Velázquez's portrayals of court dwarfs and idiots.

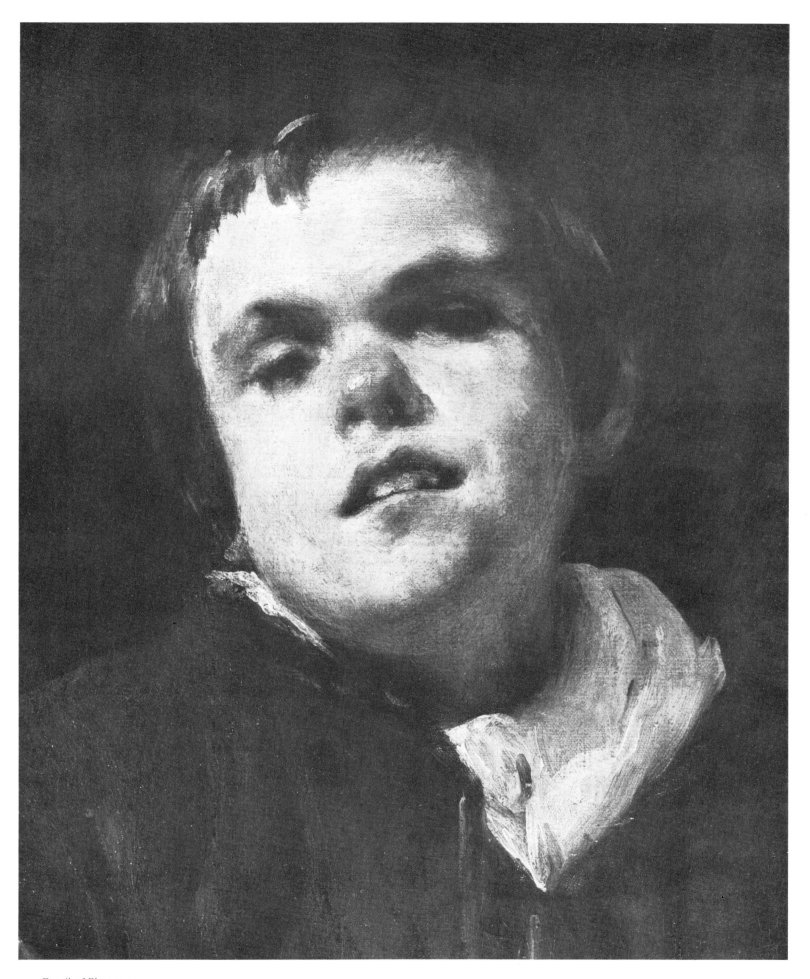

203. Detail of Plate 102.
This was one of the paintings by Velázquez, including three of the dwarfs, of which Goya made etchings in 1778–9. The unique
proof of his etching of Lezcano is lost, but two drawings are known.

204. Édouard Manet (1832–83). '*Velázquez painting*'. *Homage to Velázquez*. Signed with monogram. *c.* 1860. Canvas, 18 × 15 in. (46 × 38 cm.). Private collection. The seated figure of the artist recalls the self-portrait in *Las Meninas*; on the easel is a detail of *The Little Cavaliers* (Louvre), the painting which Manet copied in paint and etching (Plate 205) before his visit to Spain in 1865, believing it to be by Velázquez.

admiration for the Spanish painter dates even from before his visit to Spain (Plates 204, 205), though he could have seen hardly a single autograph work. When he eventually went to Madrid in 1865, his enthusiasm was unbounded. Velázquez alone was worth the journey, he wrote to his friend Fantin-Latour, 'C'est le peintre des peintres. Il ne m'a pas étonné, mais m'a ravi.' ('He is the painter of painters; he has not astonished me, he has captivated me.')

From the early nineteenth century onwards, in France and England, Velázquez has been admired and copied – from originals, from replicas, even from photographs – by the artists of every school, whether avant-garde or 'academic'. In recalling the variety of Velázquez's paintings in Madrid, R. A. M. Stevenson, painter and critic, whose sensitive appreciation of Velázquez is matched by his admiration and understanding of impressionism, in his famous monograph on the artist (first published in 1895) observed 'how often he forestalled the discoveries of recent schools of painting'. He goes on to say how 'the names of Regnault,

Manet, Carolus-Duran, Henner, Whistler and Sargent, rise to one's lips at every turn in the Prado; one thinks, but less inevitably, of Corot, when one sees the landscape of Velázquez.' He might have added Millais, Degas and Renoir, and, to bring the list up-to-date, we could now add the name of Francis Bacon.

The first monograph on Velázquez was published in London in 1855 by William Stirling, later Sir William Stirling-Maxwell Bart., the great British pioneer in the study and collecting of Spanish art. His *Velázquez and his Works* was quickly translated into German (1856) and French (1865). Carl Justi, who acclaimed it the first readable biography of the artist, followed with his classic monograph of 1888, published in English the following year, the first and still the finest book on Velázquez and his times. Generations of art historians have echoed the views expounded by Justi. 'Velázquez', he wrote, 'in each individual work is new and special, both as regards invention and technique ... what eminently distinguishes him from all other original painters is his artlessness and uncoloured truth to Nature ... By his official position completely restricted in the choice of his subjects, he seems, in his inmost soul, interested only in his optic pictorial problems.'

It is not difficult, in pursuit of the essential Velázquez, to discount these praises as more or less conventional, as the expression of a simplistic view of his painting, now superseded, which admired the representation of external reality above all. It has, indeed, been argued in recent times that such a view does not penetrate to the true meaning of Velázquez's work and is not sensitive to its implications. The critics and artists quoted above were blind, so the argument goes, to spiritual, symbolical and allegorical undertones, and deaf to the range of tone, from the reverent to the satirical. For some modern critics, a religious undertone provides a unifying factor in much of the oeuvre, even in some of the mythological and genre subjects. And the portraits of Philip IV, in distinction to the artist's other portraits, are representations not of the sitter himself, but rather of the King's majesty, of the King in his quasi-divine character unblemished by age or temporal accident.

No attempt to interpret Velázquez's paintings has gone further than those concerning his two late masterpieces of figure composition: *Las Hilanderas*, or the *Fable of Arachne*, and *Las Meninas*. Is there any justification for reading so much more into his paintings than meets the eye? Nowhere in the whole of Velázquez's

205. Édouard Manet (1832–83). *Les Petits Cavaliers* (The Little Cavaliers). 1850–1. Etching, 9¾ × 15½ in. (24.8 × 39.4 cm.). Signed (in the third state): éd. Manet d'après Velasquez.
The painting, acquired by the Louvre in 1851, was admired and copied by Manet and other artists, believing it to be by Velázquez. Manet copied it in oils, watercolour and etching before his visit to Spain in 1865.

oeuvre is there a single piece that can be certainly identified as an allegory. Nor is there any allusion to such interpretations in the documents or in his biographers, even though Palomino was himself much concerned with the language of allegory and symbolism. In the only painting in which Velázquez is known to have introduced an allegorical figure, the lost *Expulsion of the Moriscos,* the figure of Spain was placed in a prominent position and is fully described by Palomino. Velázquez himself described the *Water Seller* as just that when he valued it in 1627; his *Bacchus* was given this title in 1629 and *Las Hilanderas* was no more than the *Fable of Arachne* according to its title in 1664.

It is not easy, therefore, to set aside the firm consensus of opinion of more than two centuries – however those two centuries were making use of ancient formulas of praise – concerning the greatest of Velázquez's merits. Nor, for that matter, is it easy to find a satisfactory definition of the exact nature of the reality which Velázquez is striving to represent. If his pictures must be described in comparisons, they seem to me more 'real' than 'spiritual', direct (though allusive) rather than allegorical, grave rather than burlesque.

Most recently, a suggestion that Velázquez's most discussed painting, *Las Meninas,* contains a message of 'deep concern with the professional status of the painter' has won considerable support. It has been seen as alluding to contemporary pressure on artists to perform their duty to society at large and in little as payers of sales tax and guild tax, and as subject to military service. Certainly, at times of financial and military crisis in the seventeenth century, these obligations were revived and enforced. Certainly, Velázquez was a member of the Painters' Guild. On the whole, however, as a servant of the crown he was excused these obligations. His achievement as a painter, his position at court and his knighthood were undoubtedly all valuable contributions to the painters' cause, their exemption from taxation and the recognition of painting as a noble and liberal art. No doubt all were subjects of concern for him. To press the 'professional' interpretation too hard, however, is to impose modern preoccupations, modern conditions, on the past. The 'message' of *Las Meninas* to Velázquez's contemporaries and immediate successors is less explicit. It is his own immortality, says Palomino, that Velázquez has achieved by portraying himself in a picture of the 'Empress', just as Titian had done by painting himself holding an image of Philip II, and Phidias by placing his portrait on Minerva's shield. It is surely relevant that what is perhaps Palomino's greatest tribute is paid to Velázquez in the chapter devoted not to his painting but to his latest and most important royal appointment as chief Chamberlain. The new office, Palomino reflects, was a great honour, but one that demanded all a man's time, and, he continues, 'although we professors of painting are very proud of Velázquez's elevation to such honourable positions, at the same time we are sorry to have missed thereby so many proofs of his rare ability that would have multiplied his gifts to posterity'.

206. Coat of arms of Velázquez, according to his friend Lázaro Díez del Valle. Drawing in the margin of his manuscript: *Origen e illustracion Del nobilissimo y Real Arte de la Pintura y Dibuxo,* 1656.

APPENDIX I

Pacheco's Biography of Velázquez and other Notices

From Francisco Pacheco, *Arte de la Pintura*, (Seville, 1649)*

Lib. I, cap. VIII [1956, I, pp. 154 ff.]
Of other famous painters of our time, who won special honours for their painting

[Rubens, during his visit to Spain in 1628] had little to do with artists. Only with my son-in-law, with whom he had previously communicated by letter, did he make friends and he admired his works for their *modestia*. They went together to see the Escorial.

• • •

Diego Velázquez de Silva, my son-in-law, rightly occupies the third place. After five years of education and training, impressed by his virtue, integrity and excellent qualities, and also by the promise of his great natural genius, I gave him my daughter in marriage. And since a master is more to be honoured than a father-in-law, it is only right to attack the effrontery of one who wishes to take to himself this honour, robbing me of the glory of my old age. I consider it no disgrace for the pupil to surpass the master; it is more important to tell the truth. Leonardo da Vinci was none the worse for having Raphael for a pupil, nor Giorgio da Castelfranco [Giorgione] for Titian, nor Plato for Aristotle, since none affected the renown of the teacher for excellence.

I write this not only for the sake of extolling the present subject, which will be done elsewhere (in my Eulogy of him) [never published], but much more out of gratitude and reverence to his Catholic Majesty, our great King Philip IV, whom heaven protect for many years, for it is from his liberal hand that Velázquez has received and continues to receive the greatest honours.

Desirous, then, of seeing the Escorial, he left Seville for Madrid about the month of April in the year 1622. He was very well received by the two brothers don Luis and don Melchior del Alcázar, and especially by don Juan de Fonseca, His Majesty's royal chaplain, who was an admirer of Velázquez's paintings. He made at my request a portrait of don Luis de Góngora [Plate 29], which was very much praised in Madrid, and at that time there was no opportunity to portray the King and Queen, although this was attempted. In 1623 he was summoned back by the same don Juan de Fonseca (by order of the Conde-Duque). Velázquez lodged in Fonseca's house, where he was well looked after and entertained, and he painted his portrait. That night a son of the Conde de Peñaranda, Chamberlain of the Cardinal Infante, took the portrait to the Palace. In one hour it was seen by everyone at the Palace, including the Infantes and the King, which was the greatest honour. He was commanded to make a portrait of the Infante, but it seemed more desirable to make one of His Majesty first, although this could not be done so soon because of his many engagements. In fact, the King's portrait was made on 30 August 1623, and was to the liking of His Majesty, the Infantes and the Conde-Duque, who declared that the King had not been successfully portrayed till then; and all who saw it felt the same. Velázquez also made *en passant* a sketch of the Prince of Wales, who gave him a hundred *escudos*.

His Excellency the Conde-Duque spoke to Velázquez for the first time encouraging him for the honour of his native city, and promising him that he alone should portray His Majesty and that all other portraits would be withdrawn. He commanded him to move to Madrid and he confirmed his title on the last day of October 1623, with a salary

*Translated from the edition of F. J. Sánchez Cantón (Madrid, 1956). Plate references and other author's interpolations are in square brackets.

of twenty ducats a month plus payment for works and also free medical attention and medicines. Once, when he was ill, the Conde-Duque, at His Majesty's command, sent the King's physician to visit him. After this, Velázquez having finished the portrait of His Majesty on horseback, all painted from life, even the landscape, the King was pleased to give permission for it to be shown in the Calle Mayor, outside San Felipe, where it won the admiration of all the court and the envy of artists, for which I can vouch. Very elegant verses were written about the portrait and some of them will accompany this discourse. His Majesty ordered Velázquez to be awarded payment of three hundred ducats and a pension of a further three hundred, which required the authorization of His Holiness Urban VIII, which was granted in the year 1626. Velázquez continued to enjoy the favour of lodgings to the value of two hundred ducats a year.

Recently Velázquez painted a large canvas with the portrait of King Philip III and the sudden expulsion of the Moriscos, in competition with three Painters to the King. Having surpassed them all in the opinion of those persons appointed by His Majesty as judges (who were the Marquis Giovanni Battista Crescenzi, Knight of Santiago, and Fray Juan Bautista Maino, a Dominican, both connoisseurs of painting), Velázquez was granted the favour of a very honourable office in the Palace, that of Gentleman Usher, with salary, and not content with this, the King added the allowance given to members of the court of twelve reals a day for his food, and many other allowances. And in fulfilment of the great desire Velázquez had to see Italy and the magnificent things to be found there, His Majesty, having made him several promises, kept his royal word and with much encouragement gave him leave to go, four hundred silver ducats for his journey and arranged for him to be paid two years' salary. Then he took leave of the Conde-Duque, who gave him a further two hundred gold ducats and a medal with the portrait of the King and many letters of recommendation.

Velázquez left Madrid, by order of His Majesty, with the Marquis Spinola; he sailed from Barcelona on the feast of St. Lawrence in the year 1629; he went to stay in Venice, where he lodged in the house of the Spanish ambassador, who honoured him greatly and seated him at his table; and because of the wars that were in progress when Velázquez went out to see the city, the Ambassador sent his servants with him to guard his person. Next, leaving behind the disturbances, on his way from Venice to Rome he passed through the city of Ferrara, where the governor at the time, appointed by the Pope, was Cardinal Sacchetti, who had been Nuncio in Spain, Velázquez went to present letters and to kiss hands (though he failed to present other letters he had to another Cardinal). The Cardinal received Velázquez very well and made a special request that, during the days that he was there, he should stay in his palace and eat with him. Velázquez modestly excused himself on the grounds that he did not eat at the ordinary hours; but nevertheless if it pleased His Excellency he would obey and change his ways. In view of this Sacchetti ordered a Spanish gentleman from amongst those who served him to take great care in attending Velázquez and to prepare lodgings for him and his servant, and to regale Velázquez with the same dishes as were prepared for his own table; and to show him the most notable things in the city.

Velázquez stayed there for two days and on the last night, when he went to take his leave, the Cardinal kept him for more than three hours as they sat discussing different matters, and he ordered the person who was looking after Velázquez to prepare horses for the following day and to accompany him sixteen miles to a place called Cento, where he spent a short but very enjoyable time. And taking leave of his guide, he followed the road to Rome, passing through Our Lady of Loreto and Bologna, where he did not stop even to present letters to Cardinal Ludovisi or Cardinal Spada, who were there.

He arrived in Rome, where he stayed for a year, much befriended by Cardinal Barberini, the Pope's nephew, by whose order he was lodged in the Vatican Palace. He was given the keys to certain apartments; the principal one was painted in fresco all the upper part above the hangings, with stories from the Holy Scriptures by Federico Zuccaro, among them the story of Moses before Pharaoh, which is engraved by Cornelis [Cort]. He left that lodging because it was very isolated and he did not want to be so much alone, being satisfied to be given facilities by the guards to enter without trouble when he

wished, to draw from Michelangelo's Last Judgement or the works of Raphael of Urbino, and he spent many days there to his great profit. Afterwards, seeing the palace or *vigna* of the Medici, which is by the Trinità del Monte, it seemed to him a suitable place to study and spend the summer, for it was in the highest and most airy part of Rome, and had most excellent antique statues for him to copy. So he asked the Conde de Monterrey, the Spanish Ambassador, to negotiate with the Florentine Ambassador for him to be given rooms there. Although it was necessary to write to the Duke himself, this was arranged and he stayed there for more than two months, until a tertian fever forced him to move down near the house of the Count who, during the days that Velázquez was indisposed, did him great favours, sending his doctor and medicines at his own expense. And the Count ordered that everything that Velázquez wanted should be prepared in his house, as well as sending many presents of sweetmeats and frequent messages on his behalf.

Amongst other works Velázquez made in Rome an admirable self-portrait, which is in my possession, that is worthy of the admiration of connoisseurs and a tribute to art. He resolved to return to Spain because he was much needed, and on his way back from Rome he stopped in Naples, where he painted a beautiful portrait of the Queen of Hungary [cf. Plate 61] to bring to His Majesty. Velázquez returned to Madrid after an absence of a year and a half, arriving at the beginning of 1631. He was very well received by the Conde-Duque, who sent him immediately to kiss His Majesty's hand, to thank him very much for not having allowed himself to be portrayed by another painter and for waiting for him to portray the Prince. This he promptly did, and His Majesty showed much pleasure at his return.

The liberality and affability with which Velázquez is treated by such a great Monarch is unbelievable. He has a workshop in the King's gallery, to which His Majesty has the key, and where he has a chair, so that he can watch Velázquez paint at leisure, nearly every day. But what surpasses all other favours is that when Velázquez painted him on horseback he had the King seated for three hours at a time, with all his vigour and grandeur held in check. And the royal breast, not satisfied with all these favours bestowed on Velázquez in the course of seven years, has given his father three appointments as Secretary in this city, each of which is worth a thousand ducats a year; and he appointed Velázquez in less than two years Gentleman of the Wardrobe and Gentleman of the Bedchamber (in this year 1638), honouring him with his key, a thing that many members of military orders would like to have. By virtue of the care and dedication with which Velázquez endeavours to better himself daily in His Majesty's service, we expect advancement and improvement in the profession for one who has deserved it and the favours and rewards due to his good talent, which employed in another field would certainly not have won him the position he has today. And I on whom so great a part of his good fortune has fallen bring to an end this chapter with the following verses: [The verses that follow are a poem by Jerónimo González de Villanueva and a sonnet by Pacheco, both dedicated to Velázquez's lost equestrian portrait of Philip IV. The former being a long eulogy of the King rather than of his portrait is omitted here]

TO DIEGO DE SILVA VELÁZQUEZ.

painter to Our Catholic King Philip IV, on the occasion of his painting the portrait of the King on horseback, this sonnet was offered by his father-in-law Francisco Pacheco, while he was in Madrid:

Hasten, oh valiant youth, to pursue the course you have embarked on with such success, so that the possession rather than the hope of the position you have attained in painting may be rewarded by royal favour.

May you be inspired by the august, eminent figure of the greatest monarch in the world, in whose appearance any change is dreaded by those who succeed in looking on such brilliance.

Temper your flight to the warmth of this sun and you will see how fame spreads your renown, thanks to your talent and your brushes.

For the planet protecting that great firmament will illuminate your name with new glory, for he is greater than Alexander and you are his Apelles.

Lib. III. cap. I [1956, II, p. 13]
On sketches, drawings and cartoons, and the various ways of using them

... it seems to me that even the clothed [wax or clay] model does not give much life to the figure, since it is a dead thing, although for keeping [the pose] it is more to the purpose than the live figure. But I keep to nature for everything and it would be best of all if I could always have it before me at all times, not only for heads, bodies, hands and feet, but also for cloths, silks and everything else. That is what Michelangelo Caravaggio did with such success, as one can see in the Crucifixion of St. Peter (although copies). That is what Jusepe de Ribera does, for of all the great paintings belonging to the Duque de Alcalá his figures and heads look alive and the rest painted, even beside Guido Bolognese [Reni]. And in the case of my son-in-law who follows this course one can also see how he differs from all the rest because he always works from the life.

Lib. III, cap. VIII, [1956, II, pp. 137, 144–6, 154]
On the painting of animals and birds, fish-stalls and bodegones and the ingenious invention of portraits from the life

Well, then, are bodegones not worthy of esteem? Of course they are, when they are painted as my son-in-law paints them, rising in this field so as to yield to no one; then they are deserving of the highest esteem. From these beginnings and in his portraits, of which we shall speak later, he hit upon the true imitation of nature, thereby stimulating the spirits of many artists with his powerful example. Thus, I myself ventured on one occasion, when I was in Madrid in the year 1625, to please a friend by painting him a small canvas with two figures from the life and flowers, fruits and other trifles, which belongs today to my learned friend Francisco de Rioja. And I was so successful that compared with this other works by my hand looked painted.

• • •

I said that in portraits the true imitation of the model lies in the outlines, that is to say that without drawing it cannot be achieved. So that those who have excelled as draughtsmen will excel in this field.

• • •

Other artists who made portrait drawings were Leonardo da Vinci, Federico Zuccaro, Hendrick Goltzius, Cavaliere Giuseppe [d'Arpino], but the one who made most studies in Rome was Il Padovano. There was no person of high rank whom he did not sketch in pencil, on blue paper heightened with white. From these drawings which decorated his studio he afterwards painted portraits in colour. Don Juan de Jáuregui, a ceaseless worker, by means of his portrait drawings holds the position he does for his very successful paintings. In this doctrine my son-in-law Diego Velázquez de Silva was brought up when he was a boy. He used to bribe a young country lad who served him as a model to adopt various attitudes and poses, sometimes weeping, sometimes laughing, regardless of all difficulties. And he made numerous drawings of the boy's head and

of many other local people in charcoal heightened with white on blue paper, and thereby he gained assurance in portraiture.

• • •

[After praising many portraits he has seen] I shall not mention 150 of my own in colour (ten full-length and more than half of them small); ten of Marquesas, three of Condes and one of a Duquesa (but the best of all is that of my wife, front view and on a round panel) in order to point out that of my son-in-law, Diego Velázquez de Silva, executed in Rome and painted in the manner of the great Titian and (if I may be permitted to say so) not inferior to his heads.

APPENDIX II

Palomino's Life of Velázquez

From Antonio Palomino de Castro y Velasco, *El Museo Pictórico y Escala Óptica* (Madrid, 1715–24), Vol. 3, *El Parnaso Español Pintoresco Laureado* (1724), pp. 321–54.*

207. *Portrait of Palomino.* Engraving by H.V. Ugarte. 1759. $7\frac{3}{4} \times 10\frac{7}{8}$ in. (19.8 × 27.5 cm.).

Don Diego Velázquez de Silva,
Knight of the Order of Santiago, Gentleman of His Majesty's Bedchamber, etc. In which is included the coming to Spain of Rubens, of Angelo Michele Colonna and Agostino Mitelli, and their works; and also the coming of Morelli.

I

THE BIRTH, PARENTAGE, NATIVE CITY, AND EDUCATION OF
VELÁZQUEZ IN THE ART OF PAINTING

He was a native of Seville.

Abuse of surnames introduced in Andalusia.

He was of Portuguese extraction.

Ancestry of Velázquez.

Velázquez's upbringing.

Velázquez's study of the humanities and philosophy.

Velázquez's beginnings as a painter in the house of Herrera the Elder.

Velázquez moves to the school of Pacheco.

Don Diego Velázquez de Silva was born in the year 1594 [1599] in the famous city of Seville, one of the most illustrious cities on which the sun shines. His parents were Juan Rodríguez de Silva and Doña Jerónima Velázquez, both endowed with distinction, and nobility, and both natives of Seville. He chiefly used his mother's surname, an abuse introduced in some parts of Andalusia which is the cause of great disputes in cases of establishing lineage. His paternal grandparents were from the kingdom of Portugal, members of the most noble family of Silva, which owed its renown to Silvius, posthumous son of Aeneas Silvius, one of the kings of Alba Longa from whom, according to immemorial tradition, it is descended. His ancestors served the kings of Portugal and experienced the power of fate: they rose to high rank; fortune discharged her wrath; their condition was transformed and they were brought down from their position of eminence to suffer misfortune; they were left with no other heritage than their services and their worth, ever maintaining as their guide the merits of their forefathers.

Nobility originates in the virtue of some one of our ancestors, but hereditary nobility depends on the preservation of that original character. Velázquez, from his earliest years, showed signs of his good disposition and of the good blood which flowed in his veins, although his circumstances were modest. His parents brought him up, without fuss or grandeur, on the milk of the fear of God. He applied himself to the study of the humanities, surpassing many of his contemporaries in his knowledge of languages and philosophy. Though he displayed ability, quickness and aptitude in every subject, he showed signs of a special bent for painting; in this he was most gifted, so that his school note-books sometimes served him as sketch-books for his ideas. His zeal impressed his parents with a high opinion of his talent, which in the course of time he developed to such great advantage. They allowed him to follow his inclination without going further in his other studies, either because they found his natural propensity for them sufficient, or because they acknowledged the force of his destiny. They handed him over for instruction to Francisco de Herrera, who is called in Andalusia Herrera the Elder, a stern man and not very merciful, but a man of perfect taste in painting and the other arts.

After a little time he left this school and entered that of Francisco Pacheco, a man of extraordinary accomplishment and great learning and knowledge of painting, about

* Translated from the edition published by M. Aguilar (Madrid, 1947), pp. 891–936. Plate references and other author's interpolations are in square brackets.

which he wrote several books and composed many elegant poems, which won him the applause of all the writers of his time.

The house of Pacheco was a gilded cage of Art, the academy and school of the most talented sons of Seville. And so Diego Velázquez lived happily in the continual exercise of drawing, the first element of Painting and principal gateway to Art. This we are told by Pacheco himself,[1] with his usual simplicity and candour and with the authority of the master. *In this doctrine*, he says, *my son-in-law Diego Velázquez de Silva was brought up, when he was a boy. He used to bribe a young country lad who served him as a model to adopt various attitudes and poses, sometimes weeping, sometimes laughing, regardless of difficulties. And he made many drawings of the boy's head and of many other local people in charcoal heightened with white on blue paper, and thereby he gained assurance in portraiture.* He took to painting with most extraordinary originality and remarkable talent animals, birds, fish-stalls and *bodegones* with perfect imitation of nature, with beautiful landscapes and figures; different foods and drinks; fruits, and poor and humble furnishings, with such mastery of draughtsmanship and colouring that they appeared real. He rose in this field so as to yield to no one, thus winning great fame and well-deserved esteem by his works. Of these we should not pass over in silence the painting known as the Water Seller [Plate 39], an old man very badly dressed in a shabby coat, torn so as to show his chest and stomach with its scabs and thick, hard callouses. Beside him is a boy to whom he is giving a drink. So celebrated was this painting that it has been kept to this day in the Buen Retiro Palace.

Velázquez made another painting of two poor men eating at a small and humble table [Plate 35], on which are some earthenware vessels, oranges, bread, and other things, all observed with extraordinary meticulousness. Similar to this is another painting of a badly dressed boy, with a little cloth cap on his head, counting money on a table and adding up the total on the fingers of his left hand with particular care; behind him is a dog looking at some *dentones* and other fish, like sardines, which are on the table. There is also a Roman lettuce (what they call 'hearts' in Madrid) and a cauldron upside down; to the left is a dresser made of two shelves, one with some large herrings and a big loaf of Seville bread on a white cloth; the other with two white earthenware plates and a small earthenware oil jar with green glaze. To this painting he put his name, but it is now very worn and darkened by time. There is another similar painting showing a board that serves as a table, with a stove on which a pot is boiling, covered with a bowl – one can see the fire, the flames and sparks vividly – and a little tin kettle, a porous jar, some plates and bowls, a glazed pitcher, a mortar and pestle with a head of garlic beside it. On the wall can be descried a small rush basket with a rag and other odds and ends hanging from a hook. Watching over this is a boy with a jug in his hand and on his head a cap, presenting in his very rustic costume a most odd and amusing figure.

Everything that our Velázquez did at that time was in this vein, in order to distinguish himself from everyone else and follow a new trend. Knowing that Titian, Dürer, Raphael, and others had the advantage over him, their fame being greater now that they were dead, he had recourse to the fertility of his invention, and took to painting with bravado rustic subjects, with strange lighting and colours. Some people remonstrated with him because he did not paint more serious subjects with delicacy and beauty, in emulation of Raphael of Urbino, and he politely replied: *That he preferred to be first in that kind of coarseness than second in delicacy.*

Certain painters have become famous for the eminence they achieved and the perfection of their taste in this type of painting. Not only our Velázquez had a fancy for such low themes; many others have been carried away by this taste and a special partiality for such subjects. Peiraikos, the famous painter of antiquity, according to Pliny,[2] by choosing humble subjects achieved the greatest glory and highest esteem for his works, wherefore they gave him the nickname *rhyparografos*, a Greek expression meaning painter of low and coarse themes.

From these beginnings and in his portraits, which he executed admirably, not being content that they should merely be surpassingly good likenesses but making them expressions besides of the air and bearing of the sitter (for so great was his eminence), he hit upon the true imitation of nature. He stimulated the spirits of many artists to follow

School of Pacheco.

1. Pacheco, Arte de la Pintura, lib.III, cap.8.

Velázquez's first studies.

Famous painting of the Water Seller by Velázquez.

Other paintings of tavern scenes by Velázquez.

Another painting of a little bodegón.

Velázquez's ingenious reply to an objection.

Peiraikos, painter of bodegones *in antiquity.*
2. Pliny, Nat. Hist., XXXV, 112.

3. Pacheco, Arte de la Pintura, *lib.III, cap.8.*

Luis Tristán, very famous, and followed by Velázquez.

Definition of the works of Greco.

Velázquez's study of books on painting.

4. [Trattato della Nobiltà della Pittura, *Rome, 1583.*]

Velázquez indefatigable in the study of painting.

Velázquez's marriage.

5. Pacheco, Arte de la Pintura, *lib. I, cap.8.*

his powerful example, as Pacheco relates[3] – for he happened to be one who painted things of this kind in imitation of Velázquez.

Velázquez rivalled Caravaggio in the boldness of his painting and was the equal of Pacheco on the side of the theoretical. He admired Caravaggio for his extraordinary and subtle talent and he chose Pacheco as his teacher because of his knowledge of the field, which made him worthy of the choice. Some paintings had been brought from Italy to Seville, which greatly stimulated Velázquez to attempt undertakings which should be not inferior to these. They were by artists who flourished at that time: Pomarancio, Cavaliere Baglione, Lanfranco, Ribera, Guido Reni, and others. The paintings which were most agreeable in his sight were those of Luis Tristán, a pupil of Dominico Greco, a painter of Toledo, whose unusual opinions and lively conceptions were congenial to Velázquez's taste. For this reason he declared himself Tristán's follower and gave up painting in the manner of his master, having realized from the very beginning that such a feeble style of painting, though rich in erudition and of excellent draughtsmanship, did not suit him, being contrary to his proud nature and his taste for grandeur. He was called a second Caravaggio because he imitated nature so successfully and with such great propriety, keeping it before his eyes in all things and at all times. In his portraits he imitated Domenico Greco, whose heads, he considered, could never be too highly praised; and to tell the truth he was right in all that, as he did not share in the extravagance that flared up in El Greco at the end. For of him we can say: *that what he did well no one did better; and what he did badly no one did worse.* And in the end Velázquez illuminated Art with the energy of the Greeks, with the diligence of the Romans, and with the tenderness of the Venetians and Spaniards. He so entered into all these works that if all their vast number were lost, they could still be known in the small compass of his.

He was well versed in the study of various authors who have written distinguished precepts for painting: he investigated the proportions of the human body in Albrecht Dürer; anatomy in Andreas Vesalius; physiognomy in Giovanni Battista Porta; perspective in Daniele Barbaro; geometry in Euclid; arithmetic in Moya; architecture in Vitruvius and Vignola and other writers in whom, with the diligence of a bee, he skilfully selected, for his own use and for the benefit of posterity, what was most advantageous and perfect. He studied the nobility of painting in Romano Alberti,[4] whose treatise was written at the request of the Roman Academy and venerable Brotherhood of the glorious Evangelist Saint Luke. Federico Zuccaro's *Idea* informed his own painting, he embellished it with the precepts of Giovanni Battista Armenini, learning how to carry out these precepts quickly and economically from Michelangelo Biondo. He was stimulated by Vasari's lives of illustrious painters, and Raffaello Borghini's *Riposo* influenced him to become an erudite artist. He also equipped himself with a knowledge of sacred and secular writings and of other important subjects in order to enrich his mind with every kind of learning and a universal appreciation of the arts. This is what Leon Battista Alberti advises, putting it in these words: *But I would very much want the Painter to be as learned as possible in all the Liberal Arts; above all I wish him to be expert in Geometry.* Velázquez also knew and was friendly with poets and orators, for it was from such talented persons that he learnt greatly to enrich his compositions.

Finally, Velázquez was as studious as the difficulties of this art required, persevering without concern for anything but the glory and fame that can be attained with knowledge, trusting to time and labour, which never fail to give an honourable reward to those who seek it. He had five years of education, and in that time his work progressed to a stage beyond his years. He took a wife, choosing, to the credit of his taste and honour, Doña Juana Pacheco, daughter of Francisco Pacheco, Officer of the branch of the Holy Inquisition in Seville, and of very good family. Velázquez in his art surpassed his father-in-law and master without arousing his emulation or envy; on the contrary Pacheco took it as a cause for pride, and rightly so. This he admits, at the same time complaining of someone who wished to arrogate to himself the honour of having been Velázquez's teacher, thus robbing him of the glory of his old age (for he was over 70 when he wrote). After praising Rómulo Cincinnato and Peter Paul Rubens, among others, he writes:[5] *Diego Velázquez de Silva, my son-in-law, rightly occupies the third place. After five years of*

education and training, impressed by his virtue, integrity and excellent qualities, and also by the promise of his great natural genius, I gave him my daughter in marriage. And since a master is more to be honoured than a father-in-law it is only right to attack the effrontery of one who wishes to take to himself this honour, robbing me of the glory of my old age. I consider it no disgrace for the pupil to surpass the master; it is more important to tell the truth. Leonardo da Vinci was none the worse for having Raphael for a pupil, nor Giorgio da Castelfranco [Giorgione] for Titian, nor Plato for Aristotle, since none affected the renown of the teacher for excellence. I write this not only for the sake of extolling the present subject, which will be done elsewhere, but much more out of gratitude and reverence to his Catholic Majesty our great King Philip IV, whom heaven protect for many years, for it is from his liberal hand that Velázquez has received and continues to receive the greatest honours.

Pacheco's ingenuousness and modesty.

II

OF THE FIRST AND SECOND JOURNEY THAT VELÁZQUEZ MADE TO MADRID

In these exercises Velázquez occupied the years of his youth, but fortune did not overlook his merits, for just as the earth revolves, so was it inevitable that his calm should be disturbed. No one is so forgotten that fortune does not remember one day either to overthrow his happiness or to raise his hopes for new successes. Whoever died in the same condition in which he first opened his eyes to find himself a frail part of his first mother, the earth? Velázquez interrupted his studies with a view to demonstrating his talent at court and advancing his art by the sight of the admirable paintings in the palace and other royal seats, in the churches and in private houses, as well as those in the Royal Monastery of San Lorenzo el Real, the eighth wonder of the world and the first in greatness, a work worthy of the great Monarch and second Solomon, Philip II, King of [the two] Spains.

San Lorenzo del Escorial, the eighth wonder.

Velázquez eventually left Seville, accompanied only by a servant, and made his way to Madrid, Court of the Spanish Kings and noble theatre of the greatest talents in the world. He arrived there in the month of April in the year 1622 and there fortune favoured him. He was visited by many noblemen, some prompted by friendship, others by reports of his ability and great accomplishments. He was very kindly treated by the two brothers Don Luis and Don Melchior del Alcázar, the latter a distinguished and talented Sevillian, who died at Court at the age of 37 in 1625, mourned by the Muses with suitable laments for the loss of one they greatly honoured. He was shown particular friendship by Don Juan de Fonseca y Figueroa, His Majesty's royal chaplain, a magnate of the Church and canon of Seville Cathedral, a most illustrious person who, for all his intellect and great erudition, did not disdain to practise the noble art of painting and was a great admirer of Velázquez. At the request of his father-in-law Francisco Pacheco, Velázquez made a portrait of the famous and excellent poet Don Luis de Góngora y Argote [Plate 29], prebendary of Cordova Cathedral and honorary chaplain to His Majesty, a portrait that won the highest praise from all the courtiers, though, as is their way, it was not lasting. Not having at that time the opportunity of portraying the King and Queen, although he tried, Velázquez returned to his home town.

First journey that Velázquez made to Madrid.

Velázquez was very well received in Madrid.

Velázquez returned to Seville.

In the year 1623 he was summoned back by the same Don Juan de Fonseca, and was given a stipend of 50 ducats by order of Don Gaspar de Guzmán, Conde de Olivares and Duque de Sanlúcar, High Chancellor, chief Chamberlain and Prime Minister of Philip IV. Velázquez lodged in Fonseca's house, where he was well looked after and entertained, and he painted his portrait which was taken the same night to the palace by a son of the Conde de Peñaranda, Chamberlain of the Most Serene Cardinal. In one hour it was seen by all the grandees, the Infantes Don Carlos and Cardinal Don Fernando, and by the King, which was the greatest honour. He was commanded to make a portrait of the Infante, but it seemed more desirable to make one of His Majesty first, although this could not be done so soon because of his many engagements. In fact, the King's portrait was made on 30 August 1623, and was to the liking of His Majesty, the Infantes, and the Conde-Duque, who declared that no one up till then had been successful in portraying the King (though Vicente Carducho and his brother Bartolomé, Angelo Nardi, Eugenio Caxés and Jusepe Leonardo had all attempted it). All who saw it felt the same: Don Juan

Velázquez returned to Madrid, summoned by the Conde-Duque de Olivares.

First portrait of Philip IV by Velázquez.

Description of the portrait of the King by Velázquez.

Portrait by Velázquez of the Prince of Wales.

6. *Teatro de las Grandezas de Madrid, cap. 14, fol. 195.*

The King's order that no one except Velázquez should portray him.

Salary of Court Painter 20 ducats a month.

Sonnet by Don Juan Vélez de Guevara on the portrait of His Majesty by Velázquez.

Lodgings two hundred ducats a year.

Painting of the expulsion of the Moriscos, by the hand of Velázquez.

7. *Pacheco, Arte de la Pintura, lib.II, cap.8, fol.117.*

Hurtado de Mendoza Duque del Infantado, chief Majordomo, the Admiral of Castile, the Duque de Uceda, the Conde de Saldaña, the Marqués de Castel-Rodrigo, the Marqués del Carpio, and other gentlemen. The portrait showed His Majesty dressed in armour and mounted on a fine horse and was executed with the care and attention required for so great a subject, on a large canvas, life-size, and even the landscape was taken from nature. He also made *en passant* a sketch of His Serene Highness, Charles Prince of Wales, titular King of Scotland, only son and heir to the kingdoms and dominions of James I, King of Great Britain, Scotland, and Ireland, who at the time was at court, lodged in the Palace. He gave Diego Velázquez 100 *escudos* and honoured him with an unusual show of affection, for this Prince was extremely fond of painting. Gil González Dávila, His Majesty's Chronicler, wrote an account of the Prince's entry into Madrid, which took place on Friday, 17 March 1623.[6]

Velázquez was naturally encouraged by the Conde-Duque de Olivares for the honour of his native city and was promised that he alone should portray His Majesty and that all other portraits would be withdrawn. Thus he would enjoy the same pre-eminence as Apelles, who alone was permitted to paint the image of Alexander, and as Lysippus who sculpted him in bronze and Pyrgoteles in marble, an edict observed faithfully by the Greeks, as is related by Mario Equicola d'Alveto in his book *De Natura, & Amore*, lib. 2, fol. 96.

Velázquez was ordered to move to Madrid and his title of Court Painter was confirmed on the last day of October 1623, with a salary of 20 ducats a month plus payment for his works and free medical attention, and medicines and lodging.

After this, Velázquez having finished the portrait of His Majesty on horseback, in such a spirited pose, with such dignity and brio as to rival Apelles, celebrated by the pens of the Greeks and Romans, the King was pleased to give permission for it to be shown in the Calle Mayor, outside the Convent of San Felipe, where it was the admiration of all the Court, the envy of artists and the rival of nature herself. On this subject many fine poems were written, some of which are quoted by Pacheco in his treatise on painting (lib.1,cap.8), for he was at the time in Madrid, in the year 1625, as he says in his book (page 430). But we should not overlook the celebrated sonnet of the illustrious Don Juan Vélez de Guevara.

<div align="center">SONNET</div>

Oh brush, you render boldness and strength with a fulness so well simulated that you make ferocity fearful and gentleness appear pleasurable.

Say, are you making a portrait or are you bringing it to life? For this royal image is so surpassingly excellent that I would judge the canvas to be as alive as insensible things are dead.

The portrait so splendidly reveals the royal authority it is heir to that it even commands the eye.

And since you have made it a likeness of power you have imitated what is most difficult, for to be obeyed is easier.

On His Majesty's orders, Don Diego Velázquez was awarded payment on this occasion of 300 ducats and a pension of a further 300 which required the authorization of His Holiness Pope Urban VIII. There followed in the year 1626 the favour of lodgings to the value of 200 ducats a year.

Later, he painted on His Majesty's orders the canvas showing the expulsion of the Moriscos by the pious King Philip III, a well-deserved punishment for such infamous and seditious people; for, unfaithful to God and the King, they remained obdurate in their Mohammedan faith and had a secret understanding with the Turks and Moors of Barbary to revolt.

Don Diego Velázquez painted this history-piece in competition with three Painters to the King,[7] Eugenio Caxés, Vicente Carducho and Angelo Nardi. He having surpassed them all in the opinion of those persons appointed by His Majesty as judges – the

Reverend Father Fray Juan Bautista Maino and Don Giovanni Battista Crescenzi, Marqués de la Torre – his painting was chosen to be hung in the *Salón grande*, where it still is today.

In the middle of this picture is King Philip III, in armour with baton in hand, pointing to a crowd of men, women, and children who are being led away lamenting by soldiers; in the distance are carts and part of the sea coast with ships to transport them. Several authors have written of this event[8] and some affirm that the Moriscos numbered more than 800,000, others more than 900,000.

At the right of the King, Spain is represented by a majestic matron seated at the foot of a building, in her right hand a shield and some arrows, in her left hand some ears of corn. She wears Roman armour and at her feet is this inscription on the socle:

> *To Philip III, most gracious of Kings, Catholic King of [the two] Spains, the Netherlands, Germany, and Africa, fosterer of peace and justice, maintainer of the public order, in recognition of his successful expulsion of the Moors, Philip IV, mighty in valour and in virtue, greatest of the great, with a spirit born for greater things on account of the antiquity of so great a lineage, moved by duty and reverence, erected this monument, 1627.*

Velázquez finished the painting in the year mentioned, as is attested by the signature that he placed on a parchment painted on the bottom step, which reads thus:

> *Diego Velázquez of Seville, Painter to Philip IV, King of Spain, by whose command he made this in the year 1627.*

In this year His Majesty appointed Velázquez to the position of Gentleman Usher, with salary, a very honourable office, as is known from the records of the Royal Council. And in the year 1628, His Majesty, considering himself well served and pleased with Velázquez's talents, favoured him with the Court allowance of 12 reals a day and a dress allowance of 90 ducats a year.

In this same year there came to Spain Peter Paul Rubens, a man of prodigious genius, skill, and fortune[9] – as he is called by various writers and as he is revealed by his works. He came as Ambassador Extraordinary of the King of England to treat for peace with Spain, by arrangement with the Archduke Albert and Her Serene Highness Doña Isabel Clara Eugenia his wife, because of the great esteem in which they held Rubens and because of the great fame of his erudition and talent, which we spoke of in our Life of him.

He had little to do with painters, according to Pacheco, except for Don Diego Velázquez, with whom he had previously corresponded, but with him he became close friends. Rubens praised Velázquez's works for their great quality and simplicity [*modestia*]. They went together to the Escorial to see the celebrated Monastery of San Lorenzo el Real and they both took especial delight in admiring the many and admirable works of genius in that sublime structure, in particular the original paintings of the greatest artists to flourish in Europe. These provided a new stimulus to Velázquez and revived the desire he had always had to go to Italy to inspect and study those splendid paintings and sculptures which are the torch that lights the way for art, and the worthy objects of admiration.

<div align="center">

III

OF THE FIRST JOURNEY TO ITALY MADE BY DON DIEGO
VELÁZQUEZ BY PERMISSION OF HIS MAJESTY

</div>

In fulfilment of the great desire that Don Diego Velázquez had to see Italy[10] and the great things to be found there, His Majesty, having made him several promises, kept his royal word, and with much encouragement, gave him leave to go and 400 silver ducats for his journey and arranged for him to be paid two years' salary. Then he took leave of the Conde-Duque who gave him a further 200 gold ducats, and a medal with the portrait of the King and many letters of recommendation. He left Madrid with Don Ambrogio Spinola, Marqués de los Balbases, Captain-General of the Catholic armies in the Low Countries. He embarked at the port of Barcelona in the month of August (the most convenient time for a sea voyage) on the feast of Saint Lawrence in the year 1629. He went

Description of this painting.
8. *P. Ordoño,* Le Mercure François, etc.

Personification of Spain.

Velázquez appointed Gentleman Usher with salary.

Velázquez awarded the Court allowance of twelve reals a day, and dress allowance of ninety ducats a year.
Arrival in Spain of Rubens as Extraordinary Ambassador.
9. *Johannes Faber ed.,* Historia de Plantis [*Francisco Hernández,* Nova plantarum ... Mexicanorum historia, *Rome, 1651*], *fol.831.*

Rubens's friendship with Velázquez.

Admiration of the splendid paintings in the Escorial.

10. Pacheco, ubi supra.

Velázquez embarks in Barcelona for Italy.

Arrival in Venice.

He was much honoured by the Spanish Ambassador.

Great paintings in Venice and other marvels.

11. V. Carducho, Diálogos de la Pintura, *Madrid, 1633, fol. 17.*

The celebrated Gloria *of Tintoretto.*

Wars of Chiaradadda painted by the hand of Titian.
Academy of Venice and the talents which it has given to the world.

Copy which Velázquez made of a picture by Tintoretto.

The good reception which Velázquez had in Ferrara.

Velázquez continues his journey to Rome without stopping.

Velázquez was in Rome for a year, very well assisted by Cardinal Barberini.

to stay in Venice (the famous city founded in the Adriatic) where he was to see and admire the greatness and the singularity of its site and the various nations that traded there. He lodged in the house of the Spanish Ambassador, who honoured him greatly and seated him at his table; and because of the wars that were in progress when Velázquez went out to see the city, the Ambassador sent his servants with him to guard his person. They took him to the palace and to the church of San Marco, stupendous in size, plan, and majesty, with all the rooms painted by Jacopo Tintoretto, Paolo Veronese, and other great artists. What aroused his great admiration was the Sala del Gran Consiglio, which is said to hold 12,000 people.[11] The sight of it arouses wonder and admiration. In it is that famous painting of the *Gloria*, which Jacopo Tintoretto, most excellent and learned painter (like another Zeuxis of antiquity, superior to everyone of his time), executed with such harmony in the choirs of angels, such diversity of figures, with such varied attitudes: Apostles, Evangelists, Patriarchs, and Prophets, that it seems that the hand answered to the conception. The ceiling and walls are painted with history pieces and portraits of the Doges of that Republic, for which they employed Tintoretto at a salary of 600 ducats. Velázquez saw in a large room paintings by Titian of the wars of Chiaradadda, a province that borders on the Empire.

He also saw the School of Saint Luke, or Academy, where painters meet to study, and from which so many famous ones have emerged to do credit to their native city as a school for colour: such as the great Titian, Veronese, Tintoretto, Antonio Licinio de Pordenone, Jacopo Bassano, and his son, Bassanino, Fray Sebastian del Piombo, Giovanni Bellini, master of Titian, Gentile Bellini, his brother, Giovanni Battista Timoteo, Jacopo Palma, Jacopo Palmeta, his grandson, Giorgione, Andrea Schiavone, the sculptor Jacopo Sansovino, Simone Peterzano, pupil of Titian, and many others whose famous works survive and whose portraits adorn the Academy.

During the days that he was there Velázquez drew a great deal, particularly after the picture by Tintoretto of the Crucifixion of Christ Our Lord, with its abundant figures and admirable invention. The picture is current in the form of an engraving.

Velázquez made a copy of a picture which shows Christ administering communion to the disciples, by the same Tintoretto, which he brought to Spain and with which he waited on His Majesty.

He came to love Venice; but because of the great disturbances there (due to the wars which were then in progress), he determined to leave and go on to Rome. He went to Ferrara which at the time was governed, by order of the Pope, by Cardinal Giulio Sacchetti, a Florentine, Bishop of Frascati, who had been Nuncio in Spain, to whom he went to give letters and to kiss hands. The Cardinal received him very well and made a special request that, during the days that he was there, Velázquez should stay in his palace and eat with him. Velázquez modestly excused himself on the grounds that he did not eat at the ordinary hours; but nevertheless if it pleased His Eminence he would obey and change his ways. In view of this Sacchetti ordered a Spanish gentleman from amongst those who served him to take great care in attending Velázquez and to prepare lodgings for him and his servant, and to regale Velázquez with the same dishes as were prepared for his own table; and to show him the most notable things in the city. He was there for two days, and although he was only passing through he looked with attention at the works of Garofalo; and on the last night when he went to take leave, His Eminence detained him for more than three hours, as they sat discussing different matters. His Excellency ordered the person who was looking after Velázquez to prepare horses for the following day and to accompany him 16 miles to a place called Cento, where he spent a short but very enjoyable time. And taking leave of his guide, he followed the road to Rome passing through Our Lady of Loreto and Bologna, where he did not stop even to present letters either to Cardinal Niccolò Ludovisi of Bologna, Grand Penitentiary and Bishop of Policastre, or to Cardinal Baltasar Spada, Patriarch of Constantinople and Bishop of Sabina, who were there, in order not to delay the satisfaction of his impatient desires.

He arrived at last in the city of Rome, where he stayed for a year, much befriended by Cardinal Francesco Barberini, nephew of Pope Urban VIII, by whose order he was

lodged in the Vatican Palace. He was given the keys to certain apartments; the principal one was painted in fresco, all the top part from the hangings upwards, with stories from the Holy Scriptures by Federico Zuccaro. He left that lodging because it was very isolated, and in order not to be so much alone, being satisfied to be given facilities by the guards to enter when he wished, to draw from the works of Raphael and from the Last Judgement which, by order of Pope Julius II, Michelangelo Buonarroti had painted in fresco in the Papal chapel. On this Michelangelo had spent eight years, unveiling it in 1541.

Painting of the Last Judgement by the hand of Michelangelo.

Velázquez spent many days here, to the great profit of his art, making sundry drawings, some in colour, others in pencil, of the Judgement, of the prophets and sibyls, of the Martyrdom of Saint Peter, and the Conversion of Saint Paul, all marvellous works, executed with profound skill. He also drew from the excellent paintings of Raphael Santi of Urbino in the Papal apartments: from a large picture where Theology is placed together with Philosophy, and between them the Sacred Host above the altar, with the doctors round it, and behind them other saints discussing this mystery, the whole executed with singular decorum and admirable arrangement. He also drew from another scene representing Saint Paul in Athens preaching to the philosophers; and also another famous painting of the celebrated Mount Parnassus with the Muses and the poets and Apollo playing a lyre in their midst.

Velázquez studied the works of Michelangelo and Raphael.

Afterwards, seeing the palace or *vigna* of the Medici, which is by the Trinità del Monte Monastery (belonging to the Order of Minims), it seemed to him a suitable and convenient place to study and spend the summer in, for it was in the highest and most airy part of Rome, and had most excellent antique statues for him to copy. So he asked Don Manuel de Zúñiga y Fonseca, Conde de Monterrey (who was at that time in Rome as Ambassador of His Catholic Majesty) to negotiate with the Florentine Ambassador for him to be given rooms there. Although it was necessary to write to the Grand Duke, this was arranged under the auspices of the Count, who highly esteemed Velázquez both for his endowments and for the way in which His Majesty honoured him. He stayed there for more than two months until a tertian fever forced him to go down near the house of the Count who, during the days that Velázquez was indisposed, did him great favours, sending his doctor and medicines, at his own expense. And the Count ordered that everything that Velázquez wanted should be prepared in his house, as well as sending many presents of sweetmeats and frequent messages on his behalf, until he recovered from his illness and continued his studies of the eminent paintings and statues which are the wonder of that great metropolis of the world.

Velázquez moved to the Palace or vigna *of the Medici.*

Velázquez caught a tertian fever and was much befriended by the Spanish Ambassador.

Don Diego Velázquez painted at this time the celebrated picture of the brothers of Joseph when, envious of his predestined fortune, after other outrages they sold him to those Israelite merchants and brought his tunic stained with the blood of a lamb to his father Jacob [Plate 72] who, to his great sorrow, was persuaded that some wild beast had torn him to pieces.[12] This is given expression so fine that it seems to compete with the very reality of the event. It is no less the case with another picture which he painted at the same time of the fable of Vulcan, when Apollo informed him of his misfortune: the adultery of Venus with Mars [Plate 71]. Vulcan stands in his forge, near the burly Cyclopes, his assistants, so pale and perturbed that he seems unable to breathe. These two paintings Velázquez brought to Spain and offered to His Majesty, who regarded them with the esteem that they deserved and ordered them to be placed in the Buen Retiro. That of Joseph was later transferred to the Escorial, and is now in the chapter house.

Celebrated picture which Velázquez made in Rome to bring to the King.

12. Genesis, cap. 37.

Another picture which Velázquez made of the Forge of Vulcan.

Velázquez resolved to return to Spain because he was much needed in the service of the King. On his way back from Rome, he stopped in Naples, where he painted a beautiful portrait to bring to His Majesty of the Most Serene Infanta Doña María of Austria, Queen of Hungary [cf. Plate 61], who was born in Valladolid on 18 August in the year 1606 and in 1631 married the Most Serene Ferdinand III, King of Bohemia and Hungary, her cousin, son of the Emperor Ferdinand II, whose happy lot it was to be elected King of the Romans on 22 December 1636. Velázquez returned to Madrid after an absence of a year and a half, arriving at the beginning of 1631. He was very well received by the Conde-Duque, who sent him immediately to kiss His Majesty's hand, to

Portrait which Velázquez painted of the Most Serene Queen of Hungary, María of Austria.

Velázquez returned to Spain after a year and a half's absence.

thank him for not having allowed himself to be portrayed by any other painter, and for waiting for him to portray the Most Serene Prince Baltasar Carlos. This he promptly did [Plate 80], and His Majesty showed much pleasure at his return.

The liberality and affability with which our Velázquez was treated by such a great Monarch is unbelievable. He ordered him to be given a workshop inside his royal palace, in the gallery which is called 'del Cierzo'; to which His Majesty had the key and where he had a chair so that he could watch Velázquez paint at leisure; just as the great Alexander did with Apelles, whom he often went to watch when he was painting in his workshop, honouring him with very special favours, as Pliny relates in his Natural History.[13] Just so His Caesarean Majesty the Emperor Charles V, although engaged in many wars, liked to watch the great Titian paint; and the Catholic King Philip II went very frequently to watch Alonso Sánchez Coello paint, favouring him with singular signs of love.[14] Thus did His Majesty honour Velázquez – imitating and even exceeding his heroic predecessors – with the office of Gentleman of the Wardrobe, one of the offices or employments in the royal household which is held in great esteem. The King also honoured him with the key of his chamber, a thing which many knights of military orders covet. And continuing in his preferment Velázquez came to hold the office of Gentleman of the Bedchamber, although he did not exercise it until the year 1643.

Of the many notable portraits which Don Diego Velázquez painted at this time, probably the foremost is that of Francesco, third [first] of this name, Duke of Modena and Reggio [Plate 96], when he was at this Court of Madrid in the year 1638, when he was god-parent to the Most Serene Infanta Doña María Teresa, with Madame Marie de Bourbon, Princess of Carignan, whom His Majesty Philip IV, her uncle, favoured with special attentions. The Duke did great honour to Velázquez, applauding his rare talent. Having had his portrait painted, very much to his liking, the Duke rewarded him most liberally, in particular with a very exquisite gold chain which Velázquez used sometimes to wear round his neck, as was the custom on festive occasions at the Palace.

Velázquez also made about this time a celebrated picture of the dead Christ on the cross [Plate 113], life-size, which is in the cloister of the convent of San Plácido in this court. There is another in the Buena Dicha [Oratory], which is a very careful copy, on the first altar on the right-hand side, entering the church. Both have two nails in the feet on the suppedaneum in accordance with the opinion that Velázquez's father-in-law held on the subject of the four nails.

In the year 1639 he painted the portrait of Don Adrián Pulido Pareja [cf. Plate 78], native of Madrid, Knight of the Order of Santiago, Captain-General of the Armada and of the Fleet of New Spain, who was here at the time with various claims relating to his service with His Majesty. This portrait from life is among the most celebrated which Velázquez painted, and therefore he signed it, a thing which he seldom did. It was painted with both fine and coarse brushes that he had with long handles and which he sometimes used for effects of greater distance and boldness; so that though close up the picture cannot be understood, from a distance it is a miracle. The signature is in this form:

Diego Velázquez, Court Painter to Philip IV, executed this in the year 1639.

It is said that when this portrait was finished Velázquez, who was painting in the Palace, had placed it in a position where there was little light. The King came down, as was his custom, to watch Velázquez paint and seeing the portrait and mistaking it for the sitter in person said with surprise: *What, are you still here? Have I not already dismissed you? Why have you not gone?* At last, surprised that the supposed Pulido Pareja did not make the correct obeisance or reply, His Majesty realized that he was looking at the portrait and turning to Velázquez, who was modestly pretending not to notice, he said : *I assure you that I was taken in.* Today this exceptional portrait is in the possession of His Excellency the Duque de Arcos.

IV

HOW VELÁZQUEZ ATTENDED UPON HIS MAJESTY ON
HIS EXPEDITION TO THE KINGDOM OF ARAGON

In the year 1642 Velázquez accompanied His Majesty on the expedition he made to the

kingdom of Aragon, for the purpose of establishing peace in the principality of Catalonia. The King returned to his court on Saturday 6 December.

In the year 1643, His Majesty commanded Don Gaspar de Guzmán, Conde-Duque de Olivares, to retire to the city of Toro, which he was not to leave without the King's express permission, and where he died on 22 July 1645. His body was conveyed across Madrid to its tomb in the convent of Discalced Carmelites in the town of Loeches. Diego Velázquez did not fail to mourn his death, as Olivares had been the making of him and he owed him special respect. Nevertheless, His Majesty continued to honour Velázquez as before. Thus he was ordered to attend when His Majesty made another expedition to Aragon to give by his presence strength and valour to his soldiers in the war against Catalonia. Velázquez accompanied His Majesty to Saragossa and Fraga. And when the city of Lérida after being besieged by the French army surrendered on the appearance of its King and natural Lord on 31 July of that year, His Majesty made his entry to mighty applause on Sunday, 7 August. Diego Velázquez painted an elegant life-size portrait of His Majesty to send to Madrid, representing him as he appeared when he entered Lérida [Plate 106], holding the military baton and dressed in crimson cloth, a portrait that had such a fine air, such grace and majesty that it looked like another living Philip. One could truly say of it what was said of the portrait of Alexander when, because of his haste to attack his enemies and put good order among his soldiers, he was painted by Apelles with a thunderbolt in his hand and his fingers resembling the original so vividly that the Macedonians declared that, of the two Alexanders, the one that Philip had begotten was invincible, and the one painted by Apelles was inimitable.[15]

Diego Velázquez also painted two portraits, one of His Catholic Majesty, the King our lord, Philip IV, and the other of the Most Serene Cardinal Infante, Ferdinand of Austria, from the life, standing, holding a gun, their dogs on leashes, resting [Plates 87, 89]. It seems that Velázquez saw them at the hottest moment of the day, arriving tired from their exercise of hunting, which is as arduous as it is delightful, in lively disarray, their hair dusty and not as it is worn today by courtiers, their faces bathed in sweat, just as Martial, on a similar occasion, painted Domitian, handsome with sweat and dust:

> Here, graced by the dust of Northern war, stood Caesar, shedding from his face
> effulgent light.[16]

Diego Velázquez could emulate many other poets, who tell how much grace can be added to beauty by an effect of fatigue, insouciance, and disarray. These two paintings are in the Torre de la Parada, a country seat for recreation belonging to Their Majesties. Velázquez also painted an admirable portrait of the very eminent and Catholic lady Señora Doña Isabel of Bourbon, Queen of Spain, richly attired and mounted on a fine white horse [Plate 82], of which the colour could be described as swan-like. It is a horse of royal size and appears both light and steady. Although it is known to have been chosen from many for its neatness, grace, docility, and safety, it is not so much this that makes it look so proud. It is the gold that gently curbs it, seeming to bite the bridle with reverence, in homage to the heavenly contact with the reins, touched by the hand worthy to hold the sceptre of so great an Empire. The portrait is life-size and hangs, with the portrait of the King our Lord on horseback [Plate 83], already mentioned, in the gilded hall in the Buen Retiro Palace, one on either side of the principal door. Above the door is another picture of the Most Serene Prince Baltasar Carlos [Plate 84]. Although very young he is armed and on horseback with a generalissimo's baton in his hand; the cob on which he is mounted, rushing with great impetus and speed, seems to be breathing fire, impatient with pride, as if anxious to seek a battle in which the victory of his master is assured.

Velázquez painted another picture, an admirable figure composition with the portrait of this prince being taught how to ride a horse by Don Gaspar de Guzmán, Conde-Duque de Sanlúcar, his Master of the Horse [Plate 91]. This painting is today in the house of the Marqués de Heliche, the Conde-Duque's nephew, where it is highly appreciated and esteemed.

Diego Velázquez painted another portrait of his great protector and Maecenas, Don

Retirement of the Conde-Duque de Olivares to the city of Toro, by order of His Majesty.

Velázquez again attends the King on his expedition to Aragon.

Velázquez portrays the King as he was dressed for his triumphal entry into Lérida.

Famous judgement of the portrait of Alexander by Apelles.

15. Pliny, Nat. Hist., XXXV, 92.

Two other portraits of the King and the Cardinal Infante.

16. Martial, Epigrams, VIII, 65.

These two paintings are in the Torre de la Parada.

Portrait of the Serene Highness Isabel of Bourbon.

Portrait of Prince Baltasar.

Another picture of Prince Baltasar, and the Conde-Duque teaching him to ride.

Portrait of the Conde-Duque Olivares on horseback, by Velázquez.

Gaspar de Guzmán, third Count of Olivares, mounted on a spirited Andalusian horse [Plate 92], which had drunk from the Betis not only the swiftness of its waters, but also the majesty of its flow, the froth from its mouth spraying with silver the gold of its bridle; an effect as difficult to reproduce in the manner of the ancients, as it was for the famous Protogenes.[17] The Count is dressed in armour, inlaid with gold, and a hat with splendid plumes, and holds in his hand a general's baton. He looks as if he is riding into battle, sweating under the weight of his arms and eager for the fray. In the distance, the troops of the two armies can be distinguished and the fury of the horses and the fearlessness of the combatants are admirably portrayed; one seems to see the dust and smoke, hear the clamour, and fear the havoc. This portrait is life-size, and among the greatest of Velázquez's paintings. A panegyric in its praise was written by Don García de Salcedo Coronel, Master of the Horse to the Most Serene Cardinal Infante, a man of such great talent and superior intellect that he could with very good reason say with Ovid:[18]

It is but mortal, the work you ask of me; but my quest is glory through all the years,
to be ever known in song throughout the earth.

Velázquez painted another portrait of Don Francisco de Quevedo Villegas [cf. Plate 192], Knight of the Order of Santiago, and Lord of the town of Torre de Juan Abad, whose printed works are testimony of his rare talent. Divine Martial of Spanish poetry, and of prose a second Lucian, he can only be praised with the words that Lucretius used to sing the praise of Ennius:[19]

as our Ennius sang, who first bore down from pleasant Helicon the wreath of deathless leaves.

Quevedo is portrayed in spectacles, which he was accustomed to wear. For this reason the Duke of Lerma in the ballad he wrote in reply to a sonnet sent to him by Francisco de Quevedo asking for gifts of a sphere and a case of mathematical instruments, wrote:

Don Francisco, maintain your candour in verse and in prose, seeing that your eyes are clear as crystal.

Velázquez also painted a portrait of His Excellency Señor Don Gaspar de Borja y Velasco [cf. Plate 16], Cardinal of the Holy Church, with the title of the Holy Cross in Jerusalem, Archbishop of Seville and of Toledo, President of the Royal Council and of the Supreme Council of Aragon. The portrait is today in the palace of the Duke and Duchess of Gandía. Velázquez also portrayed Don Nicolás de Cardona Lusigniano, Master of the Chamber of the King our Lord, Philip IV. Another very celebrated portrait is that of Pereyra, Knight of the Order of Christ, who was also Master of the Chamber, which is painted with singular mastery and dexterity. He also portrayed Don Fernando de Fonseca Ruiz de Contreras, Marqués de la Lapilla, Knight of the Order of Santiago, member of the Councils of War and of the Chamber of the Indies. He painted another portrait of His Majesty, armed and mounted on a fine horse; and after he had finished it with his usual care, he wrote on a large rock:

Philip the Great, fourth of this name, the most powerful King of the two Spains and Supreme Emperor
of the Indies, in the 25th year of the 17th century A.D. in his 20th year.

And on a little stone he placed – as if stuck on with seals – a piece of paper somewhat creased, painted from nature with his usual care, for him to put his name on when the picture had been displayed for everyone to criticize and judge, and after he had considered the faults that had been found with it. For he held the public to be a more discerning judge than himself. Velázquez presented his work to the public for judgement and the horse was censured on the grounds that it offended against the rules of art, with opinions so contrary that it was impossible to reconcile them. Whereupon Velázquez was angry, and wiped out the greater part of his painting. In place of his signature – since he had erased it – he wrote: *Diego Velázquez, Painter to the King, expunged this.* I do not know if this judgement of his picture was based on any profound understanding of art, for not everything that appears defective to the eyes of the ordinary man is so. Neither is that which is praised as good, for in this respect we see every day how not only ignorant people are in error but also people of great learning, quality, and judgement. That is why it is always dangerous to meddle in the affairs of others. For very often what looks like

17. Pliny, Nat. Hist., *XXXV, 105.*

18. Ovid, Amores, *I, 15 [transl. G. Showerman, Loeb Class. Lib. 1914].*

Portrait of Quevedo by Velázquez.

19. Lucretius, De rerum natura, *I, 117 [transl. C. Bayley, Oxford, 1947].*

Portrait of Cardinal Don Gaspar by Velázquez.

Portrait of D. Nicolás de Cardona, and many other portraits by Velázquez.

Velázquez's judiciousness over the criticism of a horse in his portrait of the King.

rough scrawls to the ordinary man are considered marvels by the expert. What amazes me is the example Velázquez set us with his action: for one thing, his modesty in effacing his painting, and, for another, his mistrust of pleasing. For having left what was criticized effaced, he was content to make it known that it was he himself who had done this, and refused to repeat the work of executing the same thing that he had already done. For if it were to be right it had to be as it was before and if it were to be done according to some inept notion of what was right it was better left effaced. The difference of opinions made the undertaking impossible. This was very like what happened to Luca Giordano over the figure of a horse which he painted in a picture for the Comendadoras de Santiago of this Court. While he was painting it in the *Salón de las Comedias* in the palace, the varied and conflicting opinions about the symmetry and proportions of the horse were so numerous that since there was no means of conforming to the advice of all those who considered themselves experienced in the matter, Charles II had to command it to be left as it was, on the advice of a member of the profession; otherwise it would never have been finished. A very wise decision! For knowledge about the handling of horses and their symmetry and proportions – such knowledge can be conceded to all who claim it – is not the same as the understanding of the effect on the eye of the contours produced by their various chance movements and their diminishing forms when foreshortened, together with the effects of distance and of the atmosphere that surrounds them. Pliny, in his *Natural History*, Book 35, says that Alexander of Macedon often used to come to the studio of Apelles and enjoyed not only his artifice, but also his urbanity. When the King was in his workship, talking inexpertly about matters of art, Apelles told him that he should accept a friend's advice to keep silent on that subject so that the boys who ground his colours should not laugh.[20] What Pliny writes about Alexander, Plutarch relates of Megabizus in that treatise in which he deals with the difference between flatterer and friend. There he says that when Megabizus, a noble of Persia, seated beside Apelles, was endeavouring to say something about lines and shadows, Apelles said to him: *Do you not see that the boys who are grinding the colours gave you their attention a little while ago when you were silent, admiring the purple and gold that make you illustrious? Well, those same boys are now laughing at you, because you are beginning to speak about things of which you have no knowledge.* Aelianus[21] tells the same story, with the single difference that he tells it of the painter Zeuxis. It could also be true of him, for one Megabizus is enough to anger many Zeuxes and Apelles.

Velázquez's portrait in the condition just described was in the passage between the palace and the Encarnación. Velázquez also at this time portrayed with the utmost success a lady of singular perfection. The portrait was the subject of this epigram by Don Gabriel Bocángel, which I thought I should not omit, with its great discernment expressed in so few words, to delight the readers' taste:

> *You have succeeded in imitating*
> *the superb eyes of Lisi so perfectly*
> *that you could deceive*
> *our eyes, our hands.*
> *Silvio, you offended her beauty,*
> *which has no equal, for you,*
> *not nature, created her equal.*

He also painted the portrait, after his death, of the Venerable Father and Master Fray Simón de Roxas, a famous man of letters and of virtuous life [cf. Plate 15]. He also painted his own portrait on various occasions [cf. Plate 69], notably in the picture of the Empress of which special mention will be made [Plate 184]. At this time he also painted a large figure composition representing the capture of a fortress by Ambrogio Spinola [Plate 122], for the Salón de las Comedias in the Buen Retiro Palace, a work of the highest quality. So too was another painting of the Coronation of Our Lady [Plate 117], which was in the oratory of the Queen's apartment in the Palace, not to mention many other portraits of famous men and of Court entertainers [Plates 100, 101], which are on the staircase leading to the Jardín de los Reynos in the Retiro, which Their Majesties take to get to their carriages.

Similar case of what happened to Luca Giordano.

Wise decision of Charles II.

Inexpertness of some people on the subject of painting.

20. *Pliny*, Nat. Hist., *XXXV, 85.*

21. *Aelianus,* Variae Hist., *lib. 2, cap. 2.*

Portrait of a lady of very great beauty, by Velázquez.

Portrait of the Venerable Father and Master Fr. Simón de Roxas, by Velázquez.

Large picture of the capture of a fortress by Velázquez, and another of the Coronation of Our Lady.

V

ACCOUNT OF THE SECOND JOURNEY TO ITALY MADE
BY DON DIEGO VELÁZQUEZ BY ORDER OF HIS MAJESTY

Velázquez departs for Italy for the second time.

In the year 1648 Don Diego Velázquez was sent by His Majesty to Italy on an extraordinary embassy to the Pontiff Innocent X and to buy original pictures and antique statues, both by Roman and Greek artists, and casts of some of the most celebrated examples to be found in various places in Rome. They are distinguished both by their dress and their manner of execution, for the Romans used to sculpture their images dressed and the Greeks naked in order to display the excellence of their art – as seen in the works of the Athenian Glycon in the statue of Hercules, Praxiteles and Phidias in the Bucephalus of Alexander the Great, Apollonius Nestor in the torso of Hercules so revered by Michelangelo; and many other Greek statues.

Famous statuary of the Greeks.

Don Diego Velázquez, then, left Madrid during the month of November of the year mentioned of 1648. He embarked in Málaga with Don Jaime Manuel de Cárdenas, Duke of Nájera, who was going to Trent to wait on the Queen our lady Doña María Ana of Austria, daughter of the Emperor Ferdinand III and of the Empress Doña María, Infanta of Spain.

Famous things that Velázquez noticed in Genoa.

They stopped in Genoa, where he saw in passing some works by Lazzaro Calvo and in the main Piazza Maggiore del Consiglio the portrait of Andrea Doria, the renowned admiral, a statue executed in marble by Fray Angelo di Montorsoli. Six yards high, on a great pedestal, he wears antique armour, and carries a baton in his hand and he has Turks at his feet. Its size makes it a formidable spectacle.

Famous things which Velázquez saw in Milan.

Velázquez went on to Milan, though he did not stay to see the entry of the Queen, which was to be celebrated with great ostentation. He did not fail to see some of the remarkable works in sculpture and painting which are in that city, such as the marvellous Last Supper of Christ and His apostles, a work of the felicitous hand of Leonardo da Vinci; and lastly he saw all the paintings and churches that are in that illustrious city.

Other particular works that he noted in Venice.

He went on to Padua and from there to the Republic of Venice, to which he was much attached, because it was the workshop of such excellent artists. He saw many works by Titian, Tintoretto and Paolo Veronese, who are the 'authorities' whom he had attempted to follow and imitate after the year 1629, when he was in Venice for the first time.

Sketch of the Gloria of Tintoretto.

Here he found occasion to buy the paintings from a ceiling with scenes from the Old Testament by Jacopo Tintoretto; the principal one, oval in shape, showing the children of Israel collecting the manna, as is written in Exodus, all marvellously executed. He bought another picture of the Conversion of Saint Paul, and another of the Gloria, which is attributed to Tintoretto, very full of figures most harmoniously arranged, and executed with supreme facility and fluency. This is why it is judged to be by the hand of Tintoretto, like the large version which he painted in Venice and for which he must have made this sketch: one of his works which is most worthy of fame for its perfection and marvellous grandeur.

He also bought a Venus and Adonis embracing, with a little Cupid at their feet, by the hand of Paolo Veronese, and some portraits.

He found, also by Veronese, two large pictures with scenes from the Life of Christ: one was the miracle of the blind man to whom Christ gave sight – and both were miracles of art. But because they were painted in tempera, Velázquez did not dare to take them away, considering it wiser to go without them than to expose them to the risk of damage on the ship.

Noteworthy sights of Bologna.

Velázquez took the road to Bologna to see, in San Giovanni in Monte, the remarkable panel of Saint Cecilia with four other Saints painted by Raphael of Urbino; and the Saint Petronio in marble by Michelangelo; and above the door of Saint Petronio the bronze portrait of Pope Julius II.

Velázquez communicates in Bologna with Mitelli and Colonna.

He met Angelo Michele Colonna and Agostino Mitelli, the famous Bolognese fresco painters, by whom there are many works in Italy that bear witness to their excellence, and he treated with them about their coming to Spain.

Velázquez was lodged in the house of Count di Segni, by whom he was well entertained the whole time that he stayed in Bologna. When he arrived there the Count went

to receive him, with other gentlemen in carriages, more than a mile outside the city.

He went to Florence, where he found much to admire. The Dukes had always so favoured the arts of drawing, that from her illustrious Academy there have come such excellent talents as Dante Alighieri, no less a painter than a poet; and the divine Michelangelo Buonarroti, who is alone sufficient to make her famous in the world. After having seen the most renowned products of that sublime workshop of the arts and talents, he went on to Modena where he was much favoured by the Duke, who showed Velázquez his palace and the curious and valuable things that he possessed. Among them was the portrait which Diego Velázquez painted of the Duke when he was in Madrid.

In Florence Diego Velázquez found much to admire.

The Duke sent Velázquez to see the palace and pleasure house that he has seven leagues from Modena, painted in fresco by Colonna and Mitelli; all the walls covered with figures, compartments, cartels, and ornaments done with such artifice that the beholder finds it difficult to persuade himself that it is painting.

Palace of the Duke of Modena.

He went on to Parma to see the cupola of Antonio Correggio, so celebrated in all the world, and the paintings by Mazzolino [Francesco Mazzola] *il Parmigianino* (for although we said in the first volume that he was called Lattanzio Gambara, it was wrong information), each one being a new glory to his native country.

Famous paintings of Parma.

From here Velázquez started for Rome. On his arrival it was necessary for him to go to Naples to talk to the Conde de Oñate, Viceroy of the Kingdom at that time, who had orders from His Majesty to assist him freely and lavishly in all that he needed for his purpose. He visited José de Ribera, member of the Order of Christ, whose works in Naples were a credit to the Spanish nation, and who was called in Italy *il Spagnoletto*.

Velázquez arrives in Naples, where he is well entertained by the Viceroy.

Velázquez returned to Rome, where he was greatly befriended by the Cardinal Patron Astalli Pamphili, a Roman nephew of Pope Innocent X, and by Cardinal Antonio Barberini, by Abbot Peretti, by Prince Ludovisi and by Monsignor Camillo Massimi and many other gentlemen; and also by the most excellent painters, such as Mattia [Preti], Knight of the Order of Saint John, Pietro da Cortona, Monsieur Poussin and by the Bolognese Cavaliere Alessandro Algardi and the Cavaliere Gianlorenzo Bernini, both very famous sculptors.

Velázquez arrives in Rome where he is much favoured by the Pope and certain Cardinals and other princes and artists.

Without neglecting his official business, Velázquez painted many things, chief among them the portrait of His Holiness Innocent X [Plate 150], from whom he received great and very distinguished favours. And in remuneration, the Holy Father, wishing to honour him in recognition of his great accomplishment and merit, sent Velázquez a gold medal with His Holiness's portrait in low relief, hanging from a chain. Velázquez brought a copy of his portrait of the Pope to Spain [cf. Plate 153]. It is related that when he had finished it and it was placed in a room within the antechamber of the palace, the chamberlain of His Holiness was about to enter and, seeing the portrait (which was in a dim light), thought it was the original, and turned to go out, telling various courtiers who were in the antechamber to speak quietly as His Holiness was in the next room.

Velázquez made a portrait of Cardinal Pamphili [Plate 158]; the illustrious lady Donna Olimpia [cf. Plates 145, 146]; Monsignor Camillo Massimi [Plate 159], chamberlain of His Holiness and a famous painter; Monsignor Abbot Hippolito, also chamberlain of the Pope; Monsignor Majordomo of His Holiness [cf. Plate 155]; Monsignor Michelangelo, the Pope's barber; Ferdinando Brandano, chief officer of the Pope's secretariat; Girolamo Bibaldo; and Flaminia Triunfi, an excellent painter. He made other portraits which I do not mention because they remained unfinished, although they did not lack resemblance to their originals. All these portraits he painted with long-handled brushes and in the vigorous manner of the great Titian, nor were they inferior to Titian's heads. No one who has seen what there is by his hand in Madrid can question this.

Other portraits which Velázquez made in Rome.

When it was decided that Velázquez should make a portrait of the Sovereign Pontiff, he wanted to prepare himself beforehand with the exercise of painting a head from life; and he made one of Juan de Pareja [Plate 149], his slave and a painter himself, with such likeness and such liveliness that when he sent it with Pareja for the criticism of some friends, they stood looking at the painted portrait and the model with admiration and amazement, not knowing which one they should speak to and which was to answer them.

Portrait of Pareja by the hand of Velázquez.

Of this portrait (which is half-length, from life) a story is related by Andreas Schmidt,

Andreas Schmidt, Flemish painter.

Velázquez was Roman Academician.

Statues which Velázquez collected for the King on his second journey to Italy.

22. '*This is the case of the Laocoön in the palace of the emperor Titus, a work superior to any painting and any bronze. Laocoön, his children, and the wonderful clasping coils of the snakes were carved from a single block in accordance with an agreed plan by those eminent craftsmen Hagesander, Polydorus, and Athenodorus, all of Rhodes.*'
Pliny, Nat. Hist., *XXXVI, 37* [*transl. H. Rackham, Loeb Class. Lib.*].

23. *Pliny,* Nat. Hist., *XXXVI, 58.*

Statue of Cleopatra.

Statue of Apollo.

Statue of Mercury.

Statue of Niobe.

Statue of the god Pan.

Statue of a faun.

Statue of Bacchus.

a Flemish painter now at the Spanish court, who was in Rome at the time. In accordance with the custom of decorating the cloister of the Rotunda (where Raphael of Urbino is buried) on Saint Joseph's day, with famous paintings, ancient and modern, this portrait was exhibited. It gained such universal applause that in the opinion of all the painters of the different nations everything else seemed like painting but this alone like truth. In view of this Velázquez was received as Roman Academician in the year 1650.

He resolved to go back to Spain on account of the frequent letters he received from Don Fernando Ruiz de Contreras, in which His Majesty repeatedly ordered him to return.

The principal statues he chose from so great a number were the group of the Trojan Laocoön and his two sons, which is in the Belvedere, enveloped in the intricate coils of two serpents which wrap them round with marvellous twists and turns. Of these three persons, one is in a state of great pain, another in the act of dying, while the third shows compassion. Pliny says that this work is to be preferred to and placed above all other works of painting and sculpture, and that it was made from a single stone, with the approval and advice of the Senate of Athens, by three excellent artists: Agesander, Polydorus, and Athenodorus, all Rhodians. Pliny's reference to them is markedly enthusiastic and elegantly expressed.[22]

Velázquez also chose a fine colossal statue of the naked Hercules (which they call the Old Hercules) leaning against a tree, all of one piece of marble, wearing the skin of the Nemean lion and with his club in his hand. The legs and hands are modern by Jacopo [Giovanni Battista] della Porta of Porlezza, a distinguished sculptor and architect. On the trunk are carved certain Greek characters which mean that Glycon of Athens made the statue.

[He chose] another standing nude of Antinous, which some say is Milon, a whole figure except that one arm is missing. The statue was so revered by Michelangelo Buonarroti that he did not dare to replace the arm. It has a sash tied over the left shoulder. Antinous was a very beautiful youth, the friend, in the immodest sense, of the Emperor Hadrian.

Velázquez brought back another statue, a marvellous image of the Nile, the river of Egypt, leaning to his left on a sphinx. He holds in his left hand the cornucopia of abundance and has around him 17 children, made from the same block of marble. On the base are carved crocodiles and various other animals of Egypt which hide in the Nile itself. This admirable statue was found near Santo Stefano, and was called Cacus. It is mentioned by Pliny.[23]

He also brought to Spain a statue of Cleopatra. She holds her right arm over her head, and seems to faint and swoon from the poison introduced into her breast by the bite of the asp whereby she chose to end her life, so as not to fall into the hands of her enemy Augustus, already triumphant over her and her lover Mark Antony.

He brought back another statue of Apollo standing, nude, with drapery round his shoulders and over his left arm, just as he has shot his arrow. Moreover, his bow is broken; the quiver hangs from his neck on a band and his right hand rests on a tree trunk of marble which has a serpent wound round it. The statue bears the reputation of being by some excellent Greek sculptor.

There was also a Mercury, a very beautiful nude, wearing on his head the winged cap, carrying in his left hand the caduceus and in his right hand a purse, because the ancients made Mercury god of eloquence and of trade and profit, and messenger of the gods.

Velázquez also brought back another statue of Niobe in the act of running, dressed in a very thin robe, which the air seems to set in motion. She holds her right arm raised and with the left gathers up her mantle which is wrapped round it.

He also brought back the statue of Pan, god of the shepherds, nude, clad only in an animal's skin; he is placed against a tree-trunk on which a flute is carved. And an old faun, god of the forests and woods, with a child in his arms, a standing nude, leaning against a tree trunk, and wrapped in a tiger's skin.

He also brought back another statue of Bacchus, nude, leaning against a tree trunk, and at his feet a dog eating grapes. And a Venus naked, as when she rises from the sea,

with a dolphin below, with foam in its mouth, and on it some little cupids. This is a very famous statue, smaller than life-size and of singular beauty and lacking only a soul to appear alive.

Statue of Venus.

There was also another statue of a naked man, with his right arm raised and the fist clenched, holding his clothes with his left hand, and with a tortoise at his feet. They say that it is a player of *morra* and the owner of the original in Rome believes it to be so; others say that it is the Consul Brutus, chief of the conspirators against Julius Caesar.

Statue of a naked man.

He also brought a small statue of a nymph, half draped, leaning with her left arm on a rock on which is carved a sea-shell; she is believed to be the goddess Venus.

Statue of a nymph.

Another statue was of a naked man falling to the ground as though swooning. He has a thick cord round his neck and his arms hanging on the ground, and he is considered to be a gladiator sentenced to death. Others believe that he might be one of the three Curiatii, Alban brothers who fought the three Roman Horatii for the liberty of their country and were conquered and killed, leaving Alban territory subjected to the Romans.

Statue of a gladiator.

He also brought back a naked figure, resting on a cushion, of Hermaphrodite whom the poets imagine to have been produced by the union of the nymph Salmacis (companion of the Naiades) with the son of Mercury and Venus, a youth of singular perfection who, when the gods at the entreaty of the nymph Salmacis had turned them into one person, retained the signs of both sexes. It is the most beautiful statue imaginable.

Statue of a hermaphrodite.

There was another standing hermaphrodite and a little statue of the goddess Vesta; another of a naked nymph seated with a shell in her hand as though pouring water, which is thought to be Diana.

Statue of another hermaphrodite and the goddess Vesta, and another of Diana.

There was also a struggle between two naked men, less than life-size, doubtless gladiators, by an excellent artist.

Two more gladiators.

Also a standing gladiator, in fierce and violent motion, a Greek work, as is shown by the Greek inscription which is carved on a marble tree trunk and which signifies in our language that Agasias Dositheus had made it.

Another statue of a gladiator.

This gladiator has opposite him a naked man, seated with sword in hand, and at his feet a small boy holding a bow, with a shield and a helmet on the ground. It is a very fine statue and so strongly built that it seems to breathe. It is believed to be one of those gladiators who in ancient times of their own free will were led into the palaestra with their weapons in their hands and exposed themselves to the peril of their life for a small reward.

Another seated gladiator.

He also brought back a statue of Mars nude, with only a helmet on his head, standing with sword in hand; and a nude Narcissus, standing with open arms, enamoured of himself and of the beautiful form which he sees beneath the water, which he thinks is a living body – a mad passion that cost him his life. For it he was turned into a flower called by his own name, in fulfilment of the prophecy of the soothsayer Tiresias.[24]

Statue of Mars.

24. *Ovid,* Metamorphoses, *III, 510.*

Velázquez also brought back the image of a goddess of gigantic size, holding in her left hand a crown of leaves tied with a ribbon, with the other raising her dress which is thin and light and shows her feet. She has naked arms and part of her breast is bare. On her shoulders are small clasps that hold her dress and round her waist is a sash with a little bow. The statue is of marble, by the hand of a fine artist, and it is thought to be the goddess Flora.

Statue of Flora.

There was also a Bacchus, young, naked, leaning against a tree trunk on which he has thrown a garment; he has his right arm raised and in his hand a bunch of grapes. Also a naked figure drawing a thorn from his foot with extreme care and attention; and an unknown goddess, draped, who is considered to be Ceres, but has no particular attributes.

Another statue of Bacchus.

Statue of a naked figure drawing a thorn from his foot and another of Ceres.

A large lion with neck and shoulders covered with long hair, to signify its ferocity and nobility. Likewise many portraits, draped, armed, and naked; such as that of Hadrian, Trajan's successor, an excellent prince, and such a devotee of all the arts that he was architect, sculptor, and musician; but he was yet more famous for military discipline than for anything else. Also that of Marcus Aurelius, philosopher and emperor; of Livia, wife of Caesar Augustus and mother of the Emperor Tiberius; of Julia, daughter of Julius Caesar and wife of the great Pompey; of Faustina; of Numa Pompilius; of Septimius Severus; of Antoninus Pius; of Germanicus; of Domitian; of Scipio Africanus; of Titus,

Various half-length portraits in marble, which Velázquez brought from Italy.

son of Vespasian, a courteous prince, who conquered the Jews and demolished the city of Jerusalem in revenge for the death of Christ; and many other emperors, great consuls; and a very great number of heads of men and women. Also the head of Moses by Michelangelo, which is in the mausoleum of Julius II in S. Pietro in Vincoli; of which the Cardinal of Mantua said that this figure alone was enough to do honour to Pope Julius II, such is its grandeur and majesty![25]

25. Giorgio Vasari, Le Vite, III.

His desire to see Paris would have obliged Diego Velázquez to return to Spain by land, but he decided not to do so because of anxiety about the hostilities, although he had a passport from the Ambassador of France.

Velázquez returns to Spain after his second journey to Italy.

He embarked in Genoa in the year 1651, performing his duty with the promptitude with which he always obeyed the orders of His Majesty. Although he encountered many severe storms he arrived at the port of Barcelona in the month of June. He went on to Madrid, and after making his reverence to the King, he received the honour of a mention in a letter written with the royal hand to Don Luis Méndez de Haro, in which he said amongst other things: 'Señor Velázquez has arrived, and has brought some paintings', etc. This is mentioned by Don Bernardino Tirado de Leiva in the settlement of the lawsuit over the annual tribute [*soldado*] of this city, which was mentioned in lib. 2. cap. 3., vol. 1., page 162.

Death of the Queen and second marriage of Philip IV.

During this autumn of Velázquez's absence, the Queen Isabel of Bourbon had died and the King was married a second time to the Most Serene Queen Mariana of Austria. She landed in Denia, and after the King had celebrated his marriage in the town of Navalcarnero he entered Madrid in the year 1649. Velázquez was not present at these functions, for he only returned from Italy in the year 1651, having gone in 1648.

Girolamo Ferrer cast the statues in the moulds brought by Velázquez.

The casting of the statues was next dealt with. It was done by Girolamo Ferrer, who came from Rome for this purpose, since he was eminent in this kind of work, and Domingo de la Rioja, an excellent sculptor of Madrid. Some statues were cast in bronze for the *pieza ochavada,* a room which was designed and arranged by Velázquez; as was also the *salón grande* and the *escalera del Rubinejo,* the staircase which Their Majesties henceforth went down to get to their carriages. The choice of this staircase was due, as it were, to his skill, for previously Their Majesties had gone down through the corridors and the principal staircase to the vestibules. The rest of the statues were cast in plaster and were placed in the *bóveda del Tigre* and the lower gallery, the *galería del cierzo* and other places.

VI

IN WHICH HIS MAJESTY PHILIP IV CONFERS ON DON DIEGO VELÁZQUEZ THE APPOINTMENT AS CHIEF CHAMBERLAIN OF THE PALACE

Diego Velázquez appointed chief Chamberlain.

In the year 1652 His Majesty honoured Don Diego Velázquez with the appointment as chief Chamberlain of his Imperial Palace, as successor to Don Pedro de Torres, and he held this position, filling it to the complete satisfaction and pleasure of His Majesty, until the year 1660, when he died. He had as successor Don Francisco de Rojas y Contreras, His Majesty's Secretary and Gentleman of the Bedchamber, who formerly held the same office in Flanders under the Cardinal Infante Don Ferdinand of Austria.

Reflection on Velázquez's employment as chief Chamberlain.

On the subject of this position as Palace Chamberlain, Gil González Davila, Chronicler of His Catholic Majesty our lord Philip IV, in the *Teatro de las Grandezas de Madrid,* tells in great detail of the tasks involved and the qualities and abilities which it demands. This appointment was a great honour for Velázquez, although there are those who think that it was a matter requiring most careful consideration. For it seems that the reward of professional men should be treated very differently from that of any other kind of merit or service. When it is a matter of men without occupation, by giving them something to do their merit is increased by the reward; but in the case of professional men, the reward robs them of merit. For if the reward is based on the exercise of their profession they will hardly be able to pursue it if they have no opportunity to practise it. And so it seems that the rewards of artists should be purely honorary and monetary rewards (when they are personally necessary) should be conferred as an honour, as a stimulus and reward of excellence: the latter to enable them with ease to capture the more hidden beauties of art, concerned only with winning the praise of posterity, and giving them

more and more opportunities to contribute to their fame with the fruits of their study. This is the reward that gives the greatest credit to the excellence of the artist. For to restrict the exercise of his profession, even with honorary employment, is a kind of reward that appears to wear the disguise of punishment. He who has failed in the administration of his office is suspended, so how is it that what has to be a reward for some is for others a punishment? It might well be considered that the most valuable feature of the honour is serving His Majesty; but let them serve in that line which they followed in order to win their Sovereign's favour and not in tasks quite foreign to the exercise of their talent. For no matter how much this talent is applied to such tasks, the most valuable part of serving and deserving will be wasted, since anyone with moderate talent is capable of filling domestic posts – without any other preparation than ordinary practice – but not everyone is capable of exercising a higher skill. Nature herself, it seems, gives us to understand how much it costs her to bring forth an eminent man, so many being spoiled, as we see in various professions, and remaining on the slope of the mountain without being able to get to the top. And, finally, for service in any domestic office, there will be found many to equal and even excel the most celebrated artist; but for a work requiring exceptional talent, there will be very few, perhaps none. It may, therefore, be a wise suggestion to employ a person on that in which he can be unique and not that in which he is merely ordinary.

To restrict the exercise of talent is more of a punishment than a reward.

A person should be employed in that in which he is unique, not that in which he is ordinary.

This was well practised by His Catholic Majesty Charles II, for although he granted almost countless favours to Luca Giordano and his family, he never granted him one that would impede the progress of his talent; on the contrary, he tried to stimulate it by providing more and more opportunities for it to bear fruit, in the decoration of his palaces, chapels, and temples. Even the position of Keeper of the keys (to which His Majesty appointed him when he came to Spain, which is that of Assistant to the Chamberlain) was intended as an honourable form of admittance, and he was spared the burden of administering it.

Example of Luca Giordano whom the King never burdened with tasks of office.

The office of chief Chamberlain of the Palace, in addition to being a great honour, is such an onerous one that it needs a whole man. And although we professors of painting are very proud of Velázquez's elevation to such honourable positions, at the same time we are sorry to have missed so many proofs of his rare ability, that would have multiplied his gifts to posterity. But the aptitude that he had for any employment and the high opinion His Majesty had formed both of his integrity and his talent, made him deserving of the highest honours; they all seemed unequal to the great profusion of his merits.

Office of chief Chamberlain gives much to do.

His Majesty held Velázquez as a person in such high esteem that his trust in him was more than that of a King to a vassal. He discussed with him very difficult problems, especially in those more intimate hours, after the noblemen and other courtiers had retired. Proof of this is the occasion when a certain son of a great gentleman, filled with the hardihood of youth, had some rather intemperate words with Velázquez for not wanting to relax some formality of his office. When he told his father about the incident, believing he had done something amusing, his father said: 'How can you have been guilty of such misconduct towards a man whom the King esteems so highly and with whom he converses for hours on end? Go, and unless you give him complete satisfaction and recover his friendship do not return to my presence.' Such was the opinion held of Velázquez even by great noblemen. And he well deserved it for his behaviour, his integrity, and honourable procedure in the face of base envy, which never rests, preying always on the magnificence of others: a necessary affliction of the fortunate, which only the unfortunate are spared.

Great display of the King's benevolence that Velázquez enjoyed.

<div align="center">

VII

IN WHICH THE MOST ILLUSTRIOUS WORK OF DON DIEGO VELÁZQUEZ IS DESCRIBED

</div>

Among the marvellous paintings made by Don Diego Velázquez was the large picture with the portrait of the Empress (then Infanta of Spain), Doña Margarita María of Austria, when she was very young [Plate 184]. There are no words to describe her great charm, liveliness and beauty, but her portrait itself is the best panegyric. At her feet kneels

Picture which Velázquez painted with the portrait of the Empress, and in which he portrayed himself.

Description of the figures in this painting.

Doña María Agustina, the Queen's *menina*, daughter of Don Diego Sarmiento, serving her water from an earthenware jug. At the other side is another *menina*, later a Lady of Honour, Doña Isabel de Velasco, daughter of Bernardino López de Ayala y Velasco, Count of Fuensalida, His Majesty's Gentleman of the Bedchamber; from her movement and gesture she seems about to speak. In the foreground is a dog lying down, and beside it Nicolasito Pertusato, a dwarf, treading on the dog to show that, although ferocious in mien, it allowed this tamely and gently; for while it was being painted it remained motionless in the position in which it was placed. The dog is heavily shaded and important, giving great harmony to the composition. Behind is Mari-Barbola, a dwarf of formidable aspect; further back in the distance and in half-tone is Doña Marcela de Ulloa, Lady of Honour, with a *Guarda Damas*, who gives marvellous effect to the arrangement of the figures. On the other side is Don Diego Velázquez painting. He holds his palette of colours in his left hand, a brush in his right, the key of his office as Usher and Chamberlain at his waist and on his breast the badge of the Order of Santiago which His Majesty ordered to be painted in after Velázquez's death. Some say that His Majesty himself painted it to encourage practitioners of this most noble art, by the example of so exalted a recorder. For when Velázquez painted this picture the King had not yet bestowed on him the honour of knighthood. I consider this portrait of Velázquez to be no lesser work of artifice than that of Phidias, the renowned sculptor and painter, who placed his portrait on the shield of the statue he made of the goddess Minerva, executing it with such artifice that if it were removed the statue itself would be completely ruined.[26]

Phidias on his statue of Minerva.

26. *Pliny,* Nat. Hist., *XXXVI, 18.*

Titian in his portrait of Philip II.

Titian made his name no less eternal by portraying himself holding in his hands another portrait with the image of King Philip II. Thus, just as the name of Phidias was never effaced so long as his statue of Minerva remained whole, and Titian's as long as that of Philip II survived, so too the name of Velázquez will live from century to century, as long as that of the most excellent and beautiful Margarita, in whose shadow his image, under the benign influence of such a royal mistress, is immortalized.

The canvas on which he is painting is large, and nothing of what is painted on it can be seen, for it is seen from behind resting on the easel. Velázquez showed his indisputable talent by revealing, through an ingenious device, what he was painting, availing himself of the clear light of a mirror which he painted at the back of the room and facing the picture, with its reflection showing our Catholic King Philip and Queen Mariana. On the walls of the room represented in the picture – the Prince's chamber – where it was in fact painted, several paintings can be seen, though not clearly. They are known to be by Rubens and to represent subjects from the Metamorphoses of Ovid. This room has several windows which are seen diminishing in size so as to create an effect of great distance; the light from the left enters through them but only through the first and the last. The floor is smooth and represented with such perspective that it seems one could walk across it, and the ceiling displays the same quality of perspective. On the left side of the mirror is an open door leading to a staircase and in the doorway is Joseph Nieto, the Queen's Chamberlain, very lifelike, despite the distance and the reduction of scale and of light in which he is placed. The figures are set off by aerial perspective; their disposition is superb; the invention is new; in short there is no praise too high for the taste and skill of this work: for it is truth, not painting. Don Diego Velázquez finished it in the year 1656, leaving in it much to admire and nothing to surpass. If he were less modest, Velázquez could say of this painting what Zeuxis said of the beautiful Penelope, the work with which he was greatly satisfied: that it would be easier to envy it than to imitate it.[27]

Portrait of the Queen's Chamberlain, called Joseph Nieto.

27. *Pliny,* Nat. Hist., *XXXV, 63* [*referring, however, to an athlete, not the Penelope.*]

This painting was highly esteemed by His Majesty, who frequently came to watch it being executed. So too did the Queen Doña Mariana of Austria, and the Infantas and Ladies-in-waiting, who considered this an agreeable and pleasurable entertainment. It was placed in the lower apartment of His Majesty, in his bureau, together with other excellent paintings, and when in recent times Luca Giordano came and happened to see it, he was asked by Charles II, who saw his look of astonishment: 'What do you think of it?' And he replied: 'Sire, this is the Theology of Painting', by which he meant to convey that just as theology is superior to all other branches of knowledge, so is this picture the greatest example of painting.

Giordano's judgement of the picture of the Empress by Velázquez.

VIII

OF THE PAINTINGS THAT VELÁZQUEZ TOOK TO THE ESCORIAL BY ORDER
OF HIS MAJESTY; AND OF THE PAINTINGS IN THE SALÓN GRANDE (GREAT
HALL) CALLED THE HALL OF MIRRORS

In the year 1656 His Majesty ordered Don Diego Velázquez to take to San Lorenzo el Real 41 original paintings, some of them from the auction of the King of England, Charles Stuart, first of this name; others brought by Velázquez from Italy and mentioned in chapter V, and others given to His Majesty by Don García de Avellaneda y Haro, Conde de Castrillo, who had been Viceroy in Naples and was at the time President of Castille. Diego Velázquez made a description and memorandum of these paintings with information about their merits, their provenance and their painters, and the places where they were hung. This document, which was to be shown to His Majesty, was written with such authority and elegance as to be proof of his learning and great knowledge of art, which is so remarkable that only he could give the paintings the praise they deserve.

In the year 1657 Diego Velázquez wanted to return to Italy, but the King did not permit him on account of his protracted stay on his last visit. But since His Majesty wished to see the ceilings or vaults of some of the rooms in the palace painted in fresco, this method of painting being the most suitable for walls and ceilings and the most lasting of any used by painters, and much practised in antiquity, Michelangelo Colonna and Agostino Mitelli came from Italy for this purpose. As we have already said, Velázquez had been in touch with them in Bologna.

In the year 1658 they arrived in Madrid, where they were well received and looked after by Don Diego Velázquez. He lodged them in the Casa del Tesoro in a room on the first floor, and had charge of the monthly payments they received, an arrangement that was also under the supervision of the Duque de Terranova, as Superintendent of the Royal Works.

They painted the ceilings of three adjoining rooms in the lower apartments of His Majesty: on one they represented Day, on the second Night and on the third the Fall of Phaethon in the river Eridanus, all with noble composition, action and artifice, and with excellent decoration by the hand of Mitelli, who was singularly talented for this, as all his works prove.

In the same apartments they painted a gallery overlooking the Queen's garden. Here Mitelli painted all the walls, uniting the real and imitation architecture with such perspective, art, and felicity that it deceived the eye and made it necessary to touch it to make sure that it was really only painted. By Colonna's hand were all the trompe l'oeil images – figures in high relief, scenes in bronze bas-relief, heightened with gold, dolphins and river-gods, garlands of leaves, fruits, and other objects, and a little black boy going down a staircase looking like a real one – and the real little window introduced into the body of the painted architecture. It is worth noting that those who looked at this vista doubting whether the window was simulated – as indeed it was not – were also in doubt whether it was real – an equivocation caused by the great naturalness of the other, simulated objects. But owing to the vicissitudes of time, the building deteriorated and it became necessary to restore it and so relinquish many excellent marvels of art. I rated them so 40 years ago, and I do not wish the memory of them to perish.

At this time they deliberated about what was to be painted in the *Salón grande*, which has windows above the principal entrance to the palace, and, having chosen the Fable of Pandora, Diego Velázquez made a plan of the ceiling with the distribution and design of the paintings, and in each section was written the story to be represented.

They began this work in the year 1659, about the month of April. It fell to Don Juan Carreño to paint in fresco the god Jupiter and Vulcan, his blacksmith and chief engineer, showing him that statue of a woman which Jupiter had ordered him to fashion with the utmost perfection that his talent permitted and which he had done to the best of his ability. Thus he produced a marvellous statue, of singular beauty. In the background was painted the forge and workshop of Vulcan, with its anvils and vices and other blacksmith's tools, and in it the Cyclopes, whom he had as workmen, who were called Brontes, Steropes, and Pynacmon.[28]

Paintings taken to the Escorial.

Michelangelo Colonna and Agostino Mitelli, their coming to Spain.

Paintings which Colonna and Mitelli executed in fresco in the palace.

Painting of the gallery in the palace which overlooks the Queen's garden.

Painting of the salón *in the palace, called the Hall of Mirrors.*

Velázquez designed the distribution of the ceiling.
What Carreño painted there.

28. *Virgil,* Aeneid, *lib. 8, 425.*

The Fable of Pandora in the middle of the ceiling painted by Colonna.

It fell to Michelangelo Colonna to paint the scene where Jupiter commanded the gods that each should bestow on Pandora a gift whereby she would be made more perfect: Apollo, music; Mercury, discretion and eloquence; in short, each of them enriched her with what came from his own store. Because she had acquired so many gifts from the gods, they called her Pandora in Greek: from *Pan*, which means 'all'; and from the word *Doron* which signifies 'endowment'; and the two names together mean 'endowed with all'. The gods and goddesses are seen beautifully placed on thrones of clouds, with their own attributes to identify them; presiding over them all is Jupiter on an eagle, with Pandora and Vulcan below. This is the principal theme and is in the middle of the ceiling: its form is somewhat oval, and the whole ceiling somewhat concave.

What Rizi painted in the salón.

It fell to Francisco Rizi to paint Jupiter handing to Pandora an exquisite gold vessel, saying that in it was the dowry for her support, and that she should look for Prometheus who was a person worthy to be endowed with what she had.

In another part of the ceiling Rizi painted Pandora offering that vessel of gold to Prometheus, who with a very lively gesture and movement rejects her and takes his leave, without wishing to listen to her any longer. For he was so cautious and wise that he knew that her composure and fine bearing and the clever way she persuaded him were somewhat deceptive. In the background are Hymen, god of marriage, and a little cupid going out through a door, considering his arms to be useless there.

Prometheus, aware that Pandora was going to meet his brother Epimetheus, warned him; and advised him, since he was younger and not very clever, that if that woman chanced to arrive at his door he should on no account allow her to enter, as she was a deceiver. Pandora went to Epimetheus's house at a time when she knew that Prometheus was absent, and managed to charm him with the flattery of her sweet words and she convinced him so effectively that he married her, without heeding his brother's advice or considering the consequence that could arise from the afflictions, disturbances, and other trials that matrimony brings with it. The painting of the marriage of Epimetheus and Pandora was begun by Carreño; and when it was far advanced he was interrupted by a very serious illness so that it was necessary for Rizi to finish it. Rizi also painted the scenes on the imitation gold shields in the four corners of the room. But after some years, when the opportunity arose to erect scaffolding in order to repair the damage done to the painting by rain, Carreño repainted almost the whole composition in oils.

What Carreño painted in oils in the salón *in the palace.*

What Mitelli painted in the salón *in the palace.*

To Mitelli fell the decoration, which he executed in the grand manner, enriching it with such fine architecture, ground work, and massive ornament, that it seems to add strength to the building. What is particularly worth noticing is the great facility and skill with which it is carried out. Colonna painted certain still-life motifs, garlands of leaves, fruit, flowers, shields, trophies, as well as fauns, nymphs, and beautiful children standing on the raised cornice of imitation jasper, and he also painted a garland of gilded laurel which encircles the whole room. The room was made so beautiful that it rejoices the eye, refreshes the memory, enlivens the understanding, instructs the mind, raises the spirit, and lastly expresses all majesty, talent, and grandeur. The King went up every day, and sometimes the Queen our Lady Doña Mariana of Austria and the Infantas went to see how the work was progressing. His Majesty asked the artists many questions which showed the love and affability with which he always treated members of this profession.

Their Majesties frequently went up to watch the ceiling of the salón *being painted.*

Cartoons which were made for the said work.

For all these subjects excellent drawings or cartoons were made, actual size and on tinted paper, which served as half-tone for the white highlights. This kind of drawing is very famous and is practised by great artists;[29] therefore, Vasari wrote: *Questo modo è molto alla pittoresca, e mostra più l'ordine del colorito*. And those drawings that Colonna made were extremely pleasant, for they looked as if they were coloured; the reason being that since the paper was pure blue, he heightened with white, and blended with red earth, following the same process as in painting.

29. Vasari, Le Vite, I cap. 16.

There are many artists who refuse to make their cartoons actual size for work in oils, but for work in fresco this is essential, so as to make sure that the work is divided accurately and to scale and in order to see the effect that the selection and judgement of the painter will have on the whole.

Painting of the hermitage of Saint Paul in the Retiro, by Colonna and Mitelli.

After Mitelli and Colonna had finished the work in the palace, the Marqués de Heliche

took them to the Buen Retiro to paint the hermitage of Saint Paul, the first hermit, which they did with equal magnificence and art. They painted there the Fable of Narcissus, with admirable architecture, ornament, and columns which conceal the fact that the ceiling is concave. And in the oratory of this hermitage is a picture representing the visit of Saint Anthony Abbot to Saint Paul the Hermit, an excellent work by Velázquez [Plate 116]. In a garden which the said Marqués has in Madrid, near San Joaquín, Colonna and Mitelli also made many paintings. The Atlas by Colonna, bowed down and carrying on his shoulders a sphere with all the circles and celestial signs, is wonderful. It is done with such art that it looks like a statue in high relief, as if there was air between the wall and the figure, an effect caused by the shade or shadow which seemed to be thrown by the light on the wall. They also painted on a fountain a decoration with two terminals, an object of great *capricho*, but now it is all very damaged by the harmful effects of time. There were in this garden many excellent works of sculpture and painting, which have by now all been lost.

Paintings by the 'Colonnas' in the garden of the Marqués de Heliche, next to San Joaquín.

From here they were taken to the Convent of Our Lady of Mercy to paint the whole church. And after they had both agreed on the work with the monks, while he was painting the cupola, Agostino Mitelli died on 2 August in the year 1660, on Monday, the feast of Our Lady of the Angels. The death of such an illustrious painter was a cause of public grief in the whole court and was a great loss to the monks. He was buried in the convent itself with great solemnity and many elegant verses were written on his death, and also the following epitaph:

Painting of the cupola of the church of la Merced in this court, by Colonna and Mitelli.

Death of Agostino Mitelli.

COMMEMORATIVE TOMB AND FUNERAL EULOGY
at the
obsequies given to Agostino Mitelli, dedicated to his ashes
by an admirer, in the name of the students of Art.

Consecrated to the gods below [Dis manibus sacrum]

AGOSTINO MITELLI OF BOLOGNA,
the celebrated painter, supreme master of perspective, and
wonderful rival of Nature, under whose hand, to Nature's
envy, images almost came to life, died at Madrid, 2 August 1660.

Here thou liest. May the earth be light upon thee [Hic situs
es[t]. Sit terra tibi levis].

This work was suspended as the result of so sad and unexpected an occurrence, and in the meantime Colonna painted the ceilings of the garden house which the Marqués de Heliche built on the road to the Pardo, owned today by the Marqués de Narros, where many other artists both Spanish and foreign also painted. The work was in the charge of Don Juan Carreño and Don Francisco Rizi. The best pictures to be had were copied on the walls with great exactness. There are examples by Raphael, Titian, Veronese, Van Dyck, Rubens, Velázquez, and many others, in gold frames which are also painted, and with hangings of cloth marvellously simulated. On the outside of the house, the walls were painted in fresco, with designs of clocks, with remarkable peculiarities, which the sun revealed on certain days. This has now fallen into ruin through the ravages of time.

Paintings by Colonna in the garden house of the Marqués de Heliche, on the road to the Pardo.

Although the work of la Merced – the Church of Our Lady of Mercy – was suspended for a time, the cupola was finished with great success and to the approbation of all the court, by Angelo Michele Colonna who, although he applied himself more to figures than to ornament, did so not because he did not know how to paint ornament but in order to leave to Mitelli that class of work in which he excelled most. When it was finished, he left Madrid for Italy in the month of September in the year 1662, although others say that he went to France.

Colonna returned to Italy.

IX
WHICH DISCUSSES THE IMAGE OF THE HOLY CHRIST
OF THE PANTHEON, AND THE COMING TO SPAIN OF
MORELLI

In the year 1659 there arrived in Spain the bronze and gilt image of Christ on the Cross [Plate 112], which the Duke of Terranova had commissioned in Rome, by order of the

The most holy Christ of the Pantheon of the Escorial.

King, for the royal chapel of the Pantheon, the burial place of the Catholic Monarchs of Spain. The artist was a nephew of Giuliano Finelli, a follower or pupil of Algardi, who, despite his youth, exceeded expectations in the execution of this work. It was brought to the palace during the month of November, and was seen by His Majesty in the *pieza ochavada*. Afterwards he commanded Diego Velázquez to give orders for it to be taken to San Lorenzo el Real and to go there himself in order to see how it should be put in position. Velázquez did as His Majesty commanded.

Morelli came to Spain.

In this year Giovanni Battista Morelli, a native of Rome and a famous sculptor, pupil of Algardi, came to Valencia from Paris on account of having suffered I know not what mishap which obliged him to flee, after working there as a sculptor highly esteemed by the Most Christian King. He had made marvellous figures in clay, in the round and in relief, as can be seen in the works he executed in Valdecristo (one of the monasteries of the holy Carthusian Order in that kingdom) and other works which I have seen in Valencia in the house of Don Juan Pertusa, Knight of the Order of Montesa, one of the most illustrious families in that city, and in other places – all so excellently done that they seem to be imbued with the spirit and liveliness of Tintoretto. After he had made these figures, he decided to send a sample of his work to Don Diego Velázquez, as protector of this branch of art, and a person in whom practitioners of all the arts always found due esteem and favour, as was experienced on many occasions, which could be enumerated at length. So he sent Velázquez a letter together with [a sculpture of] winged children with the symbols of the Passion of Christ in semi-relief. When Don Diego Velázquez and his son-in-law, Juan Bautista del Mazo, Painter to His Majesty and Velázquez's successor as Court Painter, saw them, they judged them to be very fine and worthy to be seen by His Majesty. They were shown to the approval and great satisfaction of the King, and afterwards they were framed and placed in the palace; and they were paid for by Velázquez, on behalf of His Majesty. Later, when he saw how much they were liked, Morelli sent some more figures in clay, and a large figure of the dead Christ in full relief, supported by weeping angels, executed with great decorum; a Saint John Baptist [cf. Plate 23]; a sleeping Christ Child; a Saint Philip Neri, half-length and in full relief like the preceding pieces.

Correspondence that Morelli had from Valencia with Velázquez.

Velázquez wished to see Morelli. Morelli came to Madrid when Velázquez had already died.

Various statues by Morelli.

Velázquez wished to see Morelli and bring him to the palace to work and he wrote to him accordingly, but the sculptor was unable to come to Madrid until the year 1661 when, to his sorrow, Velázquez had already died. He brought a large number of small statues of the gods, following in each of them the practice for which the Greeks were unrivalled, which is to match expression and lively action to the subject represented. The sound of Orpheus's music as he plays his lyre is signified by a little boy sleeping to the sweet melody of the tune. The crown of towers on the temples of Cybele, whom the poets feigned to be the mother of all the gods, is the symbol of her greatness – and so she was painted by the ancients. Mercury, as god of Peace, shows the tranquillity of his spirit; Mars, fury; Jupiter, power, and likewise with all the rest, such as Neptune, Vulcan, Saturn, and others. All are worthy of great appreciation and esteem. These statues are in a room in the vaults of the *Jardín de la Reyna* – the Queen's Garden.

His Majesty ordered Morelli to make a figure from life of the god Apollo, naked except for a drape to make it decorous with, at his right hand, a very beautiful boy holding his lyre, for the ancients attributed to Apollo the invention of musical composition. His Majesty very frequently went down to watch Morelli work at modelling and sculpture. When this figure was finished it was placed in a garden. Morelli made another statue of clay of a Muse, with a little boy at her side holding her musical instrument; this was placed in a niche on the private staircase to the King's room. He made the model for the gilt bronze masks on the fountain in Aranjuez, which was executed in 1662, with many water spouts and adorned with many marble statues. He began certain stucco ornaments in some of the apartments in that palace, but they were left unfinished partly on account of the death of Philip IV and partly because he was given inadequate means. Morelli went back to Valencia with the intention of returning later to finish them. Indeed he did come, but he was overtaken by death in Madrid and they remained as they were. He was particularly good at carving, and modelling in clay.

The King frequently went down to watch Morelli work.

X

HOW VELÁZQUEZ AT THE COMMAND OF HIS MAJESTY WAITED UPON THE
FRENCH AMBASSADOR EXTRAORDINARY, WHO CAME TO SPAIN TO TREAT
OF THE MARRIAGE OF THE MOST SERENE INFANTA OF SPAIN, DOÑA
MARÍA TERESA OF AUSTRIA; AND ABOUT SOME PORTRAITS THAT
VELÁZQUEZ PAINTED AT THIS TIME.

To return, then, to the year 1659. On 16 October, the Maréchal Duc de Gramont, Governor of Béarn, Bordeaux, and Bayonne, Ambassador Extraordinary of the Most Christian King Louis XIV, entered Madrid to discuss the joyful nuptials of His Majesty with the Most Serene Doña María Teresa Bibiana of Austria and Bourbon, who was then Infanta of Spain. He entered the palace under the protection of the Lord Admiral of Castile. The King received him in the *salón*, standing beside a console table and remaining in this position all the time the function lasted. The *salón de los espejos* was splendidly and richly decorated, and beneath the canopy was a chair of inestimable worth. This decoration was under the direction of Diego Velázquez as head Chamberlain and of the Tapestry Keeper. Since the Maréchal was pleased to inspect closely the King's apartments, His Majesty ordered Diego Velázquez to attend him with great solicitude and show him the most precious and notable objects in the palace. On Monday 20 October, at two o'clock in the afternoon, the Maréchal entered the palace by the private staircase leading to the park garden. He was accompanied by his two sons, the Comte de Guiche, Field Marshal of one of the regiments of Guards of the Most Christian King, and the Comte de Louvain, and other gentlemen. Don Diego Velázquez showed them all the rooms in the palace, in which they found much to admire, because of the quantities of original paintings, statues, objects of porphyry and other treasures, with which its great fabric is adorned.

He likewise found much to admire in the decoration of the houses he visited, and particularly in those belonging to the Admiral of Castile, Don Luis de Haro, the Duque de Medina de las Torres and the Conde de Oñate, who own very fine original paintings. When the Maréchal departed for France, he left with Don Cristóbal de Gaviria, of the Order of Santiago, Captain General of the Spanish Guards, and conductor of Ambassadors, a most exquisite gold watch which he was to give to Don Diego Velázquez.

In this year of 1659, Velázquez executed two portraits which His Majesty ordered him to make, to send to the Emperor in Germany. One was of the Most Serene Prince of Asturias, (Don) Philip Prosper [Plate 181], who was born on Wednesday, 28 November, in the year 1651 [1657], at 11.30 in the morning. It is one of the finest portraits that Velázquez ever painted, despite the great difficulty of painting children, because they are exceedingly lively and restless. He painted the Prince standing and dressed in a manner befitting his tender years; beside him a hat with a white plume on a plain stool. On his other side is a crimson chair, on which he lightly rests his right hand; in the upper part of the picture is a curtain; at the back of the room an open door is represented, and all is done with extreme grace and art and with the beauty of colour and grand manner of this illustrious painter. On the chair is a little bitch which seems to be alive and is a likeness of one for which Velázquez had much affection. It appears that he followed the example of Publius, an excellent painter, who portrayed his beloved little bitch Issa in order to immortalize her, as Martial[30] wittily relates: he could have said the same about Velázquez.

> That death should not rob him of her altogether, Publius portrays her in a picture, wherein you will see an Issa so like that not even the dog herself is so like herself. In fine, set Issa alongside her picture; you will think either that each is genuine or you will think that each is painted.

The other portrait was of the Most Serene Infanta Doña Margarita María of Austria [Plate 176], very finely painted, with the majesty and beauty of the original. On her right, on a little console table is an ebony clock, with bronze figures and animals, very elegant in form. In its centre is a circle in which is painted the chariot of the sun, and in the same circle is another smaller circle with the divisions of the hours.

The Duc de Gramont comes to discuss the nuptials of the most Christian King with the Infanta Doña María Teresa.

Velázquez waits upon the Ambassador of France by order of the King.

Houses of noblemen visited by the Ambassador of France.

On departing, the Ambassador left Velázquez a gold watch.

Portrait of Prince Prosper by Velázquez.
Portraits of children very difficult.

Famous reflection on the portrait of a little bitch.

30. Martial, Epigrams, I, 109.

Portrait of the Infanta Doña Margarita of Austria.

Small portrait of the Queen by Veláz-quez.

At this time Velázquez made another portrait of the Queen our Lady on a circular sheet of silver, of the diameter of a Segovian piece-of-eight, in which he proved himself no less ingenious than subtle, since it is very small, highly finished and an extremely good likeness, and painted with skill, strength, and smoothness. And to be sure, it seems that he who can infuse in so small a space as much spirit as there is in this portrait, would make nature jealous – if she were capable of jealousy. Velázquez is more justly deserving of immortal fame than Marcellus, the famous sculptor is [deserving] of praise for having carved a ship with all its rigging, out of a cherry stone, so that a bee placed on its sail covered it all with its wings. This work caused such wonder that, according to Cicero, men would have numbered its creator among the gods. The fact is that the man succeeds who has, besides keen vision, great depth of reflection, and such delicacy of execution that his painting seems to have a soul; who adds to great natural genius long years of study and many years' practice.

Marcellus, great sculptor on a small scale.

Seldom did Diego Velázquez take up his brushes after this and so we can say that these portraits were the ultimate in perfection by his eminent hand. They made him supremely esteemed and appreciated, so that favoured by fortune, nature and genius though he was, and much envied, he himself never felt envy. He was very pithy in his remarks and repartee. His Majesty said to him one day that there were not lacking people who declared that his skill was limited to knowing how to paint a head; to which he replied: 'Sire, they favour me greatly, for I do not know that there is anyone who can paint a head.' What a remarkable reaction to jealousy in a man who had proved his universal command of the art – of which he left so many other documents to posterity – by the witness of so many superb pictures of 'subjects'.

Acrimony of painters.
Velázquez's smart reply.

XI

OF THE MOST EXTRAORDINARY HONOUR THAT HIS MAJESTY CONFERRED ON DIEGO VELÁZQUEZ IN REWARD FOR HIS VIRTUE AND SERVICES

In the year 1658, when Don Diego Velázquez was at the Escorial with the King, His Majesty, considering that the genius, ability, personal merits, and other services perfor-med by Don Diego Velázquez made him deserving of further promotion, one day during Holy Week, conferred on him the honour of membership of whichever he wished to choose of the three Military Orders. Velázquez chose the Military Order of the Knights of Santiago. If death had not overtaken him, it would have been the beginning of a rise to the greater honours due to his personal fitness for them, which offered material for cultivating more elevated fortunes.

Singular honour done by the King in the Proofs of Velázquez.

I have heard it said by a person of high standing that when the Proofs [of Nobility] were delayed through some impediment due to jealousy, of which there was a great deal, the King, learning of the matter, commanded the President of Orders, the Marqués de Tabara, to send him the statement which His Majesty had to testify to in the Proofs of Velázquez, and when they came the King said: 'Write that I am certain of his nobility.' At this, no further inquiry was necessary. Oh, magnanimity worthy of such a great King, perfecting with his own hand the work he had brought about and which others had sought to discredit, and at the same time sparing Velázquez the embarrassment of delay and the increased expense of a new report! Finally Velázquez's title was conferred by the Council of Orders on Thursday, 27 November [1659], and on Friday, the feast of Saint Prosper Martyr, the 28th of that same month and year, in the convent of the nuns of Corpus Christi, Velázquez received the habit with the usual ceremonies, and to the great pleasure of everyone, from the hands of Don Gaspar Juan Alonso Pérez de Guzmán el Bueno, Conde de Niebla, who later became Duque de Medina-Sidonia. His patron was His Excellency Don Baltasar Barroso de Ribera, Marqués de Malpica, Knight Comman-der of the Order of Santiago.

Velázquez receives the habit of the Order of Santiago.

He was sent back to the palace and was most honourably received by His Majesty and all the noblemen and servants of the King's chamber. It was a day of high festival in the palace, because it was Saint Prosper's Day, the birthday of the Most Serene Prince Prosper. So Don Diego Velázquez could take everything as omens of his prosperity, even

the experience on this occasion of having had to struggle against envy. For virtue is perfected in conflict and its splendour is commonly diminished if it has no darkness against which to shine. His natal horoscope was undoubtedly lucky and propitious, like the one described by Julius Firmicus Maternus, in which he who is born will excel in painting and through it be distinguished with the highest honours.

In this year Lázaro Díez del Valle wrote a eulogy and catalogue of those painters who, because they were famous, were honoured with membership of Military Orders, and he dedicated it to Don Diego Velázquez, as we have mentioned in vol. 1, lib. 2, cap. 9, para. 4.

Manuscript of Don Lázaro Diez del Valle.

XII
OF THE JOURNEY THAT VELÁZQUEZ MADE WITH HIS MAJESTY TO IRÚN, AND OF HIS ILLNESS AND DEATH

In this year 1660, in the month of March, Don Diego Velázquez left Madrid to prepare lodgings for our great monarch Philip IV on the journey His Majesty was making to Irún, with the Most Serene Señora Infanta of Spain, Doña María Teresa of Austria. Don Diego Velázquez left Madrid a few days before His Majesty. He took with him Joseph de Villareal, Keeper of the Keys and Surveyor of the Royal Works, and other servants of His Majesty needed on the journey, all under his jurisdiction and orders. Joseph Nieto went as Chamberlain of the Most Christian Queen. The journey began by way of Alcalá and Guadalajara; they arrived at Burgos, where Velázquez had orders from His Majesty that the Keeper of the Keys was to remain, as His Majesty had to stop in that city, and the rest of them continued on their way to Fuenterrabía, where Velázquez lodged His Majesty in the Castle, which had already been prepared by the Baron Watteville, governor of the city of San Sebastián. Velázquez was in charge of the building of the Conference Hall, which was erected on the Isle of Pheasants, in the river Bidasoa, close to Irún, in the province of Guipúzcoa. Don Diego Velázquez went on board a barge with the Baron to go to the Conference Hall, which is not far from Fuenterrabía, to see what state it was in, for it had been much enlarged since the year 1659, when Cardinal Giulio Mazarin and the Conde-Duque of Sanlúcar settled the peace between the Catholic King of Spain and the Most Christian King of France. He had orders from His Majesty to be present at the decoration of this hall and of the Castle, and to be in the city of San Sebastián for the arrival of His Majesty, who was to stay there for some days.

Velázquez waits upon His Majesty during the journey to Irún.

Joseph Nieto, the Queen's Chamberlain.

Conference Hall erected on the Isle of Pheasants.

He returned with His Majesty to Fuenterrabía at the beginning of June, and was present at all the functions that His Majesty held in the main room of the Conference Hall, until Monday 7 June, the day of the handing over of the said Most Serene Infanta to the Most Christian King of France Louis XIV. Here, I cease; for to describe the grandeur and splendour that such great monarchs displayed on such a happy occasion requires a longer account and a more elegant pen.

Day of the handing over of the Most Serene Infanta of Spain to the Most Christian King.

The presents that the Most Christian King made His Majesty on this day of a Golden Fleece in diamonds, a gold watch adorned with diamonds, and other very choice and exquisite jewels of inestimable value, were given to Don Diego Velázquez on his behalf at the palace of the Castle of Fuenterrabía.

Presents which the Most Christian King made to Philip IV.

Don Diego Velázquez was not the one who showed that day least consideration for the adornment, gallantry, and finery of his person; for in addition to his gentlemanly bearing and comportment, which were courtly, not to mention his natural grace and composure, he was distinguished in dress by many diamonds and precious stones. It is not surprising that in the colour of his cloth he was superior to many, for he had a better understanding of such things, in which he always showed very good taste. His whole costume was trimmed with rich Milanese silver point lace, according to the fashion of the time, which favoured the *golilla*, though coloured, even on expeditions. On his cloak he wore the red insignia [of Santiago]. At his side was a very fine rapier with silver guard and chape, with exquisitely chased designs in relief, made in Italy. Round his neck was a heavy gold chain with a pendent badge adorned with many diamonds, on which were enamelled the insignia of Santiago, and the rest of his apparel was worthy of such a precious decoration.

Splendour and finery with which Velázquez attended this function.

Don Diego Velázquez returns, attending His Majesty, from Irún to Madrid.

Omen of Velázquez's death.

Mortal illness of Velázquez.

Death of Velázquez, to the great sorrow of the King and all the court.

Preparations of the bier, corpse, and funeral of Velázquez.

He was buried in the parish church of San Juan.

They bury the body of Velázquez in the parish church of San Juan in the vault of Don Gaspar de Fuensalida.

Epitaph on the death of Don Diego Velázquez.

On Tuesday 8 June, His Majesty left Fuenterrabía, with Velázquez in attendance on him, for this is what His Majesty had commanded. His assistant, Joseph de Villareal was to go ahead preparing lodgings. The return journey was made through Guadarrama and the Escorial to Madrid.

When Velázquez entered his house he was received by his family and friends with more amazement than joy, the news of his death having been given out at court, so that they hardly believed their eyes. It seems that this was an omen of the short time he was to live afterwards.

On Saturday, the feast of Saint Ignatius Loyola, and the last day of the month of July, Velázquez, having attended His Majesty all the morning, was troubled by a burning sensation that obliged him to retire through the passage to his apartments. He began to suffer great anguish and pains in the stomach and heart. He was examined by Doctor Vicencio Moles, his family physician; and His Majesty, solicitous for his health, sent doctors Miguel de Alva and Pedro de Chavarri, court physicians of His Majesty, to see him. Recognizing the danger, they said that it was the beginning of a sudden acute syncopal tertian fever; a condition very dangerous on account of the great weakening of the spirit; and the continuous thirst which he felt was a strong indication of the obvious danger of this mortal illness. He was visited, on His Majesty's orders, by Don Alfonso Pérez de Guzmán el Bueno, Archbishop of Tyre, Patriarch of the Indies, who delivered to him a long sermon for his spiritual comfort. And on Friday, 6 August, in the year of Our Lord 1660, on the feast of the Transfiguration of the Lord, after receiving the holy sacraments and giving power of attorney for making his will to his intimate friend Don Gaspar de Fuensalida, His Majesty's Keeper of the Records, at two o'clock in the afternoon, at the age of 66 [61], he gave up his soul to Him who had created him for the wonder of the world. This brought the deepest sorrow to everyone, and not least to His Majesty, who at the height of his illness had made it known how much he loved and esteemed Velázquez.

They put on his body the humble underclothing of the dead and then dressed him as if he were alive [cf. Plate 25], as was customary with knights of military orders, with the capitular cloak, with the red insignia on the breast, hat, sword, boots, and spurs. In this manner he was placed that night on his own bed in a darkened room, with large candelabra with tapers on either side and more lights on the altar, where there was a Crucifix, and he remained there until the Saturday, when they moved the body to a coffin with gilt nails and corner plates, and with two keys, lined with plain black velvet, trimmed and garnished with gold *passementerie* and surmounted by a cross with the same garniture. When night came, and with its darkness put everyone into mourning, they carried him to his last resting-place in the parish church of San Juan Bautista, where he was received by His Majesty's Gentlemen of the Bedchamber. They carried him to the catafalque which had been made ready in the middle of the principal chapel and the body was placed on top. On both sides there were twelve large silver candelabra with tapers, and a great number of flames. The whole of his burial service was carried out with great ceremony, with excellent music from the Royal Chapel, with the softness and measure, the number of instruments and voices that were customary at functions of such great solemnity. There were present many noblemen and Gentlemen of the Bedchamber, and servants of His Majesty. Afterwards, they removed the coffin and handed it over to Don Joseph de Salinas, of the Order of Calatrava, and His Majesty's Groom of the Bedchamber, and other Gentlemen of the Bedchamber who were there, and they carried it on their shoulders to the burial vault of Don Gaspar de Fuensalida who, as a sign of his love, gave permission for it to be deposited there.

The following epitaph was dedicated to Velázquez by his very dear and gifted pupil Don Juan de Alfaro, a celebrated son of Cordova, who had it printed and to whom is owed the most important part of this account. Aided by the great erudition of his brother, Doctor Enrique Vaca de Alfaro, he summarized in these few lines what was closely packed in a life of many years.

Epitaph on the Death of Don Diego Velázquez

CONSECRATED TO POSTERITY

Here lies, alas, Don Diego Velázquez y Silva of Seville. A distinguished painter, born in the year 1594 [1599], he devoted himself to the most noble art of painting, under the very careful tuition of Francisco Pacheco, who wrote most elegantly on painting. He was First Court Painter to Philip IV, Most August King of [the two] Spains, most punctilious servant of the Bedchamber, chief Chamberlain of the Royal Palace and other residences. Consequently upon his conscientious performance of these offices, he was sent with a large sum of money to Rome and other cities in Italy, to seek out, acquire, and bring back with him fine paintings or any other objects of this kind, such as marble or bronze statues. He also painted at this time a wonderful head of Pope Innocent X and was rewarded with a gold chain of extraordinary worth with, hanging from it by a ring, a gold medal set in jewels bearing the Pope's image in relief. Finally, he was decorated with the insignia of Santiago; and after his return to Madrid from Fuenterrabía, a town on the French border, with his most mighty King, from the wedding of Her Serene Highness María Teresa Bibiana of Austria and Bourbon (her marriage, that is to say, to the Most Christian King of France, Louis XIV), being taken by a fever due to the fatigue of the journey, he died at Madrid on 6 August 1660, at the age of 66 [61]. He was buried with honours in the parish church of San Juan on the night of the 7th of the same month, with the greatest pomp and at enormous expense, but not too enormous for so great a man. In the company of heroes, he lies in the vault of Don Gaspar Fuensalida, royal secretary and his very dear friend. This brief epitaph was composed in honour of his master, a famous man, to be revered by all ages, by his sorrowful disciple Juan de Alfaro of Cordova, with the aid of his brother Enrique, the physician, while Painting herself mourned with them.

Even after his death Velázquez was pursued by envy, so that certain malevolent people tried to deprive him of the good will of his Sovereign with calumnies perversely imputed. It was then necessary for Don Gaspar de Fuensalida, as friend and executor and in his capacity as Keeper of the Records, to reply to some of the charges in a private audience with His Majesty, and assure him of the faithfulness and loyalty of Velázquez and the rectitude of his conduct in everything. To this His Majesty replied: 'I well believe all that you tell me about Velázquez, because he was most prudent.' By this His Majesty gave proof of the high opinion he had of Velázquez, giving the lie to some of the false shadows with which they tried to tarnish the bright splendour of his honourable conduct and of the great loyalty with which he always served his sovereign master, from whose royal and noble liberality he received so many favours that they can hardly be counted. But although in this account of his life some of them have been touched on, they will be summarized here together with others on which it has been possible to obtain information.

Velázquez pursued by envy even after death.

The King's reply to the calumnies against Velázquez.

XIII

COMPENDIUM OF THE HONOURS THAT HIS MAJESTY PHILIP IV CONFERRED ON DON DIEGO VELÁZQUEZ TOGETHER WITH THE OFFICES AND EMPLOYMENTS HE HAD IN THE ROYAL HOUSEHOLD

In the year 1630 His Majesty granted Don Diego Velázquez the favour of a wage of 12 reals a day, and a dress allowance of 90 ducats a year.

He conferred on him the honour of a grade of Wand of Office of Court Constable, the value of which is fixed at 4,500 ducats.

He conferred on him the favour of a dwelling house more expensive than his position entitled him to, valued at 200 ducats a year.

His Majesty conferred on him the favour of a pension of 300 ducats, which he received with the dispensation of His Holiness in the year 1626, and an allowance of 500 silver ducats in the year 1637.

He conferred on him the honour of an appointment as Actuary, promoted by the chief Court Weight Office to the equal of that of the Criminal Actuaries, and set at 6,000 ducats.

His Majesty conferred on him the favour, from the year 1640 onwards, of 500 ducats a year paid out of the provisions for the daily expenses of the royal household.

He conferred on him the favour of 60 ducats a month for his assistance with the royal works, under the management of the most excellent Marqués de Malpica, Superintendent of the Works.

He was granted the favour of spacious lodgings in the Casa del Tesoro, which is inside the palace. The rooms he had still exist.

He was granted the favour of the habit of the Order of Santiago, with which he was invested.

His Majesty granted him various favours for his son-in-law and grandsons, both in the royal household and in the Audience Chamber, of great rank and importance.

The Offices and Positions He Held in the Royal Household

His first appointment was that of Court Painter, which he held from the year 1623.

He took the oath as Gentleman Usher, a highly honourable post, in the year 1627.

He advanced to be Gentleman of the Wardrobe; and in the year 1642 Gentleman of the Bedchamber; and in 1643 Chief Chamberlain of the Palace, and he died while still performing this office to the great satisfaction and pleasure of His Majesty. From the King's royal hand he received other favours and large allowances, in addition to those mentioned and added pleasure in the execution of his functions, which were worthy of the greatness of such a King and of the merits of so punctilious a vassal and so excellent an artificer. His fortune, skill, and talent, together with his honourable conduct, established him as the model and pattern of great artificers. A statue was erected to him, as an everlasting memorial to future centuries and for the edification of posterity.

Notes

Preface

p. 7 Pacheco I, pp xxxvii-xlvi, gives a summary of Pacheco's life (but with the incorrect date of death), which he spent in or near Seville, with visits to Madrid, Toledo and the Escorial. He is included in Palomino's *Parnassus*. For a study of his Academy and his treatise, see Brown 1978, Part I. On Pacheco as a painter, see Muller 1960-1. There is no modern monograph. On Palomino, see Aparicio Olmos and Gaya Nuño 1956. Born near Cordova, he studied for a time with Alfaro, settled in Madrid in 1678, was appointed Painter to the King in 1688 and ordained priest in 1725. In the prelude to his *Parnassus*, Palomino (pp. 766-7) describes his debt to Alfaro's manuscript, and to other sources.

On Alfaro, who describes himself as a pupil of Velázquez, see chapter 5 and note to p. 90.

Pacheco's and Palomino's biographies of Velázquez are printed in *VV* II and *Velázquez. Homenaje*, 1960. The latter publication also reprints the English, French and German versions of the life of Velázquez from the abbreviated editions published in 1739, 1749 and 1781 respectively.

On Pacheco, Palomino and their treatises and other sources, see also Calvo Serraller, with bibliographies.

Quotations in English from Pacheco and Palomino are to be found in most biographies of Velázquez. But Pacheco on Velázquez is not among the extracts in Holt or Enggass and Brown. The latter publication contains, however, a translation by Brown of the most extensive extract to date from Palomino's *Life of Velázquez*.

CHAPTER I: *The Artist's Life*

p. 9 For the certificates of Velázquez's parents' marriage, his baptism, that of his brothers and future wife, see Docs. 1-7, 9, 11.

Occasionally he signs *Velazquez*. On signed paintings, which are rare, see MacLaren and Braham, p. 58, note 11.

Contract of apprenticeship, Doc. 8.

Pacheco I, p. 370, II, p. 8 records his visit to Toledo; II, p. 165 his presence in the Escorial in the same year.

On the 'Marian War', and Seville's devotion to the mystery and the celebrations of 1617, see Kendrick 1960, pp. 88-103 and 207; for the festivals, Alenda y Mira, pp. 188-91.

p. 10 On 'Theory and Art in the Academy of Pacheco', see the recent important detailed study by Brown 1978, pp. 19-83.

p. 11 Examination certificate: Doc. 10.

Doc. 4 for Juana Pacheco's baptism; Doc. 12 for her marriage to Velázquez. On the marriage celebrations, see Fichter.

Docs. 13, 15 for the baptism of Velázquez's daughters, Doc. 14 for the contract of apprenticeship of Diego de Melgar.

p. 12 Doc. 18 for power of attorney given to Pacheco. For the houses owned by Velázquez and rented, Docs. 16, 17, 19, 20.

Melchior del Alcázar, 'a celebrated devotee of the mystery' (Kendrick 1960, p. 98), died in Madrid 1625 (Pacheco I, pp. 251-2). On the part played by both brothers in the lay celebrations, see Ortiz de Zúñiga, pp. 268 ff. Luis del Alcázar became chief accountant to Olivares in 1636 (Rodríguez Villa, p. 46).

On Fonseca and his collection, valued by Velázquez, see López Navío 1961.

Pacheco's *Libro de Retratos* remained unfinished; a facsimile edition of the surviving drawings and verse eulogies was published 1886 by José María Asensio.

Docs. 20, 21 establish Velázquez's presence in Seville in 1623.

The account book entry was first noted by Huxley, pp. 111-12, without mention of the sum paid, but with the suggestion that the portrait may have been made after the Prince left Madrid. According to the English date, ten days behind the reformed calendar in use in Spain, Charles left Madrid on 30 August and spent only two days in the Escorial; the payment was recorded several days later.

For Velázquez's appointment, see Docs. 22-4; the final decree of 31 October 1623, signed by the King (not in *VV* II) was in the Exhibition *Velázquez y lo Velazqueño*, no. 277 (Plates cxxvii-viii).

p. 14 Pacheco as witness: the occasion must have been in 1625 or 1626 when we know Pacheco was in Madrid. Palomino says it was in 1625 (Pacheco II, p. 198, I, p. xliv).

Velázquez's application to Rome to be allowed to enjoy the benefice is dated 14 October 1626. See Harris 1981a.

On Cassiano dal Pozzo's account of his visit, see Harris 1970.

p. 15 Martínez, p. 117. According to an editorial note, the painting was said to have been removed by the French General Sebastiani, but there is no record of it after the fire.

Docs. 30, 36-9 for Velázquez's awards; Doc. 56 for permission to transfer his office of Usher to Mazo.

Rubens's activity in Spain and in the Spanish Netherlands earned him a place in Pacheco's *Arte* (I, pp. 151-5) and in Palomino's *Parnassus*, pp. 856-60. For Rubens's well-known comments on the painters and paintings in Spain in a letter from Valladolid, 24 May 1603, see Magurn, p. 33; for his letters about the Escorial, the scenery, his drawing and the painting after it, pp. 412, 414.

Docs. 43-5 for the known letters of recommendation; Doc. 41 for permission to go to Italy.

p. 16 The letters about Velázquez's stay in the Villa Medici (not in *VV* II) were published by Orbaan, pp. 28 ff., their corrected dates – 20 April and 14 May – by Brunetti, p. 296. Galileo arrived 3 May. For the correspondence about his stay and the pleasure of his conversation, see Del Lungo and Favaro, pp. 262-3.

p. 17 Velázquez was back in Madrid by May 1631 (at the latest) when he is recorded valuing pictures. See Azcárate, p. 363.

For the payment of 1634, Doc. 61; see also Harris 1980.

p. 18 See Doc. 53 for the appointment and the report on the portraits by Velázquez and Carducho in December 1633, the year of the publication of Carducho's *Diálogos*.

For Velázquez's appointment in 1638, see Doc. 65.

Notice of Pacheco's death (his burial certificate) in 1644 (not 1654, as previously believed) was first published in Doc. 93.

Brown and Elliott provide the first – and an invaluable – detailed study of the building and decoration of the Buen Retiro Palace, its historical setting, and its usage.

p. 19 Newsletter: *Noticias de Madrid*, published by Rodríguez Villa, p. 27. See also Doc. 65.

Alpers, in her comprehensive study of the Torre, covers the contribution of

Rubens and his school and that of Velázquez. See p. 33 for the question of his exact function. The abbreviation 'R.ª' is generally accepted as meaning 'Reforma'. p. 33 for the Duke of Modena's visit to the Torre.

The Duke of Modena on his return journey wrote about an equestrian portrait being painted in Madrid (Justi 1923, II, p. 407).

Docs. 73, 74 for the letters from Fulvio Testi, the Duke of Modena's Ambassador in Madrid.

p. 20 On the festivities in 1637, see Varey 1968.

p. 21 On the portraits and moulds for England, see Harris 1967.

p. 22 Doc. 90 for the 'aviso' – a manuscript newsletter, dated 5 January 1644. Velázquez's appointment: Docs. 86, 95; Iñiguez Almech, p. 662.

p. 24 Palomino, p. 1009; Martínez, p. 132.

On the Fraga portrait, see Docs. 91, 92 and Beruete y Moret.

On María de Agreda and her correspondence with Philip IV, see Kendrick 1967, chapters ix-xi; for the standard edition of the letters, see *Cartas de Sor María y de Felipe IV*.

Docs. 100-2 specify that the appointment was as 'Veedor y Contador' of the *pieza ochavada*. Docs. 103-4, 113 for orders for payment of arrears.

p. 25 Martínez, pp. 118-19.

Doc. 109 for the royal order dated 25 November 1648.

The Embassy evidently left Madrid before Velázquez: Docs. 110-11 and note 1.

One of Palomino's informants was very possibly Baltasar del Mazo Velázquez, the artist's grandson, who figures as Head of Chandlery in the inventory of the Alcázar. See Fernández Bayton 1975, p. 175.

Doc. 114 for the dispatch and the reply approving of the Ambassador's actions.

Later account: a letter, dated 13 January 1652, Doc. 143. The Ambassador goes on to warn the Duke that if he does send any gift of paintings he should not set too high a value on them. Velázquez, he says, had to pay a lot of duty on the paintings he brought from Italy as the customs officials imagined that anything for the King must be very important.

For Velázquez's probable itinerary, see Pita Andrade 1960b, pp. 151-2.

p. 26 Doc. 120 for the instructions about Cortona. There is no record of any contact between Velázquez and Cortona, even though Palomino says Cortona befriended the Spaniard in Rome.

Arrival in Modena: Doc. 130: the letter, dated 12 December 1650, says Velázquez had arrived that morning.

Cardinal de la Cueva fiercely attacks Velázquez and his mission ('this man goes around asking for statues and paintings without paying for them') in three letters, Docs. 115-17, the last announcing his return from Naples where he had gone to get money: Doc. 113.

His visit to Gaeta is mentioned in a letter from Madrid, 21 June 1650: Doc. 124.

For the correspondence about the 'obra', see Docs. 120 ff. and Harris 1960b. Palomino describes Velázquez's mission in words very similar to those of Carducho on Primaticcio's (p. 95). Philip IV and Velázquez would probably both have known of Leone Leoni's collection of casts in his house in Milan (Boucher, pp. 23-6).

On Hubert Le Sueur's and Poussin's commissions for casts, see Haskell and Penny, pp. 31, 32; Velázquez might have come across Le Sueur in Rome, though the exact dates of his visit in 1631 are not given. On Poussin's difficulties, see Harris 1960b, p. 123.

p. 27 For the application to make casts of statues in the Vatican Belvedere, see Martínez de la Peña y González, pp. 1-7.

For the surviving bronze casts, see Harris 1960b; Sánchez Cantón 1961a.

See the inventory of 1686 published by Bottineau; the previous inventory of 1666 is unpublished.

On Velázquez's admission to the Academy of St. Luke and the Virtuosi, see Harris 1958.

Díez del Valle, *VV* II, p. 61.

There is no evidence that Velázquez did give a self-portrait to the Academy. The inventory, nos. 52, 53: Doc. 209.

pp. 27-8 For the Pope's recommendation of Velázquez and the Nuncio's reply, see Docs. 131, 139; Harris 1958.

p. 28 The King's acknowledgement of the Viceroy's letter and his assistance: Doc. 133.

Colonna and Mitelli: Doc. 130; Velázquez's first contact with them is not known and they did not go with him to Spain.

Boschini, pp. 56-9.

pp. 28-9 Tintoretto's *Paradiso*: Doc. 158; Pita Andrade 1960c believes the painting mentioned by the Ambassador to be the version now in the Prado, and points to the interest of the 'memorias' left by Velázquez in Venice and

Rome, with references to vases as well as to paintings and sculptures.

p. 29 Doc. 135 for the announcement of Velázquez's arrival in Madrid and of part of the 'obra' shipped from Naples; Doc. 137 for the Nuncio's report of his return, and Doc. 139 for his promise to support Velázquez's ambition to become a member of a military order.

For the Florentine Ambassador's report, see Justi 1923, II, pp. 151-2.

Doc. 145 for Velázquez's appointment as Chamberlain; Docs. 165-6 for the order for him and other officials to be lodged in the Casa del Tesoro.

p. 30 Andrés, p. 409, for Chifflet's account.

Santos 1657, fols. 42-47v.

The *Memoria*: Doc. 177, with brief bibliography; see also Gaya Nuño 1963, no. 1.131.

Vitelleschi: Doc. 171; Pita Andrade 1960c, pp. 289-90. He mentions the 'memoria' or inventory enclosed with the letter but has not yet published it. John Evelyn, who visited the house of Vitelleschi in 1644, 'certainly thought it one of the best collections of statues in Rome', pp. 283, 365.

Mazo: Doc. 173; Caturla 1955, p. 73, on Mazo's visit to Italy.

p. 31 Malvasia, II, pp. 406-9, on their work in the royal palace; he says that it took three attempts to get Colonna and Mitelli to go to Spain; he does not mention Velázquez's intervention. He likens the King of Spain's collection of casts (on which he says he spent 30,000 scudi) to those acquired by Primaticcio for François I. Palomino (pp. 121-2), on the propriety of Catholic artists using statues as models, says these were available thanks to Philip IV and Velázquez.

p. 32 Velázquez's letter: Harris 1960a.

Guidi's *Christ* (Plate 112): Tormo 1925, pp. 131-2; Gómez Moreno, p. 514. Paintings taken to the Pantheon: those listed by Francisco de los Santos 1657, fol. 142 (without mention of Velázquez), included El Greco's *'Gloria'*. Fuensalida, in his deposition in support of Velázquez's proofs of nobility: *VV* II, p. 333.

On Morelli see Agulló and Pérez Sánchez, pp. 109-20.

Gramont, pp. 43-7. Pita Andrade 1960a, p. 405, publishes instructions for the reception of Gramont; the King was to await him in the *sala ochavada*.

p. 33 The miniature, recorded only by Palomino, is lost.

The proceedings relating to the proofs and eventual investiture of Velázquez are printed in *VV* II, Doc. 183, pp. 301-77.

p. 34 On Velázquez's exemption, see Valgoma y Díaz-Varela, pp. 683-7. A copy of the statutes of the Order was in Velázquez's library (Doc. 209, p. 399, no. 562).

p. 35 Castillo 1667. Docs. 186 ff. for the accounts of the expenses on the journey.

Velázquez's letter, dated 3 July 1660, Doc. 195.

p. 36 According to the burial certificate, Doc. 204, Velázquez died on 7 August, but this may have been the date of the burial. Palomino gives the date of death as 6 August, as in the epitaph by the Alfaros, and so does Díez de Valle, Doc. 203: 'Velázquez', he writes, 'whom his Majesty loved well', died on Friday 6 August at 3 p.m. His wife, according to the burial certificate, Doc. 206, died on 14 August.

His possessions were not released until 11 April 1666 (Doc. 224).

For the inventories of his apartment in the palace and of his personal possessions in the Casa del Tesoro, see Docs. 205 and 209; see also Sánchez Cantón 1942.

Palomino's account of the richness of his attire at the ceremony on the Isle of Pheasants is supported by the number of jewels, gold chains and watches in his possession, among them a badge of the Order of Santiago, 'of small, thin diamonds, with two diamond rosettes' (Doc. 209, no. 98).

CHAPTER 2: *Early Work in Seville: 1617-1623*

p. 37 For Velázquez's signatures on paintings, see MacLaren and Braham, p. 58, note 11.

The inventory has never been published. The paintings by Velázquez recorded then are: *A Stag's Head* (see López-Rey 1979, no. 33), *Expulsion of the Moriscos* (lost) and *Bacchus* (Plate 64).

The paintings mentioned by Pacheco known today are the portraits of *Góngora* (Plate 29) and the *Queen of Hungary* (Plate 61), the latter possibly not the version painted in Naples, according to Pacheco.

p. 43 Pacheco's precepts: Pacheco II, pp. 208-12: The Virgin of the Immaculate Conception; pp. 318-19: St. John the Evangelist, who, he says, should be shown as an old man at the time he wrote the Apocalypse; pp. 362 ff.: Christ crucified with four nails.

p. 44 Apsley House paintings: 'Catalogue of the principal pictures found in the baggage of Joseph Bonaparte. Made by Mr. Seguier on their arrival in

London: No. 22 Water Seller, No. 137 Boys drinking, M. A. Caravaggio'
(Wellington, I, pp. xvii, xx).

On the *bodegones*, see especially the latest detailed study by Haraszti-Takács,
pp. 21–48.

p. 49 Pacheco I, p. 414: advice to Catholic painters.

p. 52 On Montañés, see Proske.

p. 53 Gaya Nuño 1961. Despite the obvious similarities to the low-life
characters in the picaresque novel, Velázquez's characters are not rogues as
they are in literature. Compare, for instance, the *Old Woman Cooking Eggs*
(Plate 28) and the very similar scene in *Guzmán de Alfarache*, noted by
Brigstocke, pp. 176–8.

p. 54 Unfortunately Ribera's biographer Mancini (I, pp. 149–50) does not
name his Spanish patron. For the history of the rediscovery of the paintings,
see Felton. For the latest assembly of the various versions of the Five Senses
– originals and copies – see Pérez Sánchez and Spinosa, nos. 2–6. Some of
these half-length figures behind tables with still-life had not surprisingly
been previously attributed to Velázquez.

The Spanish name of the prior of the hospital in 1593, Camillo Contreras,
is a possible argument in favour of the reading 'Seville'. Mancini, I, p. 224;
II p. 112, note 886.

For the record of Caravaggios in Spain, see the pioneer article by Ainaud de
Lasarte, 1947; the same author, 1957, for Ribalta's copy of the *Crucifixion of
St. Peter*.

On Caravaggio and Spanish naturalism, see the exhibition *Caravaggio y el
Naturalismo Español* (Pérez Sánchez 1973), and many publications celebrat-
ing the fourth centenary of Caravaggio's birth.

Pacheco I, p. 144, says Caravaggio was one of the six painters from Italy
honoured by Philip III; II, 13 for his mention of the copies of Caravaggio's
Crucifixion of St. Peter. Ponz, p. 791, mentions a good copy in the Church of
San Felipe Neri, Seville; Ribalta's small signed copy was probably in Valen-
cia.

For Pacheco's drawings for his *Libro de Retratos*, see Asensio; Pacheco 1868.

CHAPTER 3: *At Court: the 1620s*

p. 57 The death of Villandrando in December 1622, a few months after
Velázquez's first visit to Madrid, left a vacancy that the artist from Seville
was soon to fill (González died five years later). See López-Rey 1968–9.

p. 58 For the eulogies see *VV* II, pp. 11–15. Pacheco's sonnet is published
in translation in Appendix I (pp. 193–4), that of Vélez de Guevara in Appen-
dix II (p.200).

López-Rey (1979, no. 36) believes the early portrait to be underneath the
Philip IV in Black (Plate 52) – visible in the radiographs; but even if this were
true it cannot be said to have survived.

p. 59 López-Rey (1979, nos. 50, 49) includes both the São Paulo and
Metropolitan Museum portraits as autograph but gives opinions for and
against their acceptance.

p. 60 On the *golilla*, one of the many dress reforms introduced by Philip IV
and worn throughout his reign, see Anderson, pp. 1–19.

p. 61 Harris 1970, for extracts from Cassiano's diary and discussion of the
portraits of Olivares by Rubens and Pontius.

p. 64 Carducho, pp. 270–1: Caravaggio and his evil influence; p. 190: why
great painters were not good portraitists.

p. 66 Martínez, p. 117, gives a detailed account of the competition; accord-
ing to the footnote, Velázquez's painting was said to have been removed by
the French General Sebastiani, but there is no knowledge of it after the fire.
Portraits for the Duke of Mantua: Luzio, pp. 56 ff.; the letters from the
Ambassador, Alessandro Striggi, Docs. 31–3. The ordering of the portraits
was, he says, a strategy to win support for the Duke's proposed marriage.
The friend was Gaspar de Fuensalida, Witness 95 in the proofs for Veláz-
quez's admission to the Order of Santiago: *VV* II, p. 333.

p. 67 Rubens's letter: Magurn, p. 292.

Pacheco I, p. 153, expresses amazement at the number of paintings Rubens
made in such a short time.

p. 68 Commission of 1628: Harris and Elliott. López-Rey 1979, no. 48,
points out that the evidence for dating Velázquez's portrait either October
1628 or December 1630 is inconclusive; for stylistic reasons he prefers the
later date. As a model for other portraits of the Queen it is more likely to
have been painted in Madrid than Naples, i.e. in 1628, but possibly never
sent to Vienna.

p. 74 Ponz, p. 1587 (1794, comparing the physiognomy of figures in some
of Velázquez's *bodegones*). Earlier, p. 525 (1776), he describes the subject
simply as a figure playing the part of Bacchus in a sort of Bacchanal. Goya's
etching is dated 1778.

Plate 66: Soria 1953, pp. 278–83, first suggested this engraving as a source.
Angulo 1961 compares the message of the engraving to Velázquez's attitude
to the subject, in an article arguing convincingly against the interpretation
of Velázquez's mythologies as burlesque.

CHAPTER 4: *First Visit to Italy: 1629–1631*

p. 75 Pacheco I, pp. 150–1; Palomino, pp. 242 and 844, and later writers
repeat Pacheco's account of Diego de Rómulo.

On Ribera in Rome, see Chenault 1969, pp. 561–2; 1976, pp. 305–7.
Martínez, pp. 33–5.

p. 76 Harris 1980, for the payment in 1634.

See Costello for the disproof of the story of the 12 pictures. Nevertheless,
it has died hard.

On Cassiano's *Museum Chartaceum*, see Haskell 1963, pp. 101–4. On the
doubts about the busts, see above, note to p. 21.

Justi's account of Velázquez's impressions of Rome given in the guise of a
diary (1922, I, pp. 297–302; not in the English edition) was attacked when
it appeared in the first edition of his *Velazquez* but, as he explained (1906,
p. 246), the diary was a literary form and not intended to give the impression
of an authentic document.

p. 77 Palomino only mentions his meeting with Ribera on his second Italian
visit.

The copy of Tintoretto's *Last Supper* was brought to notice and published
by Norris. López-Rey 1963, no. 9, does not accept the identification. The
explanation may be that Palomino failed to question the attribution given
to the painting in the palace inventory.

For the *Views of the Villa Medici Gardens* see chapter 7.

Florentine Ambassador's letter: Doc. 45. The Ambassador stressed Veláz-
quez's position at the Spanish court, a favourite of the King and Olivares,
but Velázquez apparently put off his visit to Florence for twenty years.

For portraits of the Condesa de Monterrey, see López-Rey 1963, nos. 581,
582. His no. 582 was in the exhibition *Velázquez y lo Velazqueño*, Madrid,
1960, no. 165, and, as he says, is certainly not by Velázquez (or Ribera); but
it is possibly a copy of a lost original. Camón Aznar 1964, I, pp. 425 ff.,
identifies the portrait in Berlin (López-Rey 1963, no. 593) as that of the
Condesa de Monterrey because of the likeness to her tomb portrait in
Salamanca. But this painting is also of doubtful authorship.

For the portrait of the Queen of Hungary, see above, p. 68.

p. 79 On the portrait in Rome (Plate 68), see Trapier, p. 157 and note 263
for opinions on whether the sitter is Bernini or Velázquez. In the exhibition
Velázquez y lo Velazqueño it appeared (no. 87) as 'Velázquez, *Self-Portrait* (?)',
with bibliography and an account of varying opinions.

Wittkower 1958, p. 113, on the influence of Velázquez on Bernini's self-
portraits in the Prado and Borghese Gallery, writes: 'In fact some of Ber-
nini's pictures of the 1640s are superficially so similar to those of the great
Spaniard that they were attributed to him.'

López-Rey 1979, no. 96 (among others), includes the Valencia painting
among the autograph works ('fragment of a much damaged painting'); for
replicas see López-Rey 1963, nos 177–8, 182–4.

The drawing from the collection of Stirling-Maxwell (Plate 70) appeared as
the frontispiece to his *Catalogue of Prints*, 1873. If the inscription is to be
trusted, this may be a copy of a drawing rather than a painting by Velázquez.
Mentioned by Brown 1975, p. 61; McKim Smith, no. 17, fig. 10 as among
the 'Questionable Drawings'; Benesch, no. 21, fig. 38 as 'Velázquez, Self-
portrait'.

p. 80 First recorded in the Buen Retiro by the Portuguese poet Manuel de
Gallegos in his *Silva topográfica*, 1637: *VV* II, pp. 27–31. He makes clear
reference to *Joseph's Coat*, but the other painting he records by Velázquez,
Apollo and Marsyas, is either a mistake for *Apollo and Vulcan* or a reference
to a lost painting. It is unlikely to be the lost painting of the subject usually
attributed to the artist's last years, a companion to Plate 165.

Justi 1889, pp. 168 ff. For the possible Christian meaning, Harris 1938, p.
74.

p. 81 Plate 72: 1668, fol. 80 (*VV* II, pp 63–5); not mentioned in the 1657
edition. Two old copies of the painting show the original width (cf. López-
Rey 1979, p. 288, fig. 112; Angulo Iñiguez 1978, p. 84, fig. 3). For reference
to Alfaro's painting, see Valverde Madrid, p. 191.

p. 84 Martínez, p. 118. 'He arrived in Madrid', Martínez adds, 'with some
excellent paintings with which His Majesty considered himself well served'.

p. 85 For instance, Tintoretto's *Christ Washing the Disciples' Feet* (Escorial)
from the collection of Charles I, admired by Velázquez when it came to Spain
and possibly known by him in Venice.

CHAPTER 5: *Madrid, 1631–1649: Portraits*

p. 86 Report on royal portraits: Doc. 53, see above, note to p. 16.

p. 87 See López-Rey 1963 on the many portraits of Philip IV and Baltasar Carlos.

On Pareja, see Gaya Nuño 1957.

Mazo's marriage to Francisca Velázquez: Doc. 51; his appointment as Gentleman Usher: Doc. 58; as Court Painter: Doc. 214. For other documents concerning Mazo and his family, see López Navío 1960; on Mazo, see also Gaya Nuño 1960, and Trapier 1963.

p. 90 For Alfaro's reference to himself as Velázquez's pupil, see the heading of his sonnet that prefaced *Festejos de Pindo* (1662) by his brother Enrique Vaca de Alfaro, co-author of Velázquez's epitaph published by Palomino and author of a poem dedicated and devoted to Velázquez (*VV* II, pp. 36–8). On Alfaro see Palomino, pp. 999–1005, Ramírez de Arellano, pp. 68–76, Viñaza, IV, 1894, pp. 76–80, Valverde Madrid, with documents. The sonnet is published by Ramírez de Arellano and Viñaza.

p. 91 Plate 79: Brown and Elliott, pp. 55–6, 253–4, are surely correct in relating this portrait to the ceremony of swearing the oath of allegiance to the Prince, which took place in the church of San Jerónimo on 7 March 1632. The ceremony was postponed from 22 February, when the Prince (born 17 October 1629) would have been 2 years and four months old, which was, as they point out, presumably his age according to the original inscription, where the number of years is now missing. For this reason López-Rey interpreted it as 1 year and four months and dated the portrait 1631 (1979, no. 51). Following this dating Camón Aznar, I, pp. 437-40, suggested it was the Wallace Collection portrait of Baltasar Carlos, where he appears a little older, that commemorates the ceremony of 1632.

That Velázquez played an important part in the execution of the portraits of Philip III and the two Queens is generally acknowledged and they are rightly included in his oeuvre, even though they are not wholly autograph. The suggestion that the portrait of Philip III and possibly that of Philip IV were begun in 1628 is supported by orders (1 June and 3 September 1628) for Velázquez to be given from the armoury everything he needed for the portraits he was making of the King and his predecessor (a month later an order was given for Rubens to be given what armour he needed for his portrait of the King on horseback). See Beroqui, p. 77. The portrait of Philip IV, however, which is wholly autograph, appears to have been executed entirely after Velázquez's return from Italy.

p. 92 On Rubens's decorations for the entry into Antwerp, see Martin.

p. 99 On the portrait of *Prince Baltasar Carlos in the Riding School*, see Harris 1976; Levey, p. 142.

p. 103 The complicated story of the commission, completion and arrival in Madrid of the equestrian statue of Philip IV by Tacca is admirably summarized, with reference to the documents published by Justi, by Brown and Elliott, pp. 111–14.

pp. 103–4 On Montañes's visit to Madrid to make a bust of the King to send to Florence and Velázquez's portrait of him see also Sánchez Cantón 1961b; Proske, pp. 121–3.

p. 104 Baldinucci, p. 70. Movement, he claims, gives likeness to a portrait.

p. 108 The assertion made by Brown and Elliott, pp. 132–3, 254–5, that the six portraits of jesters formerly in the Buen Retiro are the subject of a document of payment to Velázquez made in December 1634 and were installed in a special room, which they call the *Pieza de los Bufones*, is not substantiated and has been challenged by López-Rey (*GBA* 98, 1981, pp. 163–6). Their argument was restated and again refuted (*ibid.*, pp. 191–2). López-Rey 1979, no. 102, questions the traditional identification of the dwarf called *El Primo* (Plate 103) and suggests that the so-called Sebastián de Morra, his no. 103 (Plate 104) might be the dwarf painted at Fraga. In any case they are of about the same date. I have given them their traditional names.

p. 113 On the portrait of Philip IV at Fraga, see Beruete y Moret; Docs. 91, 92.

p. 115 For the proposed dating of *The Lady with a Fan*, see Harris 1975.

CHAPTER 6: *Madrid, 1631–1649: Subject Pictures*

p. 117 For various opinions on dating, possible influences and the unusual subject-matter of Plate 109, see MacLaren and Braham, pp. 119–31; see also Trapier 1948, pp. 118–21, who aptly notes that the figures and their attitudes 'recall the wooden polychrome figures grouped in much the same relationship to each other in the *pasos* of Holy Week processions.'

p. 118 Pacheco II, pp. 362 ff., on Christ crucified with four nails. Montañes

(Plate 111): Proske, pp. 39–42.

Plate 112: See above, note to p. 32.

p. 120 The story of the scandal that was the origin of the 'Christ of San Plácido' is published (from a contemporary manuscript) by Mesoneros Romanos, Appendix 3, pp. 376–8.

Brown and Elliott, p. 254, argue convincingly for the original placing of the altarpiece in the hermitage of Saint Paul by 1633; they suggest it was moved to the hermitage of Saint Anthony, where it is recorded in 1701, when the former hermitage underwent alterations and was painted by Colonna and Mitelli. But it was in the oratory of St. Paul's hermitage that Palomino saw the *Saint Anthony Abbot and Saint Paul the Hermit*.

p. 124 The Queen's oratory is not included in the inventories of the Alcázar made in 1666, 1686 or 1701 – before Palomino.

Pacheco II, p. 302: The Virgin after her Assumption; II, p. 197: God the Father should have long hair and beard.

p. 125 The first reconstruction of the *Salón* was made by Tormo 1911–12, a basic article; see also Justi I, 1922, pp. 357 ff., and most recently the detailed reconstruction (according to the 1701 inventory) and study of the paintings in Brown and Elliott, pp. 141–92. Rubens's equestrian portrait of the Cardinal Infante at Nördlingen (Prado) was one of the paintings bought by Philip IV at the sale of the artist's estate.

On Velázquez's only surviving history painting, see in particular Saxl, pp. 314–18; Brown and Elliott, pp. 178–84, with notes on other literature.

p. 130 On the concern for the accuracy of the hunting scenes painted in Antwerp, see Alpers, pp. 124–7.

Juan Mateos, *Origen y Dignidad de la Caça*, 1634. Another manual known to Velázquez was Alonso Martínez de Espinar's *Arte de Ballesteria y Monteria*, 1644. On Velázquez's *Boar Hunt*, see MacLaren and Braham, p. 101 ff.

On the comparison with the *Riding School* (where Juan Mateos is portrayed), see Harris 1976.

p. 132 'Four portraits of different persons and dwarfs by Velázquez', according to the inventory of 1701. See Alpers, pp. 128–30 and 290 ff. The identity of these sitters is not certain (see p. 129, notes 279, 80).

Alpers, pp. 133–6, puts forward good reasons for the presence of Aesop and Menippus but rejects the suggestion that they are in the tradition of Ribera's philosophers and beggars; a formal relationship, however, cannot be denied.

p. 134 Angulo Iñiguez 1960, p. 176, while pointing out several Spanish representations of Mars with moustache, rejects any sign of burlesque and suggests that Velázquez's Mars reflects the military state of the country. Salas 1977 sees the pagan god as if ridiculed and suggests the painting may imply criticism of dreams of military grandeur.

p. 136 On the Venus, see MacLaren 1943, before the discovery of the 1651 inventory; MacLaren and Braham, pp. 125–9 for the history of the painting and a study of its subject and sources; here it is pointed out that during cleaning in 1966 there was no evidence of extensive repainting of the face as had previously been suggested. López-Rey's discovery (1979, no. 106) of mention of the painting in 1692 on the ceiling of a room in the late owner's house – possibly a bedroom – may explain why this masterpiece of Velázquez escaped the notice of Palomino.

CHAPTER 7: *Second Visit to Italy: 1649–1651*

p. 141 For a recent study of the *Views* with evidence for dating, see Harris 1981b.

p. 143 On Andreas Schmidt (called in Spain Andrés de Smidt), see Lafuente 1944, pp. 94 f.; Agulló and Pérez Sánchez, pp. 110–13; Agulló Cobo, pp. 102, 161–2, 184. By 1663, the date of his only known painting, he had settled in Spain, where he was a friend of Morelli, whom he probably knew in Rome. He made his will in Madrid, where he still lived in 1678.

p. 146 The report on Donna Olimpia is cited in Chiomenti, p. 173, note 10. On the paintings by and attributed to Velázquez in the Carpio collection, see Pita Andrade 1952; Harris 1957; Pita Andrade 1960a, pp. 406–13. Several additional documents are cited in López-Rey 1979.

The earliest certain mention of the portrait in a family inventory is in that of the Pope's great-nephew Giovanni Battista Pamphili, undated; see Garms, p. 318: 'Ritratto di papa Innocenzo X. di p. 5 e 6 a sedere mano di Diego Valasco con cornice liscia indorata'.

On the 'memorial', see above, note to p. 30.

p. 147 See Kris and Kurz, p. 63, on the motif of the lifelikeness of portraits, that goes back to an anecdote in Pliny.

It was no doubt El Greco's debt to Titian that caused Palomino to stress Velázquez's admiration of his portraits.

p. 150 Reynolds, 23 June 1786, to the Duke of Rutland: Hilles, p. 152.

See Boschini, pp. 56–9 (*VV* II, pp. 34–6) for Velázquez's visit to Venice and his conversation in Rome with Salvator Rosa, not elsewhere mentioned.

p. 151 The Pope's rewards: see above, p. 27.

For Neri's signed copies, see López-Rey 1963, nos. 444, 445.

p. 153 Giovanni Giacomo Rossi, *Effigies ... summorum Pontificum et Cardinalium, defunctorum ab anno 1608*, Rome [n.d.].

The oval form of the copy (Plate 157) suggests that it might have been made for engraving, but neither this nor the original appears to have been the model for the engraving in Rossi's *Effigies*. On the Hispanic Society portrait, see Trapier 1948, pp. 304–9. On the 'lost' portrait belonging to the Marqués del Carpio, see Pérez Sánchez 1960. The painting in the Hermitage can be identified by the number 4688 on the front with the old copy of Plate 158 recorded in Mayer, no. 429.

On Velázquez and Camillo Massimi, see Harris 1958, 1960.

One other extant portrait convincingly dated to Velázquez's stay in Rome is López-Rey 1979, no. 113; the identification of the sitter by Mayer as the Pope's barber (mentioned by Palomino) is without foundation. The unfinished Roman portraits mentioned by Palomino have not survived; possibly they suffered the fate of those which Baldinucci says were finished by another painter at the owner's request (see *VV* II, p. 70).

CHAPTER 8: *Last Years: 1651–1660*

p. 155 The *pieza ochavada*, 'designed and arranged by Velázquez', according to Palomino, is described by the Tuscan Ambassador, Lodovico Incontri, in a letter from Madrid, 30 August 1651, quoted by Justi II, 1923, pp. 141–2. On Mazo's portrait, see Bottineau 1955, pp. 114–16. The *pieza ochavada* is first described in the 1666 inventory (unpublished), which is referred to in the publication of the 1686 inventory by Bottineau, 1958, pp. 55–61.

For the *Salón de los espejos*, not included in the 1666 inventory, see Bottineau 1958, pp. 34–47.

p. 156 For the drawings, see Harris 1961; for the modello (Plate 166), see Feinblatt 1965 and Bonet Correa 1964.

p. 159 The identification of the subject by Angulo Iñiguez 1948 was followed by the discovery of the inventory in which the painting was listed in 1664 by Caturla 1948. For Alfaro's will (1680), see Valverde Madrid, p. 200.

p. 166 Palomino's detailed descriptions of the portraits of the Prince and Princess suggests that he must have seen versions of them or was quoting someone, possibly Alfaro, who had seen the originals. No other version of the Prince is known; in a replica of the portrait of Margarita (now in Budapest) the clock is a little clearer but in neither version are the details Palomino gives recognizable.

On the amulets worn by the Prince, see Hildburgh 1955.

p. 170 Sánchez Cantón 1943, pp. 9–10, cites the first mention of *Las Meninas* in the 1666 inventory of the Alcázar. For the description of the painting in 1686 and a full description of the room where it hung in 1686, see Bottineau 1958, pp. 296–9.

p. 171 For the description of the room in the 1686 inventory (it is not in the previous one), see Bottineau 1958, pp. 450–3.

p. 174 Van Eyck's painting, taken to Spain by Mary of Hungary in 1556, is not identified in the royal inventories before 1701.

Comparison with a Dutch interior was suggested by Saxl, p. 321. Allegory: as an example of this kind of interpretation, see, for instance, Emmens.

The painter's standing: Brown 1973, p. 109. His Chapter 4, 'On the Meaning of *Las Meninas*', is a detailed study of earlier views on the meaning of the painting, rejecting both Justi's and Emmens's, with an exposition of the author's thesis that whatever the painting represents it is meant as a blow struck for the nobility of painting and painters and is related to the battle for painting to be declared a liberal art that was still being fought.

In the summer of 1656, French peace plans, involving the marriage of Louis XIV to María Teresa were first mooted or revived (Hume, pp. 464–6), thus making the Infanta Margarita, the protagonist of *Las Meninas* and the King's only other child at the time, his only hope of perpetuating the Habsburg rule in Spain (this view was put forward by Salas 1977).

p. 175 Vasari, VII, p. 452.

p. 176 Clark, pp. 31–40.

CHAPTER 9: *Summing Up*

p. 178 López-Rey 1979 has only 129 entries that include half a dozen drawings and one miniature, but opinions on autograph and non-autograph works are by no means unanimous. McKim Smith classifies the drawings anew, introducing some new problems. One etching, a portrait of Olivares, has been attributed to Velázquez: see López-Rey 1963, no. 651 (of doubtful authorship). The only contemporary writer to say that he used a graver as well as canvas is Enrique Vaca de Alfaro in his *Lyra de Melpómene*, 1666; *VV* II, pp. 36–8.

On the economic decline of Seville, see Angulo Iñiguez 1981, I, p. 5.

p. 179 For contemporary records of every kind of festival, see Alenda y Mira; for modern accounts (with references to Velázquez), see Varey 1968, 1972; Varey and Salazar 1966.

On Philip IV's correspondence with the nun, see Saxl, pp. 318 ff. Kendrick, 1967, chapters IX–XI.

p. 180 Vaca de Alfaro: see note to p. 90.

Palomino, pp. 161–3, summarizes the fight for painting to be declared a tax-free liberal art, won in 1677 after the seventh demand. Lópe's and other pleas are published in the appendix to Carducho's *Diálogos*. Calderón in his deposition in 1677 cites Philip IV's attitude to Velázquez as an example of the high esteem in which painting has been held through the ages. See Wilson; see also Lafuente 1944. For a recent detailed study of the Liberal Arts campaign, see Gállego 1976.

p. 181 On the theatre, see Shergold, and Shergold and Varey; on festivals and performances in the Buen Retiro, Brown and Elliott, pp. 199 ff.

Zurbarán and Cano were witnesses 84 and 85, *VV* II, pp. 328–9.

p. 184 See the biography of Goya by his son [1831], English translation, Harris 1969, pp. 23–4.

Velázquez was the only Old Master copied by Goya in engraving.

For the catalogue of his copies after Velázquez, see Tomás Harris, II, nos. 4–19.

For Goya's letter from Bordeaux, 20 December 1825, and on the miniatures, see in particular Sayre.

p. 185 Quevedo, 'El Pincel' [1629], *Las tres Musas ultimas castellanas*, 1670. *VV* II, pp. 19–20.

Anton Rafael Mengs, *Obras*, Madrid, 1780, p. 210; *VV* II, p. 135.

p. 188 *Manet raconté par lui même*, pp. 42–3. References to Velázquez and Romanticism, Impressionism, Modern Art and Picasso are given in the subject index of Gaya Nuño, 1963, p. 135. See also Crombie, pp. 124–8; Réau; *Art into Art*, pp. 41–7; Stevenson, p. 126; the list is endless.

p. 189 Stirling's *Velázquez* first appeared in a less full version, with a catalogue of paintings instead of prints after the paintings, in his *Annals*, 1848.

Justi 1889, pp. 6, 4.

Religious interpretation: an extreme example is the *Water Seller*; not only has it been invested with a sacramental quality, it has been related to the Three Ages of Man and interpreted as an allegory of Providence and a 'personal emblem of Prudence and Good Counsel' (see in particular Moffitt).

The king's quasi-divine character: this view was first put forward by López-Rey 1963, pp. 37–40, as an illustration of what he called the 'divine-human polarity of Velázquez's art'.

Interpretations of *Las Meninas* and *Las Hilanderas*: see, for instance, Emmens, cited above (*Las Meninas*), and Tolnay (*Las Hilanderas* and *Las Meninas*), who invests both paintings with symbolical meaning, explaining the pictures on the wall in the latter painting as myths symbolizing the victory of divine art over craftsmanship – the reason for Velázquez's inspired attitude. Similar attempts to 'explain' Velázquez's paintings in terms of symbol and allegory have been attempted by later critics. Karr, pp. 128–202, placing *Las Meninas* in the tradition of gallery pictures (not for the first time; see Brown 1978, p. 87, note), also takes the paintings on the wall to be a commentary, and a very complicated one, on the main subject, as 'images of punishment for temerity', connected somehow with 'the artist's boldly assertive stance'.

p. 190 'Professional status': Volk 1978, p. 75. In this article the author pursues the theme first elaborated by Brown though indicated by previous critics – the theme of *Las Meninas* as a 'subtle proclamation of the nobility of painting'. She surveys the history of the professional status of the artist in the seventeenth century, with reference to a number of previously unpublished documents (extracts printed in an Appendix). But, as she herself admits, the message that she attributes to *Las Meninas* was perhaps less recognized in Madrid in the seventeenth century than it is today; which is surely an argument against its being accepted as a message of concern for the artist's status, rather than a statement of Velázquez's pride in his achievement, as it surely is.

Bibliography

The texts of Pacheco and Palomino, together with other important sources, such as Velázquez's friends Jusepe Martínez and Lázaro Díez (or Díaz) del Valle and various contemporary eulogies in verse, later biographies and commentaries and most of the known documents, were collected in one volume of major usefulness published on the occasion of the third centenary of Velázquez's death: *Varia Velazqueña*, vol. II, Madrid, 1960. The many other publications to which the centenary gave rise are included in the monumental bibliography compiled by Juan Antonio Gaya Nuño: *Bibliografía crítica y antológica de Velázquez*, Madrid, 1963. With 1,814 entries covering the literature on the artist from his own time until 1961, this is an invaluable aid to the study of every aspect of Velázquez. The same author recorded in chronological sequence a selection of later bibliography up till 1964 in his article on Velázquez in the *Encyclopedia of World Art*, New York [etc.], vol. 14, 1967. Since then the literature on Velázquez has continued to grow and it is no easy task to keep pace with it. Two Catalogues Raisonnés have appeared within the last two decades, both by José López-Rey: *Velázquez. A Catalogue Raisonné of his Oeuvre*, London, 1963, covering all the works by or attributed to the artist, and *Velázquez: the Artist as a Maker*, Lausanne–Paris, 1979, restricted to those which the author considers autograph. Reference to the latter catalogue is given in the captions to the illustrations of Velázquez's works.

A list of all the literature that has contributed to the present brief study of Velázquez would fill many pages. I can only hope that no direct source or debt has been overlooked. I have attempted in the following bibliography to include the principal works consulted as well as the books and articles referred to in abbreviated form in the notes and captions.

ABBREVIATIONS

AEA Archivo Español de Arte
BM Burlington Magazine
GBA Gazette des Beaux-Arts
JWCI Journal of the Warburg and Courtauld Institutes
VV I, II Varia Velazqueña, Madrid, 1960, vols. I, II
Doc. refers to the numbered documents published in chronological sequence in *Varia Velazqueña* II.
L–R in the captions refers to the catalogue entries in López-Rey, 1979.
Pacheco references in the notes are to Sánchez Cantón's edition of the *Arte de la Pintura*, 1956.
Palomino references in the notes are to M. Aguilar's edition of the *Museo Pictórico*, 1947.

AGULLÓ, MERCEDES, and PÉREZ SÁNCHEZ, ALFONSO E., 1976. 'Juan Bautista Morelli', *AEA* 49, pp. 109–20.

AGULLÓ COBO, MERCEDES, 1978. *Noticias sobre pintores madrileños de los siglos XVI y XVII*, Granada.

AINAUD DE LASARTE, JUAN, 1947. 'Ribalta y Caravaggio', *Anales y Boletín de los Museos de Arte de Barcelona* 5, pp. 345–410.

AINAUD DE LASARTE, 1958, 'Francisco Ribalta. Notas y Comentarios', *Goya*, pp. 86–9.

ALENDA Y MIRA, JENARO, 1903. *Relaciones de Solemnidades y Fiestas públicas de España*, Madrid.

ALPERS, SVETLANA, 1971. *The Decoration of the Torre de la Parada*, London and New York (Corpus Rubenianum, vol. 9).

ANDERSON, RUTH MATILDA, 1969–70. 'The Golilla: a Spanish Collar of the 17th Century', *Waffen and Kostum-Kunde*, 11–12, pp. 1–19.

ANDRÉS, GREGORIO DE, 1964. 'Relación de la visita de Felipe IV en 1656 al Escorial por su capellán Julio Chifflet', *Documentos para la historia del Monasterio de El Escorial*, Madrid, VII, pp. 405–431.

ANGULO IÑIGUEZ, DIEGO, 1947. *Velázquez. Como compuso sus principales cuadros*, Seville.

ANGULO IÑIGUEZ, DIEGO, 1948. 'Las Hilanderas. Sobre la iconografía de Aragne', *AEA* 21, pp. 1–19.

ANGULO IÑIGUEZ, DIEGO, 1960. 'La Fábula de Vulcano, Venus y Marte y "La Fragua" de Velázquez', *AEA* 33, pp. 149–81.

ANGULO IÑIGUEZ, DIEGO, 1961. *Velázquez y la mitología*. III Centenario de la muerte de Velázquez. Instituto de España, Madrid, pp. 47–62.

ANGULO IÑIGUEZ, DIEGO, 1970. *Pintura del siglo XVII* (Ars Hispaniae, XV), Madrid.

ANGULO IÑIGUEZ, DIEGO, 1978. 'Varia. Retrato del Conde Duque de Olivares. "La Túnica de José"', *AEA* 51, p. 84, fig. 3.

ANGULO IÑIGUEZ, DIEGO, 1981. *Murillo*, Madrid.

APARICIO OLMOS, EMILIO M., 1966. *Palomino: su arte y su tiempo*, Valencia.

Art into Art. Works of Art as a Source of Inspiration, 1971. An exhibition presented by the Burlington Magazine at Sotheby & Co., London.

ASENSIO, J.M., 1886. *Francisco Pacheco, sus obras artísticas y literarias*, Seville.

AZCÁRATE, JOSÉ MARÍA, 1960. 'Noticias sobre Velázquez en la Corte', *AEA* 33, pp. 357–85.

BALDINUCCI, FILIPPO, 1682. *Vita del Cavaliere Bernini*, Florence.

BARRIONUEVO, JERÓNIMO DE, *Avisos*, ed. Paz y Melia, Biblioteca de Autores Españoles, vols. 221, 222, Madrid, 1968–9.

BATICLE, JEANNINE, 1960. 'Recherches sur la connaissance de Velázquez en France de 1650 à 1830', *VV* I, pp. 532–52.

BENESCH, O., 1979. *From an Art Historian's Workshop*, Lucerne.

BEROQUI, PEDRO, 1917. 'Adiciones y correcciones al Catálogo del Museo del Prado', III, *Boletín de la Sociedad Castellana de Excursiones*.

BERUETE, AURELIANO DE, 1898. *Velázquez*, Paris. (English edition London, 1906.)

BERUETE Y MORET, AURELIANO DE, 1911. *El Velázquez de Parma. Retrato de Felipe IV, pintado en Fraga*, Madrid.

BIRKMEYER, KARL M., 1958. 'Realism and Realities in the Paintings of Velasquez', *GBA* 52, pp. 63–77.

BONET CORREA, ANTONIO, 1964. 'Nuevas obras y noticias sobre Colonna', *AEA* 37, pp. 307–12.

BOSCHINI, MARCO, 1660. *La carta del navegar pittoresco*, Venice, pp. 56–9 (ed. Anna Pallucchini, Venice, 1956).

BOTTINEAU, YVES, 1955. 'Portrait of Queen Mariana in the National Gallery', *BM* 97, pp. 114–16.

BOTTINEAU, YVES, 1956, 1958. 'L'Alcázar de Madrid et l'inventaire de 1686.

Aspects de la cour d'Espagne au XVIIe siècle', *Bulletin Hispanique*, 58, pp. 421–52; 60, pp. 30–61, 145–79, 289–326, 450–83.

BOUCHER, BRUCE, 1981. 'Leone Leoni and Primaticcio's Moulds of Antique Sculpture', *BM* 123, pp. 23–6.

BRAHAM, ALLAN, 1970. *See* Maclaren.

BRAHAM, ALLAN, 1972. *Velázquez* (Themes and Painters in the National Gallery, 3), London.

BRIGSTOCKE, HUGH, 1978. *Italian and Spanish Paintings in the National Gallery of Scotland*, HMSO.

BROWN, JONATHAN, 1970. *See* ENGGASS.

BROWN, JONATHAN, 1975. 'Spanish Baroque Drawings in North American Collections', *Master Drawings*, 13, pp. 60–3.

BROWN, JONATHAN, 1978. *Images and Ideas in Seventeenth-Century Spanish Painting*, Princeton.

BROWN, JONATHAN, and ELLIOTT, J.H., 1980. *A Palace for a King: The Buen Retiro and the Court of Philip IV*, New Haven and London.

BRUNETTI, ESTELLA, 1960. 'Per il soggiorno fiorentino del Velázquez', *VV* I, pp. 296–300.

CALVO SERRALLER, FRANCISCO, 1981. *Teoría de la pintura del siglo de oro*, Madrid.

CAMÓN AZNAR, JOSÉ, 1964. *Velázquez*, Madrid.

CAMÓN AZNAR, JOSÉ, 1970. 'Copia de un dibujo de Velázquez', *Goya*, pp. 30–1.

CARDUCHO, VICENTE, 1633. *Diálogos de la Pintura*, Madrid (ed. Francisco Calvo Serraller, Madrid, 1979).

'Cartas de algunos Padres de la Compañía de Jesús sobre los sucesos de la monarquía entre los años de 1634 y 1648', *Memorial histórico español*, Madrid, vols. 13–19, 1851–1918.

Cartas de Sor María de Agreda y de Felipe IV, ed. Carlos Seco Serrano, Biblioteca de Autores Españoles, vols. 108, 109, Madrid, 1958.

CASTILLO, LEONARDO DEL, 1667. *Viaje del Rey Nuestro Señor Don Felipe Cuarto el Grande a la Frontera de Francia*, Madrid.

CATURLA, MARÍA LUISA, 1948. 'El coleccionista madrileño D. Pedro de Arce, que poseyó "Las Hilanderas" de Velázquez', *AEA* 18, pp. 293–304.

CATURLA, MARÍA LUISA, 1958. 'Sobre un viaje de Mazo a Italia', *AEA* 28, p. 73.

CATURLA, MARÍA LUISA, 1960a. 'Cartas de pago de los doce cuadros de batallas para el Salón de Reinos del Buen Retiro', *AEA* 30, pp. 333–55.

CATURLA, MARÍA LUISA, 1960b. 'Velázquez y Zurbarán', *VV* I, pp. 463–70.

CEÁN BERMÚDEZ, J.A., 1800. *Diccionario histórico de los mas ilustres profesores de las bellas artes en España*, Madrid.

CHENAULT, JEANNE, 1969. 'Ribera in Roman Archives', *BM* 111, pp. 561–2.

CHENAULT, JEANNE, 1976. 'Jusepe de Ribera and the Order of Christ: New Documents', *BM* 118, pp. 305–7.

CHENAULT PORTER, JEANNE, 1979. 'Ribera's Assimilation of a Silenus', *Paragone*, 30.2 (no. 355), pp. 41–55.

CHIOMENTI, DONATA, 1979. *Donna Olimpia*, Milan.

CLARK, KENNETH, 1960. 'Six Great Pictures, 3: "Las Meninas" by Velázquez', *Sunday Times*, London, 2 June 1957, p. 9. Reprinted in *Looking at Pictures*, London, 1960.

COSTA, FELIX DA, [1696], 1967. *The Antiquity of the Art of Painting*, Introduction and notes by George Kubler, New Haven and London.

COSTELLO, JANE, 1950. 'The Twelve Pictures "Ordered by Velázquez" and the Trial of Valguarnera', *JWCI* 13, pp. 237–84.

COVARRUBIAS OROZCO, SEBASTIÁN DE, 1943. *Tesoro de la lengua castellana*, ed. M. de Riquer, Barcelona.

CROMBIE, THEODORE, 1963. 'Velázquez Observed. New Looks at an Old Master', *Apollo*, 78, pp. 124–8.

CRUZADA VILLAAMIL, G., 1885. *Anales de la vida y de las obras de Diego de Silva Velázquez. Escritos con ayuda de documentos*, Madrid.

DEL LUNGO, ISIDORO, and FAVARO, ANTONIO, 1915. *Dal Carteggio e dai Documenti. Pagine di Vita di Galileo*, Florence.

DÍEZ (OR DÍAZ) DEL VALLE, LÁZARO, 1656, 1659. *Epílogo y nomenclatura de algunos Artífices ... Origen e illustración del nobilíssimo y Real Arte de la pintura y dibujo ...* (manuscript in the Instituto Diego Velázquez, Madrid). Extracts printed in *VV* II, pp. 59–62, and *Velázquez. Homenaje*, pp. 24–9.

ELLIOTT, J.H., 1976. *See* Harris.

ELLIOTT, J.H., 1970. *Imperial Spain 1469–1716* (2nd edn.), Harmondsworth.

ELLIOTT, J.H., 1980. *See* Brown.

EMMENS, J.A., 1961. 'Les Ménines de Velasquez: Miroir des Princes pour Philippe IV', *Nederlands Kunsthistorisch Jaarboek*, 12, pp. 51–79.

ENGGASS, ROBERT, and BROWN, JONATHAN, 1970. *Italy and Spain 1600–1750.*

Sources and Documents, Englewood Cliffs, N.J.

EVELYN, JOHN, 1955. *The Diary of John Evelyn*, ed. E.S. de Beer, Oxford.

FEINBLATT, EBRIA, 1965. 'A "Boceto" by Colonna-Mitelli in the Prado', *BM* 107, pp. 349–57.

FELTON, CRAIG, 1969. 'The Earliest Paintings of Jusepe de Ribera', *Bulletin, Wadsworth Atheneum*, Hartford, Connecticut, 5, pp. 2–11.

FERNÁNDEZ BAYTON, GLORIA (prepared by), 1975, *Inventarios Reales. Testamentaría del Rey Carlos II 1701–1703*, I, Museo del Prado, Madrid.

FERNÁNDEZ BAYTON, GLORIA (prepared by), 1981. *Inventarios Reales. Testamentaría del Rey Carlos II 1701–1703*, II, Museo del Prado, Madrid.

FICHTER, W.L., 1960. 'Una poesia contemporánea inédita sobre las bodas de Velázquez', *VV* I, pp. 636–9.

GÁLLEGO, JULIÁN, 1974. *Velázquez en Sevilla*, Seville.

GÁLLEGO, JULIÁN, 1976. *El Pintor de Artesano a Artista*, Granada.

GARMS, JOERG, 1972. *Quellen aus dem Archiv Doria-Pamphilj zur Kunsttätigkeit in Rom unter Innocenz X*, Rome, p. 318.

GAYA NUÑO, JUAN ANTONIO, 1953. 'Después de Justi. Medio siglo de estudios Velazquistas', Appendix to the Spanish edition of Justi, *Velázquez y su siglo*, Madrid.

GAYA NUÑO, JUAN ANTONIO, 1956. *Palomino*, Cordova.

GAYA NUÑO, JUAN ANTONIO, 1957. 'Revisiones sexcentistas. Juan de Pareja', *AEA* 30, pp. 271–85.

GAYA NUÑO, JUAN ANTONIO, 1960. 'Juan Bautista del Mazo, el gran discípulo de Velázquez', *VV* I, pp. 471–81.

GAYA NUÑO, JUAN ANTONIO, 1961. 'Peinture picaresque', *L'Oeil*, 84, pp. 52 ff.

GAYA NUÑO, JUAN ANTONIO, 1963. *Bibliografía Crítica y Antológica de Velázquez*, Madrid.

GENSEL, WALTHER, 1905. *Velazquez. Des Meisters Gemälde* (Klassiker der Kunst), Stuttgart and Leipzig.

GÓMEZ MORENO, M.E., 1963. 'La escultura religiosa y funeraria en El Escorial', *El Escorial 1563–1963, IV Centenario de la fundación de San Lorenzo el Real*, Madrid, II, pp. 491–520.

GRAMONT, ANTOINE, DUC DE, 1827. Mémoires, in Claude B. Petitot (ed.), *Collection des mémoires relatifs à l'histoire de France*, series 2, 57, Paris.

GUDIOL, JOSÉ, 1960. 'Algunas réplicas en la obra de Velázquez', *VV* I, pp. 414–19.

GUDIOL, JOSÉ, 1974. *Velázquez*, London.

HARASZTI-TAKÁCS, MARIANNE, 1973–4. 'Quelques problèmes des *bodegones* de Velasquez', *Bulletin Musée Hongrois*, 40–43, pp. 21–48.

HARRIS, ENRIQUETA, [1938]. *The Prado. Treasure House of the Spanish Royal Collections*, London and New York.

HARRIS, ENRIQUETA, 1957. 'El Marqués del Carpio y sus cuadros de Velázquez', *AEA* 30, pp. 136–9.

HARRIS, ENRIQUETA, 1958a. 'Velázquez en Roma', *AEA* 31, pp. 185–92.

HARRIS, ENRIQUETA, 1958b. 'Velázquez's Portrait of Camillo Massimi', *BM* 100, pp. 279–80.

HARRIS, ENRIQUETA, 1960a. 'A Letter from Velázquez to Camillo Massimi', *BM* 102, pp. 162–6.

HARRIS, ENRIQUETA, 1960b. 'La Misión de Velázquez en Italia', *AEA* 33, pp. 109–36.

HARRIS, ENRIQUETA, 1961. 'Angelo Michele Colonna y la decoración de San Antonio de los Portugueses', *AEA* 34, pp. 101–5.

HARRIS, ENRIQUETA, 1967. 'Velázquez and Charles I. Antique Busts and Modern Paintings from Spain for the Royal Collection', *JWCI* 30, pp. 414–19.

HARRIS, ENRIQUETA, 1969. *Goya*, London.

HARRIS, ENRIQUETA, 1970. 'Cassiano dal Pozzo or. Diego Velázquez', *BM* 112, pp. 364–73.

HARRIS, ENRIQUETA, 1975. 'The Wallace Collection. The Cleaning of Velázquez's Lady with a Fan', *BM* 117, pp. 316–19.

HARRIS, ENRIQUETA, 1976. 'Velázquez's Portrait of Prince Baltasar Carlos in the Riding School', *BM* 118, pp. 266–75.

HARRIS, ENRIQUETA, 1980. 'G.B. Crescenzi, Velázquez and the "Italian" landscapes for the Buen Retiro', *BM* 122, pp. 562–4.

HARRIS, ENRIQUETA, 1981a. 'Velázquez and his Ecclesiastical Benefice', *BM* 123, pp. 95–6.

HARRIS, ENRIQUETA, 1981b. 'Velázquez and the Villa Medici', *BM* 123, pp. 537–41.

HARRIS, ENRIQUETA, and ELLIOTT, JOHN, 1976. 'Velázquez and the Queen of Hungary', *BM* 118, pp. 24–6.

HARRIS, TOMÁS, 1964. *Goya Engravings and Lithographs*, Oxford.

HASKELL, FRANCIS, 1963. *Patrons and Painters. A Study in the Relations between Italian Art and Society in the Age of the Baroque*, London.

HASKELL, FRANCIS, and PENNY, NICHOLAS, 1981. *Taste and the Antique. The Lure of Classical Sculpture*, New Haven and London.

HERNÁNDEZ PERERA, JESÚS, 1960a. 'Velázquez y las joyas', *AEA* 33, pp. 251–86.

HERNÁNDEZ PERERA, JESÚS, 1960b. 'Carreño y Velázquez', *VV* I, pp. 482–98.

HERRERO GARCÍA, MIGUEL, 1943. *Contribución de la literatura a la historia del arte*, Madrid.

HILDBURGH, W.L., 1955. 'Images of the Human Hand as Amulets in Spain', *JWCI* 18, pp. 67–89.

HILLES, F.W., 1929. *Letters of Sir Joshua Reynolds*, Cambridge.

HOLT, ELIZABETH GILMORE, 1958. *Literary Sources of Art History* (2nd ed.), New York.

HUEMER, FRANCES, 1977. *Rubens Portraits I*, London (Corpus Rubenianum, vol. 19).

HUME, MARTIN, 1907. *The Court of Philip IV. Spain in Decadence*, London.

HUXLEY, GERVAS, 1959. *Endymion Porter*, London and Toronto.

IÑIGUEZ ALMECH, FRANCISCO, 1960. 'La Casa del Tesoro, Velázquez y las obras reales', *VV* I, pp. 649–82.

Inventarios Reales. See Fernández Bayton.

JUSTI, CARL, 1888. *Diego Velazquez und sein Jahrhundert*, Bonn. (English edition, *Velazquez and his Times*, London, 1889.)

JUSTI, CARL, 1906. 'Das Tagebuch des Velazquez', *Kunstchronik*, p. 246.

JUSTI, CARL, 1922–3. *Diego Velázquez und sein Jahnhundert* (3rd edition), Bonn.

JUSTI, CARL, 1953. *Velázquez y su siglo*, Spanish edition, with appendix by Juan Antonio Gaya Nuño, Madrid.

KARR, MADLYN MILLNER, 1976. *Velázquez. The Art of Painting*, New York, Hagerstown, San Francisco, London.

KAUFFMANN, C.M., 1982. *Catalogue of Paintings in the Wellington Museum*, HMSO. (Published after this book went to press.)

KENDRICK, T.D., 1960. *Saint James in Spain*, London.

KENDRICK, T.D., 1967. *Mary of Agreda, 1602–65*, London.

KRIS, ERNST, and KURZ, OTTO, 1979. *Legend, Myth and Magic in the Image of the Artist*, New Haven and London.

LAFUENTE FERRARI, ENRIQUE, 1943. *Velázquez. Complete Edition*, London and New York.

LAFUENTE FERRARI, ENRIQUE, 1944. 'Borrascas de la pintura y triunfo de su excelencia', *AEA* 17, pp. 77–103.

LAFUENTE FERRARI, ENRIQUE, 1960. 'Velázquez y los retratos del Conde-Duque de Olivares', *Goya*, pp. 64–73.

LASSAIGNE, JACQUES, 1973. *Les Ménines*, Fribourg.

LEVEY, MICHAEL, 1971. *Painting at Court*, London.

LIGO, LARRY L., 1970. 'Two Seventeenth-Century Poems which Link Rubens' Equestrian Portrait of Philip IV to Titian's Equestrian Portrait of Charles V, *GBA* 75, pp. 345–54.

LÓPEZ NAVÍO, J., 1960. 'Matrimonio de Juan Bautista del Mazo con la hija de Velázquez', *AEA* 33, pp. 387–419.

LÓPEZ NAVÍO, 1961. 'Velázquez tasa los cuadros de su protector D. Juan de Fonseca', *AEA* 34, pp. 53–84.

LÓPEZ-REY, JOSÉ, 1946. 'On Velázquez's Portrait of Cardinal Borja', *The Art Bulletin*, 28, pp. 270–4.

LÓPEZ-REY, JOSÉ, 1960. 'Nombres y Nombradía de Velázquez', *Goya*, pp. 4–5.

LÓPEZ-REY, JOSÉ, 1963. *Velázquez: A Catalogue Raisonné of his Oeuvre*, London.

LÓPEZ-REY, JOSÉ, 1968. *Velázquez' Work and World*, London.

LÓPEZ-REY, JOSÉ, 1968–9. 'Muerte de Villandrando y fortuna de Velázquez', *Arte Español*, pp. 1–4.

LÓPEZ-REY, JOSÉ, 1979. *Velázquez: The Artist as a Maker. With a Catalogue Raisonné of his extant Works*, Lausanne-Paris.

LOZOYA, MARQUÉS DE, 1953. *La Rendición de Breda*, Barcelona.

LUZIO, A., 1913. *La Galleria dei Gonzaga Venduta all' Inghilterra nel 1627–28*, Milan.

MCKIM-SMITH, GRIDLEY, 1980. 'The Problem of Velázquez's Drawings', *Master Drawings*, 18, pp. 3–24.

MACLAREN, NEIL [1943]. *Velázquez. The Rokeby Venus* (Gallery Books, no. 1), London.

MACLAREN, NEIL, and BRAHAM, ALLAN, 1970. *National Gallery Catalogues, the Spanish School*, revised edition, London, National Gallery.

MCVAN, 1942. 'Spanish Dwarfs', *Notes Hispanic*, 2, New York, The Hispanic Society of America, pp. 97–129.

MADRAZO, PEDRO DE, 1884. *Viaje artístico de tres siglos por las colecciones de cuadros de los reyes de España*, Barcelona.

Madrid hasta 1875. Testimonios de su historia. Exhibition, Museo Municipal, Madrid, 1979–80.

MAGURN, R.S., 1955. *The Letters of Peter Paul Rubens*, Cambridge, Mass.

MALVASIA, CARLO CESARE, 1678. *Felsina pittrice, vite de' pittori bolognesi*, 2 vols., Bologna.

MANCINI, GIULIO, 1956. *Considerazioni sulla pittura*, I, text, ed. Adriana Marucchi, II, *Commento*, by Luigi Salerno, Rome.

Manet raconté par lui même et par ses amis, 1945, Geneva.

MARTIN, JOHN RUPERT, 1972. *The Decorations for the Pompa Introitus Ferdinandi*, London and New York (Corpus Rubenianum, vol. 16).

MARTÍNEZ, JUSEPE, [1675?], 1866. *Discursos practicables del nobilísimo arte de la pintura*, ed. V. Carderera, Madrid.

MARTÍNEZ DE LA PEÑA Y GONZÁLEZ, DOMINGO, 1971. 'El segundo viaje de Velázquez a Italia: dos cartas inéditas en los Archivos del Vaticano', *AEA* 44, pp. 1–8.

MAYER, AUGUST L., 1936. *Velázquez. A Catalogue Raisonné of the Pictures and Drawings*, London.

MESONEROS ROMANOS, RAMÓN DE, [1861], 1976. *El Antiguo Madrid*, Madrid.

MOFFITT, JOHN F., 1978. 'Image and Meaning in Velázquez's Water-Carrier of Seville', *Traza y Baza*, 7, Barcelona, pp. 5–23.

MORENO VILLA, JOSÉ, 1939. *Locos, Enanos, Negros y Niños Palaciegos. Siglos XVI y XVII*, Mexico.

MULLER, PRISCILLA E., 1960–1 [1961]. 'Francisco Pacheco as a Painter', *Marsyas*, 10, pp. 34–44.

MULLER, PRISCILLA E., 1972. *Jewels in Spain 1500–1800*, New York.

NORRIS, CHRISTOPHER, 1932. 'Velázquez and Tintoretto', *BM* 60, pp. 157–8.

ORBAAN, J.A.F., 1927. 'Notes on Art in Italy. Velázquez in Rome', *Apollo*, 6, pp. 28–9.

ORTIZ DE ZÚÑIGA, DIEGO, 1796. *Anales de Sevilla*, IV, Madrid.

PACHECO, FRANCISCO, [Seville, 1649], 1956. *Arte de la Pintura*, ed. F.J. Sánchez Cantón, Madrid.

PACHECO, FRANCISCO, [1599], 1868. *Libro de descripción de verdaderos Retratos de Ilustres y Memorables varones*, ed. José María Asensio, Seville.

PALM, ERWIN WALTER, 1967. 'Diego Velázquez: Aesop und Menipp, Lebende Antike', *Symposium für Rudolf Sühnel*, Berlin.

PALOMINO DE CASTRO Y VELASCO, ANTONIO [Madrid, 1715–24], 1947. *El Museo Pictórico y Escala Óptica*, ed. M. Aguilar, Madrid.

PANTORBA, BERNARDINO DE, 1960. 'Notas sobre cuadros de Velázquez perdidos', *VV* I, pp. 382–99.

PÉREZ SÁNCHEZ, ALFONSO E., 1960. 'Sobre la venida a España de las colecciones del Marqués del Carpio', *AEA* 33, pp. 293–5.

PÉREZ SÁNCHEZ, ALFONSO E., 1973. *Caravaggio y el Naturalismo Español*. Catalogue of exhibition, Seville.

PÉREZ SÁNCHEZ, ALFONSO E., 1976. *See* Agulló.

PÉREZ SÁNCHEZ, ALFONSO E., and SPINOSA, NICOLA, 1978. *L'Opera completa del Ribera*, Milan.

PITA ANDRADE, JOSÉ MANUEL, 1952. 'Los cuadros de Velazquez y Mazo que poseyó el séptimo Marqués del Carpio', *AEA* 25, pp. 223–36.

PITA ANDRADE, JOSÉ MANUEL, 1960a. 'Noticias en torno a Velázquez en el Archivo de la casa de Alba', *VV* I, pp. 400–13.

PITA ANDRADE, JOSÉ MANUEL, 1960b. 'El itinerario de Velázquez en su segundo viaje a Italia', *Goya*, pp. 151–2.

PITA ANDRADE, JOSÉ MANUEL, 1960c. 'Dos recuerdos del segundo viaje a Italia', *AEA* 33, pp. 287–90.

PONZ, ANTONIO, [Madrid, 1772–94], 1947. *Viaje de España*, ed. Casto María del Rivero, Madrid.

POZZO, CASSIANO DAL, 1626. 'Legatione del Signore Cardinale [Francesco] Barberini in Spagna', MS. Vatican Library, Barberini lat. 5689.

PROSKE, BEATRICE GILMAN, 1967. *Martínez Montañés, Sevillian Sculptor*, New York.

RAMÍREZ DE ARELLANO, R., 1853. *Diccionario biográfico de artistas de la provincia de Córdoba*, 'Colección Documentos Inéditos para la Historia de España', 107, Madrid.

RÉAU, LOUIS, 1963. 'Velázquez et son influence sur la peinture française du XIX^ème Siècle', *Velázquez, son temps, son influence*, Casa de Velázquez, Actes du colloque 1960, Paris, pp. 95–103.

RODRÍGUEZ VILLA, ANTONIO, 1886. *La corte y monarquía de España en los años de 1636 y 1637*, Madrid.

SALAS, XAVIER DE, 1962. *Velázquez*, London.

SALAS, XAVIER DE, 1977. 'Rubens y Velázquez', *Studia Rubeniana* II, Madrid.

SÁNCHEZ CANTÓN, F.J., 1916. *Los Pintores de Cámara de los Reyes de España*, Madrid.

SÁNCHEZ CANTÓN, F.J., 1925. 'La Librería de Velázquez', *Homenaje a Menéndez

Pidal, Madrid, pp. 379–406.

SÁNCHEZ CANTÓN, F.J., 1942. 'Cómo vivía Velázquez', *AEA* 25, pp. 69–91.

SÁNCHEZ CANTÓN, F.J., 1943. *Las Meninas y sus Personajes*, Barcelona.

SÁNCHEZ CANTÓN, F.J., 1960. 'La Venus del Espejo', *AEA* 33, pp. 137–48.

SÁNCHEZ CANTÓN, F.J., 1961a. *Velázquez y 'lo Clásico'*, Madrid.

SÁNCHEZ CANTÓN, F.J., 1961b. 'Sobre el "Martínez Montañés" de Velázquez', *AEA* 34, pp. 25–30.

SANTOS, FRANCISCO DE LOS, 1657. 1668. *Descripción breve del monasterio de S. Lorenzo del Escorial*, Madrid.

SAXL, F., 1957. 'Velasquez and Philip IV', *Lectures*, London, I, pp. 311–24.

SAYRE, ELEANOR A., 1966. 'Goya's Bordeaux Miniatures', *Boston Museum Bulletin*, 64, pp. 84–123.

SHERGOLD, N.D., 1967. *A History of the Spanish Stage*, Oxford.

SHERGOLD, N.D., and VAREY, J.E., 1963. 'Some Palace Performances of Seventeenth-century Plays', *Bulletin of Hispanic Studies*, 40, pp. 212–44.

SORIA, M.S., 1953. 'La Venus, Los Borrachos y la Coronación de Velázquez', *AEA* 24, pp. 269–84.

SORIA, M.S., 1957. 'Una carta poco conocida sobre Velázquez', *AEA* 30, pp. 135–6.

STEVENSON, R.A.M., [1895], 1962. *Velazquez*, ed. Theodore Crombie, London.

STIRLING, WILLIAM, 1848. *Annals of the Artists of Spain*, London.

STIRLING, WILLIAM, 1855. *Velazquez and his Works*, London.

STIRLING-MAXWELL, WILLIAM, 1873. *Essay towards a Catalogue of Prints Engraved from the Works of Velázquez and Murillo*, London.

STIRLING-MAXWELL, WILLIAM, 1891. *Annals of the Artists of Spain* (revised), London.

TOLNAY, CHARLES DE, 1949. 'Las Hilanderas and Las Meninas. An Interpretation', *GBA* 35, pp. 21–38.

TOLNAY, CHARLES DE, 1961. 'Las pinturas mitológicas de Velázquez', *AEA* 34, pp. 31–45.

TORMO, ELÍAS, 1911–12. 'Velázquez, el Salón de Reinos del Buen Retiro, y el poeta del palacio y del pintor', *Boletín de la Sociedad española de excursiones* 19, pp. 24–44, 85–111, 191–217, 274–305; 20, pp. 60–3 (reprinted in Elías Tormo, *Pintura, escultura y arquitectura en España*, Madrid, 1949).

TORMO, ELÍAS, 1925. 'Los cuatro Crucifixos de El Escorial', *AEA* 1, pp. 131–2.

TRAPIER, ELIZABETH DU GUÉ, 1948. *Velázquez*, New York.

TRAPIER, ELIZABETH DU GUÉ, 1963. 'Martínez del Mazo as a Landscapist', *GBA* 80, pp. 293–310.

TROUTMAN, PHILIP, 1965. *Velasquez*, London.

VALBUENA PRAT, ANGEL, 1943. *La vida española en la Edad de Oro según las fuentes litearias*, Barcelona.

VALGOMA Y DÍAZ-VARELA, D. DE LA, 1960. 'Por que el Santiaguista Velázquez no residió en galeras', *VV* I, pp. 683–91.

VALVERDE MADRID, JOSÉ, 1974. *El Pintor Juan de Alfaro*, Estudios de Arte Español, Real Academia de Bellas Artes de Hungría, Seville.

VAREY, J.E., 1963. *See* Shergold.

VAREY, J.E., 1968. 'Calderón, Cosme Lotti, Velázquez and the Madrid Festivities of 1636–1637', *Renaissance Drama*, New Series I, Northwestern University Press, Evanston, pp. 253–82.

VAREY, J.E., 1969. 'La mayordomía mayor y los festejos palaciegos del siglo XVII', *Anales del Instituto de Estudios Madrileños*, 4, pp. 145–68.

VAREY, J.E., 1972. 'Velázquez y Heliche en los festejos madrileños de 1657–1658', *Boletín de la Real Academia de la Historia*, 169, pp. 407–22.

VAREY, J.E., 1973. 'Processional Ceremonial of the Spanish Court in the Seventeenth Century', *Studia Iberica, Festschrift für Hans Flasche*, Berne, Munich, pp. 643–52.

VAREY, J.E., and SALAZAR, A.M., 1966. 'Calderón and the Royal Entry of 1649', *Hispanic Review*, 34, pp. 1–26.

Varia Velazqueña. Homenaje a Velázquez en el III centenario de su muerte, 1660–1960, 2 vols., Madrid, 1960.

VASARI, GIORGIO, 1878–85. *Le opere. Le vite …*, ed. G. Milanesi, Florence.

Velázquez. Homenaje en el tercer centenario de su muerte, Instituto Diego Velázquez, Madrid, 1960.

Velázquez y lo Velazqueño, 1960. Exhibition, Madrid.

VIÑAZA, EL CONDE DE LA, 1889–94. *Adiciones al Diccionario Histórico de Ceán Bermúdez*, Madrid.

VOLK, MARY C., 1978. 'On Velázquez and the Liberal Arts', *Art Bulletin*, 58, pp. 69–86.

VOLK, MARY C., 1960. 'Rubens at Madrid and the Decoration of the Salón Nuevo at the Palace', *BN* 122, pp. 168–180.

WELLINGTON, EVELYN, 1901. *Catalogue of Pictures et Apsley House*, 2 vols., London, New York and Bombay.

WETHEY, HAROLD, 1955. *Alonso Cano*, Princeton.

WETHEY, HAROLD, 1960. 'Velázquez and Alonso Cano', *VV* I, pp. 452–5.

WILSON, EDWARD M., 1974. 'El texto de la "Deposición a favor de los profesores de la Pintura", de Don Pedro Calderón de la Barca', *Revista de Archivos, Bibliotecas y Museos*, 77, pp. 710–27.

WILSON, EDWARD M., and MOIR, DUNCAN, 1971. *A Literary History of Spain. The Golden Age: Drama 1492–1700*, London and New York.

WITTKOWER, RUDOLF, 1955. *Gian Lorenzo Bernini: The Sculptor of the Roman Baroque*, London.

WITTKOWER, RUDOLF, 1958. *Art and Architecture in Italy 1600–1750*, Harmondsworth.

List of Plates

Index